TUGBOATS *of* NEW YORK

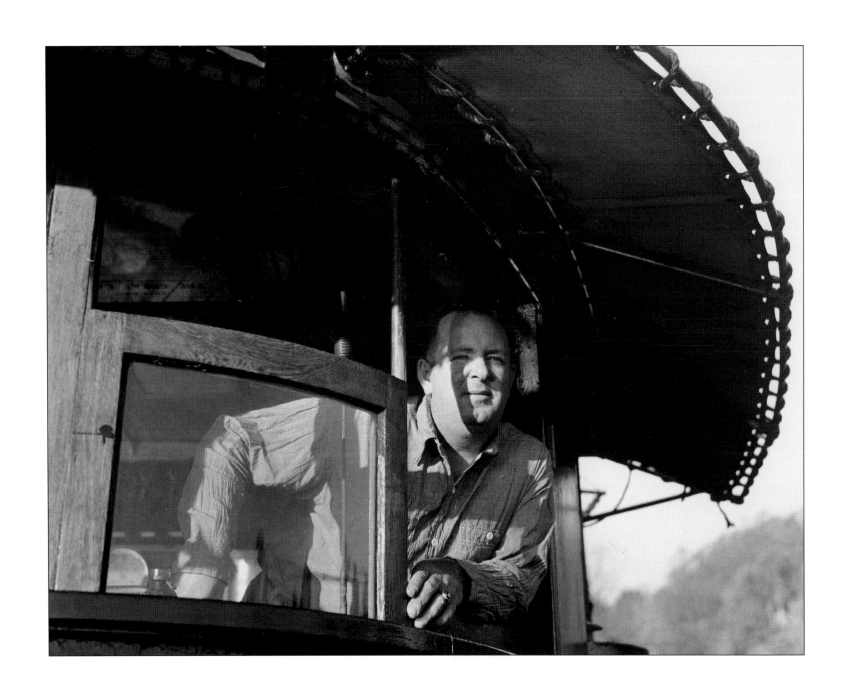

TUGBOATS *of* NEW YORK

An Illustrated History George Matteson

⌐ NEW YORK UNIVERSITY PRESS *New York and London*

FRONTISPIECE: "Captain Norris Brown of the tug *Hustler*
in the pilothouse as it traverses a section of the Erie Canal."
Photograph by Harold Corsini, October 1946, Special Collections,
Photographic Archives, University of Louisville.

NEW YORK UNIVERSITY PRESS
New York and London
www.nyupress.org

Book design by Charles B. Hames

Library of Congress Cataloging-in-Publication Data
Matteson, George, 1948–
Tugboats of New York : an illustrated history / George Matteson.
p. cm.
Includes bibliographical references and index.
ISBN 0–8147–5708–1 (cloth : alk. paper)
1. Tugboats—New York (State)—New York—History. I. Title.
VM464.M36 2005
387.2'32'097471—dc22 2005003060

New York University Press books are printed on acid-free paper,
and their binding materials are chosen for strength and durability.

Printed and bound in China

10 9 8 7 6 5 4 3 2

Contents

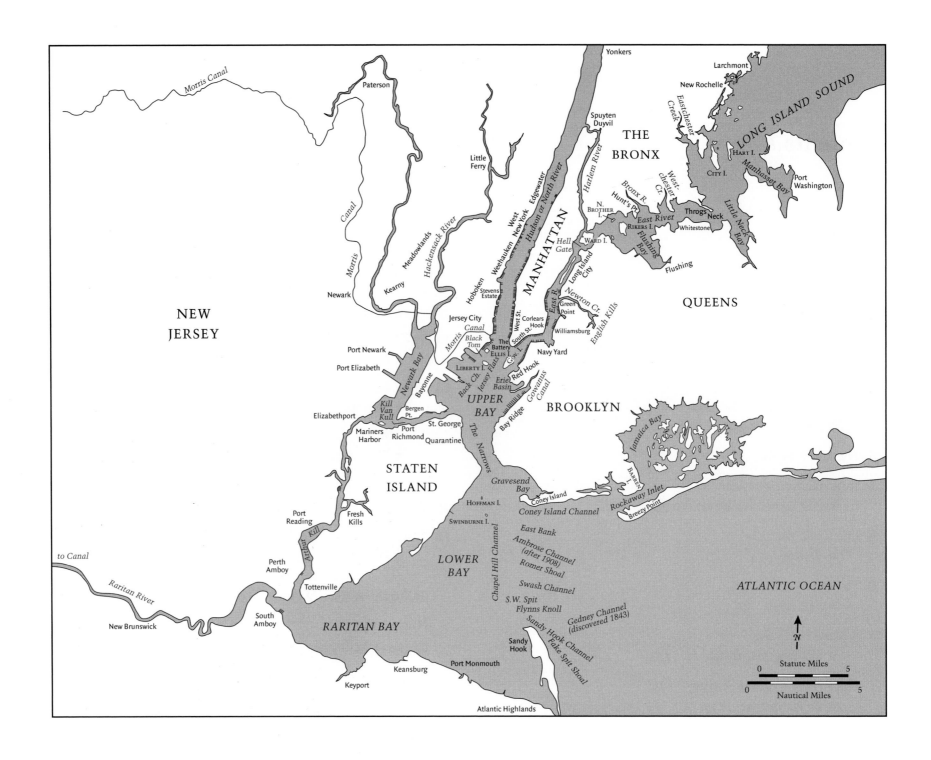

Introduction

New York has always been a seaport town. Until very recently both the East and West sides of Manhattan were lined with ships. Brooklyn, Staten Island, and all the neighboring shores of New Jersey were frantic with the give and take of marine commerce. The newspapers carried daily shipping reports that listed the arrival and departure not only of the vessels themselves but also of the passengers on them. Crowds swarmed at the Battery to greet the maiden arrivals of ships from Europe and Asia. News from overseas was precious; news *from* the sea, of shipwreck and weather, was almost equally dear. Many ships that frequented the port, and the names of their captains, were known to the public at large. The deeds of ships and captains alike were the focal point of a broad yearning for confirmation of the American self-image of enterprise, daring, and fortitude.

But it was not only the deep-sea class of mariners who captured the popular imagination. Another, homegrown type of vessel, the tugboat, worked its way into the awareness of the people. The tug and the mariners who worked them became icons of competence and reliable service to the port. From the beginnings of the tugboat business immediately following the first successful demonstration of Robert Fulton's *North River Steamboat* in 1807 there was a steady development of technology and skills that kept pace with the magnificent expansion of New York Harbor all through the nineteenth century and

through most of the twentieth. During that time, tugs established themselves as an essential part of the well-being and efficiency of the port. They assumed the duty of transporting vast quantities of produce, goods, and raw materials. They developed the capacity not only to nudge ships to and from their berths alongshore but also to range far out to sea in all sorts of weather to find and assist ships as they approached the harbor. The tugs toughened and grew in endurance enough to tow across oceans. They facilitated a succession of new industries such as the railroads and the broad-scale transport of coal and, later, of industrial chemicals and oil.

Although every seaport in America has tugboats, their history is revealed most completely in New York. Most of the crucial development of the trade took place in New York, and that is certainly where all those developments, wherever they first arose, have been thoroughly tested.

Today, much of the activity of the harbor has shifted away from the metropolis to the great shipping terminals of Ports Newark and Elizabeth. The number of tugs has diminished along with the Port of New York's position of East Coast and national dominance. But still, a glimpse of the water from any point in the city may include a passing tugboat; and any misty night may carry the sound of a tug's horn far up into the streets. They are still with us, and so is their story.

It was my great good fortune in about 1980 to fall in company with a few of the last of the independent tugboat operators in the harbor. I already had some experience in running sailing and motor vessels and had accumulated enough sea time to have sat for my original Coast Guard license, allowing me to operate small passenger vessels up to two hundred miles offshore. But I didn't want to operate passenger vessels. I had neither the patience nor the sociability to deal with passengers and guests all the time. But most of all, I wanted to learn as much seamanship as possible; and from what I could see from the shore, New York Harbor and its tugboats were the most compelling classroom around. The challenges of general seamanship are all magnified in the practice of towing. Because each tow is different, each requires special attention to rigging and maneuver. The skills normally devoted to the piloting of one vessel must, in towing, be applied with equal devotion to all the vessels that make up the tow. An example of the considerably higher level of seamanship involved in running a tug is the Coast Guard requirement that in order to qualify to take the examination for a basic towing license, it was necessary to serve 548 days—a full eighteen months—on board a tug in training *after* receiving the basic license that I had already achieved.

All of this was based on the slim odds of getting onto a tug in the first place. I had always been told that tug crews were made up almost exclusively of the sons and relatives of former tugboatmen. It was common knowledge that in the 1970s the number of working tugs was contracting rapidly as the fortunes of New York Harbor diminished under pressure from nationwide industrial changes, labor unrest, and the ever-increasing efficiency of the tugs themselves. Any working crew member would tell you that to get a job on a tug you had to be in the union. Furthermore, to get into the union you had to have a job on a tug. It sounds impossible, but it's not. You just have to be in the right place at the right time, and you've got to be lucky.

I was lucky. I was in New York. I knew a little about boats. I was between jobs, having just completed a book about commercial fishing on the New England banks. I ran into a tugboatman who needed a deckhand right away—meaning *now*. I dropped what I was doing and set out for the slip at the foot of Canal Street on the Hudson where the tug would pick me up. I thought at the time that in choosing to hire me he must be a very good judge of seamanlike ability. Before too long I came to understand that his expectations for me—as they were for all his new hires—were just about zero and that he was as surprised as I was that tugboating became for me a twenty-year vocation.

Toward the end of one of the first trips I made on that boat, we found ourselves coming into New York from the sea at about 0200. We were coming in with a good-sized tow consisting of a dredge and a barge loaded with equipment. We had brought them from Norfolk, Virginia, by way of Chesapeake Bay, the Chesapeake & Delaware Canal, Delaware Bay, and, finally, the 140-mile stretch of open coast from Cape May, New Jersey, to Sandy Hook.

---→

The tug *Luzerne* at water station in the Erie Basin in South Brooklyn. The *Luzerne* was a ninety-four-foot coal-fired steam tug built in 1899 at Port Richmond, Staten Island, and was originally named the *Fred B. Dalzell*. At the time of this image she was owned by the Olsen Water & Towing Company, owners of seven other tugs plus a number of lighters and barges used for supplying boiler water to ships and for general towing. The tall ladder propped against the side of the deckhouse is used for scaling the great distance between the deck of the tug and that of the ship. The bent-in condition of the railing around the deckhouse roof attests to years of working alongside ships whose flare of bow and stern inflicts frequent and cumulative damage. The Olsen company was founded in about 1918 and continued until the early 1950s, when it was acquired by Moran Towing.

Although many of the tugboatmen pictured in this book were identified by their photographers, the deckhand standing here is, unfortunately, anonymous. Photograph by Todd Webb, March 1947, Special Collections, Photographic Archives, University of Louisville.

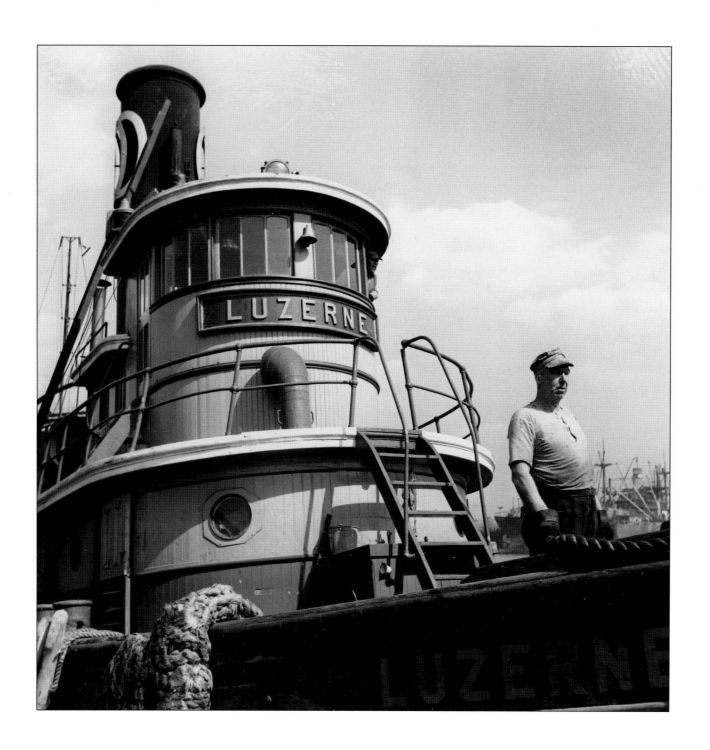

It was winter. It had not been particularly windy or rough on the way up the shore, but there had been a large ocean swell generated by a storm far out at sea. Five- to seven-foot waves had set us rolling rail to rail all the way up the coast. We had shipped a lot of water, and the dredge—heavy, low, and square—had shipped a great deal more. A lot of that water had evidently found its way below because, over the previous twenty-four hours, the dredge had begun to take on first a noticeable and eventually an alarming list. There was nothing to be done about it until we attained the relatively protected waters of the Lower Bay. Once there, it was important that we pull hawser as soon as possible, get the tug alongside the dredge, and start pumping it out. As the captain noted, even if the thing wasn't going to sink (which it was not likely to do now that we were in the shelter of the harbor), no self-respecting tug guy would bring a tow that looked "that freakin' awful" into the harbor. Within the tugboat community all are watchful of the practice of others. It is a way of learning as well as a way of comparing levels of skill and experience. To arrive with a half-sunk tow might easily be misconstrued. There were a few hours yet before daylight—still time to set things right.

There were four of us on board: captain, mate, and two deckhands. We hauled the tow a little way past the harbor entrance into the relative shelter of Raritan Bay, behind Swinburne Island, where the old Immigration Service crematorium once stood, and there we began to pull hawser, twelve hundred feet of eleven-inch-circumference nylon line, drawn aboard with the assistance of the slowly turning electric capstan mounted on the tug's stern deck. This was tended by the mate, while the other deckhand and I coiled the line down on the stern of the tug. The captain worked the tug from the control station atop the back end of the deckhouse. From that position he could see everything that we were doing and, with slight adjustments of helm and throttle, keep the tow laying quiet just a little off our starboard quarter, the purpose being to keep the hawser slack and riding in over the rail at an an-gle that gave those of us working on deck the most possible room and the greatest possible degree of safety from the line. We worked under floodlights, which produce a strange, isolated space where the rest of the world is cut off, the theater is small, and the breathing, the coughing, the low encouragements of those you are working with become more significant.

The coil of hawser grew on the stern, layer upon tightly packed layer, until the towing shackle appeared with a clunk at the top of the rail.[1] As big as a Rottweiler, it clambered aboard and tumbled

The *Eugene F. Moran* and the *William J. Tracy* team up on a docking job during the 1960s. It was common for a tugboat company with ship-docking contracts to hire boats from other companies to assist when several tugs were needed. The company dispatchers, responsible for scheduling their tugs as efficiently as possible, were given considerable freedom to hire in or trade off jobs with other companies as any given situation might warrant. The preferred practice was to hire in boats from companies that were not normally in direct competition for ship-docking work. Moran was and still is one of the most important ship-docking and general towing firms in the harbor; Tracy specialized in transporting coal barges around the harbor and went out of business around 1970.

The array of hawsers stowed on the stern deck of the *Eugene F. Moran* shows that she was used for a lot more than just ship docking. In fact, this boat and others of her class were extraordinarily versatile boats, capable of all manner of work within the harbor as well as coastal and ocean assignments. The tug's main hawser is the largest of the four coils. It is probably twelve hundred feet in length, coiled down in a tight pile of four or five layers. This practice allows the line to run out smoothly while at the same time storing it compactly enough to resist being disturbed by at least moderate seas washing aboard. Snaking around on top of the other three smaller coils of line are the two legs of heavy wire bridle, which are shackled into the end of the hawser and connect to either corner of the squared-off bow of the barge being towed. Mounted just aft of the deckhouse are the H-shaped towing bitts to which the hawser is secured when towing, and to the right of the bitts is the capstan, which, by taking several turns of the hawser around its revolving drum, is used to get the hawser, shackle, and bridle back aboard at the end of the voyage. Library of Congress, Prints & Photographs Division, Image 609116 262 134628.

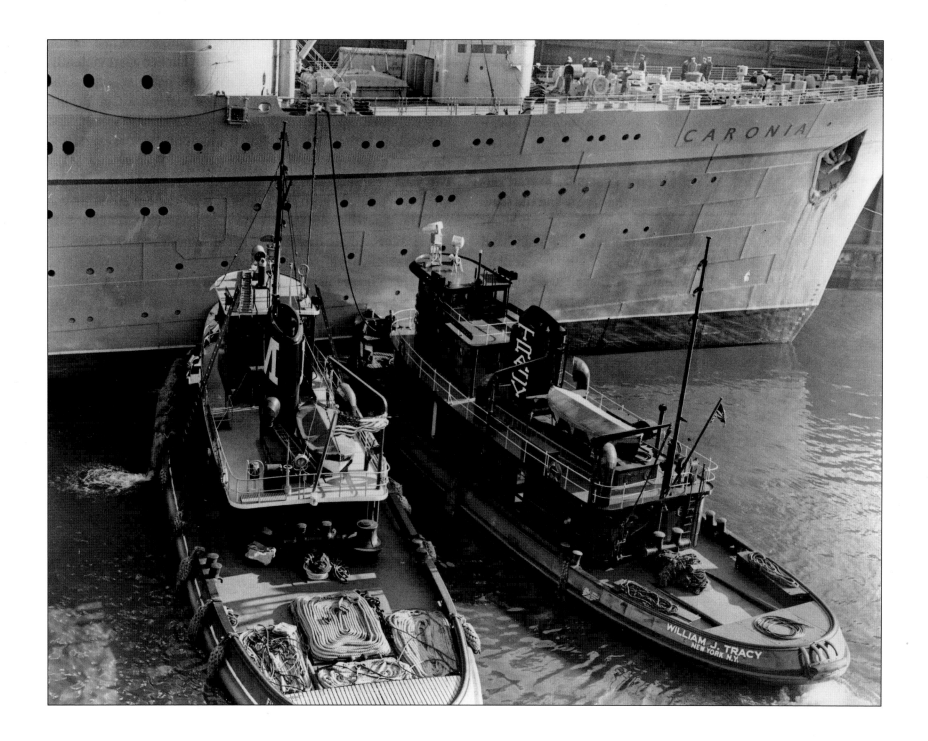

onto the deck, throwing sparks where it hit and drawing the two wire legs of the towing bridle behind it over the rail, sparking sullenly as they snaked up and over. We now had the dredge up short. We stopped heaving in line as the captain first edged the tug ahead to pull the tow directly in line with the stern and, a moment later, backed down so that the stern fender of the tug kissed up against the front of the dredge.

The captain sent the mate and me onto the dredge to start getting in the lighter hawser that connected the dredge and the scow behind. This piece of nylon was of lesser diameter and only about four hundred feet long. The two of us were able to get it in by hand by picking it up at the rail and walking inboard with it, one of us holding it there while the other went back to the rail to get another hold. Then we would again combine our efforts to haul in another thirty-foot piece. We repeated this about ten times, until the scow was close up to the stern of the dredge. The two of us were breathing hard, muttering back and forth between gasps as we coordinated our line handling so as not to leave each other unsupported.

We had just made the hawser secure and were getting ready to put out lines between the corners of the two barges when, without warning, a remnant of the big ocean swell that had plagued us all the way up the coast sneaked in over the shoals of the harbor mouth and rolled under us. The two hulls surged together with a crash and then rebounded to the limit of the bit of hawser we had just secured. The short line shrieked as it came tight and let off a burst of hot steam as it stretched to its limit but held and brought the dredge and scow recoiling back together once more. This second impact caught me unprepared and sent me flying off the stern of the dredge to land, not in the icy water where I probably would have soon died, but on the deck of the scow behind.

"Now that you're there, stay there," the mate said and tossed me the eye of the line that we would use to secure one of the corners of the barges. We passed the line back and forth until we had four parts stretched between the two bitts. The mate made his end

fast and was just stepping away when the surge returned. Again, the dredge and scow clashed together then bucked apart violently. The bitts on the dredge, to which the mate had just secured the line, peeled up off the steel deck like a scab off a Cub Scout's kneecap and disappeared over the side with a gloomy splash.

Although he couldn't see all that was going on, the captain by this time could tell that there was trouble. The impacts of the two barges coming together sent the water puddled here and there on the decks aloft in little devils of spray. "Put out anything you can," he shouted to us. The mate decided to put out as many parts of the intermediate hawser as possible, seven or eight turns between the middle bitts, four or five turns between the remaining corner bitts on the port side. We put out as much line between as many places as we could. It was a mess, but it held. When we were done I took the opportunity to leap back across onto the dredge; then the mate and I scrambled back aboard the tug.

"I guess we'll have to take this thing up through the Narrows as it is," the captain muttered. "Get a pump onto the dredge and start getting the water out." Fortunately, it being winter, we had a few more hours of darkness in which to slowly make our way up through the Narrows, pumping all the while, before we had to present ourselves to the scrutiny of our harbor brethren.

Towing is an inherently risky business, pitting men and their small but potent machinery against weather, water, and the scarcely measurable physics of ships and barges of far greater dimension. Sheer chaos lurks just beyond the horizon of skill and experience. Less than two hundred years ago a plainly conceived steamboat and her crew of ordinary boatmen attempted to assist a small ship in through the Narrows against drifting ice and a contrary current. The experiment succeeded, and so began a long refinement of machine and method that has resulted in the marine towing business of today. Much of this development occurred in and around the waters of New York Harbor. This story in many respects parallels the broader history of both New York's

and America's industrial and technological development; but it is also a story about people, in which the long American heritage of seamanship plays itself out under the lengthening shadows of our skyscrapers and the close inshore repercussions of finance and commerce. It is a story that takes into account the rise of new immigrant groups, the extinction of some livelihoods, and the creation of others. It has been the battlefield for some of the bitterest conflicts between labor and management. It goes on night and day, in all seasons, all around us.

The research for this story has come from many sources. The excellent Melville Library of the South Street Seaport Museum (now closed) and its vastly knowledgeable former historian, Norman Brouwer, were certainly the finest resource available to the study of New York maritime history. Norman's enormous contributions of both fact and encouragement have been a blessing to this project and many others.

The astonishing holdings of the New York Public Library, from the most obscure reports and pamphlets to major works, maps, photos, prints, and drawings is a treasure, as is the consistent quality of dedication and helpfulness on the part of that institution's entire roster of personnel.

The Museum of the City of New York, the New York City Archives, the New-York Historical Society, and the library of the New York State Maritime Academy at Fort Schuyler all contain enough valuable material to reward the grueling pleasures of individual research.

Farther afield, the G. W. Blunt White Library at Mystic Seaport, Mystic, Connecticut, contains a fine collection of sailing ship logbooks, plus other manuscript materials that have been invaluable. The Mariners Museum at Newport News, Virginia, though limited in its collections specific to New York, has provided generously from its manuscript archives and from its extraordinary collection of marine art, the works of James Bard in

Library of Congress, Prints & Photographs Division, neg. LC-USZ62-80149.

particular. The collections of the Steamship Historical Society, which are housed at the Langsdale Library of the University of Baltimore, the National Archives, and the Department of Prints and Photographs at the Library of Congress, have all provided invaluable material and research assistance.

The superb photographs contained in the Standard Oil Company Collection, of which this work makes extensive use, were brought to my attention by Sally Forbes, now executive director of the Beaux Art Alliance in New York City. For her assistance and that of Delinda Buie, curator at the Ekstrom Library of the University of Louisville, Louisville, Kentucky, where the collection is located, I am deeply grateful.

My good friend Charles Deroko has assisted this project from the very beginning, offering both encouragement and generous use of his valuable collection of technical information.

Special thanks are due to Deborah Gershenowitz, my editor at NYU Press, and to all those who work with her.

Finally, I wish to thank my wife, Adele, and daughter, Emily, for their love and patience.

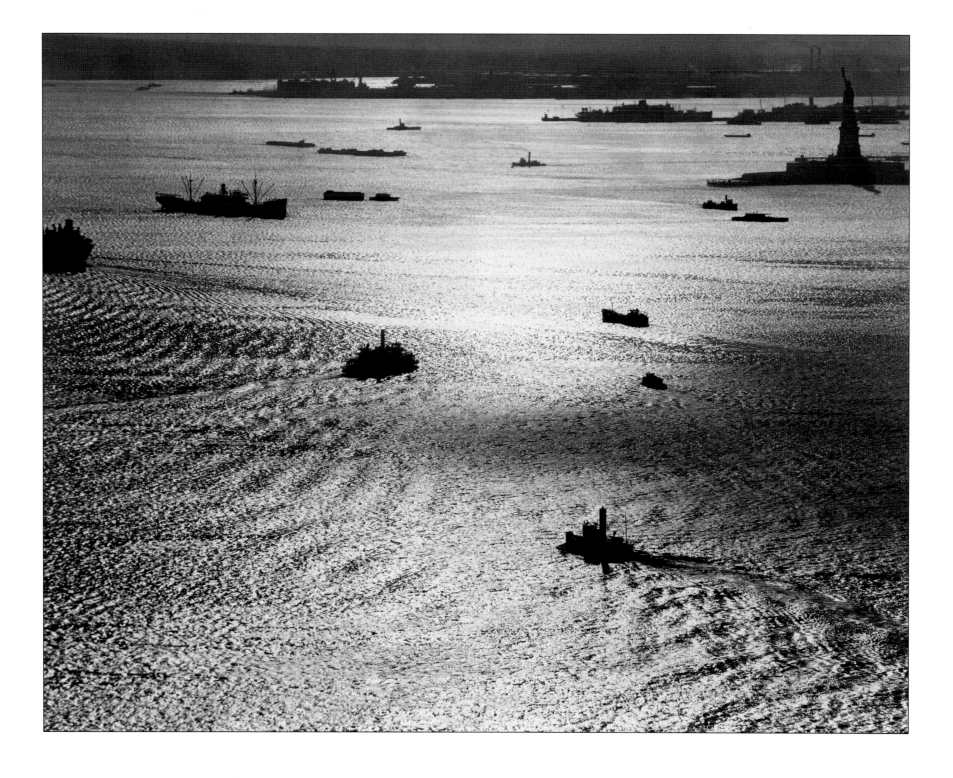

1

The Formation of New York Harbor

New York Harbor is a confluence of stone and silts, waters fresh and salt, varied peoples and ideas, infinite constructions and the raw materials necessary to them. Eleven hundred million years ago, what geologists now call the Manhattan Prong began to form under the relentless pressure of collision between tectonic plates bearing the North American and African continents.[1] The relatively soft ancient limestone seabed and the bands of harder volcanic crust that lay between the two continental masses were pushed together and upward, creating a tangled devil's-food-like mix of light and dark, hard and soft terrain. Over time the softer and more soluble marble eroded, leaving the courses for what have become most of New York's waterways. Farther west, in what is now Pennsylvania, the terrain was also tumbled and scoured, burying thick deposits of plant material that would eventually be metamorphosed into coal. A towering mountain range was thrown skyward only to be worn away and then replaced by another, equally lofty, and then yet another. The Taconic, the Arcadian, and finally the Appalachian mountain ranges successively climbed to Himalayan dimensions and then gently flowed away as sand, gravel, and clay. With the waxing and waning of these weights the bedrock faulted, generally heaving up to the east and receding to the west, producing the Palisades and behind it the slippery slope of New Jersey into Newark Bay, the Meadowlands, and the Hackensack marshes.

General view of Lower [*sic*] New York Harbor. Statue of Liberty on right. New York Harbor is divided into two general localities. The Upper Bay extends northward from the Narrows to the Battery. The Lower Bay extends southward from the Narrows to Sandy Hook.

But, regardless of such quibbles, the photographer has captured a splendid scene: the bright low sun of a midautumn afternoon, a brisk northwest wind, and an ebb tide. A century before, it was these conditions that brought sailing ships from their East River piers to Sandy Hook and on to sea without need of any tug. Photograph by Harold Corsini, November 1946, Special Collections, Photographic Archives, University of Louisville.

And then came ice.[2] As many as five times over the past million years the ice sheet has pushed down from the north. In its most recent advance, starting about one hundred thousand years ago, a mile-thick world of ice descended from central Canada and Labrador. Where the southward progress of the glacier stalled, where the rate of its melting equaled its speed of advance, it dumped its cargo of mud, sand, pebbles, cobbles, and boulders, forming a long sinuous ridge—a terminal moraine—which now describes Cape Cod, Nantucket, Martha's Vineyard, Block Island, Long Island, Bay Ridge in Brooklyn, the southern half of Staten Island, and out across New Jersey as far as the mountain states. By 18,000 B.C. the ice sheet was in full retreat, leaving the moraine to serve as a dam for its meltwater. Extensive lakes formed. Long Island Sound was entirely fresh. In fact, the Atlantic Ocean during the last Ice Age lay some 140 miles to the southeast of what are now the Long Island beaches. Most of the continental shelf was dry land and inhabited by ancient mammals. Even today their teeth come up in fishermen's nets towed far from any sight of land.

As the ice caps melted, the sea level rose about four hundred feet over the course of four thousand years, ten feet per century. The continental shelf was inundated; the terminal moraine was breached by the sea all along its length. About nine thousand years ago, Long Island Sound became an arm of the ocean; the Narrows, a tidal strait; the Hudson River Valley, 150 miles north to Albany, an estuary—a silt-choked gulley that some enthusiasts choose to call a fjord. Vagaries of terrain made Staten an island and the East River a tidal strait leading to Long Island Sound; and thus, Manhattan, the artifact of a thousand-million-year-old prong, was ready for business.

Most of that business is conducted at the will of the tides. Through the labyrinth of channels that make up the Upper and Lower bays, the Hudson, East, and Harlem rivers, the Kills that encircle Staten Island, Raritan, and Newark bays, and the Hackensack and Passaic rivers, the sea flows in and out twice daily. The rise and fall in the harbor is about five and one-half feet. At Troy, 145 miles north of the Battery, it is four and one-half. At the western end of Long Island Sound, where the East River meets the Sound at Throggs Neck, the rise and fall is seven feet. The East River currents flow at between three and four knots and, where they squeeze through Hell Gate, can run as fast as six. Along the Jersey shore of the Hudson, from Weehawken all the way down to Bayonne, the ebb current runs as fast as four knots. At the mouth of the harbor between Sandy Hook and Coney Island the tide pours in and out over the shoals at almost three knots, kicking up a cruel and sometimes deadly sea in an onshore gale. The behavior of the harbor currents and the consequences of that behavior have become a vital language learned by generations of boatmen.

Whether docking a ship at the North River piers, taking an empty scrap barge to a junkyard in the Bronx and bringing back a deeply loaded one, or delivering the components of a power plant to Albany, the tides and currents set the schedule for tugs. If done at slack water, the largest ship will almost dock itself. The trip to and from a scrap yard in the Bronx is best scheduled so as to pick up the loaded barge right at the peak of the tide. This will reward the tug with a fair current for every inch of the voyage, plus

Midtown Manhattan and Hudson River from West New York, New Jersey.
A northbound tow in the North River. The two lead barges are standard covered scows, the second in line belonging to the New York Central. The last barge in line is a covered barge equipped with a mast and two cargo booms that are used for loading heavy objects into the barge. The small second-story structure surrounding the base of the mast is a winch room containing a big horizontal cylinder gasoline engine and a winch to do the hoisting.
Photograph by Todd Webb, November 1947, Special Collections, Photographic Archives, University of Louisville.

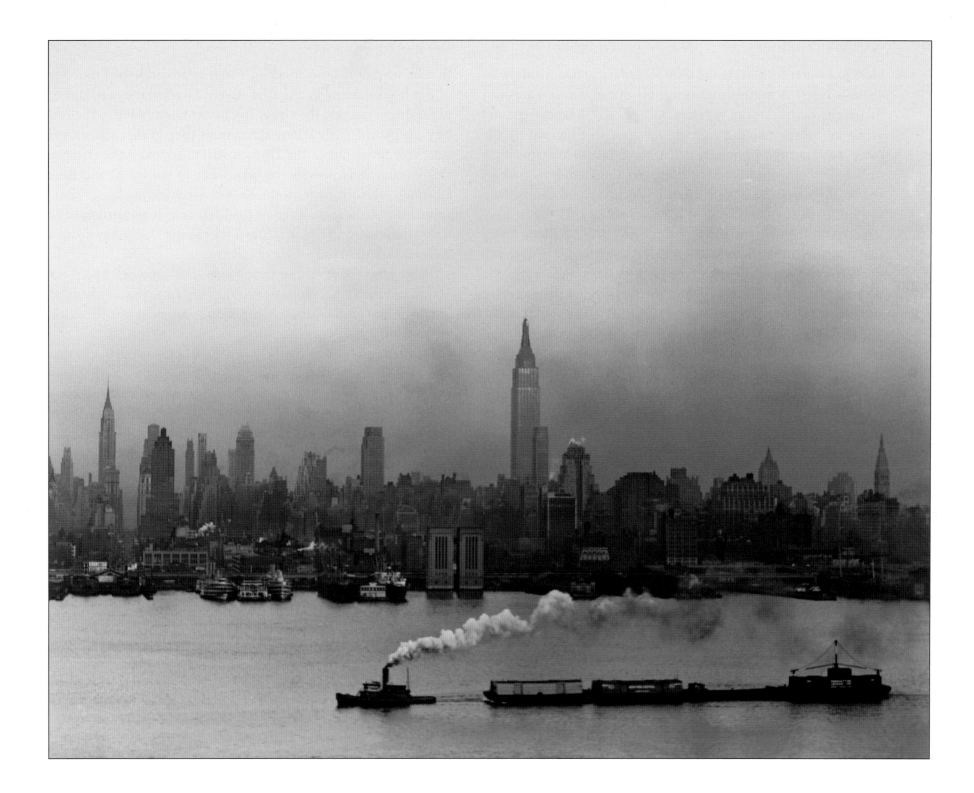

plenty of water for getting the deep loaded barge in and out of its shallow berth. A northbound vessel capable of eleven knots can depart the Battery at the very beginning of the flood current and arrive at Albany about twelve hours later still favored by the same flood current on which it left New York. Theoretically, a light bulb tossed into the East River near the Brooklyn Bridge at the beginning of the flood current could be carried east to Hell Gate through the duration of that flood and pick up the first beginnings of the ebb current at the mouth of the Harlem River, ride that current north to Spuyten Duyvil, and be discharged into the last few hours of the ebb in the Hudson River. Before long the passive voyager will arrive back at the Battery and the mouth of the East River, right where its voyage began.

Detailed knowledge of the harbor tides and currents is fundamental to the tugboatman's profession. The simple math of it is that a tug and tow proceeding through the water at a speed of four knots in a four-knot current will travel over the bottom at a speed of zero knots if it is working against the current and at a cumulative speed of eight knots if the current is fair. Obviously, in a business where time is money and where common sense is the finest wisdom, a fair current is good. Whenever possible, a tow will be scheduled to maximize the time spent in fair current. When it is necessary to go against the current, there are other strategies to minimize the foul current's effect. The current generally flows most strongly in the middle of a waterway, so hugging the bank may afford some relief. The approaches to a point of land or bend in the channel might create still water or even a back eddy to propel the tow ahead at a magical rate. The local knowledge that encompasses these benefits is closely held and only grudgingly dispensed.

Early on in my education, I was given the opportunity to steer a tow comprising two empty scrap barges out of the Kill Van Kull, which runs between Staten Island and Bayonne, bound for Stamford, Connecticut. We came out of the Kills with the last of the ebb current helping us along, planning to catch the beginning of the flood current in the East River. To get there it would be necessary to traverse the Upper Bay from Staten Island to the Battery against the fairly strong ebb current that, at that state of the tide, still flows out of the Hudson River. To avoid the effect of this current it is possible to take what is known as the Back Channel, which runs from the Kills close along the Jersey shore behind the shallows of Robbins Reef. There is little current to be found there until the back channel rejoins the Upper Bay about a half mile south of the Statue of Liberty.

"Keep over close to the Jersey side until you get up to the Statue and then cut straight across the current to the southern tip of Governors Island," the captain said as he went out the pilothouse door.

I steered carefully along the Jersey flats as far as the buoys that mark the entrance channel to the ferry dock on the south side of the Statue. There I could see by the action of the buoys' leaning and weaving in the current that we had used up all the benefits of the Back Channel route. I shaped a course across the main ship channel, stemming the current for the tip of Governors. I had gotten perhaps a quarter of the way across when the pilothouse door flew open and there was the captain, much annoyed.

"I said to go up to the Statue before you cut across."

I felt very foolish. "I was almost there."

A New York, New Haven and Hartford tugboat towing a freight barge near 125th Street. The Triboro Bridge can be seen in the background. This is the New Haven Railroad tug *Transfer No. 8*, which was configured specifically to allow it to work through the entire length of the Harlem River, where a twenty-four-foot "air draft" is required. She is approaching the main waterfront terminal of the New Haven Railroad just out of sight ahead of her on the South Bronx side of the river. From this terminal the railroad first established its practice of conducting two-carfloat tows down the length of the East River to the Upper Bay. Photograph by Gordon Parks, December 1946, Special Collections, Photographic Archives, University of Louisville.

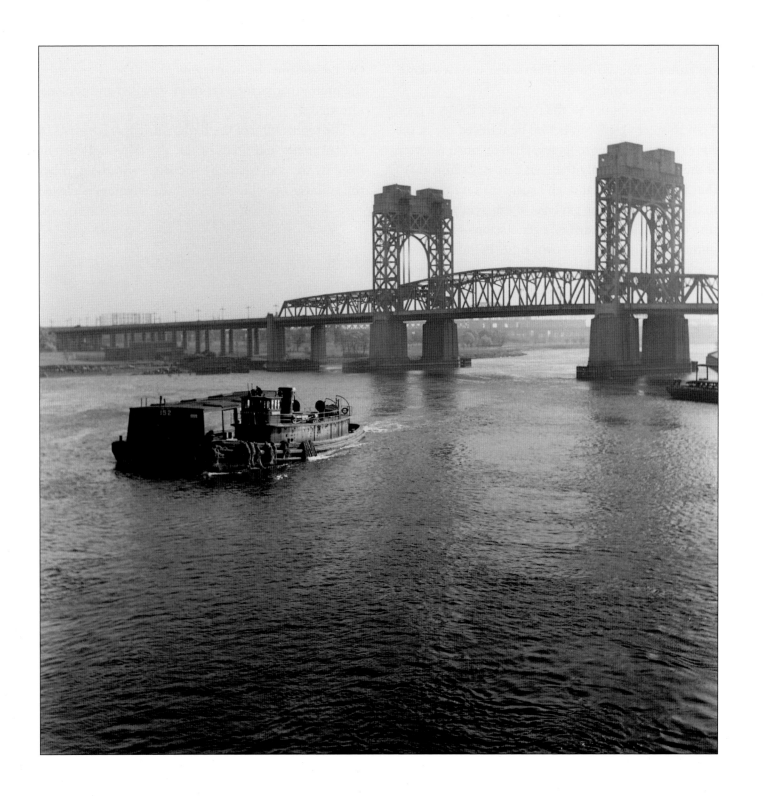

"I didn't say almost. You go to it. That's the way it's done. That's the way it's always done."

I had gone from the pilothouse to the doghouse. It was a good while before I got to steer again; but before he relieved me of the wheel, he had me steer back over to Jersey, push on until we were right abeam of the Statue, and only then cut across. I admit that I have done it that way ever since, though I suspect that I do so out of deference to the tradition at the expense of efficiency.

The gathering of local knowledge is a generations-old process that every beginner must repeat in his own time. In former times, a journeyman pilot kept a small notebook into which he copied information from his mentors' notebooks. It listed the landmarks used for ranges and steering points throughout the harbor. It made little mention of the system of government buoys because these were considered to be unreliable, especially in conditions of storm or ice. The contents of this notebook were, in effect, a trust fund, the bedrock investment of a young pilot's wealth of knowledge. If he proved to be competent, he might add to this gift and eventually pass it along.

Although government and privately published charts, as well as tide and current tables, were available throughout the nineteenth century, it has always been desirable for tug captains and a requirement for licensed pilots to be able to reproduce from memory the significant soundings and current patterns of the harbor. One captain I worked for was of the opinion that if you needed to use a chart, you shouldn't be steering at all, and if for some reason you were forced to use a chart, it should be spread out on the floor of the pilothouse so that no passing vessel could see that you needed it to get around. Most operators are not so extreme in their views. Many insist that the appropriate chart be kept open for quick reference should the need arise. Many carry the chart on their laps all the time as a comfortable habit. They browse through its intricate symbols, which over time come to represent the accumulated knowledge of their working lives.

Over a lifetime the journeyman's notebook and the chart become the promptbooks for a far more detailed and personalized store of knowledge.

The topography of the harbor as it was left to us by the shifting of continents and fields of ice, the tides and currents as they are fixed by the moon and by the slope and twist of land—these are the surfaces on which the tugboat business is played.

Chief engineer, L. Berg, and 2nd Assistant engineer, S. Szerzerbiak, in the engineroom of the tug *Hustler*.

Mr. Szerzerbiak is holding the operating and maintenance manual for the "Type PR Diesel Multicycle Engine," an Ingersoll-Rand product and, presumably, the subject of his conversation with Chief Berg. The two men are at the main deck level of the tug. The open door behind them faces into the night. In the foreground is the top of the main engine, which extends downward about eight feet to its mounting on the floors of the tug. Down there would also be found at least one diesel generator, an air compressor, a steam-heating boiler, and a host of electric pumps to move fuel oil, lube oil, sea water, fresh water, and bilge. These men must be able to maintain and, if necessary, repair all of it. Photograph by Harold Corsini, October 1946, Special Collections, Photographic Archives, University of Louisville.

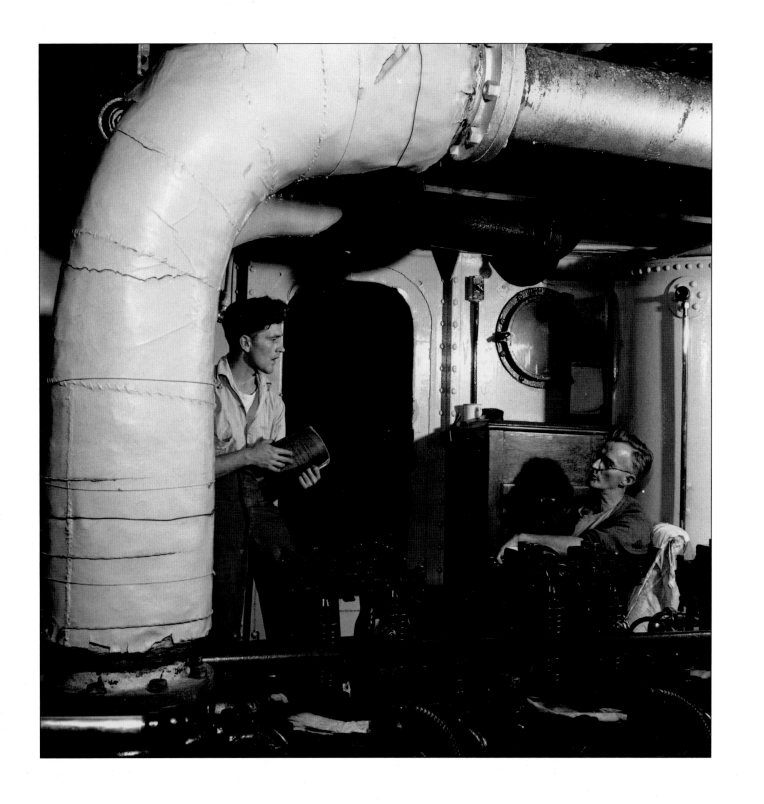

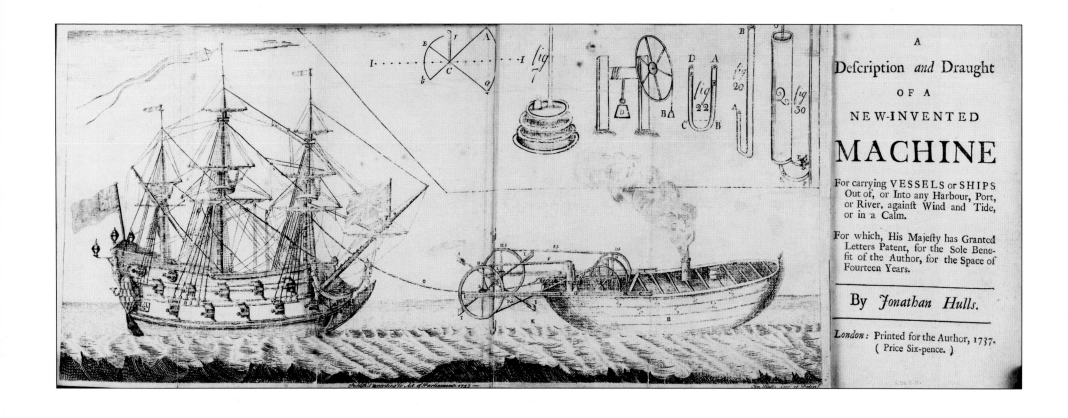

A

Description *and* Draught

OF A

NEW-INVENTED

MACHINE

For carrying VESSELS or SHIPS Out of, or Into any Harbour, Port, or River, againſt Wind and Tide, or in a Calm.

For which, His Majeſty has Granted Letters Patent, for the Sole Bene-fit of the Author, for the Space of Fourteen Years.

By *Jonathan Hulls.*

London: Printed for the Author, 1737.
(Price Six-pence.)

2

"A New-Invented Machine"

The concept of marine towing existed in theory long before the advent of steam or diesel power. A vessel had always been able to tow itself over short, becalmed distances using the oar power of its own boats. Sailing vessels that were disabled by storm or battle were occasionally towed into port or at least out of danger by other sailing ships. Various methods of securing hawsers and managing maneuvers while towing under sail were discussed in most eighteenth- and nineteenth-century texts on seamanship. In practice, however, towing under sail was never more than marginally successful. A sailing vessel, even in perfect trim, has very little power to spare above its own needs for propulsion. The ratio by which stubborn windage is converted into forward thrust at any point of sail other than directly downwind is a very slim one. Unless the sailing hull is allowed to move forward as freely as possible, an ever-larger percentage of the wind's effect is expressed as plain leeway. Particularly as a vessel's intended course edges closer to the wind, its ability to propel even itself becomes increasingly slight to the point of disappearance. Sufficient horsepower to meet the demands of even limited towing was not achieved until the advent of steam; and even with the development of steam vessels it was many years before their application specifically to towing took place.

The first practical steam engine was built in Britain by Thomas Newcomen in 1714. It derived its power not from the

Title page and frontispiece drawing of Hulls's patent. Long before the technology existed, the idea of a tugboat was alive in the imagination of Jonathan Hulls, who patented this contraption in 1737 in London. Using a gigantic atmospheric steam engine and a poorly explained drive system of ropes, pulleys, and paddles, Hulls proposed to solve the age-old problem of moving ships against wind and tide. There is no evidence that such a vessel was ever built. Rare Books Division, New York Public Library, Astor, Lenox, and Tilden Foundations.

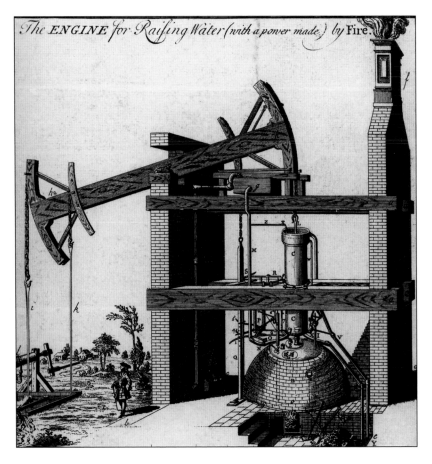

The ENGINE for Raising Water (with a power made) by Fire.

Newcomen Engine, 1717. Thomas Newcomen built the first practical steam engine in 1714 to be used for pumping water from British mines. This illustration shows such an engine in place and at work under the admiring gaze of a gentleman. The structure that supports the working beam and the chimney flue was normally sided over and roofed to create a very large building. Ashmolean Museum, the Provost and Fellows of Worcester College, Oxford.

expansive force of steam but from the contractive force of steam undergoing condensation. Live steam under negligible pressure was drawn into a cylinder by means of a piston rising by inertia. Near the top of the stroke the intake valve was closed, and the steam was then rapidly condensed by a jet of cold water sprayed directly into the cylinder. This produced a vacuum in the cylinder, permitting atmospheric pressure outside the cylinder to push the piston back down. The piston was attached to a vertical connecting rod, attached in turn to one end of a rocker arm, the other end of which was attached to a pump rod and foot sunk deep in the ground. The pump apparatus was heavy enough to provide the force to lift the piston in the cylinder after the vacuum stroke was completed, thus accomplishing the intake stroke that began the cycle. The Newcomen engine was used with great success in pumping water out of British coal mines, but it was far too ponderous to mount anywhere but on solid ground. It was set on stone foundations. Its boiler, working beam, and much else were built of timber, and in its overall aspect it more resembled an animated cathedral than a machine. No one in his right mind would consider putting one in a boat.

But, in 1737, Jonathan Hulls, an Englishman, sought to do just that. He patented the idea of mounting such an engine in a boat and harnessing it to a rudimentary stern paddle wheel. He called it "A New-Invented Machine For carrying Vessels or Ships Out of, or into Harbour Against Wind and Tide, or in a Calm."[1]

Although there is no evidence that Hulls was able to interest anyone in building his idea, the concept lived on for another sixty-three years, when, in 1801, a small towing vessel, the *Charlotte Dundas*, was built to tow coal boats on Scotland's Forth and Clyde canal. The *Dundas* was unsuccessful only because the canal proprietors decreed that its wheel wash would erode the canal banks. The experiment did, however, serve to inspire Robert Fulton, who was present at the trial run.[2]

Fulton designed the first successful steamboat, the *North River Steamboat*. On August 17, 1807, it ran from New York City to Albany, a distance of 126 miles, in about thirty-six hours. Its average speed of less than four knots was no better than a speedy passage by any one of the two hundred or so sloops that regularly operated on the river at that time, but the *North River Steamboat* proved itself able to achieve this sort of result consistently rather than by the fickle consent of wind and current. By proving the ability of his creation, Robert Fulton and his financial patron, Robert Livingston, won an outright monopoly on all steam navigation on New York State waters. This monopoly was granted by the New York State legislature and remained in force until February 1824, when it was overturned by the U.S. Supreme Court.[3]

While it remained in force, the Fulton-Livingston monopoly engendered what we recognize today as entirely predictable evils: markets were hampered and innovation quashed. For nineteen years it put the Hudson and East Rivers off-limits to further experimentation. The geographic and economic features of New York Harbor and the Hudson River made it the perfect spawning ground for steam navigation. It was a beautifully protected body of water with lucrative markets to be served. Passage between New York City and the various river towns as far north as Albany was usually slow and always unpredictable. A passenger sloop favored by the normal southwest wind and with the advantage of riding the crest of the upstream current might accomplish the northbound trip in as little as twenty-four hours, but more likely in forty-eight. The return trip, into the southwest wind and with a less favorable advantage of current, might require anywhere from four days to a full week.[4] Occasional groundings and small collisions were a regular feature of most trips. Traveling by stagecoach to Albany was an option that involved sixty hours of cramped travel, crude roads, and questionable wayside lodging.[5]

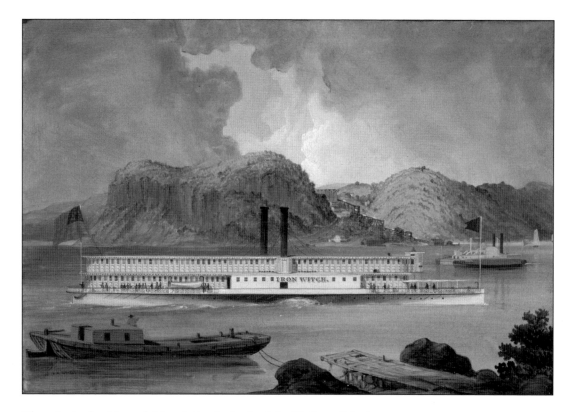

The principal subject of this 1846 painting by John V. Cornell is the passenger steamer *Iron Witch*. Designed by John Ericsson, who is better known for the *Monitor* of Civil War fame, she was the first large iron vessel built in the United States. She was fitted with very small but fast-turning paddlewheels, which proved to be ineffective and were soon replaced by experimental side propellers, which were even less effective. Eventually, under the name *Erie* she served out a creditable career using conventional side wheels.

Behind the bow staff of the *Iron Witch* is an unidentified passenger steamer with a freight barge lashed to each side. This is a demonstration of the earliest method of towing on the Hudson, dating back to 1826 and practiced by such steamers as the *Henry Eckford*, *Swiftsure*, and *Commerce*.

On the shore in the background is the slide down which blocks of ice rumbled from the ice houses located on the shore of Rockland Lake, atop the Palisades, to the Hudson River shoreline, from which they were shipped by schooner and barge to New York City and as far south as Central America. Collection of the New-York Historical Society, acc. 1929.146.

By its second season of operation, the *North River Steamboat* was offering space for seventy-eight passengers; thirty-six hours to Albany or return; seven dollars for the full voyage, or about twenty cents per mile for intermediate destinations.[6] The service was a quick success, and by 1824, when the monopoly ended, the North River Steamboat Company had five boats operating on the river in addition to vessels on Long Island Sound, the Mississippi and Ohio rivers, and several ferries in New York Harbor. Though passenger fares were the mainstay of the business, freight assumed ever-greater significance if only for the fact that most travelers of the time did so for business, accompanying their produce or manufactures to market or to customers. Originally, this cargo was stowed on the foredeck of the steamboat; but it was not long before other methods of transporting bulkier cargo were explored. The side-wheel method of propulsion imposed a severe limitation on the use of these vessels for hauling heavy freight. The wide variation in the draft of a loaded freighting vessel and an empty one would either too deeply or inadequately immerse the side wheels. Also, these early steam vessels had very little cargo capacity available once they were fitted with their machinery and loaded with fuel. Before the advent of the screw propeller the only practical means of moving heavy cargo by steam power was through the use of barges.

It soon became common for riverfront-estate owners or local entrepreneurs to operate market barges that, lashed alongside a passenger steamer, carried their produce down to the city. By the 1830s many of these vessels became quite elaborate, with two decks—the lower for rough cargo and animals, the upper for fine goods and people. The practice probably developed from a simpler form. It is likely that steamers bound up- or downriver, particularly those that served the intermediate landings along the way, would now and then piggyback a loaded sloop or flat boat alongside. Thus, as steam power became more dependable, its uses naturally became more diverse.

3

The Birth of Steam Towing in New York Harbor

All around the harbor, steam-powered freight and passenger vessels began to replace treacherous sail- and oar-powered services. Routes were opened to connect Brooklyn, Manhattan, and Staten Island, and further up the East River to Flushing and to the ports of Long Island Sound. Service to Newark, New Brunswick, and Elizabeth, New Jersey, was introduced. These vessels were able to operate safely and on schedule under most conditions of weather and current, carrying far more people, horses, wagons, swine, cattle, and goods than had been possible before, when ferrying across any of New York's waterways was a living nightmare. In the same way as the Hudson River steamers did, these new ferries began to divert from their normal business when a better opportunity presented itself. Sometimes, even with a full load of passengers on board, ferries would steam off to assist a sailing vessel in or out of port. The first record of this appears as a notice, perhaps placed as an advertisement, in the *Commercial Advertiser*, dated January 27, 1818. The notice involves a ferry on the run between Staten Island and Whitehall Street in Manhattan and may well give notice of the actual birth of the towing business in New York Harbor:

TUESDAY, JANUARY 27

The Steam Boat Nautilus, Capt. De Forest, yesterday afternoon, took the ship Corsair, Sutton, from Charleston, in tow and conducted her from a mile below fort Diamond to the

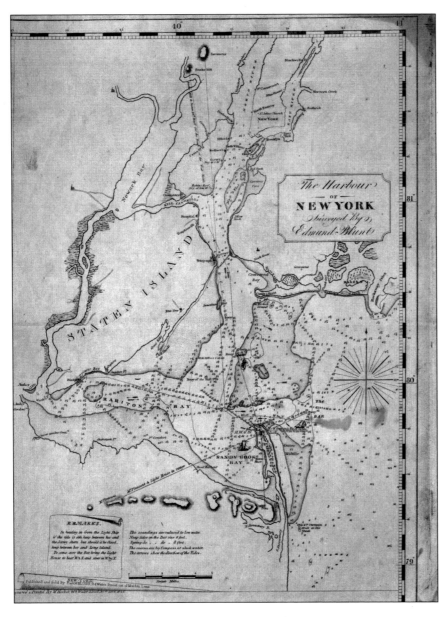

This 1827 chart of the entrance to New York Harbor, prepared by Edmund Blunt, provides depth soundings, ranges, and recommended courses for passing over the shoals just outside Sandy Hook. Incoming vessels would, if possible, pick up a pilot while still well offshore. But in severe weather pilots were often unavailable, and ship captains might be required to rely on their own information, of which this chart would be an invaluable part. Library of Congress, Map Division.

public store Wharf on Staten Island in three quarters of an hour. This Morning she towed the ship from the Wharf at Staten Island to the Old Slip in An hour and forty minutes, against wind and tide. We understand that she is employed also to tow up the British Ship Alexander Buchanan.

Indeed, on the evening of the next day, the *Nautilus* brought the *Alexander Buchanan* safely into the East River. Three weeks later she towed in the *Albion* "through large fields of ice with no damage."[1] After this initial flurry of activity there is no further mention of any towing until the following winter, when on January 16 she brought in the ship *Sterling* from a mile below the Narrows.[2] The *Sterling* was at the bitter end of a grueling ninety-day passage from Portugal with a cargo of salt; low on food and with many of her crew disabled, she needed to get in any way she could. Otherwise, the winter of 1819 was a relatively mild one in New York Harbor. There was little heavy ice, and thus the *Nautilus* was not reported as doing any more towing assignments that year.

Clearly, the need for inbound towing at this time was limited to situations in which incoming vessels were imperiled by weather, loss of crew, or damage, and these circumstances apparently never conspired often enough to support a full-time towboat operator. But even in these first experiments there are traces of three principles that would remain important to the business of towing thereafter. The first two are communication and positioning, which in the days before radio and telephone were more closely related than they are today. From the Staten Island terminus of her ferry run the *Nautilus* was ideally situated to keep abreast of developments at the Narrows and in the Lower Bay. Her operators were in the best position to learn of any work first and then to get to it quickly. The third principle is versatility. The *Nautilus* was built to operate as a ferryboat but was also fitted with towing bitts and equipment to make her useful as a

towboat when the need arose. Her towing activities were limited to the winter months, when there was occasional need due to weather and ice—right at the time when, because of the same factors, the ferry business was least profitable. By a certain versatility of design the vessel was adaptable enough to weather shifts in both the business and the meteorological climates. Communication, positioning, and versatility have remained pivotal considerations in towing ever since.

It was many years before towing in and out of port became accepted practice among sailing-vessel owners and masters. If mention of vessels being assisted into port is scarce, the mention of them being assisted out is scarcer. On January 10, 1820, the packet ship *James Monroe* set out for Liverpool at the end of a tow rope, the other end of which was secured to the steamboat *Swift*.[3] The *James Monroe*'s business as a packet was founded on the promise of regularly scheduled sailings. One can imagine that the use of a towboat to help meet this commitment might have been construed as a publicity stunt. The event did get a mention in the *Commercial Advertiser* on the next day; but whatever its immediate purpose, it was also an indication of how the ever-tightening schedules of commerce, far too important to defer to wind and tide, would soon make a lasting place for tugs.

But that time had not yet arrived. Towboats, rudimentary though they were, were waiting for work; but where were the customers? It seems perfectly obvious today that a sailing vessel approaching harbor after days, weeks, or months at sea would readily pay for a tow the last few miles to dock. Sailing ever farther into confined waters, the dangers confronting a ship compounded. Unfamiliar currents, intricate shoals, and fickle winds, combined with the potential for loss of visibility in fog, rain, and snow, made a vessel's approach to port the most dangerous part of its voyage. It might take many days to sail from Sandy Hook to dock in the East River with calm or contrary winds, adverse current, and, worst of all, ice barring the way. It would seem reason-

able to the average person that the services of a tug would be readily engaged. But the ship masters and pilots of the nineteenth century were not such average people. Schooled in self-reliance and patient fortitude, a master would be instinctively loath to surrender his command and all the self-esteem that went with it to a tugboat. Even if he were tempted, he would inevitably have to answer to his owners. Ship masters were rigidly charged not only with the safe but with the frugal operation of their commands. The captain would have to justify any unusual expense, particularly the cost of a tug, which might be construed as an admission of lack of ability on the captain's part.

Much the same argument would apply to any advice supplied by the Sandy Hook pilot who by law the ship had to engage while still outside the harbor. This worthy salt, who had clambered aboard from a small boat while the ship was still many miles offshore, was the descendant of a long tradition of expertise that entirely predated the advent of steam. The same issues of pride and economy would be alive in his conscience. How could he justify his presence on board, much less his fee, if the best he could do for his client was to deliver him into the clutches of yet another shore-side cutthroat?

If neither the ship captains nor the pilots were eager to accept the services of a tug, then forces ashore must be considered. First of all, ships were being built ever larger. The average tonnage of deep-water vessels entering New York Harbor in 1818 was around 350 tons. The *Corsair*, which was towed by the *Nautilus* in that year, registered 286 tons. By 1850 the average vessel was more like 750 tons, and some were twice that.[4] Not only did this doubling of size create difficulties for vessels conducting themselves unassisted in and out of harbor, it also greatly increased the amount of cargo that had to be handled in and out of each ship. In the past, many vessels would remain at anchor in the Upper Bay and discharge and load cargo by means of sailing lighters brought alongside, but this practice required one more handling

A sailing lighter of about 1860. These efficient little vessels handled cargo and supplies throughout the port until they were replaced entirely by towed barges and scows during the latter part of the nineteenth century. Collection of the New-York Historical Society, neg. 76795d.

vailed among deep-water sailing masters can be found in the log books of the brig *Galen*.[5] Between December 30, 1834, and March 3, 1836, the little vessel worked herself in or out of New York eight times, once being detained at her berth for ten days by ice in the East River, only to be beset for another day in the Lower Bay. Twice she worked her way up and down the Mississippi from the Gulf to New Orleans; in February 1835 she was fourteen days getting upriver, whereas one of the tugs available there since 1815[6] could have taken her in thirty hours. She sailed stubbornly in and out of Savannah, where tow boats had been on station for several years, and in and out of Delaware Bay to Philadelphia, running aground three times in the process. Finally, on February 29, 1837, returning to New York from the South, she came to anchor in Gravesend Bay just below the Narrows. All the next day the captain reported the vessel to be trapped:

> These 24 hours commence with strong gales from N.E. and Stormy. Snowing, Hailing, freezing and raining. Large quantities of ice running past us continually so that we were in constant expectation of being carried out by it. Payed out the whole length of chain. Mr. Stent the passenger left for town in the News Boat. Middle part strong gales.

By next morning conditions had improved. At daylight they caught a fair tide up the Bay and at 8:00 a.m. "hauled in to the end of Pier 10" East River—another voyage successfully completed entirely under sail. The crew poured ashore with their seabags to disappear into the flesh pots. But lo! they had apparently arrived at the wrong pier, and the next day, Friday, March 3, the captain glumly records, "At 8 a.m. a steam boat took us up the North River to the foot of Hammond Street" (today's West 11th Street).

In 1832, with its citizens increasingly resentful of their ferry services being disrupted whenever a more lucrative towing job presented itself, the City of Brooklyn passed an ordinance forbid-

of the cargo than would be necessary if the vessel could be unloaded at shore side. Furthermore, during this period there was a rapid expansion of packet services both transatlantic and coastal. The virtue of these services was a guaranteed schedule of sailings and an implied promise of prompt crossings, which attracted cargoes of high and timely value as well as passengers who wanted to minimize their time at sea. All of these factors argued for the use of tugs to ease the nettlesome business of getting in and out of port.

Ever so slowly, merchant vessels arriving, departing, and moving about in New York began to adopt the practice of "taking steam." A good example of the stubborn self-reliance that pre-

ding ferry boats from doing towing work while on their scheduled runs. The prospect of fewer ferry steamers being able to moonlight towing ships encouraged the owners of the *Nautilus,* the Richmond Turnpike Company, to build a boat especially designed for towing. Named the *Hercules,* she was the first New York vessel to attempt to turn a profit solely by towing. At a length of 116 feet 4 inches and 192 tons, she was a substantial vessel available twenty-four hours a day. But there was not enough call for her services, and she was soon converted to operate primarily as a ferry, replacing the *Nautilus* and assuming her intermittent towing role.[7] Up until about 1840 the *Hercules* was the mainstay in ship assistance, her name being used interchangeably with "the steamboat" in newspaper accounts of events in the Lower Bay. Study of the shipping pages of the *Commercial Advertiser* during this period shows that several other steamers—*American Eagle, Osiris,* and *Swift*—would also reduce their winter passenger schedules and simultaneously advertise for towing work.

In New York there are apparently no surviving records of these early attempts to split the business of towing away from the more stable trade of carrying freight and passengers. There is, however, a good description of such an attempt made around the same time in the Port of Philadelphia. The operations of the Philadelphia Steam Tow Boat Company,[8] which existed from 1832 to 1840, are probably the closest we will get to a snapshot of the economics of the earliest days of American towing. At the close of the War of 1812, Philadelphia was very nearly the equal of New York in terms of coastal and foreign trade, but from that date onward New York rose quickly to a position of dominance. Much of this difference in performance was due to the geographical situations of the two ports. The sailing distance from sea to the tip of lower Manhattan is twenty miles of sometimes difficult but normally unchallenging navigation. Entry to the port of Philadelphia, on the other hand, requires a passage of 115 miles up the Delaware Bay and River. Strong current, shoals, and, in winter, heavy ice combine to put Philadelphia at a disadvantage, normally measured in at least two days sailing time each way and in the worst winter conditions closing the port entirely for weeks at a time.

A group of merchants seeking to ease the bottleneck in their business caused by the irregularity of ship arrivals combined to form the Steam Tow Boat Company to assist vessels in and out of port. They constructed two boats that despite recurrent mechanical problems were able to operate with reasonable consistency for a little more than four years. During this time their monthly expenses averaged about $1,750 per boat, of which fuel accounted for $900; food and wages, $325; supplies such as sails, oil, rope, chandlery, and laundry, $100; and overhead, agent's and treasurer's salaries, wharfage, and advertising, $100. In the winter months, December through March, when the need for their services was most acute, the boats averaged an income of $1,900 per month—achieving a small profit. For the rest of each year they averaged only $1,000 per month, which resulted in an average year-round income of $1,300 per month—a loss of about $350 per month.

In Philadelphia there were at that time about thirty-five foreign and six hundred coastal arrivals each month. The two towboats managed around eighteen jobs per month, whereas twenty-four would have been needed to break even. Without other sources of income such as the ferry or passenger service on which the earliest New York boats relied, the Philadelphia Steam Tow Boat Company failed to ever generate a profit and ceased operations in 1840. The question of actual profit or loss, though, may be beside the point in the Philadelphia case. Profits would certainly have been welcome, but it should be remembered that the venture was founded by cooperating merchants eager to enhance the arrivals and departures of merchandise at their wharves. In this they were at least partially successful, and on

this basis the venture might also be judged a success. The use of towing services as a loss leader to other business ventures would in the coming years become a fixture in the industry. The railroads, the coal companies, the oil industry, and the sand and gravel industries of the East Coast and of New York Harbor in particular maintained extensive fleets of tugs to move their own products and equipment without any thought of operating profitably as towboat businesses per se.

In fact, the first boat built to work exclusively as a tug in New York Harbor was intended to fulfill just such a purpose. The *Rufus King* was built in 1828 to serve the New York Dry Dock Company by providing towing to and from the dry dock for vessels in need of repair. A vessel of 131 tons, she measured 102 feet 6 inches in length, with a beam of 19 feet 8 inches, not including the added width of her paddle wheels, and a 7-foot depth of hold. Her single engine measured 34-inch bore by 48-inch stroke, and her boiler operated at 18 pounds pressure. Her construction was largely paid for through a grant from the New York State legislature that was intended to enhance the utility of the Dry Dock Company. Although the *Rufus King* did some outside work around the East River and the Brooklyn Navy Yard across the way, she remained under the ownership of the dry dock for the first ten years of her career and during that time was probably never challenged to generate a profit. In fact, her captain in one account of the early days is remembered as more likely to be found in the local saloon than at the helm.

←
Throughout the nineteenth century the City of Philadelphia struggled to maintain year-round access to its wharves because of heavy wintertime ice in the Delaware River and Bay. The Steam Tow Boat Company of 1832 was the first such municipal effort. This *Harper's Weekly* illustration from 1875 shows one of the later side-wheel tugs used for this purpose. Very similar conditions were often encountered in New York Harbor, particularly in the Narrows and the Lower Bay, and many of the earliest accounts of towing operations there involve assistance to ships imperiled by ice. General Research Division, New York Public Library, Astor, Lenox, and Tilden Foundations.

STEAM NAVIGATION COMPANY.

THE SPLENDID SAFETY BARGES,
LADY CLINTON & LADY VAN RENSSELAER,

Are towed by Steamboats of great power, and employed as regular Passage Boats between the Cities of

NEW-YORK AND ALBANY.

These Barges afford a degree of SECURITY and COMFORT for Travellers which has never been equalled, and perform their passages in about the average time of the ordinary Steamboats.

For further information, inquire on board, or at the Office of the Company,

No. 82 CORTLANDT-STREET.

STEAM TRANSPORTATION.

THE STEAM NAVIGATION COMPANY

Continue to receive property at Albany and New-York, to forward on the River in either direction by the Freight Barges

ATLANTIC,	ONTARIO,
SUPERIOR,	NIAGARA,
NEW-YORK,	DETROIT,
ALBANY,	INSPECTOR;

Which are first-rate Vessels of 200 tons burthen each; two of which, towed by a powerful Steamboat, will leave

NEW-YORK at 5 o'clock, P. M. on **Wednesday** and **Saturday** of each Week; and two will leave ALBANY at 9 o'clock A. M. on the same days; leaving at each place three Boats for the reception of property. Extra Boats will also be forwarded on other days, as circumstances may require.

Merchandise, Produce, Carriages, Horses, Cattle, and almost every description of Live Stock, will be forwarded with safety and expedition.

The Freight Boats have good Cabins, and will take Passengers for One Dollar each.—Passage in the Steamboats at the lowest rates.

Arrangements are made on the Canals, with regular and responsible lines of Boats, for the immediate forwarding of property on its arrival in Albany, free from storage, if the direction for forwarding is received in season.

Insurance to a liberal amount is effected on property sent by this line.

For freight or passage, apply to the Company's Agents,

R. M'MICHAEL, at Albany, or
A. VAN SANTVOORD,
17 Coenties Slip, N. York.

4

Towing on the Hudson

While the New York Harbor steam boats experimented with different business combinations, striving for a profitable balance between passenger work and ship towing, operators up and down the length of the Hudson River were already striking that balance. In 1824 the Supreme Court threw out the Fulton Livingston monopoly, opening the Hudson River to all comers. Whereas the North River Steamboat Company had been operating only five passenger vessels on the river, sixteen new steamers appeared as soon as the monopoly was lifted. Rates for carriage of passengers and freight fell dramatically, and profitability, once assured by legislative fiat became dependent on competitive instinct and skill. The seven-dollar fare charged by North River Steamboat in 1824 had by 1845 dropped to one schilling (twelve and a half cents).[1] Speed and luxurious amenities became essential to business survival. Vessels routinely raced to arrive ahead of one another at landing points along the river and thus secure any passengers that waited there. Often they raced simply for prestige. Captains and engineers became ever more reckless, until collisions, groundings, boiler explosions, and fires were an ever-present menace. The older, slower boats were left behind to scrape for whatever work they could find at the smaller river landings and to attend to the market barges and agricultural produce that the top-flight steamers passed by in their rush back and forth to Albany.

A full-page advertisement from *Longworth's New York Directory* (1827) offers the services of the Steam Navigation Company, which combine passenger and freight barges to be towed by the steamers *Commerce* and *Swiftsure*. The passenger barge service was short-lived because speed became an ever more competitive issue in the Hudson River trade. The freight barges, however, became a fixture of local commerce. Collection of the New-York Historical Society, neg. 76791d.

But something even more fundamental was taking place. At the very time that the monopoly of the North River Steamboat Company was disallowed by the U.S. Supreme Court, the Erie Canal was opening up. The stretch from Rochester to Albany opened in October 1823, and the little schooner *Mary & Hannah* was the first to reach New York, carrying a cargo of wheat and butter.[2] Next spring, with the canal still not officially open, the traffic started to flow. An average of forty-two canal boats per day, each with 49 tons capacity, generated 185,000 tons of eastbound cargo, including 221,000 barrels of flour, 562,000 bushels of wheat, 435,000 gallons of spirits, and 32 million board feet of lumber. In the opening season of 1825, a total of 218,000 tons of goods moved on the canal, both east- and westbound. By 1840 the figure would be almost 1.5 million tons; in 1850, over 3 million; and six years after that, over 4 million.[3] Before the canal opened, it cost one hundred dollars to ship a ton of freight from Buffalo to New York, more than any of the raw materials produced in the western United States were worth in the first place. With the opening of the canal, this rate was reduced to about fifteen dollars. Shippers in Rochester found that their goods could go 396 miles to New York City for the same price as shipping 30 miles by wagon.[4]

The eastern terminus of the Erie Canal was at Albany, 126 miles north of New York City via the Hudson River. All but a tiny fraction of the material arriving at Albany from the West was bound for New York City, though the canal barges containing it could go no further under their own horse and mule power. Such an accumulation of paying cargo did not escape the notice of New York businessmen. John E. and James Mowatt, hardware merchants at 217 Pearl Street,[5] brought the year-old steamboat *Henry Eckford* to New York from New London, Connecticut.[6] At the same time, they ordered the construction of six freight barges, each about seventy-five feet in length and ninety tons. On April 12, 1825, two of these barges and the *Henry Eckford* figured in the following notice in the *Commercial Advertiser*:

STEAM LIGHTERS FOR ALBANY
The new Steam Lighter De Witt Clinton is now ready and receiving freight. The Stephen Van Rensselaer will be in readiness tomorrow and they will both start on Friday next in company with the Steam boat Henry Eckford.
Mowatt Brothers & Co.
77 Washington Street

Three days later, on the eve of their departure, the brothers again advertised: freight on board the barges would be transported at "sloop rates," passengers on the barges would travel for one dollar each; on board the *Eckford,* three dollars. They also announced that there would be "No detention to land passengers by the way." Thus, their enterprise was clearly aimed at the commercial potential laying on the terminal wharves at Albany. Soon the enterprise was renamed "The Western & Inland Company", though it continued under the Mowatts' control. With six barges in service it was possible for the *Eckford* to be constantly underway either north- or southbound with two barges while two were always being unloaded and loaded at each end of the river.

The Mowatt brothers did not continue in the business for long. Within a year all of their vessels had been transferred to the ownership of the Dutchess & Orange Steamboat Company, whose president, James Haviland, was the Mowatts' neighbor, across the street at 218 Pearl. The Dutchess & Orange Steamboat Company, in the months before taking over the Mowatt Brothers operation, had built their own steamboat, the *Sun,* which seems to have engaged more in passenger than in towing work. By 1828 the presidency of Dutchess & Orange would rest in the name of Isaac Newton, who with his son, John, would eventually control much

of the Hudson River towing industry under the banner of the New York & Albany Line.

Upriver, the development of barge transportation was being watched closely. On February 21, 1826, the *Poughkeepsie Journal* editorialized:

Many judicious persons think that the time is not distant when this mode of transport will entirely supersede the mode in present use upon the river. Would it not be wise for the proprietors of our landings to make early arrangements to meet this change, if it is to become general?

Right behind the Mowatt brothers two other freight and towing companies were formed. The Steam Navigation Company announced its service in the *Commercial Advertiser* on March 3, 1826, as follows:

The Steam Navigation Company,
Have established a line of steam TOW-BOATS, or Freight Barges, for the transportation of property on the Hudson and will commence business on the opening of navigation. . . . Boats of the first order will at all times be in readiness to receive property near the foot of State street in Albany and at or near Coenties Slip, New York. . . . Property will be received, and contracts made, by Richard McMichael, at Albany or at New York by A. Van Santvoord, No 17 Coenties Slip, Corner of Front Street.

The Steam Navigation Company had been founded by William Redfield and a group of Connecticut investors. To enter the Hudson River competition they equipped themselves for both passenger work and freight hauling. Passengers were carried either on the steamboat *Commerce* or else in what they called "safety barges," which the steamboat trailed behind by a set of hinged timber rafters. Passage on these safety barges, the *Lady Clinton* and the *Lady Van Rennselaer,* was advertised to be quieter than

on the steamer itself, but, more important, safely distant from the ever-present danger of a boiler explosion. This service found little favor with the public, due most likely to the loss of time inherent in towing compared to the free-running speed of the ordinary steamboats, and the use of these "safety barges" was soon discontinued.

The Steam Navigation Company was soon operating the *Swiftsure* to tow a fleet of eight freight barges, each of almost twice the capacity of those built by the Mowatt brothers. The steamboat carried only minimal passenger accommodations while operating between New York City and Albany in a shuttle that had three barges always loading and unloading at either end of the river and two always underway. Alfred Van Santvoord, the line's original New York agent, came to control the "Swiftsure Line," as this operation came to be known, and later the Hudson River Steamboat Company, which continued towing on the river until 1869. He also founded the Hudson River Day Line in 1856, which continues to operate passenger vessels—presently, a high-speed catamaran.

The third original towing operator on the Hudson was Philip Hart, who in cooperation with S. H. Herrick & Company offered passenger service on the steamboat *Chief Justice Marshall* and freight-barge service with the steamer *New London.* Hart's towing enterprise became the Troy Line, which by 1835 consisted of four steamers and twelve barges.

In its earliest form, towing was done by lashing the barges to both sides of the steamer and proceeding as a unit. This form of towage was adequate for the size of the tows first undertaken, but as the size, number, and type of barges in a tow grew ever more variable other methods became necessary. Whereas the earliest Hudson River tows were made up of only two barges specifically designed to accommodate the size, horse power, and turning ability of a specific steamboat—the *Swiftsure* and its stable of

custom-built barges, for example—the makeup of a flotilla soon became far more various. Individual canal boats, sloops, schooners, or even a raft of logs represented potential profit for the towboats, and a means of accommodating these miscellaneous customers was needed. To pack such varied objects alongside the towboat and still retain any maneuverability was impossible. Even if such a mixed tow could be balanced out so that the steamer might start off in control, by the time it had gone very far the ropes lashing the various vessels together would stretch and break until the whole tow fell apart.

The solution to this problem, developed by Samuel Schuyler in the late 1830s, was to tow these mixed flotillas astern—"on the hawser," as it is called. By 1846 there were fifteen hawser boats operating on the river.[7] For the next seventy-five years it was standard practice for a pair of towboats to assemble a long string of barges and sailing vessels, either at New York or Albany, and then tow the length of the river with the smaller, shallower of the two tugs dropping off and picking up additional tows at shore points along the way. The larger tug would grind along at a steady pace, while the smaller tug would pick up and drop off and then, between these assignments, pick up a line and assist with the main tow.

The shift to hawser towing allowed the towboat operators to greatly expand the capabilities of their towboats but at the cost of one of their original advantages. At first the steamboats had been able to rely on passenger carrying for a substantial part of their revenues. Towing alongside, even as it became more cumbersome, still allowed the steamers to reserve most of their deck space for passenger accommodation, thus enabling them to preserve to a large degree the flexibility of service that had been characteristic of all the early towing ventures. The change to hawser towing required that the afterdeck of the towing vessel be cleared to allow for the free sweep of the hawser from side to side as the steamer turned. The bulk of the passenger accommodations had always been located toward the stern, and to permit the new method of towing and the increased revenues that this method promised, they were sacrificed. For the first time, steamboats were operating exclusively as towing vessels and could be distinguished on sight from their passenger-carrying cousins. The needs of the growing towboat business were amply satisfied by the steady retirement of passenger vessels that were converted to towing simply by clearing off their aft deckhouses and fitting them with sturdy guards and mooring points down each side. Not only were the boats recycled for the business of river towing, but engines and machinery as well were repeatedly switched from worn-out to new hulls. It was not until 1848 that a towboat, the *Oswego,* was built expressly for Hudson River towing.

The side-wheel towboat *Gen'l McDonald,* with a helper boat, conducts a large mixed tow in the Hudson River. Included in the tow are three two-masted schooners, a two-masted coastal barge, a two-story market barge, and a host of miscellaneous canal boats and barges trailing behind. The side-wheel tug steamed constantly, while the helper boat came and went as necessary to pick up and drop off barges along the way between New York and Albany. The *McDonald* was built as a passenger steamer in Baltimore in 1852 and, as with many of her contemporaries, converted to towing later on. Steamship Historical Society of America Collections, Langsdale Library, University of Baltimore.

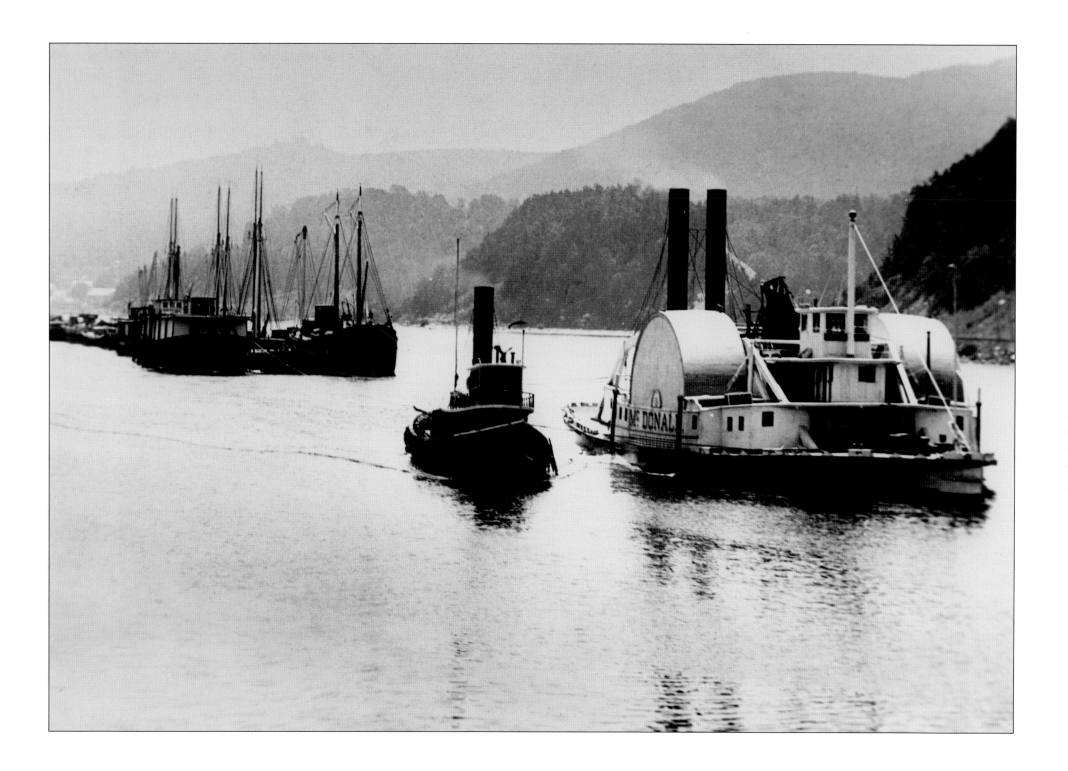

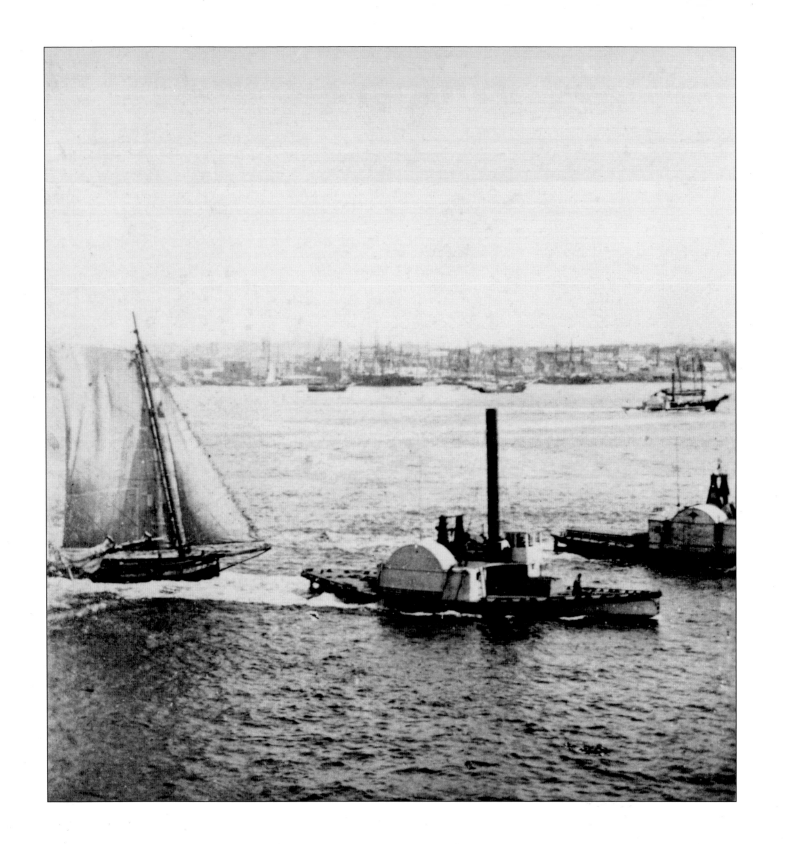

5

Steamboats in the Mid-Nineteenth Century

By 1840, even though the practice of towing was becoming established, there was not yet a distinct hull type to be called a towboat. The carriage of passengers and light freight defined the configuration of the limited number of vessels in operation. This service, with its need for speed and fuel economy, favored a shallow-draft hull form, easily driven through the water with a minimum of fuel. Engines and boilers were extremely difficult and expensive to build. It could take months to bore out a typical cylinder of perhaps forty-inch bore and six-foot stroke. Boilers were of the boxy and inefficient "flue type," in which the hot gasses of the firebox passed around the water-filled boiler vessel itself. Even though operating pressures in these boilers did not exceed twenty pounds per square inch, they were always subject to catastrophic failure. Their design was still largely experimental, and the materials they were made of, copper or wrought iron, were subject to work hardening and eventual failure even if they were not abused. It is said that the sides of a boiler of the period, when working under full pressure, could be seen to pant in and out as the internal pressure undulated with the rhythm of the engine. The boats originally put into service by Fulton were powered by crosshead engines that featured a vertically mounted cylinder with piston rod projecting upward to the middle of a horizontal crosshead. From each end of the crosshead there projected downward a connecting rod that in turn connected to a lever, to

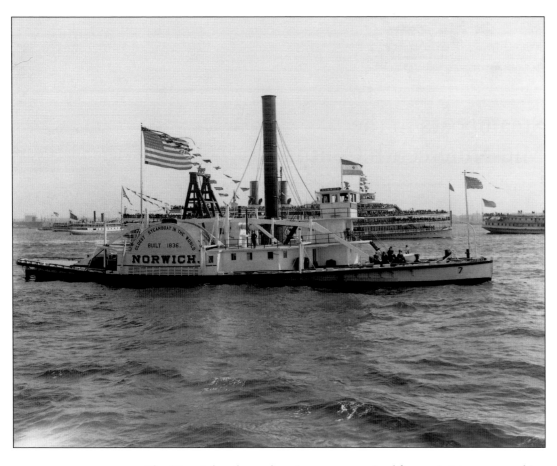

The *Norwich*—shown here in 1917—survived from 1836 to 1923, making her the oldest and the last surviving side-wheel towboat. She was built as a passenger steamer to operate between New York City and Norwich, Connecticut, and did not arrive on the Hudson River until 1842. The boat established a reputation as an icebreaker and was frequently called on to open the river passage at the beginning and end of each season. Owned by the Cornell Steamboat Company from 1848 to the end of her career, she survived a major collision, a catastrophic engine failure, two fires, and a sinking, and was finally dismantled.

She had a crosshead engine with a forty-inch-diameter cylinder and ten-foot stroke that was rated at 450 horsepower. The truss structure spanning her entire midlength along each side is the hogging frame, which reinforces the long, shallow hull and which certainly added greatly to her longevity. Library of Congress, Prints & Photographs Division, LC-USZ62-95814.

gearing, and finally to the crankshafts that drove each paddle wheel. A simpler means of power transmission was introduced to the Hudson River by Robert L. Stevens in 1822. In his configuration, power was transmitted from the engine to the crankshaft that operated the paddles by means of an overhead rocker arm, set above the uppermost deck of the vessel, which was first known as the "working" and then, later, the "walking" beam.[1] These beams were first built of timber, as in the original Newcomen engine, but were redesigned by Stevens as a lighter and stronger iron-skeleton beam.

Because of their great weight, the boilers, engines, and related machinery had to be located as near as possible to the center of the hull. The paddle wheels, actuated by the walking beam, were located either in front of or behind the machinery. At first the blades on the paddles were fixed perpendicular to the rim of the paddle wheel. This arrangement produced considerable inefficiency, as the blade descending into the water with the rotation of the wheel would slap the water, exerting most of its force upward; as it lifted out of the water later in the revolution, it would attempt to lift the water into the air, exerting most of its force downward. Only in the middle part of its pass through the water would it efficiently propel the ship forward. This problem was later solved by the introduction of the feathering paddle wheel, by which an eccentric mounted on the paddle-wheel crankshaft actuated push rods that trimmed the angle of each blade so that during its pass through the water each blade would be more nearly perpendicular to the surface of the water.

New York and the Hudson River in particular was the proving ground where all these early developments occurred and from which they were disseminated to other Atlantic and Gulf Coast ports. Because of the sheltered length of the Hudson River between New York and Albany and because of the huge quantity and value of goods passing to and from the Erie Canal, there was the potential for great reward to anyone who succeeded in improving

the performance or expanding the usefulness of the steamboat. But for all the technological developments of the Hudson River steamboats, probably the most significant design limitation was the river itself. In the twenty-mile stretch immediately south of Albany there were three sandbars, Coeyman's, Colyer's, and the Overslaught, that carried only four- to five-foot depth at Mean Low Water. Constant efforts were made to dredge these obstructions but to little avail. By 1852 the controlling depth had only increased to seven and one-half feet, and by 1900, to not more than twelve.[2] At first the relatively small size of early steamers did not require any extraordinary departures from the normal standards of hull form to accommodate this situation. But pressure toward the competitive advantages of greater speed and carrying capacity pushed the river steamers toward ever-greater waterline length without allowing proportionate increases in draft. The hulls became impossibly long and shallow, providing inadequate stiffness, particularly in view of the great weight of boilers, engine, and paddle wheels all concentrated in the midbody. Always limited by the available draft in the upper river, the steamers reached a length of about 160 feet with a beam of no more than 30 feet, not including the paddle wheels and their boxes built out on each rail. At this point the development of the Hudson River sidewheelers could go no further until, in 1827, Stevens designed the steamer *North America*. He built into it a set of arched trusses running down each side of the hull, spanning its entire middle length. This feature was called a hogging frame and, like the flying buttress of a medieval church, it stiffened up what would otherwise have been an impossibly attenuated structure. Like Stevens's other contribution, the walking beam, the hogging frame became a characteristic of all the large wooden steamers that followed and permitted them to continue to increase in length and speed. The controlling depth in the upper river was also largely responsible for the long-term survival of the side-wheel steamers on the Hudson: propeller-driven vessels, even though far more efficient in terms of

power and fuel consumption, must necessarily carry a much greater draft to allow for the complete submergence of the propeller. The side-wheel arrangement allowed the blades to be immersed to no more than the minimum draft of the hull itself.

★ Annals of the *Austin*: 1853–1856

The *Austin* was built in 1853 in Hoboken, New Jersey, for Albany & Canal Towing Line. She was a side-wheel boat, 197 feet in length and powered with a single cylinder of five-foot diameter and ten-foot stroke. She was considered to be of about 400 horsepower.

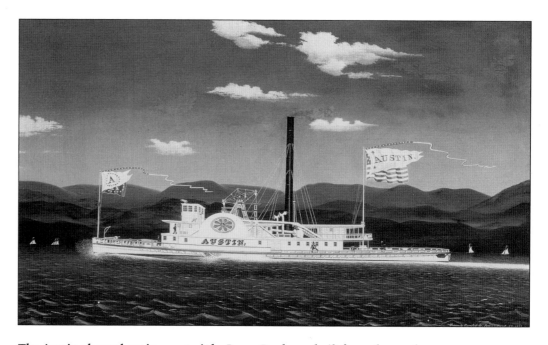

The *Austin*, shown here in a portrait by James Bard, was built for and named after Jeremiah Austin, president of the Albany & Canal Towing Line. She spent her entire career towing on the Hudson and was scrapped in 1899.
Mariners Museum, Newport News, Virginia, Q0364.

From 1853 to 1856, the *Austin* traveled the length of the Hudson 425 times, 13 times a month for as long as the winter ice would permit.[3] Her season might begin as early as the second week in March or as late as the last week in April. As soon as she was able to move, the *Austin* ran like mighty clockwork until the navigation season ended in early to mid-December. The end of her last trip of the season might leave her either in New York at the foot of Spring Street or at Albany to lay over the winter.

Running around the clock required a large crew divided into two watches: two pilots, two engineers, four deckhands (one of whom was designated as mate), four firemen, and a cook. Overseeing the whole operation was the captain. Monthly wages remained fairly constant throughout the period, with the first pilot earning $60, second pilot $45 or $50, first engineer $50, second engineer $40. Mates and cooks earned $25, firemen $20, and deckhands $15 to $20 depending on experience. The captain's compensation was somewhat flexible because a portion of his pay was calculated on the number of additional vessels he took in tow during the course of each transit. Allowing the captain to act as agent for the company while underway was a useful device for increasing business. Pending periodic settlements between the captain and the front office, he was paid $100 per month on account.

Taken as a whole, crew wages amounted to $531 per month. Provisions for the crew averaged $264 per month; other maintenance, repair, and supply costs averaged $934 per month; and, finally, coal averaged $1,760 per month. Thus the total operating expense of the *Austin* averaged almost $3,500 per month.

The beginning and end of each navigating season was decided by the weather. The number of trips were generally fewer at the beginning and end of the year, as were the number of vessels towed in each trip. During the months of ice-free operation, when the usual number of thirteen trips per month was achieved, the average number of vessels towed per trip was 21.7. In the opening and closing months of the season, when fewer than thirteen trips were possible, the average number of vessels towed per trip was 16.6. The difference in the size of the tows at the middle compared to the two ends of the season may be because early and late in the season, when the likelihood of encountering ice along the way was high, the company limited the number of vessels taken in tow to reduce the risk of getting frozen in. Current was also a factor, particularly during the spring thaw, when the "freshet" of downstream current added hours if not days to the northbound leg of the tow and transformed the normally tricky downstream leg in the narrow upper river into a hellish sleigh ride. For safety's sake, negotiating the river's bends required the tug to take smaller lots of barges. Another factor that governed the flow of traffic on the river was the condition of the Erie Canal. Because the canal was essentially a still-water route, it was subject to freezing much earlier and thawing later than the Hudson. With the canal frozen the number of customers available to the *Austin* would be much reduced while the cost of towing those remaining would be the same or, if conditions on the river were marginal, even greater.

To offset some of this increased expense the company raised its prices at the end of the season. In midseason, when towing was easy and customers abundant, the charge for towage of a standard canal boat from Albany to New York would drop as low as $15. Toward the end of the season the price would rise to $20, and at the extreme end, particularly the last few southbound trips in November and December just before the final freeze, it would cost a canaller $25. The seasonal volume of flow up and down the river in the *Austin*'s records reflects the bargemen's custom of wintering in New York City. About 30 percent more vessels went south in the last month of navigation than did during midseason, and in the spring the pattern reversed itself with a strong northerly surge.

Although Erie Canal boats made up the bulk of the *Austin*'s tows, there were several other categories of vessels involved.

Coal barges were towed for about $25. A sloop paid $23, an ice barge $25. Larger barges and schooners paid from $30 to $40. The price of towing was determined by the type and dimensions of the barge and whether it was loaded or empty.

The *Austin* normally departed Albany in the evening after spending the entire day in preparation. The first leg of the voyage, usually conducted in the dark, was the most difficult. Downstream as far as New Baltimore the river was narrow and shallow. The flotilla had to be bunched up to decrease its length in negotiating the river bends. At least one extra tug was needed to safely conduct the tow down these first twenty or so miles. Even with the assistance of an extra boat there were occasional mishaps, most frequently caused by some event that forced the *Austin* to stop its engines. The grounding of one of the barges or the appearance of another tow bound upstream threw the entire operation into chaos. The flotilla, no longer under tension, would drift off, setting some of the barges ashore, where rocks and snags could damage and sink them. Once aground or flooded, a barge was usually left behind at the insistence of the other bargemen, its problems to be sorted out by the helper tug after it had been released from its duties once the *Austin* had passed New Baltimore.

At New Baltimore, where the river widened somewhat, the flotilla was stretched out into a long string of barges lashed three abreast. The adventure continued south. One hazard of this part of the voyage was the pilot's running the tug or the tow ashore, usually due to fog at night. Collision with other vessels, particularly in fog, was another common danger. North- and southbound towboats often met along the river course and with careful steering safely passed each other only to have their unwieldy flotillas sideswipe each other. The greatest single risk, however, was being blown out of the channel when the tow arrived in the broad downstream reaches of the river—Haverstraw Bay and the Tappan Zee. A strong wind blowing at a right angle to the river course could blow the flotilla out of the channel. As soon as the flotilla grounded, the tug came to a stop and then was also blown onto the flats. There the flotilla would remain until the wind abated, often exposing it to considerable damage. The captain recorded all these and other miscellaneous damages, and the costs were routinely included in the vessel's running expenses.

In 1853 the *Austin* was usually accompanied all the way to New York by the smaller tug *Pittston*. Although there is little mention of the helper boat along the way, once the tow had reached New York the captain excused the *Pittston* to load coal for the return voyage. The *Austin* itself carried enough fuel to complete the round trip and invariably refueled in Albany, where Schuyler stored a goodly supply, which was supplemented whenever the price was right. The *Austin* burned forty-two to sixty tons of coal on each round trip of about five days. To save wear and tear on his deckhands and firemen the captain hired shore laborers to load and trim coal and to sweep the boiler flues at the end of each round trip. After 1853 there is no further mention of the *Pittston*, but other tugs are often mentioned as giving assistance either at the top of the river, along the way, or down at New York. Typically about half a dozen barges were added or dropped from the flotilla along the way, each requiring the service of a helper tug. Then, when the tow arrived at Manhattan it once again needed assistance. If the tow arrived off the city with a strong fair current the *Austin* needed help even to stop. Unable to turn the tow around to face into the current, tugs had to be called in to nudge her around, then to disassemble the flotilla out in midstream and conduct the individual barges to their scattered destinations around the harbor. It appears that the cost of this shifting at the end of the voyage was borne by the *Austin* so long as the various destinations of the members of the flotilla were right along the Manhattan or adjacent Brooklyn and Jersey waterfronts.

So, what was the end result of the *Austin*'s four years of steady effort? In every year, the operations of the *Austin* were favorable, with a combined net profit of about $154,000. Although it is

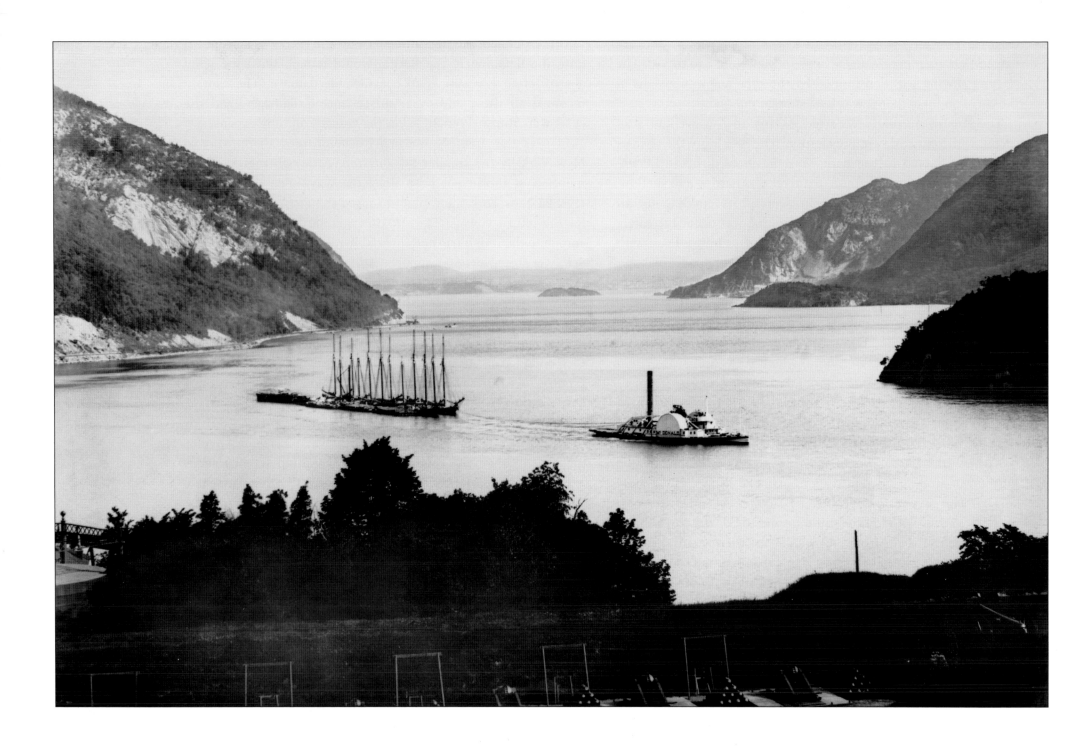

impossible to judge the absolute profitability of the company as a whole, the operations of the tug itself suggest a highly successful venture.

The single biggest obstacle to profitability seems to have been the seasonal character of the enterprise. Although the winter lay-up period could be rationalized as an opportunity to perform major repairs on the vessel and the labor customs of the time permitted the laying off of most or all of the ship's personnel, a significant portion of the carrying cost of the *Austin* continued whether it was active or not. Furthermore, the cost of mobilizing in the spring and laying up in the late fall was an expense offset by little or no income until the vessel achieved its full-scale operations with its thirteen-trip monthly schedule. During the six months running from May through October, the *Austin* churned out profits with remarkable dependability. November and December, then March and April were dreadfully costly as the flow of business died and then had to be resuscitated every year. January and February did not even exist.

The classic Hudson River towboat *General McDonald*, southbound with a mixed tow, shapes up to pass through World's End, the bottomless tidal strait around West Point. Library of Congress, Prints & Photographs Division, LC-D418-7859.

6

The Hook Boats

In 1835 the popular directory *New York as It Is* listed three tow-boats "employed in towing vessels from the Quarantine grounds, and other places, into harbour."[1] These were the *Fanny*, the *Hercules*, and the *Rufus King*, and it is likely that none of them was fully occupied by the work. It is also noteworthy that there is no mention of Sandy Hook, the entrance to the harbor, but only to the Quarantine grounds, well inside the Narrows, where inbound vessels were required to stop for medical inspections before being allowed to enter the port. The implication of the directory listing is that inbound vessels were expected to make their own way as far as the Narrows before a tug might be available. As a routine matter, the *Fanny*, the *Hercules*, and the *Rufus King* were not dependable enough to promise all-weather service all the way down to Sandy Hook or into the open sea beyond. The tugs of that period were obliged to wait in the protected waters of the harbor for the seagoing ships that would be their customers. But in just a few more years Sandy Hook and its offshore approaches would become a new and hotly contested sphere of enterprise.

Sailing ships bound in and out on voyages both foreign and domestic were growing larger, their affairs were more hurried, and they carried more timely cargo. And they carried more of the timeliest cargo of all, passengers, either berthing aft among the officers in what might be called first class or else huddled in steerage. In 1821 the total tonnage of shipping entering New York

Entitled "Towing a Vessel through an Off-Shore Blizzard," this *Harper's* **illustration from 1888 captures the essence of the role of the Hook boats. The tow is just passing the lightship that marks the approach to the risky harbor entrance. The ship, a three-masted bark, has sent down its fore and main topgallant masts for the difficult winter voyage and is reduced to a minimum of canvas by the storm. Hampered by the storm in shallow water close to shore, the bark would be in considerable danger but for the tug that has it in tow and claws its way to windward and the safety of the harbor.** New York Public Library, General Research Division, Astor, Lenox, and Tilden Foundations.

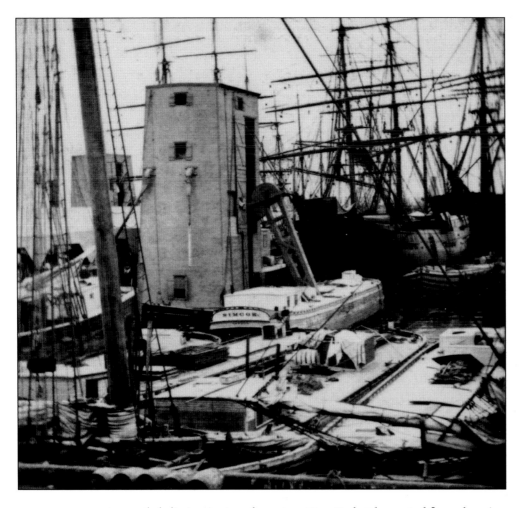

A crowded slip in nineteenth-century New York. The central figure here is a floating grain elevator extracting cargo from the Erie Canal barge *Simcoe*. In the foreground two small sailing vessels are moored across the head of the slip, and outboard of them is a raft of canal boats. In the background are two more canal boats and two deep-water square-riggers. This cluttered slip is an active place where vessels come in to load and discharge cargo almost daily. Before the advent of steam towing, the work of getting them in and out was performed by hand. As tugs became more nimble and efficient they took over more of this work. Robert N. Dennis Collection of Stereoscopic Views, Miriam & Ira D. Wallach Division of Art, Prints & Photographs Division, New York Public Library, Astor, Lennox, and Tilden Foundations.

was 154,500. By 1850 it had passed a million.[2] Pier space was in short supply. To maximize the limited facilities of the port and to ensure a steady flow of goods and materials to business and industry ashore the tug was becoming recognized as an essential participant in the commercial life of the port.

Because the slips and piers along the Manhattan waterfront were extremely crowded and because the early side-wheel tugs were quite limited in their maneuverability, tug masters usually landed their tows at the offshore ends of the piers and let the ships' crews work them up into the slip by hand. Bowsprit rigging was often removed and lower yards were tipped up to reduce the amount of dock space required for each ship and to lessen the danger of vessels becoming entangled with one another while shifting in and out. Once the vessel had completed handling cargo and was ready to sail, it was hauled back out to the end of the pier, its rigging was put right, and then a steamboat would tie alongside to take it out into the stream. The tug usually brought the ship only as far as the anchorage off the Battery or on the New Jersey side of the North River. There the ship anchored to complete its preparations for going to sea. As the nineteenth century progressed and the difficulty of finding competent crewmen increased it became common practice for a ship intending to hire crew at New York to anchor out in the harbor a day before departure and to have the hiring agents, "crimps" as they were called, bring the often drunk and unruly recruits out to the ship, where, isolated in the middle of the harbor, they could be put under the sometimes violent discipline of the mates without fear of their deserting.

Once finally ready for sea, the ship often sailed off its anchor and proceeded down the bay unassisted. Because of the wind direction, the tide, or the inexperience and persistent inebriation of the newly shipped crew, the master might hire a towboat to take him down to Sandy Hook. With a towline already secured between the ship and the towboat, the anchor was hauled up, and they proceeded down the bay. If the wind direction favored a good

departure, the ship started getting on sail as it approached Sandy Hook and, as soon as it had passed over the bar, cast off from the tug, released the pilot either to the tug or to a pilot boat waiting there, and took a departure from the twin lighthouses on the Highlands of Navesink.

The coastlines of Long Island and New Jersey converge at the mouth of New York Harbor to form a V-shaped bight that with an onshore breeze presents a serious obstacle to any square-rigged vessel attempting to get to sea. If upon reaching Sandy Hook under tow it was discovered that the wind was unfavorable for sailing clear of the coast, the ship would come to anchor just past the Southwest Spit buoy, discharge the tug and pilot, and wait there to sail from anchor unassisted when conditions improved. It was not at first the common practice for a towboat to take a vessel any great distance offshore to gain an advantageous position for getting away in less favorable conditions. Although sailing masters were becoming accustomed to the convenience that towboats could provide in getting about the harbor, they were still reluctant to depend on them as any sort of guarantee against the potentially fatal malignance of the sea.

Sailing masters continued to look upon the steamers with a dubious eye. They were quick to find fault and also quick to affix blame for whatever calamity or inconvenience might occur. Charles Sisson, master of the packet *Bridgewater*, crossly notes in his logbook, "Sunday, December 27, (1863)—Proceeded down the Bay in tow of the tug *Relief* (a most miserable apology for a tug)."[3] Captain Charles Townsend, master of the packet *Germania*, reports in his log of trying to get away from the Battery anchorage:

Wednesday November 11, 1863: 9 a.m. left Pier 12, East River with pilot on the steamer *Glide* to go to ship. Crew drunk. Commenced heaving chain at 10:30—Strong gales from WSW and tide commencing to flood. Wind and tide setting the ship in a N.E. direction.

The steamer with hawser out ahead holding the ship up to her port anchor. Just as the anchor broke ground the ship's head swung off to the eastward which brought the steamer on our port quarter about 2 ships lengths from us and just at the critical moment when we needed steam power most to avoid collision with the ship *Arcole* which was laying to the eastward of us the Steamer let go our hawser which caused us to come across the *Arcole*'s bow.

There was much damage to both ships. Townsend reports that he "employed steamer *President* to assist the *Glide* in towing ship to safe anchorage. After anchoring sent on shore for carpenter."[4]

Reading between the lines of this sorry account, it appears that the tug may have been less at fault than Captain Townsend would have us believe. It was, after all, his judgment to get that ship underway in the prevailing weather conditions, and even when he saw that the ship's bow was setting off in a precarious direction he continued heaving up the anchor. It seems clear that the *Glide* was simply overpowered by the force of the gale in the ship's rigging and in letting go the hawser was signaling to the sailing master that he must reset his anchor as quickly as possible—a task not so easily accomplished with a drunken and unfamiliar crew. It is Captain Townsend's side of the story that we are hearing, however, and he, like all captains, has the advantage of being keeper of his own log.

Such was the development of the Sandy Hook tugs that by the late 1850s sailing vessels approaching New York might encounter a tug seeking work at a radius of as much as fifty miles offshore from Sandy Hook. Captain Charles Hazzard[5] of the tugs *Leviathan* and *William H. Webb* would routinely venture that far offshore to search for incoming vessels.[6] The ship *Bridgewater*, returning from Liverpool in July 1865, encounters the tug *William Fletcher* off Fire Island, about forty miles out, at 9:30 a.m. on Thursday the 13th and arrives at Quarantine at 8:30 p.m.

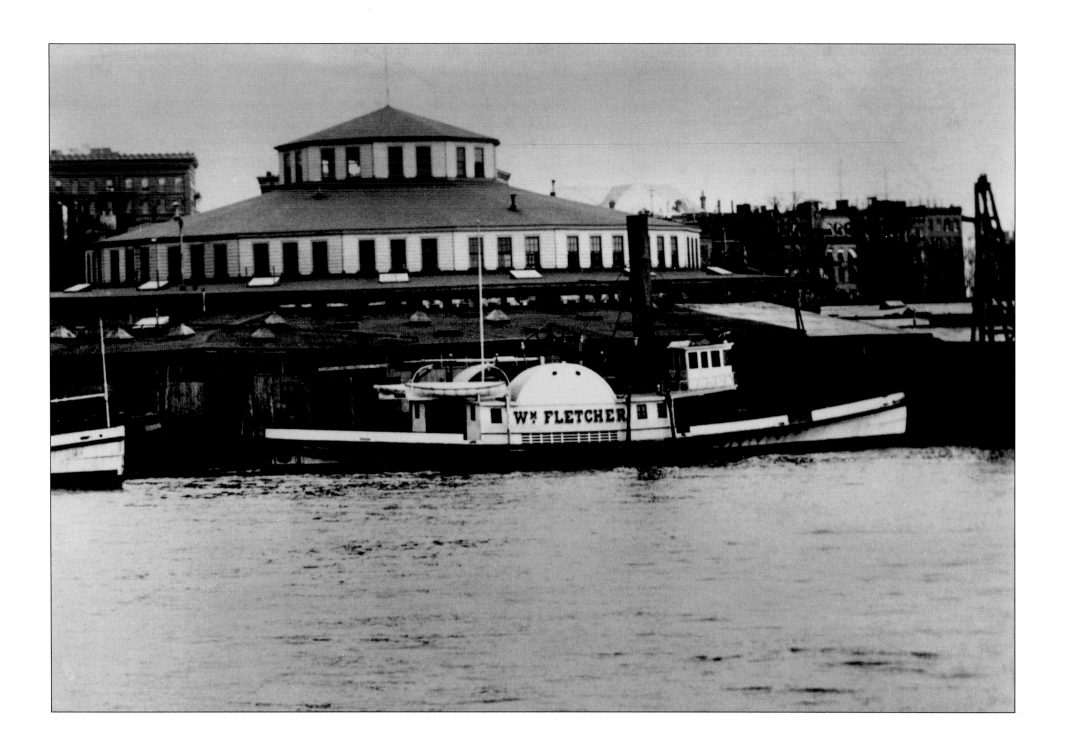

the next day, a long slow tow into the teeth of a strong northwest breeze that would otherwise have held the ship offshore for days. But most captains would not take a tug until they were right at the bar. The shorter the tow, the less the expense; furthermore, right outside Sandy Hook there would likely be a choice of tugs among which the sailing master could haggle for the best possible price. There are stories of sailing masters being able to foment bidding wars between competing tugs in the waters close to Sandy Hook, ending with one tug master towing the ship for free rather than allowing another to get the work. Conversely, there are accounts of sailing masters repeatedly rejecting the services of tugs far offshore only to arrive at Sandy Hook in worsening weather and perhaps only one tug still available, a situation in which the tug master could extract whatever fee he chose.

Towing was quite expensive. The clipper *Houqua*, arriving from China in 1850, paid $40 for towing from sea in addition to $54 for a pilot. Later during her port stay she paid $24 for towage to one of the East River shipyards, and on departure another $50 for towage to sea (the Sturgis tug *Ajax* got the work) plus another $35.88 for pilotage. By way of comparison, the master of the *Houqua* was paid only $100 per month.[7] By the late 1860s, $15 to

The **William Fletcher** was built in 1864 for Reuben Coffin and his group of associates who came mostly from Athens, New York, and who together formed the basis of the New York Towboat Company. She was built at the B. C. Terry shipyard at Keyport, New Jersey. She was 123 feet long with a beam of 22 feet and a depth of just 8 feet, fairly typical dimensions for a towing steamer of her period. Six months after her launch she was chartered by the Union Army for four months ending on June 8, 1865, after which she was returned to her owners and resumed towing off the Hook.

She is shown here moored at the Battery alongside Castle Garden late in her career when she served New York Towboat as a courier for baggage and passengers between Manhattan and the Quarantine station at the Narrows. She was abandoned in 1916. Steamship Historical Society of America Collections, Langsdale Library, University of Baltimore.

$20 seems to have been about the going rate for tows to and from sea, but if the wind were just right, the master might avoid taking steam altogether. Well into the late 1860s, logbooks record captains sailing their ships to anchor right off the Battery and, after that, buying only $5 worth of steam to be towed the final few hundred yards to the pier.

Despite the wrangling between tug operators and sailing masters, the obvious convenience of employing a tug was beginning to be appreciated all around the port. The *New York Daily Times*, in an 1857 article describing how the life of the harbor had changed under the influence of steam towboats, remembers that thirty years earlier "it was common custom for citizens to assemble on the piers and at the Battery in the mornings and Sunday afternoons to witness the evolutions of square rigged vessels as they beat out of the East River."[8] The article reports that all of this work is currently handled by tugs. In fact, two separate classes of tug had emerged: the big Hook boats, towing to sea and providing salvage services all along the coast between Boston and Cape Hatteras, and the smaller harbor boats, working close in among the piers where their small size allowed them to work their tows right up into the slips, where the larger tugs dared not go. The article numbers the seagoing fleet at eleven: *William H. Webb, Hector, Hercules, Achilles, Huntress, Jacob Bell, Ocean, Screamer, Mercury, Satellite*, and *Underwriter* (the *Leviathan* had burned off Sandy Hook the previous spring). The harbor towing fleet was estimated at fifty boats. The tone of the article suggests that the fleet of tugs was something of a municipal treasure.

During the mid-nineteenth century, more and more of the tricky and detailed work of navigation around the port was being handled by steam. For example, John Francis, captain of the little brig *Scotland*, having discharged both crew and cargo at New York in December 1859, opted to hire the tug *William Foulks* and a gang of shore laborers to have the ship towed to New Haven, where she was to take on her next crew and cargo, rather than

W.H. WEBB
1856
SIDEWHEEL TOWBOAT
LENGTH ON DECK....190 FT. 0 IN.
BEAM MOULDED.......30 „ 2 „
DEPTH OF HOLD.......12 „ 0 „

undertake the trouble and expense of going under sail.[9] In March 1859, the ship *Shooting Star* was towed from Portsmouth, New Hampshire, to New York by the tug *Wm. H. Webb*. With the tug already in Boston at the end of another job and the travel time to Portsmouth thus reduced, the price of the tow was set at $625, with the tug to supply the tow rope and a coastwise pilot.[10] In a few more years it would become commonplace for sailing vessels in search of cargoes to be towed up and down the East Coast by tugs built ever larger and more powerful to suit this rapidly expanding work. By the middle years of the nineteenth century, tugboating had become an essential business.

Side-wheel Steamer Wm. H. WEBB.

Double beam engines of high power. Built in 1856. Draft of water when launched without machinery on board, was forward 3ft. 9¾in., aft. 3ft. 2in. This vessel was originally built for a tug boat in New York Harbor. Afterwards employed at New Orleans as such. During the rebellion of the Southern States of the United States, she was fitted by the rebels as a Ram and employed in their defences on the Mississippi River, and proved formidable and an exceedingly fast vessel.

The *William H. Webb* was the largest side-wheel towboat built in New York. She was launched from the Webb yard in 1856. The hull design was by Webb, and the layout of towing gear was supervised by Captain Charles Hazzard, who became her master. Hazzard was the foremost tug captain of his day, having from an early age commanded the tugs *Yankee, Achilles, Titan,* and *Leviathan.* During his long career in offshore towing and coastal salvage, he is credited with saving innumerable vessels and lives.

The *Webb* was sold in 1860 to interests in New Orleans for towing on the lower Mississippi. During the Civil War she was converted to a Confederate gunboat and was destroyed while trying to escape from the river in the closing days of the conflict.

The lines show a very narrow, flat-sided, flat-bottomed vessel that lacks any particular grace and that probably was not particularly maneuverable. On a long straight tow in offshore waters, however, she undoubtedly performed well. She was reported to be extraordinarily fast when running light. Livingston Library, Webb Institute.

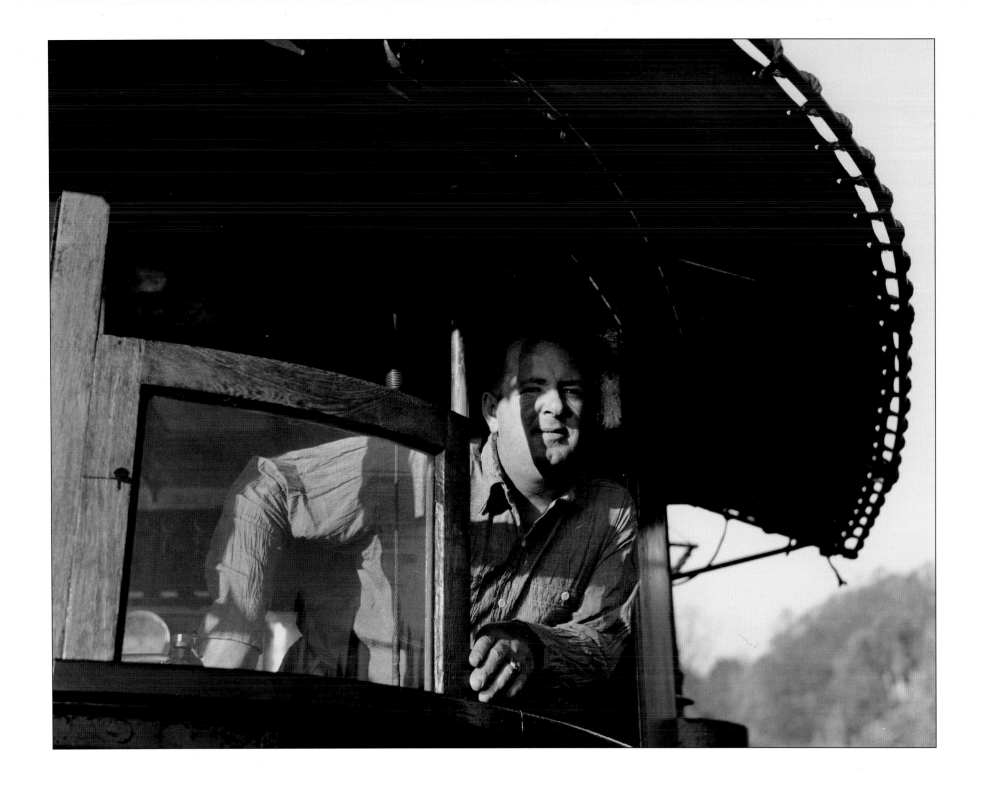

7

Early Tugboat Owners

Who were the owners of the early tugs? What led them into this new field of business and from what backgrounds did they emerge? From this distance in time it is not easy to piece together complete answers to these questions, but there are many details of individual lives still recoverable that may serve to fashion a sort of mosaic.

First, the Hudson River and the New York Harbor towing establishments were peopled by very different sets of owners, and their fortunes followed quite different courses. The Hudson River business, founded primarily on long hauls of large tows between Albany and New York City, tended toward a regularity of service and equipment that produced a notable longevity among a small number of businesses operating on those waters. There was constant competition between the principal operators, but the competition took the form of price wars and buy-outs through which the same universe of customers and equipment was frequently redistributed without a great amount of innovation. Operators were obliged to put together a substantial fleet of steamboats and barges in addition to shore facilities at both ends of their customary routes. Once the method of hawser towing was established in the early 1840s, towboats were dispatched from each end of the river on regular schedules, picking up and dropping off their charges along the length of the river in an unbending routine that persisted with little variation into the

1950s. Throughout the span of a hundred years, the Hudson River towing companies offered a sort of a Procrustean bed to their customers, forcing the various ice, brick, gravel, and stone businesses to conform their production and loading schedules to those of the towboats. This practice led to repeated attempts by New York Harbor towing operators to move into the Hudson River market, attempts that were all ultimately beaten back by price wars and buy-outs masterminded by the larger, more established companies. Because of the relative stability of their operations, the Hudson River companies tended to be very conservative in their choice of equipment. The side-wheel towboats persisted well into the twentieth century, with the *Norwich* being the last survivor, broken up in 1923. The river companies were also slow to adopt the screw propeller, oil-fired steam boilers, and, most telling to their ultimate survival, the diesel engine. Because the operations of these companies were geographically widespread and economically complex, their managers tended to be situated in offices ashore while the vessels themselves were manned by employees.

In New York Harbor the situation started off in a similar style. The first towboats—those of the Mowatt Brothers, the Richmond Turnpike Company, the Swiftsure Line, and the Albany-Troy Line—were all built to serve as part of more fully integrated freight and passenger ventures. For example, the *Rufus King*, widely described as the first New York Harbor tugboat, was in actuality an accessory to a dry-dock company. The owners of these vessels were all involved in much larger, more heavily capitalized ventures of which the towboats figured only as accessories. Likewise, a number of other tugs were built to serve broader purposes that would admit the interests of broad ownership. A consortium of ship owners and merchants including the principals of the Grinnell-Minturn Company and of the Spofford Tileston Company, shipbuilders William Webb and Benjamin Waite, and merchants Charles Marshall, Charles Lamson, William Whitlock,

and Luther B. Wyman shared the costs as well as the benefits of three of the largest tugs of the day, the *Ajax*, the *Goliath*, and the *Jacob Bell*. Such a broad alliance among some of the most competitive businessmen in American history suggests a mutual purpose of considerable weight. Beyond any expectation of dollar profits from the towing operations of these vessels, the concerned merchants were trying to provide a measure of security to their collective goods and ships moving in and out of New York. The seriousness of this purpose was further shown on April 22, 1852, when six of the major marine insurance companies, forming a Board of Underwriters, contracted with Mr. Russell Sturgis, formerly a sea captain and a marine surveyor and at that time a tug owner, to provide two first-class tugs, the *Achilles* and the *Titan*, to be always in readiness to assist vessels in distress anywhere on the coast between Boston and Cape Hatteras.[1] The agreed rate for the services of each of these vessels was a very generous fifteen dollars per hour, with the opportunity for additional compensation depending on the difficulty of the tasks undertaken. Many of the same gentlemen who ran the big merchant houses of New York were also directors of the insurance companies and members of the Board of Underwriters, and they were more than willing to invest generously in the towing business for protection of their larger business interests.

Sailing vessels visiting the Port of New York in the middle of the nineteenth century typically berthed along the East River waterfront of lower Manhattan, along South Street, which was lined on one side with crowded wharves and on the other with marine-related business. In that close-packed neighborhood existed an astonishing integration of seafaring and commercial cultures. At the top were the elite commission merchant firms such as A. A. Lowe, N. L. & G. Griswold, and Grinnell-Minturn, whose business interests spread from ship owning through import/export to banking and insurance and whose family ties stretched back into Massachusetts, Rhode Island, and Connecticut, from which they

enjoyed constant reinforcement from burgeoning industrial and textile empires.[2]

Below these large merchant houses were the small importing merchants, specializing in specific lines of goods, hardware, china, pharmaceuticals, liquors, and furs. And below these were businessmen who tended to the industries above them: the shipbuilders, spar and sail makers, chandlers, smiths, victuallers, stevedores, ballast merchants, forwarders, and agents, to name a few. Tucked in near the bottom, but no less busy, were the myriad businesses that served South Street's lowliest caste, the seamen who clambered off the ships and fervently sought out whatever quick luxuries might be found in the saloons, porterhouses, rat- and dog-fighting parlors, brothels, and waterfront missions.

All of these people were both spectators and participants in the life of the port, ready to snatch at any opportunity that might offer some advantage. Steam power as applied to navigation represented such an opportunity. Like the railroads of the decades to come and like the transistor, the computer, and the fiber-optic cable of succeeding generations, the steamboat represented an innovative terrain promising financial reward. Best of all, it was a terrain not yet fully populated. In 1821, 910 foreign vessels sailed into New York; in 1844, 2,205; in 1859, 4,007. And even as the number of vessels doubled and doubled again, their tonnage doubled and redoubled also. Vessels owned in New York in 1821 represented 236,000 tons; in 1844, it was 525,000; and in 1859, 1,444,361.[3] The maritime interests of New York were enjoying the rare blossoming that casts the scent of opportunity into all corners.

Cornelius Vanderbilt had since 1818 been a rising star in the harbor. After years of performing daring feats of salvage and rescue under sail with his fifty-three-foot sloop, the *SEALES*, he turned his attention to the possibilities of steam. He first served as a paid captain on steamboats carrying passengers between New Jersey and New York in defiance of the Fulton-Livingston monopoly. Then, in the late 1830s, he methodically took control

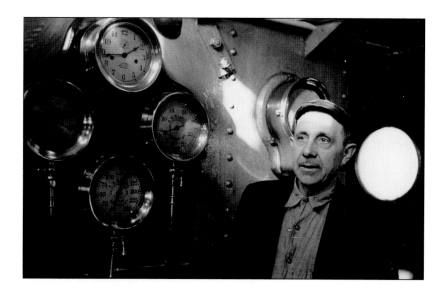

Chief Engineer Charles Swanson, *Esso Tug No. 5.*

Photograph by Sol Libsohn, January 1946, Special Collections, Photographic Archives, University of Louisville.

of the Richmond Turnpike Company, where he kept the steamers *Hercules* and *Samson* as much involved with salvage towing as their ferrying duties allowed. At the same time, he involved other family members in the ownership of the tugs *Wave, Huntress,* and *Gladiator,* which were built specifically for the Sandy Hook work. Vanderbilt soon lost interest in the businesses of ferrying and towing and turned to the possibility of fortune in deep-water steam navigation, only to discard that as well to seize the next great opportunity of the nineteenth century, railroads. However brief Vanderbilt's involvement in steam towing, his was apparently the first entrepreneurial foray into towing as a free-standing enterprise dependent entirely on a search for and satisfaction of individual customers. Vanderbilt's genius was as much as anything an ability to spy opportunity in its infancy, and his initial interest in towing indeed announced the birth of a very plump and rambunctious child.

Starting in 1849, as the scale of shipping operations in the Port of New York began a period of exponential growth that lasted until the middle of the twentieth century, there began a complementary fever of tug building. The vessels built included many of the large Hook boats, 100 to 190 feet, designed to operate outside the confines of the harbor itself, but increasingly the tug fleet comprised smaller boats designed to work within the harbor, rivers, creeks, and sounds that stretched from Troy to Sandy Hook and from New Brunswick, New Jersey, to New London, Connecticut. These smaller boats ranged anywhere from about 50 to 100, feet with vessels of the smaller size becoming more common after the introduction of the screw propeller in the late 1850s. The big sea boats were expensive to build and costly to operate. The *Leviathan* cost $70,000 to build in 1853 and required a crew of fourteen for round-the-clock operation in the approaches to New York.[4] The *Neptune* cost $80,000 to build in 1864 and carried a day crew of seven.[5] The *Achilles* cost $46,000 to build in 1851.[6] Such costs were out of the reach of all but the most prosperous firms.

A smaller side-wheel boat could be built and engined for less than $10,000. It could be crewed by as few as four men: captain, engineer, fireman, and deckhand. It could perform a wide range of work within the harbor up to and including the towage of ships to Sandy Hook so long as the weather was settled. It became common practice for the smaller tugs to engage the towage of outbound vessels, which had previously been towed in by the larger sea boats not so much because the larger boats were better suited to the towing itself but because they were able to range farther out to sea and thus able to be first to secure incoming business. The outgoing leg was negotiated ashore, where the lowest bidder was always most likely to prevail. With the rapid expansion of the port there was abundant opportunity for smaller operators.

The major part of the cost of these boats was the machinery. An engineless hull could be constructed very cheaply at any one of many building yards in the area. Engines, boilers, and all their associated running gear could cost twice as much as the hull itself and once installed required the expert services of an engineer. Indeed, the new technology of steam navigation placed machinists, foundry men, and engineers at the forefront of the nascent towing industry. In any new construction it was their contribution that represented the bulk of the capital outlay. In the normal course of operations the dependability and efficiency of the boilers and engines was critical to success. Not surprisingly, several of the earliest entrants into the field of steam towing arrived not from careers at sea but by way of the machine shop.

One of these early entrants was the Crary family, which was of Scottish descent and had lived around Stonington, Connecticut, throughout the eighteenth century.[7] The Crarys were one of the many prosperous New England families that gravitated to New York after the Revolution. Peter Crary sold all his holdings in Connecticut and with his wife, Lucretia Palmer, moved to New York City in 1791. In 1831, one of his sons, Edward, married Cornelia Livingston Fulton, the youngest daughter of Robert Fulton (and granddaughter of the vastly powerful "Chancellor" Livingston). In 1839, Edward was one of the original investors in the *Pluto*, a steam-powered ferry that ran through Hell Gate. The *Pluto* was later converted to a tugboat under different ownership and served a long career in the harbor.

Another of the Crarys of Stonington, Nathan, married Sarah Palmer and then moved with his family to upstate New York sometime between 1774 and 1779. He had a son named Humphrey who in turn had four sons: Peter, born in 1807; Alexander, born in 1809; then, by a second wife, Humphrey and Palmer, born in 1818 and 1819; and two daughters, Catherine Eliza in 1821 and Helen in 1826. The four sons, Peter, Alexander, Humphrey, and Palmer, all became involved with New York tugs.

On August 29, 1850, the younger Humphrey Crary was living at 88 Watts Street. He was thirty-two years old, and the census of

that year lists his occupation as "engineer." He was living in the household of William Foulks, a British-born ship carpenter, aged thirty-seven. Foulks was married to Catherine, aged thirty-six, and at that time they had seven children. Crary was apparently a widower living with his twelve-year-old daughter, also named Catherine. Another daughter, Helen, aged eight, was living elsewhere. Catherine was probably sent to the city to keep house for Humphrey while the younger Helen remained upstate. Four months earlier Crary and Foulks had completed their first big project. They built a steamboat that they christened, rightly enough, *Catherine.* By 1856 Foulks had become the proprietor of the highly successful shipyard of Lawrence & Foulks, which built a total of thirteen tugs for Humphrey and Palmer Crary. Foulks also joined with the Crarys in partnerships owning several more boats that he did not build himself.

Humphrey Crary pursued a long and varied career of business ventures including a boiler shop and iron works in which he was a partner with his brother, Alexander, and a towboat office that was active at 67 then 69 South Street from 1856 until 1869. Although the 1860 census lists Humphrey as a boat captain, there is no other evidence that he ever ran boats himself. By 1860 he was remarried and living at 88 Watt Street with his new wife, Emily, aged twenty-six, and his two daughters, Catherine and Helen. Within the year, however, Emily died, leaving Humphrey a widower once more.[8] Later, along with the towing office, he became involved in the liquor business and in the ownership of a brewery. He retired to Newburgh in 1868 and died there the next year at age fifty-three. His funeral was conducted in New York City from the home of his brother, Palmer.[9]

In 1844 Palmer married Margaret Newton. It is a possibility that she was a daughter of Isaac Newton, the proprietor of the Hudson River towing and passenger fleet that stemmed from the Mowatt brothers' groundbreaking enterprise. In any case, Palmer was before long deeply involved in New York Harbor towing. He

The *Peter Crary* was built in 1852 by William Foulks for parties in Hudson, New York, who were associated with Reuben Coffin, who lived right across the river in Athens. She was eighty-six feet, eight inches in length and well represents the class of smaller inshore towboats that were rapidly transforming shipping practices in New York Harbor. She served a long career under this and two other names, *Hazel Kirke* and *Naiad*, until her abandonment in 1919.

The Crary family was extraordinarily active in harbor towing during the mid-nineteenth century. Brothers Humphrey and Palmer owned part or all of a score of boats, mostly of this inshore class. Mariners Museum, Newport News, Virginia, acc. Q0405.

built his first tug, the *J. S. Underhill*, in partnership with Foulks and Daniel J. Barney in 1853. Eventually, Palmer became manager of a fleet of at least twenty-six tugboats.[10] Partners in ownership of these boats were, variously, his brothers Humphrey and Peter as well as Daniel J. Barney and William Foulks. The fleet was operated as the Blackball Line of Towboats. Sons of Alexander and Peter Crary—Byron, Spencer, Francis, and Datus—all were involved in the ownership and management of Blackball Line tugs between 1860 and 1866, when they left the water to become builders. After retiring from the Blackball Line in about 1882, Palmer lived on until 1897, dying in his sleep at home at age seventy-seven. His obituary notes that in the tugboat business he had "amassed a considerable fortune."[11]

The story of the Crary family suggests that they enjoyed a level of financial security and family connections that allowed them to invest liberally in the businesses of their choosing and to make even more money as a result. Marriages into the prominent families of the Palmers, the Livingstons, and, probably, the Newtons demonstrate that they were part of a caste of burgeoning American wealth. The fact that the Crarys chose tugboating as their investment medium suggests that steam towing at that time was viewed as an aggressive entrepreneurial activity. Their shift out of the towing business, evidenced by Palmer's retirement and the younger sons' shift into building, suggests that they eventually came to believe that their capital might be better invested elsewhere.

Another entrepreneur who started off as a machinist was Peter Hammond, twenty-two years old in 1848, married and living on Avenue D, close by the East River. By 1853 he was an engineer and had moved across town to Varick Street. In 1857 he became master of the tug *Frank*, the owner of which was George Potts of Flushing, New York. Two years later Hammond opened a towing office at 20 West Street and, in partnership with George Potts, accumulated a fleet of fourteen tugs over the next six years. Three

of the boats were newly built, two were managed by Hammond for other owners, and the rest were bought used. In 1861 a classified advertisement in *Trow's New York Directory* states,

P. Hammond & Company
Towing daily to Elizabethport, to and from sea and about the harbor by steamboats *Go Fox, Saturn, W. Putnam, Satellite* and *Frank.* Steamboats and barges always on hand for excursions.[12]

It appears that most of the capital to support this rapid expansion came from the Potts family, but this financial tide reversed itself in mid-1863, when the Potts and Hammond interests went their separate ways. By 1865 the partners had divided up the ownership of the fleet, sold the vessels to others, and left the business. It is impossible to say from this distance what caused the dissolution of what had started off as a very aggressive foray into the towing business. Among many possible causes are dishonesty on the part of one or all of the partners, illness, or, equally likely, the Potts' decision that their capital could be put to better use in some other venture. Hammond seems to have been lacking in capital of his own but was briefly lucky enough to find in the Potts family partners who were willing to finance the purchase and even the construction of steamers.

Many other would-be entrepreneurs were able to recognize the promise of the towing business but lacked the resources to purchase or build. For these there was a second but perhaps equally lucrative occupation to be found in the role of "steamboat agent." Every boat had to have someone in place to receive towing orders and to manage such of the other business of the vessel's operation as the owners might entrust to them. Before the advent of the telephone and the ship-to-shore radio, it was physically impossible for an owner/operator of a vessel to manage it from shore. He was therefore obliged to contract with an agent to take care of that part of the business for him. Likewise, a passive investor in the towing business needed an agent to conduct the

day-to-day business of the boat including the hiring of captain, engineer, and crew. Many of those who became agents along West and South streets were former operators or engineers.

William Marshall started as an engineer around 1857, opened a steamboat office at 69 South Street in 1860, and continued in that role for almost twenty years without ever taking even a partial ownership in any of the vessels that he managed. Luther Adams, originally a boat captain, managed eight tugs between 1857 and 1864, specializing in towing between the Raritan River and New York, but he held an ownership interest in only two of the boats.

There were others who came to serve as agents not through their prior experience as masters or engineers but simply by virtue of geography. In 1839 William and Theodore Dougherty were grocers situated at 75 South Street. Michael Dougherty, who may have been their father or perhaps an uncle, had been a ship master since 1835 and in 1842 became owner of the fine new tug *Jacob Bell*, one of the earliest and most successful of the Sandy Hook boats. The grocers at 75 South added "steamboat office" to their menu and continued in that role until about 1860. In 1844 Daniel J. Barney was also a grocer and then by turns a hotelier and a keeper of a porterhouse, all at 185 West Street. In 1853 he became involved with the Crarys and William Foulks in the ownership of three tugs and soon was operating a towing agency out of his hotel/saloon. John F. Tallman likewise wore the hats of grocer, captain, hotel keeper, saloon keeper, towing agent, and finally seaman during a career spanning the years 1842 to 1868. His base of operations was 425 West Street.

The gnarly trajectories of many of these early operators were probably a reflection of the general business environment of New York during that period. Competition was intense in every field, and the level of uncertainty and risk was great. Financial institutions offered little protection from and far too often were the direct cause of the frequent panics and failures that plagued New

This stereograph image shows the tug *Saturn* attending the 1860 Fourth of July Regatta just off the Battery. At this time the tug was operated by P. Hammond & Company, which enjoyed a brief prominence between 1857 and 1865. During 1862, the *Saturn* performed a four-month charter for the U.S. Army Quartermasters Department. Collection of the New-York Historical Society, neg. 41817.

York throughout the nineteenth century. The concept of diversification was at least as important then as it is today, but it was practiced by different means. To spread the risk of loss, the ownership of vessels was usually divided among many individuals. A one-sixteenth part of a ship was a significant investment, and such a position taken in sixteen different vessels was vastly more secure than outright ownership of one ship. Likewise, capital generated in one line of business frequently put to work in others. This is the reason William Foulks and Humphrey Crary, a shipbuilder and a boilermaker, readily and comfortably ventured

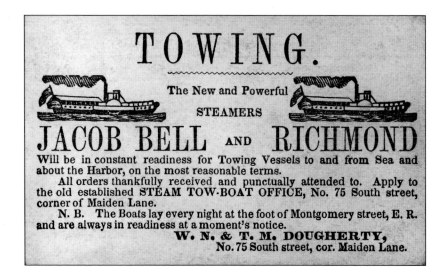

A trade card dating from the 1840s. Museum of the City of New York, Print Archives, 50.161.6.

into the operation of vessels as well. Wilson Small, an engine builder whose factory was located at the corner of Beach and West streets and who became a major figure in the internecine gyrations of Tammany Hall and later in the rebuilding of several public schools on the Lower East Side (he was referred to as "the *venerable* Wilson Small" in the *New York Times*), took part or whole interest in several boats, presumably boats for which he had supplied machinery. He apparently did not manage these vessels but put them under the agency of Luther Adams.

Others who achieved prominence in the earliest days of New York towing rose by way of their official duties. The Manhattan and Brooklyn waterfronts were divided into eleven districts, each presided over by a harbor master who saw to the fair and orderly berthing of vessels. Fees were specified for the amount of cargo handled into and out of vessels engaged in international trade, and although vessels engaged in coastal or inland trade were exempt from any cargo fees, the harbor master collected two dollars from

vessels to mediate disputes or protests between them as to priority or length of stay in particular berths. All fees connected to the operations of the port had historically been kept to an absolute minimum under pressure from the merchant oligarchs of the city, who recognized that the general prosperity of the port was far more important than whatever small and annoying tariffs could be extracted from it. The harbor masters were nominated by the governor of the state and confirmed by the state senate. Throughout the mid-nineteenth century, patronage and influence were the currency of state and city government, and the process leading to the appointment of the harbor masters was no exception.

With the small fees to which the harbor masters were entitled, it may be difficult to understand why the positions were so widely sought after that candidates were routinely expected to deliver as much as $1,500 to a senator and $2,500 to the governor's personal secretary merely to become eligible for a nomination with no guarantee of success. The majority of the candidates for harbor master appointments were not even residents of the city, and some were totally innocent of marine experience. The position was desirable, of course, because once ensconced in his waterfront district, the harbor master was transformed from a supplicant into a little king, allowed to act on his own construction of the law.[13] Ship masters and agents, stevedores, lightermen, and towboat captains were all obliged to cooperate, which inevitably took the form of cash or services. Twenty to thirty dollars was the going rate to secure a berth for a packet ship; two to three dollars settled the business for a river sloop or canal boat. Prime wharf space was held empty for a prized customer, while vessels that did not meet the harbor masters' demands were forced to move their cargo in and out while riding at anchor over in the Flats.

Between January 1 and November 30, 1859, the harbor masters collected a total of $31,250.45 in legitimate fees from the 3,346 deep-water vessels that visited the port. Another 7,500 coastal trading vessels that visited, though legally exempt from harbor

masters' fees, were nonetheless at risk of extortion. If each deep-water entrant was fleeced for $20 and each coastal vessel for $10, the under-the-table proceeds would have amounted to about $142,000, which, divided equally among the eleven districts, would amount to about $13,000 per little king. Of course, some districts, particularly those around Lower Manhattan, were far more lucrative than others.

Some harbor masters operated on an absentee basis, remaining in their upstate seats while deputies performed their duties in the city. The deputies were eager to perform these services for nothing as well as to remit to the little king one-half of any profit they might be able to originate on their own behalf. One such means of profit was the control of the contractors who worked in each district. Stevedores were forced to make payments for the privilege of handling cargo in a district, and tugboatmen were forced to remit to the harbor masters in whose districts they handled dockings and shifting. In some cases the tug captains were directly complicit in that they would extract a towing fee in excess of the actual service provided on the understanding that the excess represented the guarantee of a good berth at the end of the job. The bribe was then split between the tug operator and the harbor master.

Harbor masters' tenures were subject to the satisfaction of the governor and the state senate, and a change in the sentiment or the politics of either could spell the end of an individual's time with his nose in the oat bucket. The farsighted would look for opportunities to establish themselves in private business as a hedge against the day when their appointment might end. Why not start or buy into a fledgling tugboat company within the protected nest of your own district and force-feed it on graft so that when the patronage post came to an end it would be possible to fly off on the well-feathered back of private enterprise?

Charles Chamberlain, an auctioneer, secured appointment to harbor master in 1848. From an office at 160 South Street he

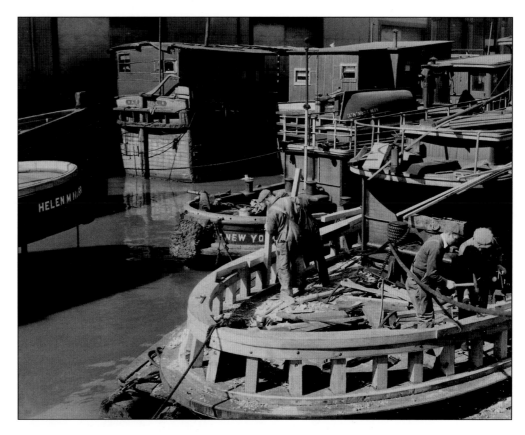

Repairs to a tug of around 1930. The wooden tugs of the nineteenth and early twentieth centuries were heavily built and exceedingly durable. So long as they towed wooden barges, the wear and tear of one wooden hull against another could be easily tolerated by both; only after barges began to be built of steel did wooden tugs become impractical and vice versa.

New York had a vast supply of highly skilled ship carpenters who could repair or rebuild a tug quickly and inexpensively. Here four men replace the white oak bulwarks of an unidentified tug. The upright stanchions have already been fitted through the outermost margin of the deck and fastened into the frame of the hull below. Now the men are attaching the rail cap. Because of the curvature around the stern, each section of rail cap is short and must be fastened to the next with long overlapping scarf joints. The bottom of each section of rail cap is mortised to accept the top inch or two of the stanchions beneath it, and the two men on the left are using bars to coax the stanchion tops into place. Once assembled, the whole is then fastened together with iron drifts, one of which is being finished off by the two men at the right. Collection of the New-York Historical Society, neg. 76796d.

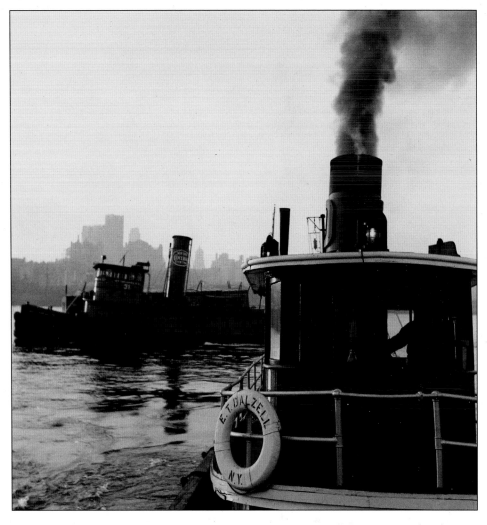

East River. New York Central and Baltimore & Ohio tug boats.

The original caption for this photograph misidentifies the *Edward T. Dalzell* as belonging to the B&O Railroad. Of course, she belongs to the Dalzell Towing Line. Built of wood in 1919, with 150 horsepower and coal-fired steam, she is the smallest of the 1946 Dalzell fleet of twelve boats.

Behind her is the *New York Central No. 31*, built of steel, 102 feet in length, and rated at 750 horsepower with oil-fired boilers. The No. 31 was the second of three sister ships built in Brooklyn in 1923. She and her two sisters remained in the New York Central fleet until 1968. Photograph by Gordon Parks, October 1946, Special Collections, Photographic Archives, University of Louisville.

ruled a large part of the East River waterfront until 1860, when scandal and state senate hearings forced him from office. He moved up the street to number 163 and set up shop as a steamboat agent. He remained in the business thereafter and eventually became a major partner in the firm that would later become the New York Harbor Towboat Company, the first such firm to survive as a multigenerational enterprise.

Reuben Coffin, resident of the prosperous Hudson River town of Athens, New York, and harbor master along the North River from the Battery to Pier 7 from 1858 to 1860, became, immediately thereafter, the principal of R. Coffin & Company, which assembled a fleet of tugs that after 1869 became the backbone of the New York Harbor Towboat Company. This firm remained a fixture in the harbor until well into the twentieth century, finishing its life under the ownership of John E. Moore when it was finally acquired by Moran Towing & Transportation.

Alexander H. Schultz, a native of Rhinebeck, New York, was a canal boatman, then a steamboat captain working between New Brunswick, New Jersey, and New York. He was for several years an alderman in the Fifth Ward of the city and in 1852 an unsuccessful candidate for state senate. He was appointed harbor master from 1848 to 1860. He operated a steamboat brokerage in partnership with his son, Peter C. Schultz, while he held office and continued thereafter. He died in 1867, and Peter remained in the business until 1886.[14]

Peter Hammond, who with the financial backing of the Potts family achieved brief prominence, was in 1860 named as one of the captains who, in collusion with the harbor masters, exacted bribes from ship masters. Charles P. Raymond also was briefly a harbor master after earlier wearing the hats of grocer, auctioneer, and "speculator." After his brief stint in public office, in 1865 he founded the towing firm of C. P. Raymond & Company, which in turn became Dalzell Towing, a harbor survivor until 1965, when it was acquired by McAllister Brothers.

★ The Cornell Steamboat Company

In the late nineteenth century the Cornell Steamboat Company became the most powerful towing organization in the United States. Headquartered on Rondout Creek, the Hudson River port of Kingston, New York, Cornell Steamboat Company was as much a creature of its geographical situation as it was of the management skills of its early proprietors, Thomas Cornell (1814–1890) and, later, his son-in law, Samuel D. Coykendall (1837–1913). Likewise, the eventual demise of the company owed as much to the disunity of later generations of the company management as to the decrease of trade and industry in the Hudson Valley. The inception of the company under Thomas Cornell and its robust midlife under Coykendall were borne on the great tide of commerce that flowed on the Hudson—coal, timber, cement, and stone from the Delaware & Hudson Canal; brick, block ice, and stone from the banks of the river. The opportunities for profit were foreseen and seized by the first two generations of management just as they were fumbled by the later ones. The company had its origin in 1837 in the canal-building era, when towing was at its earliest stage and still splitting its time carrying passengers. By its finish in 1963 the company had spanned better than a century and a quarter. In that time it had faced the rise of the railroads, the conversion from side-wheel to propeller drive and from steam to diesel. It had passed from an era when monopoly and restraint of trade were the basic tools of business to the modern time when a would-be tycoon is charged by law to grant prosperity to his competitors. A brief history of Cornell shows, in one corporate lifetime, most of the challenges that tried the early towboat companies.[15]

The town of Rondout, New York, was named for the creek that fronts it. The town, like the creek, was nothing but a backwater until, by the gravity of water, it became the eastern terminus of the Delaware & Hudson Canal. Between its opening in

Thomas Cornell (1814–1890) served one term in the U.S. House of Representatives from 1867 to 1869. Politically, he was a Lincoln Republican. Spiritually, however, he was a businessman, founder of what was for almost one hundred years the largest marine establishment in the country. Library of Congress, Prints & Photographs Division, portrait collection.

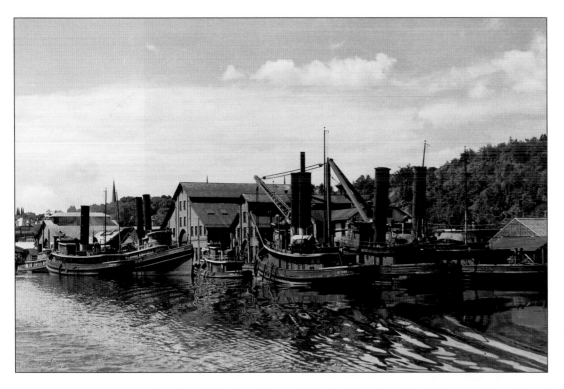

The Cornell Yard on the north bank of Rondout Creek in 1949 shows five of the company's large tugs, from left to right, the *Stirling Tomkins*, the twin-stacked tugs *Perseverance* and *Geo. W. Washburn*, the *Bear*, and the *J. C. Hartt*. Dwarfed between these giants is the smaller *Cornell 21*. The reason the five large tugs are all idle at the dock is that they are all in the process of being disposed of by the company, part of a persistent downsizing that led to the dissolution of the company on February 28, 1958.

The buildings on shore are the workshops of the company. Typically, the company contracted with a shipbuilder for a bare hull that would then be towed to the Cornell Yard, where deckhouses, interior accommodations, and all machinery was fabricated in-house.

Note that both the *Washburn* and the *Hartt* carry a second set of towing bitts on the deckhouse top. Though this arrangement raises the center of effort when towing on the hawser, it has the advantage of placing the hawser high enough that it will not chafe on the stern railing while towing. Also, the raised hawser permits safer working conditions on the stern deck while underway. Photograph by Seymour Weinstein.

1828 and its demise in 1898, the D&H Canal disgorged millions of tons of Pennsylvania hard coal as well as cement, plaster, timber, stone, and tannery products into the trans-shipment port of Rondout. The creek was also advantageously situated about midway on the Hudson between Albany and New York City in an area that was steadily increasing its output of brick, block ice, quarried stone, and cement.

Thomas Cornell started off in the marine business at age twenty-three, captaining a cargo sloop that ran in conjunction with his family's dry goods and provisioning business at Rondout. Soon the business began to focus more on acting as agents for passenger steamboats and market barges that operated from the creek. By 1850 Cornell had secured a contract with the D&H Canal Company to tow their barges on the waters of Rondout Creek and the Hudson. At this point his operations began to separate into the distinct branches of passenger carrying and towing. Although towing soon became the dominant business for Cornell, the clear division of the company's effort between passengers and towing continued to the last year of Thomas Cornell's life, for only then did he sell his last passenger steamer, the *City of Kingston*, which ended a succession of fine and highly competitive vessels that included the *Thomas Cornell* and the finest of all the Hudson River steamboats, the *Mary Powell*.

Through most of the nineteenth century the company relied on side-wheel towboats (a large steamer and a smaller helper boat) to handle either line tows either between Rondout and New York or two-stage tows from Albany to the mid-Hudson area, where a second larger Cornell tug and helper boat would take the tow the rest of the way to New York. The company was quick to adopt propeller-driven boats, and by the 1880s it was operating some of the largest and most powerful propeller tugs in the world.

The Cornell Steamboat Company combined a very high standard of equipment, personnel, and seamanship with a ferocious competitive instinct. The Cornell workshops at Rondout could

take in an empty bare hull from a local shipbuilder's yard and finish it with everything from deckhouses and interior accommodations to high-quality engines and boilers. The forced lay-up during the winter freeze—which was in all other respects a major competitive disadvantage relative to the towing companies of New York Harbor and to the railroads—could be turned to advantage by allowing for major overhaul and repair of the fleet. The Cornell tugs were kept in excellent condition. Likewise, the employees of the company from captains to deckhands and clerks to carpenters were considered the best in the valley, and their combined efforts produced an unrivaled level of dependability in towing operations.

And if a rival appeared, he didn't last long. The one-two punch of a merciless price war followed by a merciful buy-out offer was the usual tactic. In quiet negotiations, territories were divided, particularly between Cornell and the upriver towing companies. To thwart interlopers in the towing of ice barges Cornell bought up futures on a large part of the upcoming ice harvest and then threatened to torpedo the market value of the entire harvest unless its competitor withdrew. To ensure that the growing fleet of small, independently owned tugs at Albany could not be combined to mount a campaign against Rondout, Cornell quietly organized the fleet under the leadership of an ally of its own, one Ulster Davis, who through a series of gradual maneuvers brought the unruly Albany independents under control and delivered them to Cornell as a group.

This combination of quality service and relentless competitiveness brought the company into the first years of the twentieth century with a fleet of sixty-three tugs and a capitalization of over $3 million. But already there were signs of decay. The D&H Canal had closed. Mechanical refrigeration ended the natural-ice business. The need for common brick dwindled as New York City builders turned more to cast-iron and terra-cotta façades and to poured-concrete and steel framing. Railroads ran on both east and west banks of the Hudson, and in the 1930s the top of the Hudson was dredged to allow ocean-going ships access to Albany. Antitrust legislation and union organization put a muzzle on management. The entire social geography of the Hudson and the country had turned against Cornell, and its only hope of survival was rapid and farsighted change.

That challenge was not met. The company that in the 1860s had been quick to embrace the new technology of the screw propeller now balked at the next fundamental advance in technology, the diesel engine. After the death of Samuel Coykendall in 1913, leadership passed to his sons, who lacked the single-mindedness of their father. By 1949 control of the company had devolved into the hands of its bankers. The sons struggled to revive the business, but in 1957 they were forced to sell out to their last major customer, the New York Trap Rock Company, a producer of crushed stone. New York Trap Rock continued to operate Cornell as a subsidiary until 1963, when Trap Rock itself failed, was sold, and its towing operations discontinued.

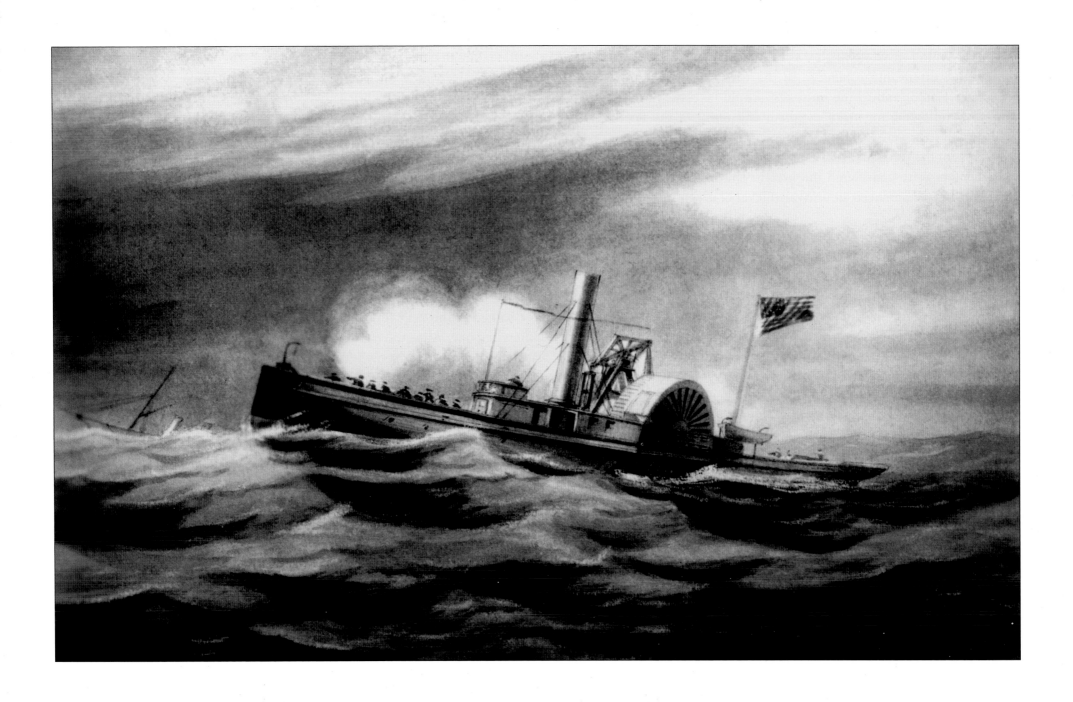

8

The Civil War

The U.S. Navy was totally unprepared for the strategic and tactical challenges posed by the outbreak of the Civil War. The entire fleet consisted of fifty-two active ships, twenty-one of them sail powered and the rest about evenly split between side-wheel and screw propelled.[1] All were deep-draft vessels intended for battles like those fought in the War of 1812: open-sea contests of maneuver and broadside. The mid-nineteenth-century warship was as much a ceremonial and diplomatic platform as it was a weapon. Thus, to "show the flag" in foreign ports around the world was the Navy's main purpose up until the spring of 1861. With the bombardment of Fort Sumter all that changed.

Realistically, serious naval preparations for the war would have been difficult because the North hoped, right up to the last minute, that secession could be avoided. Also, just as in the Army, a large proportion of the Navy's officer corps were Southerners, not to mention the senators and congressmen who were responsible for military appropriations. The outbreak of war at Fort Sumter caught the Navy and its new overseer, Naval Secretary Gideon Welles, with few resources in place. What followed was a frenzy of improvisation in which New York Harbor's fleet of tugs played a major role.[2]

The original strategy for dealing with the Rebellion was to squeeze the South economically by blockade and embargo, while avoiding the carnage that, it was feared, would make the eventual

U.S.S. *Eolus* Capturing the Blockade Runner *Lady Stirling* — off Wilmington, N.C., 28 October 1864.

The *Eolus*, a typical New York offshore tug, was built at Newburgh, New York, in 1864 and went directly into the Union Navy to be armed with one thirty-pound rifled gun and two twenty-four-pound howitzers (the poundage figure refers to the weight of the iron projectiles the gun was designed to fire). She was stationed with the North Atlantic Blockading Squadron off Wilmington, serving as a picket boat and general courier within the fleet. She is credited with capturing one blockade runner, the *Lady Stirling*, and with assisting in the capture of two others. After the war she was sold in Boston and began a career in commercial towing. U.S. Naval Historical Center.

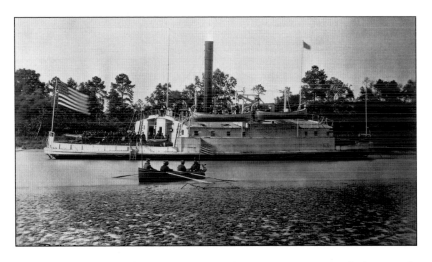

The New York City ferryboat _Commodore Perry_ was one of the vessels bought by George Morgan. She was converted by placing a belt of boiler-iron plating all around her main deck to protect her boiler, machinery, and crew. Her armament consisted of two nine-inch and two thirty-two-pound smoothbore cannon and one twelve-pound howitzer, making her a very formidable vessel. She was very active on the rivers and sounds of North Carolina and Virginia. Library of Congress, Prints & Photographs Division, LC B8184-10095.

rapprochement of the two sides all the more difficult. Key to this "Anaconda Plan,"[3] as it was called, was a seamless blockade of the entire Southern coast from Virginia to the Mexican border, combined with the seizure of the navigable headwaters of the Mississippi River as well as its outfall at New Orleans. In total, this represented a vast expanse of open coastline punctuated with shallow inlets, bays, sounds, and river channels, most of which the Navy's existing warships could not possibly negotiate because of their size, their draft, and their lack of steam propulsion. To prosecute the war, Gideon Welles realized that he would need an entirely new Navy. He set about fulfilling that need from the ranks of the nation's merchant fleet. There was no shortage of willing, sometimes overwilling, sellers offering vessels. As many

as one hundred applicants a day besieged the Navy with offers to sell coastal steamers, ferries, and tugs—often in poor condition and at wildly inflated prices.

The naval officers originally assigned to make these purchases were no match for these eager brokers and middlemen; and, after several disastrous transactions,[4] Secretary Welles realized that he must enlist a New York businessman schooled in the ways of New York business. He chose his daughter's brother-in-law, George D. Morgan, disregarding charges of nepotism with a noble argument:

> It was essential that I should have, if possible, full and thorough _personal_ knowledge of my agent, of his capacity, and above all of his integrity, which no temptation could swerve a hairs breadth from the line of rectitude. More even than this, I must, if possible, have the strongest personal hold upon his capacity, diligence, and honesty and must, if possible, have him to feel most keenly that my character and honor were indissolubly bound up with his own, and staked together upon every step he should take in each and every one of the transactions confided to him, and in the general result of them all.[5]

In the press and in congressional committee Welles was assailed and Morgan pilloried, but history has proven their choices to have been both astute and effective. Morgan was first called in May 1861 to renegotiate two earlier charter agreements that were grossly disadvantageous to the Navy. He achieved a savings of $23,000.[6] After this he was empowered by Gideon Welles to handle the purchase of more vessels under a system in which each prospective purchase was first subject to an inspection by a naval constructor, an engineering officer, and an ordnance officer to decide on the vessel's suitability. Morgan chartered a steam tug to take himself and his examiners around the harbor to look for desirable vessels. Once approved by the experts, Morgan proceeded with negotiations. He established that he would deal only with

the actual owners of the vessels, excluding all brokers and middlemen. He conducted his negotiations very rapidly, hearing an asking price from the owner and making a lower counter offer, which would usually be left on the table for the owner to accept or not. The resulting purchase agreement averaged a 19 percent savings to the government even in a market that was obviously balanced toward the sellers.[7] It is clear from his correspondence with Welles and Assistant Secretary Gustavus Fox that Morgan's involvement in his assignment was all-consuming. Two or three times a day he would communicate to Fox the details of vessel inspections, negotiations, and conversion of the new purchases to military service. Between July 1861 and January 1862, Morgan purchased 95 vessels ranging in tonnage from 90 to 2,000. Broken down by class, the list contained 37 sailing vessels, 32 coastal steamers, 8 ferryboats, and 18 tugs. He spent $3.4 million against a total of $4.2 million asked by the sellers.[8]

At the Brooklyn Navy Yard and at private shipyards around the harbor the new purchases were rapidly converted to naval service. The tugs and ferryboats were transformed into gunboats by the addition of light armor plating along deck railings and pilothouses, reinforced gun platforms at bow and stern, powder storage and berthing spaces, and, where possible, the relocation of boilers to below-deck spaces where they would be less vulnerable to enemy shot.[9] The pace of the program was hectic and at many points diverged so sharply from normal military purchasing and construction methods that long-time naval personnel were nearly driven mad. Samuel Pook, the veteran naval architect and constructor assigned to Morgan's project, suffered what appears to have been a nervous breakdown, exhibiting the conviction that he would be censured and jailed.[10] He had to be coaxed back to the job with an effusive commendation requested by Morgan and penned by Fox. But the little makeshift navy took shape regardless, and from summer through winter it voyaged south in small convoys, particularly to Hatteras Inlet on the North Car-

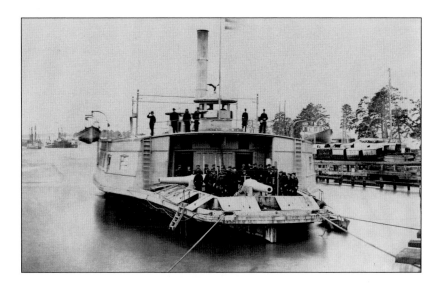

Another converted ferry, believed to be the *Commodore Morris*, showing the protective plating around the forward deck cleared away to allow the working of the guns. Note that the pilothouse windows are also fitted with plating to protect the pilot and helmsman from enemy fire. Library of Congress, Prints & Photographs Division, LC-B184-40487 ZA.

olina coast where Union forces were attempting to penetrate Albemarle and Currituck Sounds. The long coastal voyage was difficult for most of the boats. The ferries and tugs straggled down the shore manned by civilian crews, hired at New York on the theory that these men were better seasoned in the messy business of coastal navigation than were their often inexperienced naval counterparts. Only once they had passed through the inlet into the sheltered Carolina rivers and sounds were they put into the hands of naval personnel. Even then, a considerable effort was made to retain each vessel's civilian engineer, as the idiosyncrasy of each boat's machinery was seen as a daunting problem.[11]

Once the boats had arrived on station along the south Atlantic shore, they quickly proved their worth. They combined speed,

A note dated October 22, 1861, from George D. Morgan to Gustavus Fox in response to congressional inquiry regarding commercial vessels acquired by Morgan and others at the beginning of the war. What is most striking in the entire Morgan affair is the informality with which the entire purchasing program was conducted. This hastily composed note became the basis for testimony before the Senate that led to the rightful exoneration of Navy Secretary Welles and, by implication, his protégé, Morgan. Collection of the New-York Historical Society, neg. 76480d.

shallow draft, and relatively heavy armament consisting of various combinations of rifled Dahlgren and Parrot guns, as well as older smoothbore cannon and Army howitzers located at bow and stern. The ferries, in addition to their considerable firepower could ship as many as three hundred cavalry that upon nosing up to the shore could be disgorged into rebel territory with terrifying effect.

Morgan's efforts, however effective they were in creating a fleet for the North, had ruffled many feathers among vessel owners and shipyard operators intent on greater profit. The charges of nepotism increased, as did the complaint that Morgan had received a 2.5 percent commission from the sellers of the vessels, though he received no other compensation whatsoever, even as he devoted all his energies to the project to the complete exclusion of his normal business activities. In early 1862 he was replaced by the head of the Brooklyn Navy Yard, Admiral Hiram Paulding. Everything Morgan had done had to be defended before the Senate, but the defenders were many even among the ranks of the New York shipping community, and they were outspoken.[12] Morgan and Welles were soon exonerated. As the dust was settling, Fox, in a letter to Morgan, spoke of Welles: "The firmness, the integrity, and the judgement and coolness of the Secretary has been too much for his detractors. The sunlight falls full upon him."[13] This verdict has adhered to Morgan as well.

But perhaps the best testimonial to Morgan's work comes from one who was in a position to judge it in practical terms. Admiral Samuel F. Du Pont wrote to Fox on August 21, 1862, from his flagship, *Wabash*, off Port Royal, South Carolina:

in 15 minutes we put howitzers and guns on the tugs and off they go—Oh those blessed ubiquitous tugs—They were your thought, and *I* have often thought, if poor Morgan so much abused had never thought anything else, he would have earned his money. No estimate can be placed on their value here—we

have managed to repair them in turn, and they have paid for themselves ten times over.[14]

After Morgan's departure, the U.S. Navy continued to purchase tugs. In the course of the war at least forty-eight were bought from the New York area, with a number of shoal-draft propeller boats being brought to New York City from Albany and even from Lake Erie and Lake Ontario via the Erie Canal. Thirty boats were purchased from the Philadelphia/Wilmington area, and seventeen others mostly from New England. In addition to these, perhaps as many as fourteen tugs were purchased in the Mississippi River basin, bringing the total number to about 110. Of boats purchased around New York, thirty-one were propeller driven and seventeen were sidewheelers. Most of the side-wheel boats were among those acquired by George Morgan, but even in 1863 and 1864 four more were added to the roster.

The Navy tugs served both as armed combatants and as service vessels. Armed, they cooperated with their larger regular Navy brethren in both the coastal blockade and in offensive operations among the interior rivers and bays of the South. In blockade duty they were most often given close inshore patrols meant to intercept Confederate vessels threading the labyrinth of inlets and shoals along the Carolinas' shore. Interior operations found the tugs scouting far up the creeks and estuaries, sometimes in waters so confined that they were obliged to winch themselves upstream using long hawsers set out to trees ashore. Particular targets were highway and railroad bridges and riverside towns known to be supplying stores to the Confederate army. Frequently the tug/gunboats were called on to support troop movements far inland. The most important of these was the artillery support provided to General McClellan's Army of the Potomac during the ill-fated Peninsular Campaign in the early summer of 1862. Forced into retreat during the Seven Days Campaign, the Union Army would probably have been forced into wholesale surrender with their backs to the James River at Harrison's Landing were it not for the artillery support of naval gunboats.[15]

New York tugboats also assisted all along the coast in traditional towing operations. There was a constant need for tugs to move supply vessels and grounded or broken-down warships and to carry dispatches, pilots, supplies, and men. Sometimes their towing assignments carried them past enemy shore batteries. In these situations the tugs made sure to keep their loaded barges between themselves and the enemy. Barge loads of hay were considered to be best for this purpose, and it was even suggested that tugs traveling over routes subject to shelling might adopt the custom of paying hay schooners to serve them as breastworks.[16]

As the Union Navy began to penetrate the Southern coast, first at Hatteras Inlet and then more generally, their foremost obstacle was the presence of defensive shore batteries. Traditionally, ships were considered no match for fixed shore guns; but the advent of steam changed the equation. The greatest risk to a ship was to become immobilized within the shore guns' field of fire. Sailing vessels were particularly vulnerable to this predicament; steam warships were less so, and a steam warship with a tug either alongside or standing by as insurance was even better off. For shore bombardment sailing warships in the squadrons were commonly assigned a tug, which secured itself to the ship's side away from the shore guns and from that somewhat protected position provided maneuvering power.

The wear and tear on the tugs was tremendous. On blockade duty they were exposed to frequent rough weather. Working inland they grounded often. Occasionally they came under enemy fire. Almost as bad, when they fired their own guns, the recoil wracked them mercilessly, causing leaks and mechanical difficulties. Admiral Goldsborough reported to Fox in February 1862 from the Hatteras Inlet Campaign, "The firing of our heavy guns on board of our frail vessels is making their very timbers yawn, and then leak more and more."[17]

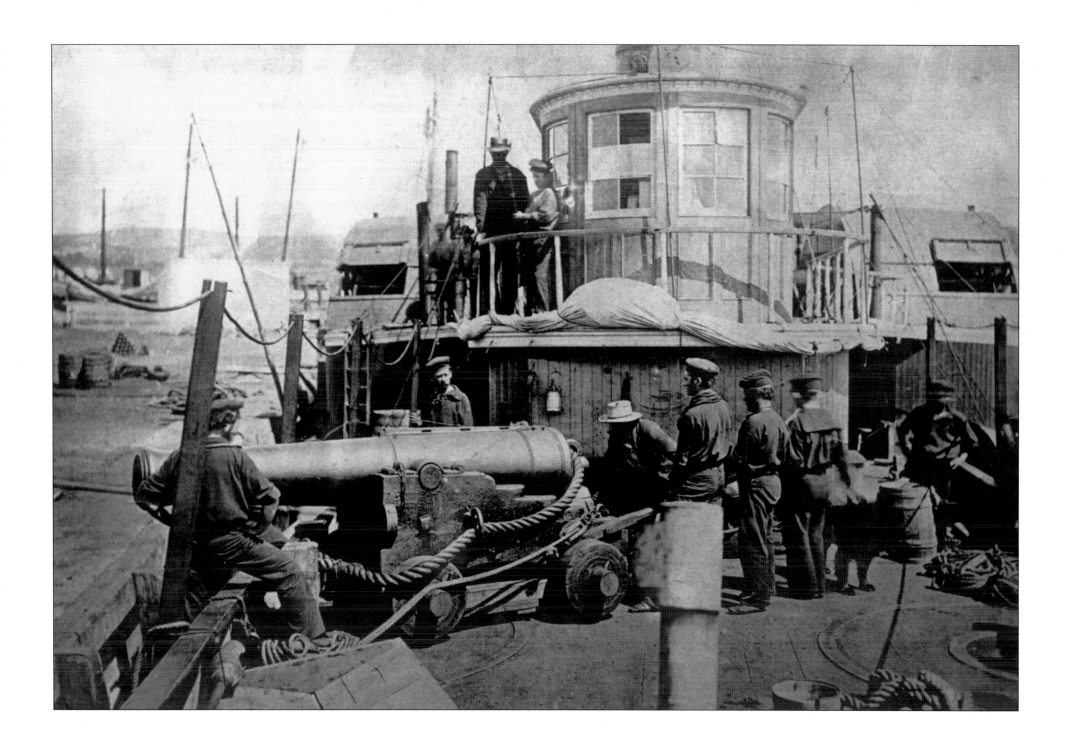

When operating in the interior the tugs were often obliged to take boiler water from brackish sources which caused their boilers to clog with salt scale. The boats were constantly being shuttled to Navy yards at Washington, Baltimore, and New York for repairs. Of the forty-eight New York tugs that served in the Union Navy, four were lost to enemy action. Two were scuttled or burned by their own crews to avoid capture, and three were either lost at sea or wrecked in noncombat situations. Of those that survived the war, seventeen were retained in government service,

with seven going to the U.S. Lighthouse Service as buoy and lighthouse tenders and the rest staying with the Navy. The remaining twenty-two tugs were sold at auctions held in Washington, Baltimore, Philadelphia, and New York during the late summer and autumn of 1865. Boats originally purchased in New York were not necessarily resold there at the end of the war, but many of the buyers in Washington, Philadelphia, and Baltimore were New York operators. The boats sold for a fraction of their original cost to the Navy, and their introduction into the commercial

U.S.S. *Thomas Freeborn*. "Some of the ship's officers and men demonstrate how her late Commanding Officer, Commander James H. Ward, was sighting her bow gun when he was mortally wounded on 27 June 1861, during an action with Confederate forces at Mathias Point, Virginia. The gun is a 32 pounder smoothbore, of 60 hundredweight, on a 'Novelty Carriage.' This mounting was developed by Commander Ward before the Civil War. Location appears to be the Washington Navy Yard, D.C."

This is probably the only photograph ever taken on board a New York side-wheel tug. In the immediate foreground is a stove pipe, which suggests that the space below decks was used for berthing. The pilothouse sports a paneled and either varnished or grained exterior and a decorative cornice molding. Most of the windows appear to be screened with wood or metal on the inside for protection. The wainscoting of the lower deckhouse also appears to be grained. Furled around the deckhouse railing is an awning that would be rigged to the makeshift vertical timbers that line the rails. It is possible that the skirts of the awning would hang down to the rail and thus conceal the crew on deck from sniper fire when the vessel operated in confined waters. The square hatches lying open on each of the paddle boxes presumably provide maintenance access to the paddles within.

The *Thomas Freeborn* was constructed in 1860 by the Brooklyn shipyard of Lawrence and Foulks. She was 140 feet in length, with 24-foot beam and 8-foot 6-inch depth. She was bought by the Navy in early 1861 and saw a great deal of action in Virginia. In July 1865 she was sold and renamed *Philip*. She disappeared from the register in 1887. U.S. Naval Historical Center.

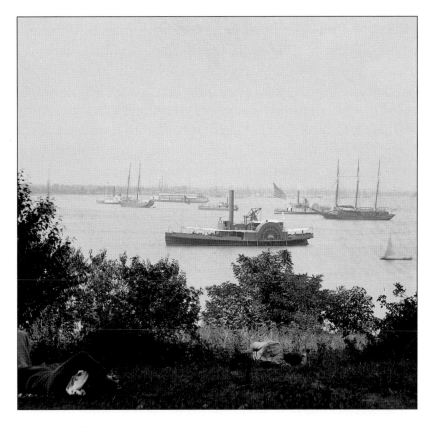

An unidentified offshore tug, converted to gunboat service, lays at anchor in the James River. Library of Congress, Prints & Photographs Division, LC-B811-2451.

market must surely have had an unsettling effect on the competitive structure of the New York towing industry. By lowering the financial threshold of entry into the towing business the postwar auctions helped to produce an oversupply of tugs that plagued New York Harbor for many years thereafter.

Just as the Navy was forced to change its fleet composition and its methods to accommodate to unusual seas, so the Union Army was also required to improvise. The naval excursions into the bywaters of the south Atlantic coast were effective in disrupting transportation and in sowing unease among the Confederate planners intent on pushing the war north in the direction of Washington; but lasting strategic gains could only be accomplished by Union Army occupation of economically significant points. Savannah, Charleston, Wilmington, New Bern, and, ultimately, Richmond were prizes that could only be won by the Army. All of these places were bounded, intersected, and barricaded by bodies of water—bays and rivers; and unless the Army was going to become web footed, it needed to learn a lot about boats. Not only were armed vessels necessary for offensive operations all along the Southern coastal plain, but a vast number and variety of transports were also needed just to keep an army in the field.

In the first stages of the Hatteras Inlet operations the Army relied on the Navy to supply both artillery support and transportation for troops. After this the Navy angled to reduce its involvement with Army operations claiming that the fleet was more than fully engaged with its own blockade duties. So the Army set about acquiring a navy of its own.[18] The vast majority of the vessels were obtained through charter agreements rather than outright purchase. The duration of the charters varied from less than a day for spot towing to a period of years. In some cases, the longer periods of charter resulted in the outright purchase of the vessel; but for the most part the Army seemed eager to avoid ownership.[19] Most of the vessels involved were under the control of the Quartermasters Department and were used for the shipment of supplies to the Army. Other Army branches that operated merchant vessels were the Commissary, the Medical, and even the fledgling Department of Aeronautics, which used at least one small steamer to deploy manned observation balloons. The variety of vessels obtained by the Army described pretty much everything known to float, from square-riggers to schooners to ocean-going passenger vessels, ferries, and tugs.

A small squadron of tugs and modified ferryboats were armed and served as gunboats in the Virginia and North Carolina waterways. Two of these, the *Charles Chamberlain* and the *Samuel L. Brewster*, had been obtained newly built in New York. Both of these side-wheel tugs remained under charter even as they engaged in combat operations in which the *Brewster* was ultimately lost, resulting in a payment of $31,353.25 to Reuben Coffin et al., her owners. This award was added to the charter fee of $120 per day already paid for her 170 days of service leading up to her destruction.[20]

Indeed, the financial advantage of chartering tugs to the Army as opposed to selling them outright to the Navy is shown in the career of the *Achilles*. In 1862 Russell Sturgis chartered the venerable tug to the Army for 206 days at a rate of either $200 per day or $20 per hour, netting $42,140. Between July 1863 and May 1864 he chartered her again for 304 days at a rate of $150 per day, netting another $45,600.[21] On May 25, 1864, the government finally purchased the boat for $45,000.[22] In December 1861

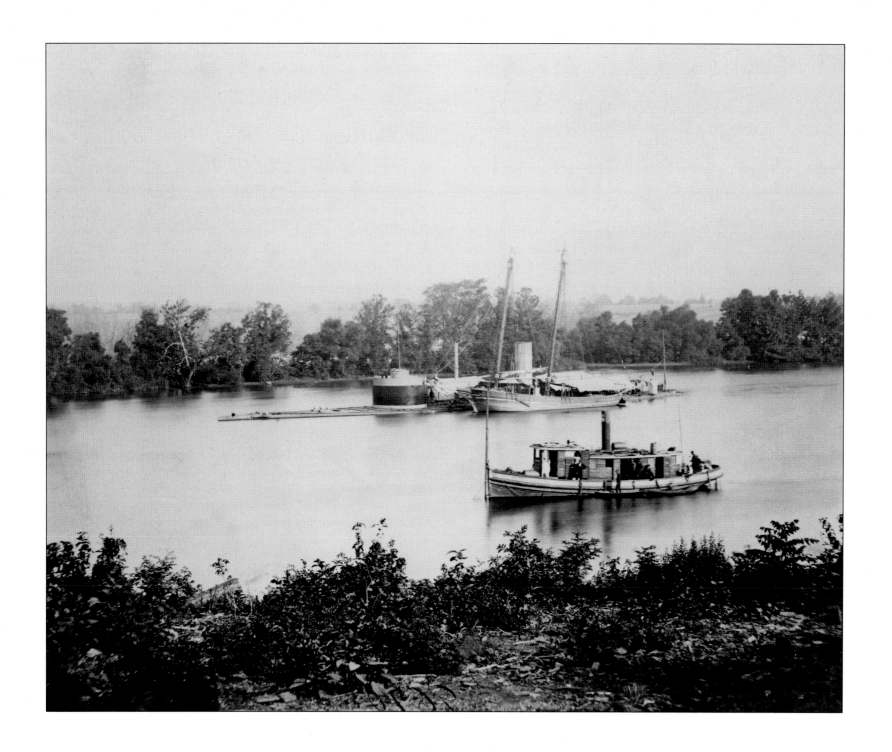

George Morgan had attempted to purchase the *Achilles* for the Navy, but Russell Sturgis quickly communicated his unwillingness to sell. Sturgis offered instead to charter to the Navy for a month or two,[23] but Morgan as quickly declined. It is likely that the purchase price Morgan had in mind was roughly the same as what he had paid for the *Underwriter*, a vessel of very similar age and capacity, which he had acquired from Peter Hammond four months earlier for $18,500.[24] Clearly, there was big money to be made by chartering a tug to the Army.

It is very difficult to determine exactly how many of the almost two thousand steam vessels chartered or purchased by the Army were tugboats, and it is even more difficult to say how many of those tugs originated from New York. The exact number is not really even significant in determining the overall impact of the Civil War on the business of New York towing because only a small part of the Army's vessel use was through charter or purchase. The bulk of the Army's contracts with suppliers required that delivery be included. Thus, a large proportion of the marine activity associated with the war was left to commercial operators. The work of the Army's Navy was mostly confined to shuttling materiel from depots in Chesapeake Bay up to forward locations on the Virginia and Carolina shores. Schooners, canal boats, and all manner of barges were loaded at rear areas and then towed to locations most convenient to the front. An important justification of the Army's reliance on the charter of vessels as opposed to outright purchase was the changing nature of the navigational limits that affected the supply of different campaigns. In some situations, such as operations far up the James River, vessels of extremely shallow draft might be required, while robust coastal vessels might be needed in another situation such as the resupply of General Sherman's army once it reached the Atlantic coast near Savannah. Through charter, the Quartermasters Department was able to retain a degree of flexibility in the face of ever-changing logistical challenges. The widespread use of tugs was a hallmark of this successful strategy.

★ Shifting

Shifting is the most demanding work in a tugboat's repertoire. Moving one or a number of barges within a tightly congested slip or work site requires a level of delicacy and precision far greater than that required for other towing assignments. Typically, tugs will receive orders to pick up (or drop off) one or a number of specific barges identified by either numbers or names. Each barge may be destined for a different customer, so the order of eventual delivery must be reflected in the order that each is added to the tow; the first to be dropped off needs to be the last added to the tow. Some delivery assignments include orders that a particular

———————————————————————➤

Tugboat pulls barge out into the Hudson River, as other tugs stand by to enter slip.

The tug *Stanwood No. 1*, built in 1903 at Port Richmond, Staten Island, as the *William J. Conroy*, shifts a deck scow out into the stream using a single line off the stem post. The deckhand on the bow of the tug tends the line that soon will be cast off so the tug can move next to the scow to make up alongside. The other tugs are apparently waiting to get into the slip to pick up tows of their own.

Note the heavy oil slick on the water in the foreground. It is only in the past thirty years or so that water pollution in the harbor has been considered a serious problem. The campaigning of environmentalists in the 1960s led to state and federal regulations prohibiting the dumping of oil and sludge into the harbor; more important, it raised a sense of awareness among marine workers—engineers and tankermen in particular—who now view the protection of water quality as a major professional obligation. Photograph by Harold Corsini, November 1946, Special Collections, Photographic Archives, University of Louisville.

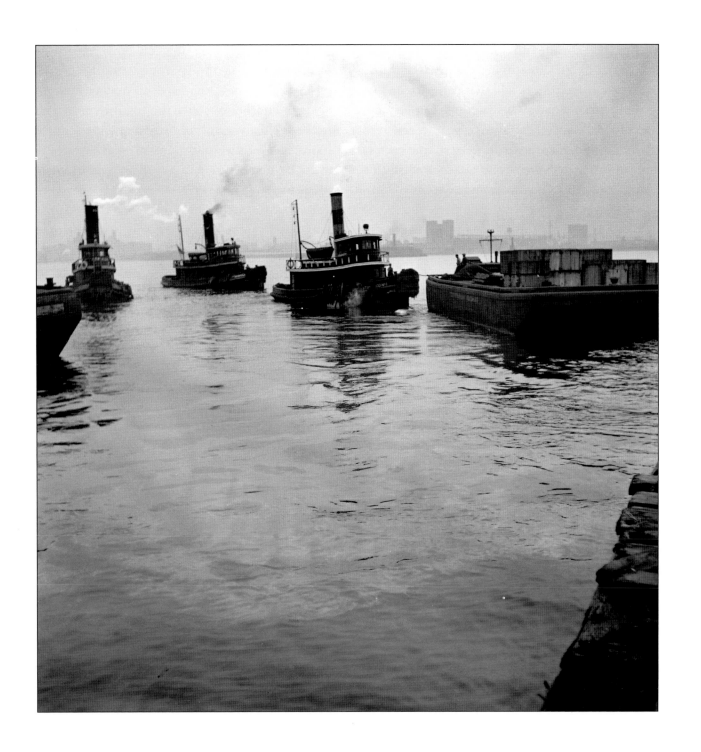

barge be landed with one side or the other facing the pier or that the bow of the barge be left in one direction or the other. If this is the case, the tug captain will attempt to add that barge to the tow in such a way that the specific delivery instructions can be most easily accomplished. To pick several scows out of a pack in a crowded slip, flip them around one way or another so that each is in its proper position in the finished tow, and to accomplish this in the minimum number of moves, can be a puzzle to rival a Rubik's cube.

By the same rule that always puts the Cracker Jack prize at the bottom of the box, the barges involved in the procedure will likely be located behind several tiers of other barges, and the shifting tug's first job is to root it out. These tugs were often referred to as "drill" tugs because that is exactly what they are required to do in these situations. To open up a raft of barges, extract one or several, and then close the raft back up in the fewest possible moves is a distinct skill at which some tug captains excel and others do not. Likewise, some boats excel at it, and others do not. The close-in work of shifting or drill work is mostly performed using the bow of the tug. The boat noses up to a barge, and a line is put out from the tug's stem post or from one of the bitts along the tug's rail on either side of the bow. The mooring lines on the barge are let go, and the tug backs away, pulling the barge with it. Enough line is put out so that the bow of the tug and the barge are about ten to twenty feet apart. This allows the tug to pull briefly on the line and then shift to neutral so that the line hangs slack and the barge drifts in the direction that the tug has started it. This slack allows the tug to reposition itself for its next move without putting any tension on the line that would change the drift of the barge. By shifting the single line from the middle of the barge to either of its corners or by transferring the line from the stem post of the tug to either of the other bitts located on the tug's bow, the angle of pull between the tug and barge may be controlled. By nudging the barge one way or another, the tug operator can draw the barge through narrow openings, stop it, flip it around, and then nudge it ahead. Likewise, he can allow the barge to nudge the bow of the tug at one angle or another to shove the tug into position for its next move. It is a delicate game of angles and momentum, similar to billiards, and intellectually similar to chess, where a series of moves must be planned out in advance. It is beautiful to watch when performed by an expert.

Key to success in shifting work is a skilled captain and crew who have worked together long enough for each to anticipate the actions of the other. In the days when engine-room orders were conveyed by the use of bells, the deckhands working out on the barges could usually keep track of the tug's intentions by careful listening. Since the advent of pilothouse control, the tug must communicate to the deckhands by voice—either through well-conditioned vocal cords or through a loudspeaker on the pilothouse roof. Even with vocal communication, however, a successful shifting boat must have a highly skilled, cohesive crew to operate smoothly. A highly polished crew can perform the most complicated maneuvers in near complete silence, each knowing exactly what to do and often using only hand signals.

Successful shifting also requires a particular type of boat, relatively small and maneuverable, particularly in reverse. Low horsepower is desirable because the work is mostly performed at low throttle anyway. Because they were able to quickly change direction from forward to reverse, single-cylinder, noncondensing steam engines were preferred for shifting work. Indeed, smooth and accurate changing of direction is absolutely essential for successful shifting. Railroad shifting tugs averaged 566 bell commands from pilothouse to engine room in an eight-hour shift.[25] During a close-in shifting operation the rate of bell signals transmitted from pilothouse to engine room might reach six per minute, and a period of such intense activity might last an hour

or more. The likelihood of a miscue at some point in this process, sending tug and barge off at the wrong speed or direction, is inevitable; and many costly accidents and time-consuming snarls have been the result. One of the greatest advances in the dependability and safety of tug operations, particularly when working close-in at ship docking and shifting, was the development of pilothouse control of the engine. Putting control of the engine directly under the hand of the man at the helm vastly improved the handling of the tug by allowing for precisely timed shifts from forward to reverse and minute adjustments of throttle settings. The development of twin-screw propulsion adapted for pilothouse control of the engines further simplified the work of shifting such that the old captains of single-screw bell boats would say that, nowadays, anybody can do it.

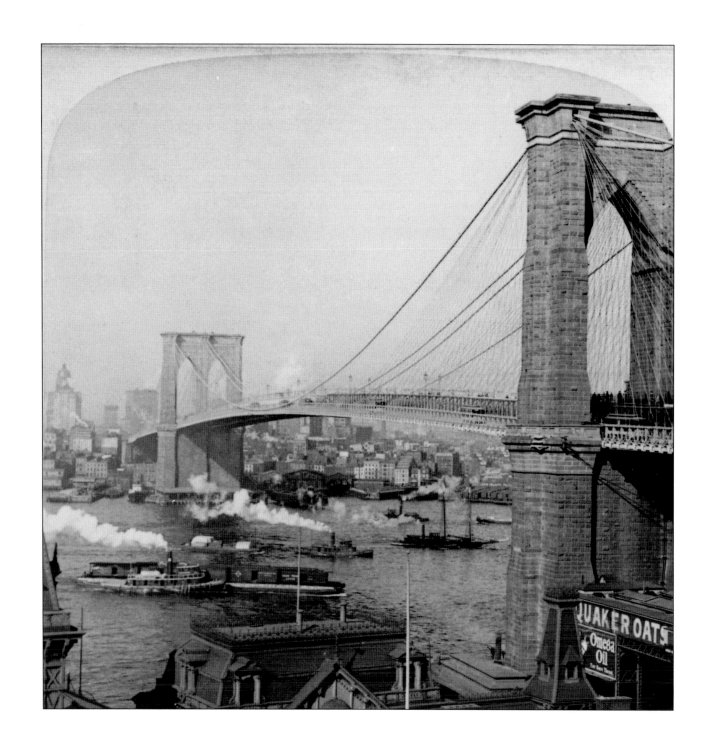

9

The Postwar Era

By the midpoint of the nineteenth century the side-wheel tug had created a burgeoning industry and was, at the same time, facing extinction at the hands of a new form of propulsion. The screw propeller had been tested sporadically in American waters since 1804, when John Stevens demonstrated a propeller-driven steam launch in New York Harbor. The British experimenter F. P. Smith and the Swedish engineer John Ericsson both patented propeller designs in 1836. In 1838 Ericsson designed the *Richard F. Stockton*, which was built in England with steam machinery installed. She was delivered to New York under sail then fired up and put to work towing on the Delaware & Raritan Canal and on the Delaware River. Meanwhile, James Van Cleve, a shipbuilder from Oswego, New York, on the shore of Lake Ontario took a license from Ericsson to build propellers on the Great Lakes. Thus, the earliest loci of development of propeller-driven vessels in the United States became Philadelphia and the Great Lakes.[1]

Although the earliest propeller steamers were intended for cargo and passenger service, tugs were soon built as well. The propeller tugs *Hercules* and *Samson* were launched at Philadelphia in 1850, and the tugs *President* and *Uncle Ben* were built at Buffalo in 1855 and 1856, respectively. Not until 1860 were propeller tugs built in New York. These were the *Resolute* and the *Reliance*, whose hulls were constructed by the B. C. Terry shipyard in Keyport, New Jersey, and whose machinery was supplied

Tug traffic crowds the East River in this 1901 stereograph image. Library of Congress, Prints & Photographs Division, LC-USZ62-134655.

by Cobb and Field ironworks in Jersey City. The actual building of these two vessels was by no means the first introduction of propeller tugs to New York Harbor. At least two boats built elsewhere were owned in the harbor prior to this, and others must certainly have passed through during the late 1850s. Also, propeller tugs were built on the Hudson River at Albany, Troy, and Newburgh prior to the building of the *Resolute* and the *Reliance.*

The practical introduction of the marine propeller would likely have occurred much earlier but for the insufficiency of boiler technology. To be effective, a propeller must rotate at far greater revolutions per minute than the side wheel. The increased revolutions per minute could be achieved with gearing between the engine and the wheel, but this added greatly to the cost and complexity of the machinery. If the propeller were coupled directly to the engine, without gearing, the increased revolutions per minute must be accomplished by delivering a greater volume of steam to the engine. Increasing the size of the boilers was an imperfect option because of weight and space limitations. The favored approach was to increase the boilers' operating pressure, which allowed the same amount of steam to do a great deal more work. The *Reliance* and the *Resolute* were provided with boilers operating at 75 pounds per square inch, twice the 30–40 psi standard of the day.

The practical acceptance of the propeller faced other obstacles. It was said that a vessel propelled from the stern would be unable to steer effectively. In fact it was soon demonstrated that the effect of the quickwater from the propeller working directly against the vessel's rudder caused it to steer better. This was particularly true when maneuvering at slow speed, when a well-timed thrust of prop wash against a properly angled rudder could turn a boat almost in place, an attribute that revolutionized the handling of tugs in close quarters. Another argument against the propeller-driven vessels was that in comparison to side-wheel boats they rolled excessively at sea. This was certainly true; but the side-

wheelers' virtue in this matter was also its nemesis. The impressive steadiness of a sidewheeler was achieved primarily because the paddle boxes, the wheels, and all the attached machinery were absorbing most of the wave action, causing tremendous strain and frequent damage. Although the crew on board might complain about the rolling of the propeller boats, the boats themselves did not. In fact, because of their freedom to roll and because the weight of their machinery was concentrated much lower in the vessel (the walking beam, its connecting rods, and the ponderous structure of the side wheels were all eliminated), the propeller boats were intrinsically more stable and, thus, more seaworthy.

It was not long before all new tug construction was of the propeller type and the paddle boats were consigned merely to serve out their useful lives, the last performing flotilla towing on the Hudson, where their size and remarkable traction still worked to their advantage. Others were eventually converted back to passenger service on minor routes in and around the harbor—an ironic reversal of the process that had first brought the side-wheel tug into existence.

The *J. G. Emmons* is the former tug *John Birkbeck*, which was built at Athens, New York, in 1854. Renamed in 1884, she was converted to passenger carrying by addition of a spacious enclosure on the stern deck. In this picture she carries a group of excursionists from the Ninth Ward. The boat is owned by the New York Towboat Company, of which James Gordon Emmons eventually became president. After the turn of the century New York Towboat specialized more and more in steamship tender work, transporting immigrants, passengers, mail, and baggage between incoming ships and the immigration office at Castle Garden. Emmons spent his life working first for Reuben Coffin and then for New York Towboat. He both captained and invested in a number of their vessels before taking over the office. He occasionally contributed waterfront gossip and historical sketches to the *Nautical Gazette*, which provide an insight into the earliest days of tugboating. Steamship Historical Society of America Collections, Langsdale Library, University of Baltimore.

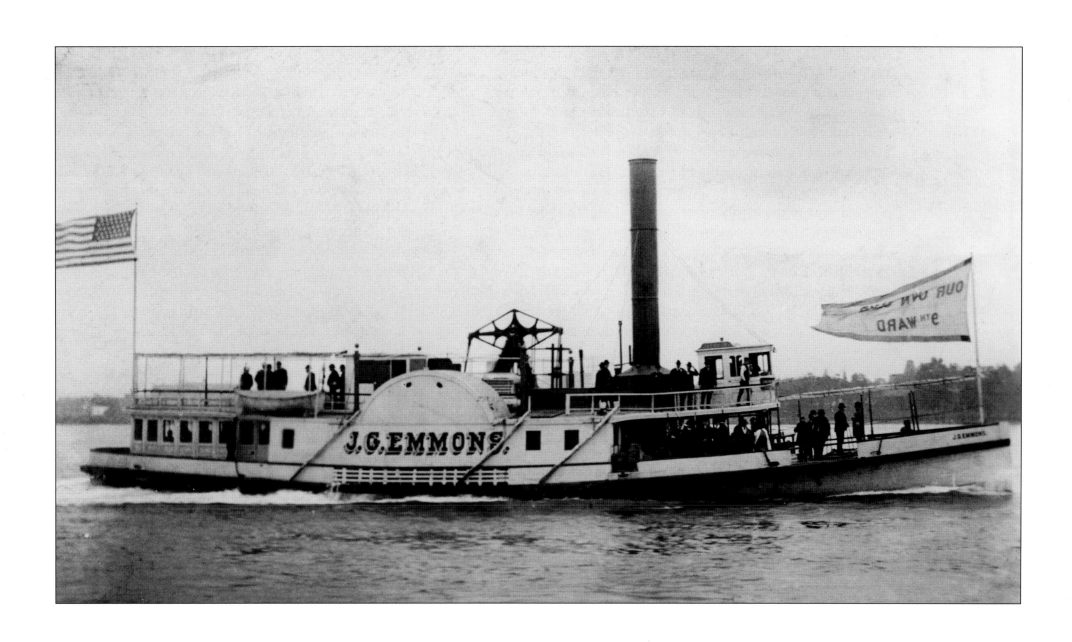

With the end of the Civil War the Port of New York settled into a position of East Coast dominance that would swell, then linger, into the middle of the twentieth century. The Southern trade in cotton began to slowly recover, while the burgeoning industrial commerce of the North, the development of the railroads, and the rapid expansion of trade overseas and into the American West all fueled New York's rise to preeminence. The dollar value of manufactured goods produced in Manhattan and Brooklyn went from 105 million in 1850 to 394 million in 1870 and just over a billion in 1890.[2] This industrial expansion applied a forced draft to the expansion of the city itself. The population skyrocketed from 650,000 in 1850 to 1,360,000 in 1870 and 2,350,000 in 1890.[3] The building out of the city swelled from lower Manhattan, up the East Side and the West Side into Harlem and the Bronx, as well as across the East River into Brooklyn and Queens. There was an economic magnetism about the city that drew more and more people, more commerce, more transportation, more raw materials, and more agricultural produce. The harbor and its fleet of tugs became a service facility vital to the city's dramatic expansion.

Tugboats continued to be essential in assisting ocean-going and coastal sailing vessels into and out of the harbor. In 1896, there were 4,460 arrivals of vessels from overseas and 10,229 from U.S coastal ports. There were 4,736 steamers, and the rest were sailing vessels, including 8,353 coasting schooners.[4] Doubling these figures to account for each vessel's eventual departure, estimating that 75 percent of these movements required the services of a tug, and assuming that many of these vessels required further tug assistance in traveling between different berths in the harbor to accommodate loading and unloading, there may have been about eighty-two ship movements performed every day. To handle the larger class of steamers, several tugs would have been employed in a single movement.

But ship assistance was only a small part of the role now played by tugs. The transportation of material and goods by barge had become fundamental to the New York economy, and hundreds of tugs participated. Vast quantities of stone, block ice, and brick came down the Hudson. So much sand was barged into the city from the north shore of Long Island that local observers wondered if the island would one day disappear entirely into the maw of New York City. More and more coal was transported around the harbor as the Industrial Age gathered momentum. The railroads came to rely more and more on the system of freight-car lighterage within the boundaries of the harbor, building ever-larger fleets of tugs to improve their service.

But just as significant as what came into the city is what went out. Cellar dirt, the debris from the excavation of building foundations; dredge spoil, the mud and silt produced by the maintenance and steady enlargement of harbor facilities; garbage; ashes; horse manure (about four hundred tons per day); and dead horses (about two hundred per day) all left the city by barge for disposal offshore or at the rendering plants at Barren Island in Jamaica Bay. An 1898 official description of Coney Island Channel, through which the bulk of the ocean disposal and rendering-plant traffic moved, lists the following daily average: "18 tows of mud containing 35,000 cubic yards; 16 tows of cellar dirt, containing 32,000 cubic

Queensboro Bridge from 63rd Street Pier, May 7, 1936.

A dredge with a sense of humor lays moored outside its dump scow in the shadow of the 59th Street Bridge. The *Grabit* is probably engaged in the construction of the East River Drive. As the city was built out and the harbor deepened to accommodate ever more commerce and ever-larger ships, vast quantities of excavated material were towed out of the harbor and dumped at sea. Photograph by Berenice Abbott, WPA Federal Art Project, Milstein Division of United States History, Local History & Genealogy, New York Public Library, Astor, Lenox, and Tilden Foundations, 1311-E2.

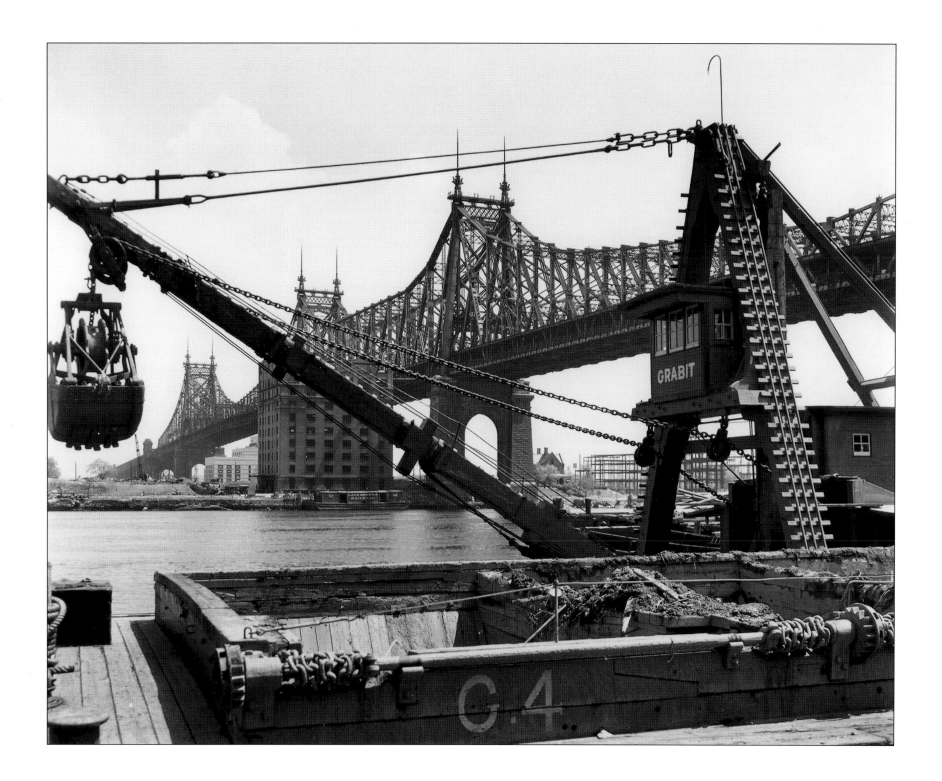

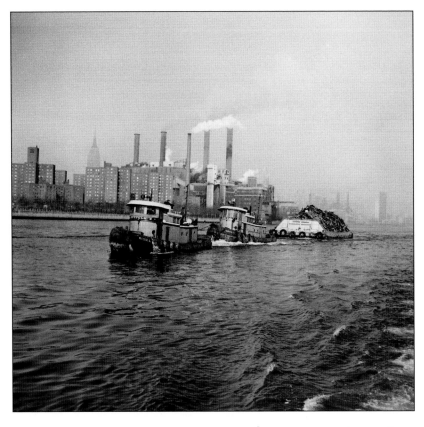

Two Newtown Creek Towing Company tugs, *Russell No. 1* and *Russell No. 2*, pair up to tow a loaded scrap-iron barge (a "scrappy") down the East River toward Bayonne or Port Newark, where scrap is collected for loading onto ships bound mostly for the East Asia, where the material will be recycled to return, it is said, as Toyotas. Local scrap yards have tended to congregate along the back creeks of the five boroughs because such locations allow access by tug and barge for large scale, economical transportation.

The two tugs are identical government-surplus boats built in New Orleans in 1941 and acquired by Newtown Creek Towing after World War II. They are diesel boats that replaced identically named steam tugs of the previous generation. Steamship Historical Society of America Collections, Langsdale Library, University of Baltimore.

yards; 12 tows of garbage, 4 tows to Barren Island, 4 tows of broken stone and gravel to Rockaway. . . . These tows engage the services of at least 50 towboats."[5] The traffic was continuous throughout the day because the garbage scows were required to dump their loads at the mouth of the harbor at high tide so that at least some of the floating debris would be carried away from the shore by the ensuing ebb tide. The tows loaded with mud and dirt were allowed to dump at any state of the tide and therefore scheduled their trips to coincide with low water at the harbor mouth, taking advantage of a fair current both ways.

In addition to the towing activities that we today associate with tugboat work—assisting ships and barging goods and material—there was constant and more or less lucrative employment available in the excursion business. Particularly on weekends, when towing business was slack, there was a demand for tugs to carry New Yorkers to the various parks and pleasure groves just outside the city as well as to the fishing banks just off Sandy Hook. The tradition of fishing excursions was established at least as early as the summer of 1816, when the steamboat *Fulton* advertised such outings in the *New York Evening Post*.[6] As time went on, tugs played an ever-greater part in this business, so much so that the dock area where smaller tugs customarily tied up in the East River close to the Battery became known somewhat derisively as the Porgy Grounds, referring to the haunts of the small fish that were a mainstay of the party-boat fishing business.

Regulation of this excursion trade was variable, with even the need for an adequate number of life jackets sometimes debated. Tugs that intended to engage regularly in the business were subject to much the same safety inspections as were regular passenger steamers, and for major harbor events such as ship parades the names of inspected tugs and their passenger capacities were published. The list for the great Naval Parade on April 29, 1889, contained fifty-seven tugboats with a combined passenger capacity of 2,752.[7]

Inevitably, disaster forced the reshaping of what had been a consistent source of income for the tugs. The first was the sinking of the seventy-four-foot tug *James D. Nichol* while on a fishing excursion in the open ocean off Long Branch, New Jersey. The boat was licensed to carry forty-five passengers but was loaded down with at least eighty-seven when it flooded and sank in choppy seas. At least forty drowned.[8] The tug was subsequently recovered, repaired, and put back in service. It was reinspected for carrying passengers and granted a license for only twenty, reflecting a considerable tightening of the rules for excursion tugs caused by her own mischief.[9]

The next and by far the most compelling disaster was the catastrophic loss of the steamer *General Slocum* on June 15, 1904. While on a Sunday school outing bound for Long Island Sound, she caught fire in the East River and was run aground on North Brother Island, where she burned to a hulk. One thousand thirty-one people perished, mostly women and children from the German community surrounding Tompkins Square on Manhattan's Lower East Side. Investigators found that firefighting equipment on board was virtually worthless from age and neglect, that life jackets were absent or so rotted as to be worthless, and that crew members had no conception of how to deal with emergencies. This catastrophe brought the entire harbor-excursion business to a virtual halt for the next year or two and triggered a steady tightening of the rules for passenger-carrying vessels, which ultimately excluded tugs from the trade.

The rules that separated tugboats from the passenger business around the turn of the century have remained in force to this day. In a few instances owners have attempted to convert tugs into passenger vessels to satisfy the public's craving to go out on a tug, but making a conversion that is satisfactory to the Coast Guard inspectors is virtually impossible. The greatest obstacle is installing enough watertight bulkheads in the tug's hull to prevent a major leak from causing the boat to sink. As designed, the engine-

This stereograph image from 1889, taken from the Brooklyn Bridge, shows a small tug with five of what are probably grain boats alongside. The white vapor emanating from the tug is exhaust steam, which indicates that it is equipped with a noncondensing engine from which the steam, rather than being returned to a liquid state and reused, is discharged through a vent on the smokestack at the completion of each stroke. Most small harbor tugs were equipped with noncondensing engines to save expense and because clean fresh water was always available from city hydrants. Vessels traveling farther afield tended to have condensing engines because they conserved water over long voyages and because condensing engines were able to extract more energy from steam, making them considerably more efficient. Robert N. Dennis Collection of Stereoscopic Views, Miriam & Ira D. Wallach Division of Art & Photographs, New York Public Library, Astor, Lenox, and Tilden Foundations, NYPG91-F194 113F.

room space of a normal tugboat is so large and so packed with machinery that it cannot be subdivided to meet safety requirements. Also, the freeboard of a typical tug is necessarily low and, thus, provides neither reserve buoyancy nor adequate protection to deck passengers in open waters.

The tightening of the rules governing the carriage of passengers was recognized as a blow to the fortunes of the tug owner. The *Nautical Gazette* of 1894 stated that the tug owner, "struggling along six days in the week, at a loss in his business, seizes the opportunity to turn loss into profit on Sunday" through the addition of excursion work to his normal towing activities. Indeed, because of this and other basic changes in the harbor world, it was becoming increasingly difficult for anyone to make a profit in the towing business.

✮ Gate Lines

Towing a barge on gate lines is a method that, if practiced with skill, affords excellent control. The scow or barge is towed astern of the tug by two lines, each running from one side of the towing bitts of the tug to the corresponding corner post of the tow. The length of each line can be separately adjusted at the towing bitt. If

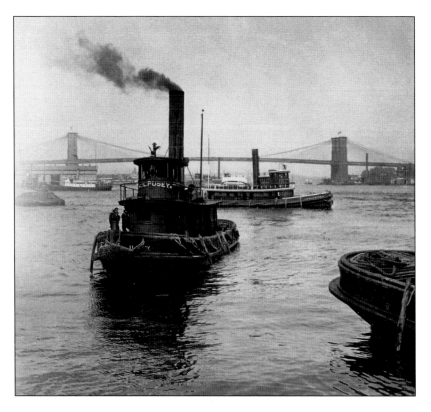

Along the East River piers near Whitehall was a favorite lay-up spot for the harbor's smaller tugs. This area was known somewhat derisively as the Porgie Grounds, perhaps because the tugs that lay there were small fish in comparison to the large company boats or because many of these small tugs derived a good part of their livelihood from taking out fishing parties on weekends.

Here, the little *J. L. Pusey* hangs off the dock, while, behind her, the more lordly Cornell tug *Volunteer* is maneuvering a fully loaded gravel barge away from the pier head. The *Pusey* was built at Wilmington, Delaware, in 1857, making her one of the earliest generation of propeller tugs. Her first home port was Philadelphia, and she did not come under New York enrollment until 1895. Her career ended with her abandonment in 1907. Library of Congress, Prints & Photographs Division, LC-USZ-62-6211.

View looking west from the Triboro Bridge showing tug and barge going through Hell Gate.

An unidentified tug of the Neptune Line tows four empty sand scows toward Long Island Sound. The north shore of Long Island provided a vast amount of sand for construction projects in the city. Most of the towing was done by the sand and gravel companies themselves; Buchannan, Colonial Sand and Gravel, Metropolitan Sand and Gravel, and Barker Brothers all operated fleets of tugs to move their product. Still, there was always spot work available for companies like Neptune that did more general towing work. Photograph by Esther Bubley, May 1947, Special Collections, Photographic Archives, University of Louisville.

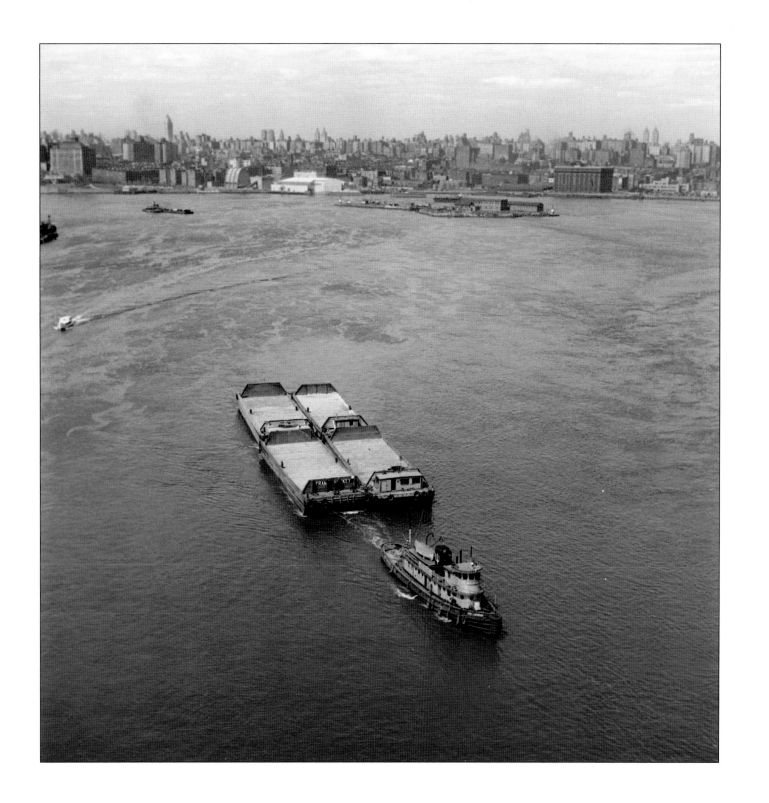

both lines are of exactly equal length, the tow will tend to follow exactly in the wake of the tug. If one line is made longer than the other, the tow will tend to steer toward the side with the longer line. In effect, the gate lines act as an adjustable bridle that can be manipulated from the stern of the tug to help guide the tow through narrow passages such as bridge openings and congested creeks. The overall length of the bridle can also be adjusted so that the tow may be brought so close that it actually touches the stern fender of the tug; or it can be paid out to the extreme length of the two lines, which relieves a good portion of the countereffort of the tug's prop-wash working against the barge. Even when towing with the lines at full length there is a greater degree of control than if the barge were towed by the normal arrangement of hawser and bridle.

The gate-line method is so named because it has long been the preferred method for towing strings of scows through Hell Gate. But gate-line towing is really at its most useful in tight places. With the tow following about twenty feet behind the tug, it is possible to do almost anything with it. At very slow speed, with careful helmsmanship and timely shifting between forward, neutral, and reverse it is possible to maneuver the tow with surprising accuracy. Much as in shifting work, where the trick is to work with the slack in the line between the stem post of the tug and the barge, gate-line work is based on nudging the scow in one direction or another by swinging the stern of the tug gently so that one gate line comes taut while the other remains slack. It is also possible to allow the barge to drift forward until it bears against the stern fender of the tug and then to nudge the barge to one side or the other, to stop it entirely, or even to send it backward.

Arranged on gate lines the tug and tow can pass through the narrowest possible openings, just as if the tug were pushing the barge. (If the barge were towed alongside, of course, the width necessary for passage would be the sum of the widths of both tug and barge.) But towing on gate lines has one decided advantage over pushing, namely, that the gate lines act as a hinge between tug and tow, allowing them to negotiate very tight turns that the rigid connection between tug and tow when pushing would not allow. With a tow of several barges in line it is possible for the deckhands to go up onto the tow and sequentially slack off the lines, securing each barge to the next so that they can negotiate the same turn when they come to it. Like a stealthy cat able to pass through any space wide enough for its whiskers, a gate-line tow can work its way through almost anything.

Brooklyn. View from the Gowanus Canal looking west from the Gowanus Parkway.

Nicely shaped up to pass through the Hamilton Avenue Bridge, one of the small tugs of the Gowanus Towing Company has a Delaware, Lackawanna & Western Railroad scow on gate lines. On the deck of the scow are canisters used for transporting dry cement. At the left of the photo is a platform used for dumping trash and construction debris from trucks into barges. Laying beneath this "tip" is a dump scow, built with six "pockets," the forward one of which is already partially filled with some sort of debris. The bottom of each pocket is fitted with hinged doors that can be opened by releasing the chains seen running upward and then to the right across each dividing bulkhead. Each chain is wound onto a cogged windlass visible at the right-hand side of each dividing bulkhead. The barge is towed to sea, and when the permitted dumping ground is reached each pocket is "knocked out" by a bargeman who uses a mallet to dislodge the cogs one after the other. The bargeman lives close to his work. The thicker section dividing pockets three and four is his home. He can be seen standing in the open scuttle. He is referred to as a captain, but his life has little prestige. Photograph by Esther Bubley, July 1947, Special Collections, Photographic Archives, University of Louisville.

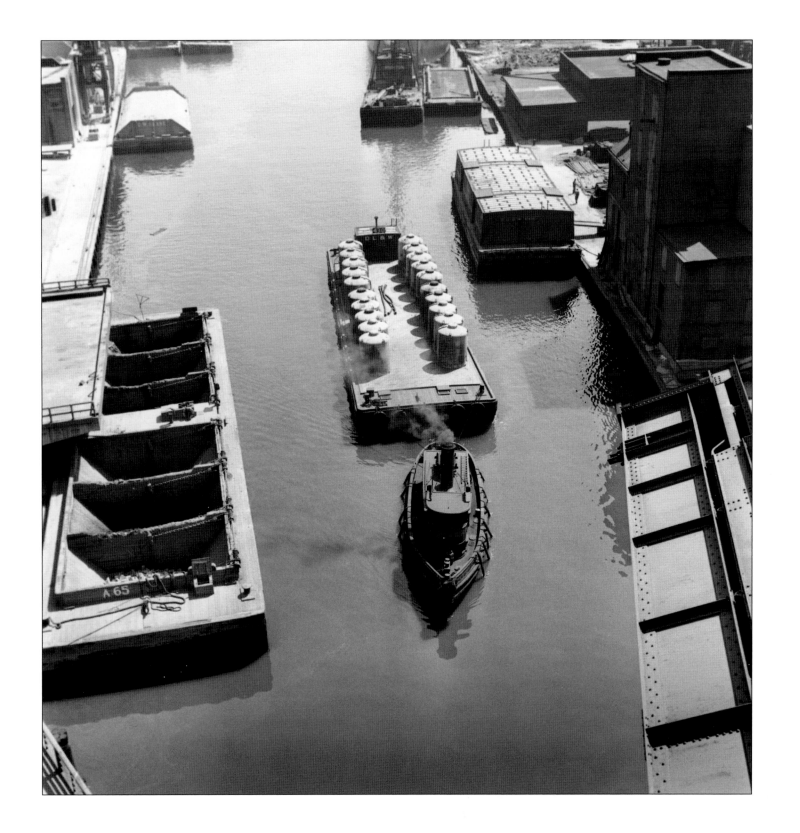

17'-6"

85'-6"
93'-8"

THE WM. CRAMP AND SONS S. & E. B. CO.
OFFICE OF CONSTRUCTION DEPARTMENT PHILADELPHIA PA.

No 201

TUG BOAT BLANCHE (1878)

Drawn By
Traced By MCBRIDE Date MARCH 28 1901 Scale ¼" Foot

Superintendent

Chief Dr.

10

A Time of Change

The steam tug *Blanche* was built on the Delaware in 1878, and though she herself never was a New York boat, many of her local contemporaries were. This set of hull lines traced by the Philadelphia shipyard of William Cramp and Sons in 1901 shows a far more sophisticated hull form than that of the *William H. Webb* shown earlier. This beautifully modeled vessel combines traits of stability and speed including the sharp hollow entry of the bow and the aggressively sculpted underbody at the stern, which allows an abundant flow of water to the tug's propeller. Overall, the design of the *Blanche* reflects a vessel adapted specifically for the purposes of towing—a reflection of the evolution of the tug as a specialized type.

After the Civil War the Delaware River shipyards—Cramp, John Dialogue, Neafie and Levy being the most prominent—took over a large share of tug building for New York owners. As effective iron and steel building methods developed in the 1890s this trend became even more pronounced. Steamship Society of America Collections, Langsdale Library, University of Baltimore.

Toward the end of the nineteenth century there were about 590 tugs operating in New York Harbor,[1] and the consensus was that few if any of them were making any money. The oversupply of tugboats in the harbor had been building since the Civil War, when the city rose head and shoulders above all competitors on the East Coast. The economic magnetism of New York seemed to attract tugboats as it did all else. Between July 6, 1857, and May 25, 1867, 205 small steamers, mostly propeller-driven tugboats, were enrolled at the New York Customs House. Of these, 44 came from the Delaware Bay ports including Philadelphia and Wilmington, and 26 came from Buffalo via the Erie Canal. Of these distant-built vessels, 43 had been in service for more than a year before leaving their home territories.[2] A migration of used tugs from one region to another usually tells of a dearth of work in the former port and an impending collapse in prices in the latter. The propeller boats were smaller, cheaper to build, cheaper to run, and, pound for pound, more powerful than the old side-wheel models. The Delaware River and Great Lakes builders were turning them out in numbers and flooding an already shrinking market for towing.

By the late 1880s the tugboat owners were hard-pressed. The majority of boats were owned by partnerships, often comprising captain, engineer, family members, and associates. Because the captain and engineer owners of a small tug could not simultaneously

South Street near Wall Street. At noon many office workers come down to the waterfront. Photograph by Esther Bubley, October 1946, Special Collections, Photographic Archives, University of Louisville.

run the boat and run the business, the securing and scheduling of individual jobs and the subsequent payment for these jobs was ordinarily handled by a towing agent, usually with offices along the Manhattan waterfront. The agent typically received a 10 percent commission on work provided and, often, a 5 percent commission on the collection of bills.[3]

The agent, at least, was perceived as providing an essential service; but there was also a second level of middleman, known as the "scalper," who had inserted himself into the system and who was difficult to dislodge. This odious character of no fixed address made his living by attaching himself to newly arrived ship captains and volunteering to act as go-between in dealing with the various waterfront hierarchies—the harbor masters, the ballast men, the lightermen, the stevedores, the customs inspectors, the chandlers, and the tugboatmen and their agents. Representing the ship's captain, the scalper extracted a percentage from the various service providers in return for bringing them the business. On closer inspection it is difficult to distinguish between a scalper and an agent in the fledgling stage of what eventually became a legitimate business. Indeed, some of the more successful scalpers were able to work their way up to ownership of tugboats and did quite well for themselves. They were, however, bitterly resented by their longer-established colleagues.

That the waterfront in general and the milieu of the tugboatmen in particular was beginning to accumulate multiple layers of extortionate characters did not bode well for the port. Much the same realignment of political and financial power that was demonstrated by the rise of Tammany Hall in the city as a whole was visited on the waterfront. The prudent control that had once rested in the hands of the city's merchant oligarchs was now passing to a more volatile insurgent democracy.

The tugboat industry of New York Harbor appears to have undergone a major sea change at the end of the nineteenth century. A large number of the founding companies and individuals left the business over a very short period of time, while a draft of newcomers appeared, several of whom established legacies that remain potent to this day. This changing of the guard was spurred by several factors. First, the disappearance of the old-guard owners may have been merely a function of age. Most of the old companies represented the first generation of tugboating, peopled by

individuals who came of age at about the same time in the late 1840s. Because the industry was in a more or less "start-up" condition at that time, its participants tended to be more closely bunched in age than in subsequent generations of the business. A similar sort of generational concentration can be seen in the leadership of today's internet/technology enterprises. Disproportionately to other businesses, the founding generation of any new area of enterprise tends to age together and eventually leave the scene together. Humphrey Crary retired to Newburgh, New York, in 1868 and died there the next year at the relatively early age of fifty-three. Russell Sturgis and Henry Storms died in 1872. Palmer Crary retired from tugboating around 1880 and eventually died in his sleep in 1897, aged seventy-seven. Charles Chamberlain died in 1880; Joseph T. Martin, in 1881;[4] William Marshall, in 1882; P. C. Schultz, in 1886; Edward E. Barrett, in 1887; C. P. Raymond, in 1894; Solomon Thomas, in 1897;[5] Charles Hazzard, in 1899; and Luther Adams, in 1900.[6] Of all these, only C. P. Raymond and Edward Barrett left companies that survived for any appreciable time after their deaths. Barrett's operation was taken over by his son, Richard; and Raymond's was renamed and carried forward by Frederick Dalzell.

The customary practice of fractional ownership of vessels also contributed to the phasing out of marine businesses from one generation to the next. The fractional owners of a tug tended to be grouped together by age, and their simultaneous retirements often led to the dissolution of the entire partnership. Laws passed in the early 1890s paved the way for the corporate ownership of business property, giving an enterprise an existence of its own, independent of the frailty of its human participants.

Another factor contributing to the rapid change in the industry's complexion was the technological switch from side-wheel to propeller-driven tugs. The older companies were heavily invested in the old-style boats, and the rapid change to newer vessels coupled with the sudden overcrowding of tugs in the harbor,

which induced falling rates of return on investment, must have been a heavy blow to the old guard. New York Harbor Towboat Company, founded in 1853 by Reuben Coffin and partners, became less and less competitive as the century wore on, until its last vestige could be found using ancient sidewheelers and excursion barges to ferry newly arrived immigrants between Ellis Island and the Battery.

The whole basis of the industry had changed. In 1889 the *Nautical Gazette* reported, "The towing 'to the Hook' which, in days gone by, was the most profitable in the port, is in such condition now as to barely pay the expenses of the tugs engaged there."[7] The only operators getting by were those "that have a regular line of business and trade that their owners can depend on." This suggests that the swashbuckling early days of tugboating were played out and that the necessity for a more cautious and incremental business strategy had emerged. Tugboating at the end of the nineteenth century was leaving behind its entrepreneurial beginnings and settling into the character of a mature service industry where success is more dependent on office discipline than on wheelhouse daring.

The overcrowding of tugs within the harbor drove towing rates downward. The rate for towing a schooner between Rikers Island and the Battery—the length of the East River in 1870—was nine or ten dollars. By 1880 it had fallen to five or six dollars.[8] The old method of waiting for incoming vessels either off the Hook or at the western end of the Sound and negotiating there a towing price over the competing offers of half a dozen other tugs had become entirely unprofitable. The only way to survive was to establish a continuing relationship with a customer and then concentrate on fully satisfying that customer's needs.

There were a variety of sources of steady work. In the area of ship docking there were the steamship companies, both foreign and domestic, which maintained regular schedules of ship movements; and there were the shipping agents who handled similar

arrangements for unscheduled "tramp" arrivals. This work had always been up for grabs locally but was now spread around so thinly that no one profited much from it. Frederick Dalzell pulled off his greatest coup when in 1910 he traveled through Europe, visiting one major steamship company after another and negotiating contracts to handle all their docking work in New York. Dalzell's audacity produced a near monopoly for him in ship docking. The contracts also gave him access to the banks, which allowed him to expand and modernize his fleet.[9] The survival of the company was guaranteed for the next fifty-five years. In addition to ship docking there was barge towing for the Hudson River producers of stone, brick, ice, and lumber and the Long Island Sound producers of sand. All around the city there was refuse-disposal work—cellar dirt, dredge spoil, and garbage.

Activity on the Gowanus Canal, Brooklyn.

The little steam tug *Columbus*, belonging to the Gowanus Towing Company, threads a gate-line tow out of the creek. That these small creek tugs specialized in gate-line work is attested to by the absence of a fender on the *Columbus*'s bow. The barge captain stands in the open doorway of the barge. His living quarters are just inside behind the two windows. The deckhand of the tug stands on the rail just outside the pilothouse waiting for instructions from the captain inside. Most likely, they are waiting for the Hamilton Avenue Bridge to open, but even if they were not forced to hold up, they would not be traveling much faster than they are shown here. The precise control necessary for gate-line work is only possible with very gentle and deliberate boat handling.

The bridge in the background carries the Sixth Avenue Local subway—the F train of today—across the canal and on to Coney Island. It was built to that height to allow the passage of coastal schooners into and out of the headwaters of the creek, which was once lined with coal and lumber yards. Other than a handful of rotting hulks in the Kill Van Kull, this bridge is the last evidence that in New York Harbor there was once an age of sail. Photograph by Todd Webb, March 1947, Special Collections, Photographic Archives, University of Louisville.

To survive, a tug operator had to latch on to one source of income and then specialize. Specialization meant that operators had to be alert to the peculiar needs of their customers, for example, arranging schedules to suit the production rates of factories and quarries or designing and building tugs especially for specific tasks—small, nimble boats for work among the backwaters; heavier, long-keeled boats for hawser work over longer routes; more seaworthy boats for work on the coast or out the Sound. Tugs were also specially equipped to meet customer demands. Tugs that handled fleets of scows were equipped with powerful pumps to assist their charges when damage or disrepair imperiled them. Some were provided with low-volume, high-pressure pumps to be used in hydrostatically testing boilers and steam systems. As the use of petroleum fuel increased some tugs were equipped to supply steam-cleaning services for the holds of barges and the fuel tanks of ships in general. Salvage and wrecking tugs were equipped with all manner of damage-control and repair equipment.

Salesmanship, competence, wit, and charm also became important business attributes. A towing competitor might easily duplicate the qualities of a specific tug, but to duplicate a personal relationship was a different matter. Reserves of common understanding and trust became as important as horsepower. These personal assets, of course, exist largely in the eye of the beholder; and that is where social and ethnic affinities enter into the mix. The language of trust is largely the language of shared origins, and in this too a fundamental change was occurring around New York Harbor.

Since colonial times, New York City had been home to a significant number of Irish immigrants. Though the majority of these were Protestants from the north, there were also a good number of Catholics, who drew little notice in the generally anti-Papist society of New York City. The tremendous inflow of refugees beginning in 1845 with the onset of the Great Famine

changed all that and led to a period of hostility and occasional open warfare between the desperate new arrivals and a resentful, increasingly nativist population. The most persistent conflict played out among the working class, and it was within this level of the economy that the newly arrived Irish were first able to establish a foothold, displacing many occupants in the process. The labor forces along the waterfront experienced this change as early as any part of the workforce. Stevedoring, ballast handling, and carting chores were quickly taken up by the Irish at the expense of a largely free-black workforce.[10] The entry of the Irish into the lower echelons of the labor pool sparked their acquisition of local political influence. Local politics begets local business. Irish boatmen and stevedores in due course became lightermen and labor contractors. The waterfront became a focal point of Irish enterprise. Soon there was a large enough contingent of Irish tug operators to be remembered today as the "Irish Navy."

Newtown Creek viewing west from Meeker Avenue Bridge.

The tug _Henry O'Brien_, built in 1903, has been waiting for the bridge to open long enough for boiler pressure to build enough to release her safety valve, but as her wake shows, she has just started to move forward through the span. Lying next to the traprock scow is the original _Russell No. 1_, a fine little steamboat built in 1930. She is apparently waiting for the shovel operator on the dock to finish unloading the traprock scow, whereupon she will shift the empty scow to lay outside the loaded Metropolitan Sand and Gravel scow behind it and then slide them both forward so the shovel operator can start unloading again. The _Russell No. 1_ will then take the empty scow out to the mouth of the creek, where it will be picked up by a larger tug to take it back up the Hudson for reloading.

The _Russell No. 1_ was sold in 1946 and then converted to diesel and renamed the _W. O. Decker_. She remains active today at the South Street Seaport Museum, the last of her type. Photograph by Alexander Alland, 1939, WPA, Milstein Division of United States History, Local History & Genealogy, New York Public Library, Astor, Lenox, and Tilden Foundations.

Distinctively Irish names are absent from the roster of tugboat owners listed in the New York enrollment documents until 1853, when Daniel Jones Barney, the West Street saloon keeper, becomes a part owner of the newly built _J. S. Underhill_. Subsequently, he invests in the _Kate_ in 1855, the _C. Y. Davenport_ in 1865, and the _Niagara_ in 1867. Also early on the scene were Thomas Kiley, Daniel Shea, and Brian Kenny. From 1854 until at least 1867 these men shared ownership and management of the tugs _Thomas Kiley_ and _Pope Catlin_. After the Civil War, Shea took over ownership of the 1854 tug _Henry Smith_, which before and during its naval service had been named the _John E. Lockwood_.

Into this emergent Irish community came two men who have had a continuing effect on harbor towing to the present day, Michael Moran and James McAllister. Moran arrived in the United States in 1850 at the age of seventeen and found work as a mule driver on the Erie Canal. In five years he was owner of a canal barge, and by 1860 he had gravitated to New York, where he became part owner of the sixty-foot tug _Ida Miller_. Today, Moran Towing & Transportation Company operates eighty-one tugs, of which twenty-five are based in New York.

James McAllister followed a somewhat different route to achieve similar results. His career began as a lighterman working sailing barges in and around Newtown Creek in the late 1860s. He purchased the small tug _R. W. Burke_ in 1876 and soon after formed Greenpoint Towage & Lighterage in partnership with others. James and his son, James P. McAllister, presided over a succession of marine businesses after that, owning tugs, steam lighters, and excursion and salvage vessels in a constantly shifting array of family and outside partnerships. By 1929 McAllister operated a modest fleet of 110 lighters and ten tugs. During the ensuing years of the Depression they lost all but two tugboats and came very near to extinction. They have clawed their way

This stereograph dating from 1892 shows sailing vessels and a pair of tugs along the crowded East River waterfront. The inshore tug is the *R. W. Burke*, which has the distinction of being the first tug owned by James McAllister, founder of the McAllister dynasty. At the time of the tug's purchase in 1876, McAllister's business sphere was still limited to the Greenpoint Lighterage Company, which had started off operating sailing lighters out of Newtown Creek. Over the ensuing decades the company would evolve into general towing, salvage, passenger excursion work, ferry operations, ship docking, and coastal barge operations to become one of the leading marine firms in the country. The *Burke* was built in Philadelphia in 1873. She was 75.5 feet long and was rated at 53 horsepower. Library of Congress, Prints & Photographs Division, LC-USZ62-134654.

back since then and now operate seventy-four tugs, of which twenty-one are based in New York.

In addition to the Moran and McAllister dynasties there was a roster of other Irish operators who enjoyed various levels of success. Henry Gillen, an early partner of the McAllisters went off on his own to form a lighterage and towing firm that lasted until the 1980s. In 1882 Patrick McGuirl founded Shamrock Towing, which lasted until 1958. O'Brien, Flannery, Kennedy, Cahill, McCaffery, McCarren, McCaldin, Daley, and McWilliams were all Irish companies that existed in the harbor during the last years of the nineteenth century. All of them succumbed to the dreadful economic conditions of the Great Depression or to their inability to obtain the capital required to make the shift from steam to diesel power.

The emergence of Moran and McAllister as the dominant companies at the beginning of the twenty-first century obscures somewhat the influence of the many non-Irish companies that also started in the late nineteenth century and competed doggedly through most of the twentieth. Non-Irish companies included E. E. Barrett & Company; Russell Brothers, which grew to include Newtown Creek Towing and Harlem River Towing; Hugh Bond's Gowanus Towing Company; C. P. Raymond & Company, which became Dalzell; Vierow, which became Downer Towing; Starin; Meseck; Reichert; and Tice. These companies followed trajectories similar to their Irish contemporaries, lacking only the bragging rights of being the last left standing. The harbor was a crowded and heterogeneous field of competition, and it seems to have held no particular favor for any one nationality.

Pretty as a picture, the *William J. McCaldin* was built at Athens, New York, in 1886. The ornate carving of her nameboard, the paneling of her pilothouse and deckhouse, and her overall grace all speak of optimism and self-esteem. Collection of the New-York Historical Society, neg. 76794d.

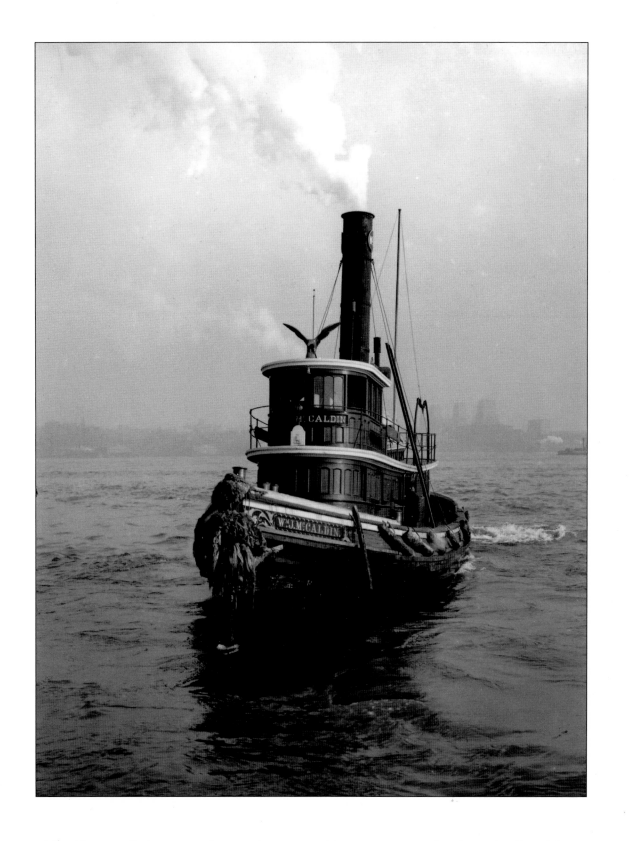

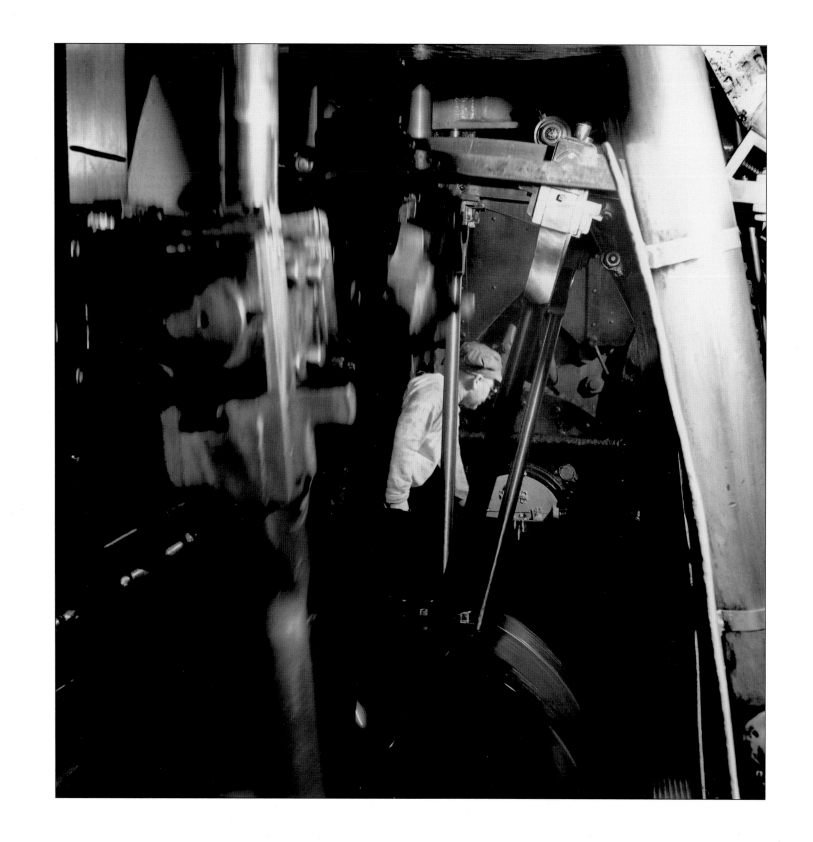

As the harbor grew ever more crowded, and the competition ever more intense, operators carved out small territories in which to specialize. The Russells controlled the towing for the majority of the businesses that fronted on Newtown Creek. Hugh Bond likewise controlled the shifting work in the Gowanus Canal. Henry Gillen built a specialty of towing barge loads of ingots and metal scrap to and from the copper smelters in Newtown Creek and the Arthur Kill. Captain Samuel L'Hommideau started up Red Star Towing, which specialized in towing to the ports along the Connecticut shore of Long Island Sound. Specialization helped to separate competitors from one another, but profits were still hard to come by. The *Nautical Gazette* repeatedly lamented that towing rates in the port were the lowest on the East Coast and that it was no longer possible for owners to even cover expenses.[11] An average harbor tug that cost $20,000 to $30,000 to build at the end of the nineteenth century could be chartered, with all running costs to be paid by the owner, for only $30 to $60 per day.[12] In April 1902, Michael Moran signed a contract with the New York City Department of Docks and Ferries to perform 2,500 hours of intermittent towing work at the rate of $4.50 per hour. This was work that an earlier contractor had abandoned because it had proven unprofitable.[13] At about the same time it was considered lucrative for small tugs to tow mackerel schooners from Sandy Hook to the Fulton Fish Market. Because of the perishable nature of their cargoes the schooners paid $25 to $30 for what would be at least five

◀

Marcellino Surinaga, oiler aboard *Esso Tug No. 5* fires boiler of tug's reciprocation steam engine.

Shot through the polished and oiled steel thicket of connecting rods and valve gear of the tug's main engine, Mr. Burinaga appears dwarfed as he works at the plate on which is mounted the boiler's fuel-oil nozzle. The *Tug No. 5* was built in 1912, and the engine, only part of which is visible here, is rated at 425 horsepower. Photograph by Sol Libsohn, January 1948, Special Collections, Photographic Archives, University of Louisville.

hours of work for the tug.[14] If this was the good work, then what was it like for the myriad small operators scratching for a living without long-term contracts or special rates?

★ The Sing Sing Stampede

"Stand aloof!" the guard shouted, but the little tug with a single canal barge alongside continued toward the dock. The usual small crowd of inmates was idling around the river's edge, fishing, drinking liquor, and enjoying the sunny day. It was August 17, 1871, a quarter to noon. The tug's captain explained to the guard that they had come up with the barge from New York to pick up a load of used furniture. It had all been arranged.

Life in the prison had a pattern to it that was figured in a web of favors and bribes. If a prisoner had the means to place a guard on a modest retainer, he might be allowed to take up residence in the prison hospital, where no work was required and special meals and entertainments could be had. Whiskey was readily obtainable. Women of all sorts were available. Evening excursions to neighboring towns could be negotiated.

The *New York Times* had in the past year identified this easygoing attitude, mixed with administrative corruption, as just one more example of the octopus-like corruption of Tammany Hall. The paper had run an exposé of bribery, favoritism, and misappropriation. The story had little effect at the time, but now it can be recognized as a preliminary skirmish in what would prove to be a much larger battle. The *Times* had begun an all-out attack on Tammany Hall that soon raged in front-page banners and detailed accountings of bribes, payoffs, kickbacks, and swindles. Later, in August, the racketeering involved in the construction of the Tweed Courthouse was exposed in dollars and cents. Ultimately, the forces of good government prevailed, temporarily. But first there was the Sing Sing Stampede.[15]

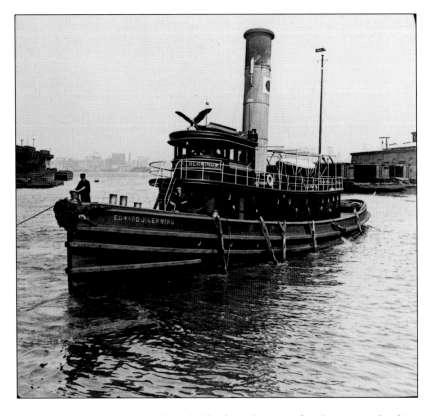

The tug *Edward J. Berwind* was built of steel in 1902 for the Berwind-White Coal Company. She was intended for local work, and at 104-foot length and 950 horsepower, she represents the larger class of harbor tug at that time. She has backed away from the dock specifically for the purpose of having her picture taken. Library of Congress, Prints & Photographs Division, stereograph collection, LC-USZ62-134653.

John Earl owned a saloon at the corner of West 10th and West Street. Watermen congregated there, and Earl served as their agent, matching up the operators of tugs and lighters with customers. Though a sideline, his practice as an agent had a degree of formality to it. Agreements were drawn out on paper and apparently either entirely prepaid or else heavily advanced because a tug captain entering into one of Earl's deals felt assured that his payment was secure. One deal involved the pickup of a load of used furniture upriver at Sing Sing. A single canal barge was required, plus a tug to tow it. It was a simple job; barges were abundant, and any little tug would do. John Earl had never seen the Sing Sing customer before (in fact, he later claimed that he was entirely unable to describe him), but by going through the formalities—particularly the money-up-front part of the deal—he was confident enough to recommend a tug. He sent the stranger up West Street to look for its captain, a man named Van Orden. The two men met in the dark on the corner of West and 11th. Some claimed that Van Orden was offered a hundred dollars for his services, but agent and captain both insisted that he received only the normal rate of seven dollars per hour.[16] Captain Van Orden also was unable to identify the man who hired him but entered into the deal because it was secured by the normal customs of the waterfront.

The tug was the *Dean Richmond*, 68 feet 10 inches long, with 13-foot 9-inch beam and 6-foot 5-inch depth. It had been built in Buffalo in 1862, and on June 6, 1864, like so many other nice little propeller boats built there around that time did, it made its way east through the Erie Canal to be enrolled at New York. The boat operated with two men, Captain Van Orden and Thomas Farrell, the engineer, and an unnamed boy, who was Farrell's nephew. Accompanying the regular crew on its trip upriver was a man sent by the customer, presumably to attend to the canal barge and to act as laborer. This fellow turned out to be none other than John "the Big Kid" Wheeler, "a noted desperado" and a denizen of New York's Ninth Ward. It is said that "the Big Kid" had with him "an immense supply of citizens' attire and false whiskers" plus $3,000 in traveling money.

The voyage upriver was apparently uneventful, but their arrival was anything but. In the words of Captain Van Orden, "We touched the dock; the convicts jumped on, I jumped off." The

original intent of the caper seems to have been to liberate no more than two or three special inmates. An old gaffer who was deeply familiar with the workings of the place confided to a reporter that the principal members of the escape party were "Tammany politicians whose presence would be desirable at the next election." The original plan likely called for the "politicians" to somehow secret themselves within the cargo of furniture and quietly slip way. But the novelty of the little steamboat's arrival apparently excited a total of eleven men to jump aboard the tug. They scared the captain off, then cast off the barge and forced the engineer and the boy to steam away. The prison guards gave chase in a couple of rowboats and an old sloop.

The race ended when the tug ran aground just north of the village of Nyack. Fortunately, or unfortunately, for the escapees there were a number of local kids out fishing in rowboats who gladly ferried them all ashore. In this way the fugitives spread out into the countryside. Rewards of $100 each were put on their heads, and for the next few days the area was alive with lawmen and zealous farmers. By the end of the month, nine of the escapees plus "the Big Kid" had been captured. Two of them were shot in the back; the rest were just hungry and disgusted, eager by then to get back to Sing Sing. Two men, Walter Williams, who was said to have been last seen carrying the $3,000 in traveling money, and William Burns, were still at large. Maybe they still are.

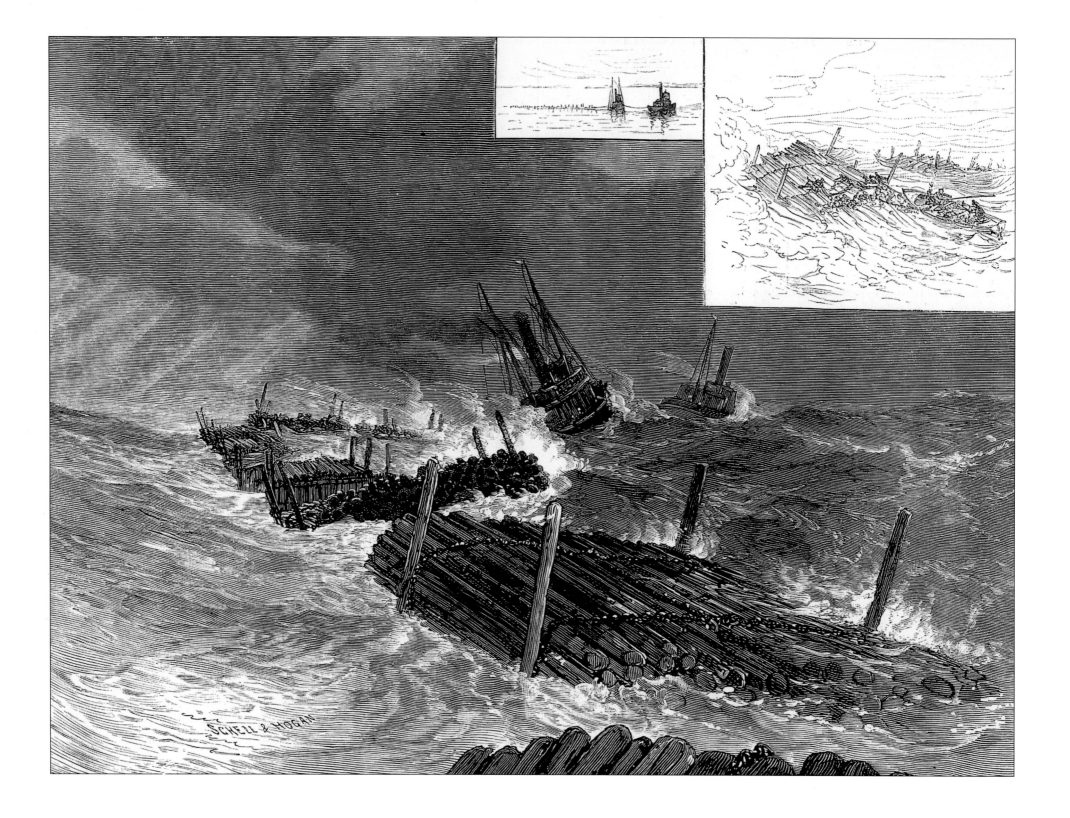

11

The Rise of Coastal Towing

The Ocean Voyage of a Lumber Raft.

In the late nineteenth century, abundant supplies of fir, spruce, and pine were still available in Maine and New Brunswick. Traditionally, most of the timber had been sawn into dimension lumber at local mills and then transported by schooner to East Coast cities. Several attempts were made to tow large rafts of logs down the coast, but the results were mixed. The tow depicted here was fraught with difficulties but ultimately successful. At least one other tow disintegrated altogether. The difficulty of the venture lay in binding together the individual logs tightly enough that they would not work loose at sea. Probably owing as much to the dwindling of usable timber supplies on the East Coast as to lack of incentive on the part of the towers, the practice was never fully developed there. On the West Coast, however, methods for towing timber rafts at sea reached a level of great sophistication and profit. *Harper's Weekly,* September 8, 1883, General Research Division, New York Public Library, Astor, Lenox, and Tilden Foundations.

The profitable, entrepreneurial days of harbor tugboating were past, but a new enterprise was opening up. Coastal towing, particularly the transportation of coal from the railheads of Norfolk, Philadelphia, and New York to New England ports, was developing rapidly. The railroads had discovered the profitability of coal transport earlier in the century. The virtue of an endless stream of fully loaded coal cars traveling generally downhill from the Appalachian highlands to tidewater ports was unmistakable. At tidewater in the ports of Norfolk, Philadelphia, and New York the railroads built terminals dedicated to the trans-shipment of coal. Some was distributed to customers by way of local railway systems, but the bulk of it was consigned for delivery by water either locally or farther afield. New England had a huge demand for coal to fuel its industries, for the production of illuminating gas, and for home heating and cooking. Railroad service to these points of demand was limited, so coastal transportation became heavily favored. Between 1869 and 1874 the Philadelphia & Reading Railroad built a fleet of fourteen steam colliers ranging from 173 feet to 350 feet long and able to carry from 500 to 1,650 tons of coal.[1] The railroad continued to operate several of these vessels until 1904, but they were never particularly successful because they were expensive to build and operate compared to the schooners that carried most of the trade. The three-masted schooner predominated until 1880, when the first four-masted

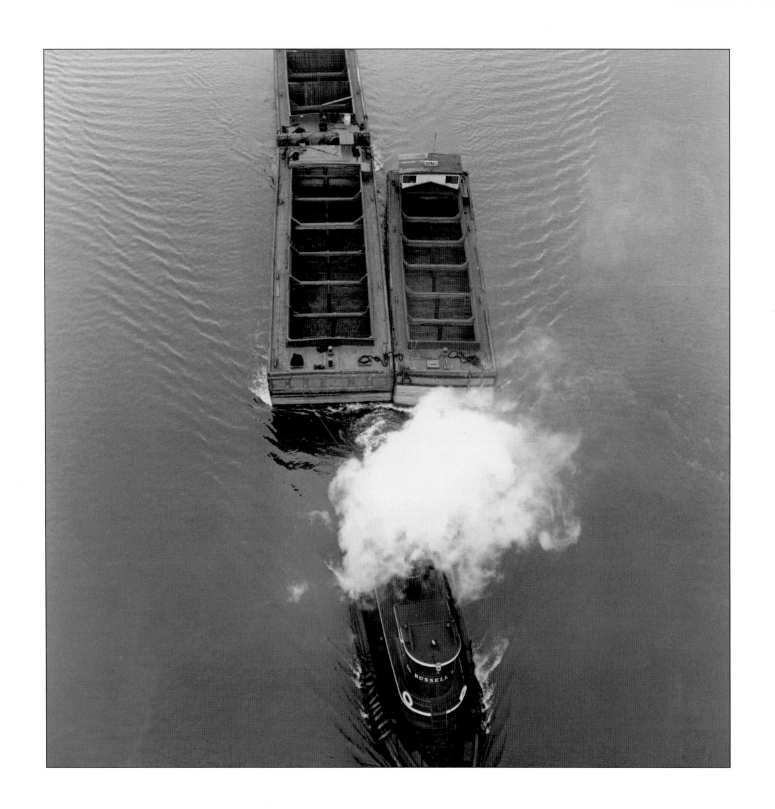

was launched, to be quickly followed by a five-masted, a six-masted in 1900, and in 1902 the only seven-masted schooner ever built, the *Thomas W. Lawson*. But, even as the schooner operators raced to increase their carrying capacity to meet the ever-increasing scale of the trade, they were faced with relentless competition from the fast-developing business of coastal towing.

The rationale for transporting coal by tug and barge was compelling. A barge designed for inland waters could be constructed without the niceties of form that are required of a sailing vessel. Carrying capacity could be maximized in an open, boxy hull, while all else in the way of complication and expense could be minimized. A coal barge of 105-foot length, 26-foot beam, and 12.5-foot depth was capable of carrying 750 tons of coal[2]—about twice the amount a sailing vessel of similar length could handle. Crew and equipment to support this volume amounted to simple domestic accommodations for the one man (and perhaps his small family) who lived aboard, a hand-operated capstan at bow and stern, an assortment of ropes for mooring and making up tows, a pump to keep the bilges dry, a bucket, a shovel, and a broom. The barge might be stationed anywhere, either waiting to load or unload or acting as a floating storage container, while the tug that moved it when necessary could be in constant operation moving other barges. The smaller type of coal barge described above could be towed in flotillas around the harbor or out Long

Empty coal barges being towed by tugboat on the Harlem River.

The *Russell No. 2*, belonging to the Newtown Creek Towing Company, tows three wooden coal boxes on gate lines. The unadorned form of this type of barge is well shown. Used as much for storing coal at waterfront locations as for transporting it, these barges were built for maximum capacity rather than speed. The planking on the bottoms of the cargo holds of the barges is visible, attesting to the diligence with which their cargo has been removed, right down to a final pass with a broom. Photograph by Gordon Parks, December 1946, Special Collections, Photographic Archives, University of Louisville.

Island Sound to ports as far distant as the Providence and Fall River. A tug might proceed from New York with a tow of half a dozen loaded barges, dropping them off as it moved down the Sound, and then return to New York, picking up other light barges on the way. The goal of every tug owner is to find work that will keep his boat in constant operation. Just as the railroad companies had discovered that shipping coal could be their life blood, many tugboat owners recognized that the longer distances and reliable cargoes of bulk coastal towing were the answer to the ruinously overcrowded business conditions in New York Harbor.

Although the relatively sheltered waters of New York Harbor and Long Island Sound permitted the use of standard tugs and square-ended barges, the longer open-sea routes between Norfolk, Delaware Bay, New York, and the Down East ports between Cape Cod and Canada's Bay of Fundy required carriers of much greater capacity and endurance. The schooners that had originally developed this trade were remarkably efficient carriers. Their uncomplicated fore and aft rig, subdivided between multiple masts, permitted a crew of about one-half the number required for a square-rigger of comparable capacity. The fore and aft rig also afforded the maneuverability and weatherliness necessary to operate safely in the constricted, often treacherous, coastal waters. The schooners, operating under the command of captains and officers who possessed extraordinary coastwise knowledge, were able to perform their tasks dependably and at a profit. Since the late 1840s tugs had been towing sailing vessels between East Coast ports either for repairs or to avoid the expense of obtaining sailing crews for short voyages, but there was no economic justification for a very expensive tug to routinely power a sailing vessel that could far more cheaply power itself with the wind.

But what if a tug could tow several large coastal carriers at once? And what if at the same time you reduced the complication

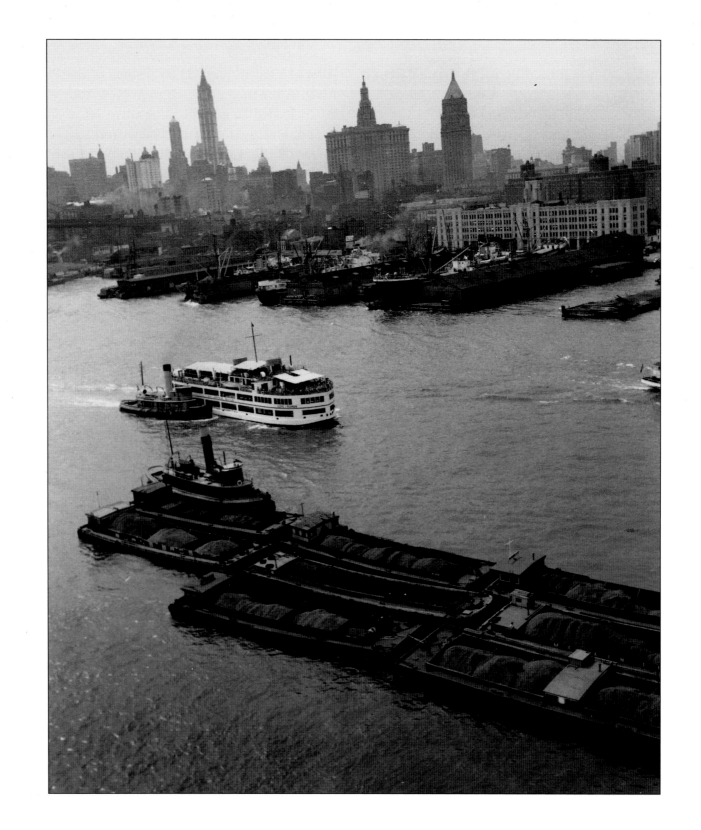

of those carriers—their rigging and their crew size—to an absolute minimum? It is impossible to say if anyone ever asked these questions, but Captain Lewis Luckenbach answered them. Born in Germany in 1836, Luckenbach came to America at age ten and grew up in Rondout, New York, the Hudson River terminus of the D&H Canal and one of the largest coal-shipping ports in the country. At Rondout he captained the tug *Blue Stone* and by 1871 had moved his operations to New York, then to Philadel-

phia, and finally back to New York, where he was a resident until his death in 1906.[3] In the early 1870s, with the backing of several Philadelphia businessmen he began to purchase ocean-going vessels, mostly square-riggers plus a few steamships. He cut down their spars to simple poles capable of carrying only enough sail to steady themselves while under tow or to limp toward shore if they were separated from the tug by force of weather. He reconfigured their decks to provide oversized hatches to speed cargo handling, and he installed steam power to facilitate hawser, sail, and anchor handling. These modifications allowed him to man the barges with as few as a captain and two seamen.

Lewis Luckenbach and his son, Edgar F., who succeeded him in the management of the company, relied entirely on conversion of deep-water vessels to fill their need for barges. Between the end of the 1870s and the eve of World War I they converted forty-one of them (including five steamers) ranging in tonnage from 845 to 2,438, the average being around 1,600 tons.[4] The economies of this method were undeniable given the late-nineteenth-century glut of square-riggers at the end of their sailing careers. But the method had offsetting disadvantages. First, most of the vessels acquired were already quite advanced in age and were thus both

◄

Coal barges and Hospital ship, which provides days outing on the river for hospitalized children in Manhattan.

The Floating Hospital, pictured here, was a motorless barge that was towed around the harbor on daily excursions during the summer months. These voyages were the last vestige of what had once been a thriving excursion-barge business. The Hospital was an outgrowth of charitable excursions first conducted in 1866 by steamboat tycoon John Starin for the benefit of newsboys, war veterans, and the needy. The *New York Times* was an early and frequent contributor. By 1873 the St. John's Guild had taken over the management of these excursions and began to include medical and dental care in each day's events. For many of the city's needy this was the first time they had ever received medical attention. The Hospital ship pictured here is the *Lloyd I. Seaman*, which operated from 1935 to 1973, when she was replaced by a new but very similar vessel, the *Lila Acheson Wallace*, which has operated ever since. The towage of the Hospital Ship has been provided gratis over the years. Here, one of the Meseck tugs is doing the work. In recent years the service has been provided by Moran.

The coal tow in the foreground is a mixed affair with barges of different size and layout. There are at least eight in the tow and perhaps as many as eleven. It is a hawser tow, with the tug at the front of the flotilla already past the camera's view. The tug at the back of the flotilla is a helper boat belonging to the Reading Railroad. It is contributing both power and steering control. With large eastbound tows heading through Hell Gate, as this one probably is, the third barge in the last tier was often left out to provide a little bit of extra swinging room as the tow worked its way through the tight left-hand turn of the Gate, which inevitably carried the back of the tow precariously close to the rocky Queens shore. Photograph by John Vachon, July 1947, Special Collections, Photographic Archives, University of Louisville.

Towage receipt. Early in what became an illustrious career, Lewis Luckenbach and his first tug, *Bluestone*, towed the schooner *William Jones* to and from the dock in Rondout Creek, Kingston, New York. His signature appears in the lower right. Mariners Museum, Newport News, Virginia.

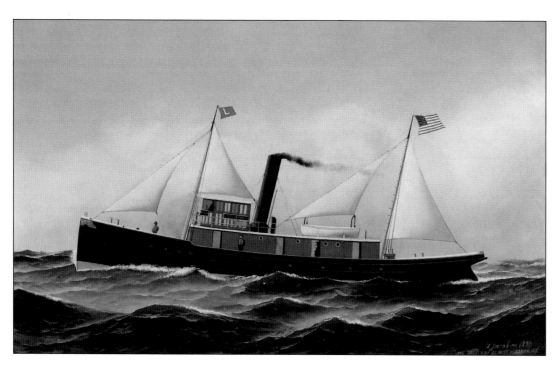

The tug *L. Luckenbach* was built for coastal towing of multiple coal barges. Although the auxiliary sails contributed a little bit of power to the tug, they were intended primarily to reduce the rolling of the tug while at sea, which would in turn increase propeller efficiency. *Tug L. Luckenbach,* oil on canvas by Antonio Jacobsen, 1890, private collection.

more costly to maintain and more prone to strain either at sea or during loading and unloading operations. Second, because each vessel had unique hull dimensions and form, each demonstrated somewhat different behavior both in a seaway and while at anchor. The goal of the coastal-towing industry was to manage as many barges as possible using a single tug, but Luckenbach's use of mixed barges tended to defeat this goal.

The only other major coastal barge operator to rely heavily on converted hulls was the firm of Thomas J. Scully, which held twenty barges all but four of which were conversions. For most coal shippers the disadvantages of conversion outweighed the relatively greater cost of standardized new construction. Of 568 barges oper-

ated on the East Coast by various companies between 1880 and 1920, only 96 were conversions; the rest were newly constructed. Most were made of wood and built by the shipyards of Robert Palmer & Son at Noank, Connecticut, and Kelly-Spear at Bath, Maine. A typical hull of about 200 feet in length, 38-foot beam, and a loaded draft of 18 feet was capable of carrying about 2,300 tons of coal. It was not long before as many as six of these barges at a time were being towed on the coast by a single tug. Clearly, this single tug must be well adapted for its task. New York shipyards, as well as those in Baltimore, Wilmington, and Philadelphia, rushed to fill the demand for tugs to enter this new and profitable towing market. Each new entry sought to refine its towing practices to achieve the most dependable and profitable operations.

The demands of the open ocean require a good-sized and exceptionally staunch vessel. A length of 160 feet, with 30-foot beam and 16-foot draft, was a typical size in about 1901. A triple-expansion steam engine of 1,400 horsepower with coal and fresh-water capacity and stores for two weeks of continuous operation would pretty much fill the available hull space. A large double crew of fourteen to sixteen men was carried. While some of the largest boats could fit a bunkroom under the main deck forward, most placed their crew accommodations, including galley, mess-room, and lavatories, within the deckhouse. The pilothouse was located forward atop the deckhouse, and behind it was accommodation for the captain and mates. Two substantial masts were fitted to carry sail mostly to control rolling and to slightly augment the tug's engine power.

To provide maximum thrust the propellers of these boats were scaled as large as possible. A rule of thumb was that the propeller diameter could be as great as four times the stroke of the engine that drove it. Thus an engine with thirty-six-inch stroke could accommodate a twelve-foot, four-bladed propeller. To work efficiently the propeller must be submerged as deeply as possible, and it must be abundantly supplied with unobstructed water to

work against. These requirements led to tugs designed very deep aft with strongly hollowed underwater features. The low height of the stern deck above the water, required for the safe and efficient use of the towing hawser, produced a low, very handsome profile above the waterline, sweeping upward gracefully toward the bow, which was intentionally modeled quite high in an attempt to reduce the amount of seawater shipped in a head sea. The overall visual effect is that of grace and lithe power.

Running light, a tug thus described had sufficient power to drive it at a speed of about 14 knots, or a twenty-four-hour running distance of almost 340 miles. One loaded barge of the type described above could be towed at 11 knots, two at a little better than 9.5 knots, three at 8.8 knots, four at 8.5 knots, and five at 8.2 knots. With one barge in tow, the tug could complete a tow of 264 miles in twenty-four hours. The delivery of five barges over the same distance required only eight hours more. By these calculations, a 400 percent increase in cargo delivered is achieved with only a 33 percent increase in time and running cost.[5] The use of the tug is maximized by almost continuous, fully loaded (cash generating), operation. Whereas a harbor tug of the period might be idle between assignments part of every day and most of every night, a coastal tug earned constantly. The *M. E. Luckenbach* is cited in 1901 as earning $11,000 per month against a monthly running cost of only $100 per day.[6] Compare this to conditions in New York Harbor and other ports, where local boats were lucky to meet expenses.

The mathematics are compelling. The practice, however, was not so simple. The makeup and conduct of a multiple-barge tow —a tandem tow, as it is now called—is a complicated puzzle. The choice of a hawser type and length suitable for the existing and anticipated conditions is crucial. The basic makeup of a late-nineteenth-century coastal tow of five 200-foot barges put the tug out ahead of the tow with a 600- to 900-foot length of ten-inch-diameter manila hawser. Each barge thereafter was separated from the next by a 450-foot length of manila. The total length of this arrangement from the bow of the tug to the stern of the last barge might have been 3,800 feet.[7] The difficulty of safely navigating such a monstrosity in coastal waters is hard to imagine. Even though the coastal barges were fitted with steering gear, conditions of wind and current often made it impossible for their helmsmen to follow directly in the wake of those ahead. This failing caused many collisions and groundings. Lightships anchored at heavily trafficked places such as Pollock Rip were hit repeatedly; and so many navigational buoys were destroyed at the mouth of New York Harbor that in 1905 the Lighthouse Service experimented with hawser cutters installed on the mooring chains of frequently hit buoys.[8]

The volume of coastal towing traffic on one day in March 1905, as extracted from the daily shipping reports of the *New York Herald*, amounts to thirty-five tugs and seventy barges moving on the coast between Norfolk, Virginia, and Portland, Maine. The largest tow comprised five barges. There was one tow of four barges, ten tows of three, ten tows of two, and nine tows of one. A similar tally, taken three years later, records 38 tugs on the move with 108 barges. The traffic was fast exceeding the number of schooners, which had formerly dominated the coal trade. The disappearance of the sailing coasters and of the vastly experienced masters and officers who commanded them does not indicate that the tasks of the tugboat masters were any easier. The risks of weather and navigation were very nearly the same for both sail and steam, the tug's only telling advantage being the ability to keep moving in light headwinds and calms, whereas the schooners in those conditions were forced to anchor and passively await the weather's next move. The most compelling advantage of steam over sail at the time was that a tug and barge combination could be expected to deliver far more cargo than a schooner. The inherent risk involved in the two modes of transportation was not all that different.

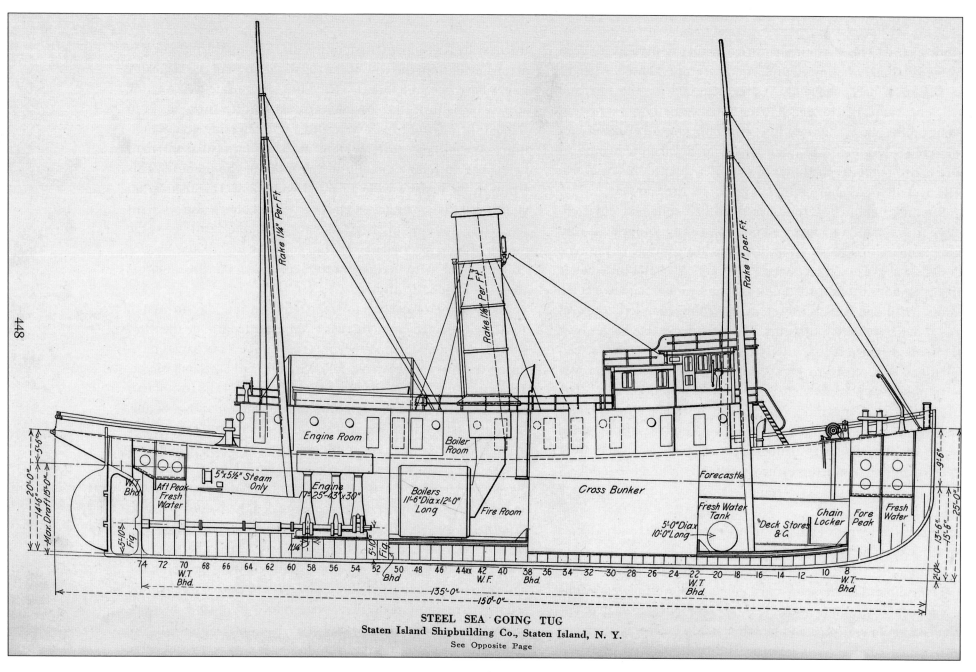

STEEL SEA GOING TUG
Staten Island Shipbuilding Co., Staten Island, N. Y.
See Opposite Page

Steel seagoing tug. These drawings provide a good sense of the general layout of a seagoing tug of 1920. This vessel is equipped with a capstan for handling the towing gear. If it were equipped with a towing winch, the machinery would be mounted in the aft-most section of the deckhouse.

Shipbuilding Cyclopedia, 1920, Science, Industry, and Business Library, New York Public Library, Astor, Lenox, and Tilden Foundations.

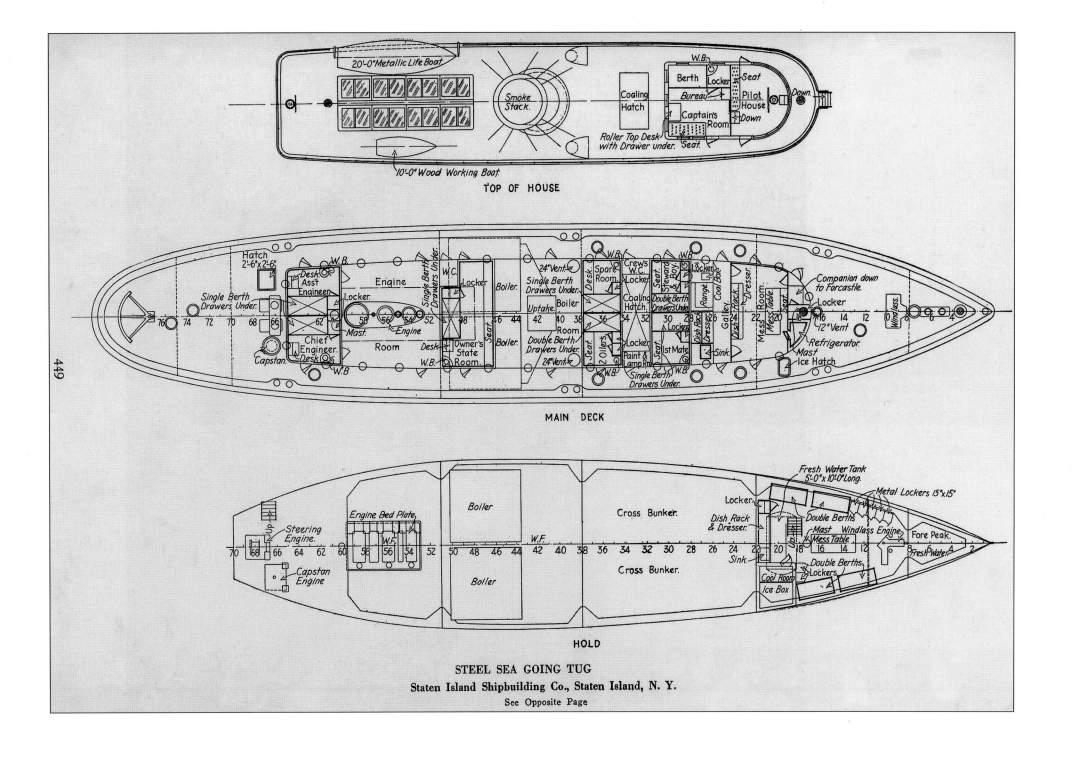

TOP OF HOUSE

20'-0" Metallic Life Boat
Smoke Stack.
Coaling Hatch
W.B.
Berth Locker Seat
Bureau Pilot House
Captain's Room Down
Roller Top Desk with Drawer under. Seat.
Down.
10'-0" Wood Working Boat.

MAIN DECK

449

Hatch 2'-6" x 2'-6"
Single Berth Drawers Under.
W.B.
Desk Ass't Engineer
Engine Room
Locker.
Single Berth Drawers Under.
W.C.
Locker Boiler
Uptake Boiler
24" Vent.
Single Berth Drawers Under.
Room
Double Berth Drawers Under.
24" Vent.
Desk. Spare Room
W.B. Crews W.C.
Coaling Hatch
Locker
2 Oilers.
Paint & Lamp Rm.
Single Berth Drawers Under.
W.B.
Locker
Seat Steward & Boy.
Locker Coal Box
Range Dish Rack
Galley Dresser
1st Mate Sink. Dish Rack
Mess Table
Mess Room
Locker
Companion down to Forcastle.
Refrigerator
12" Vent.
Mast Ice Hatch
Windlass
76 74 72 70 68 66 62 58 56 52 48 46 44 42 40 38 36 34 32 30 28 24 22 20 18 16 14 12 10 8 6 4
Mast. Engine
Chief Engineer Desk
Capstan.
W.B.
Owner's State Room.
Seat.
Seat.

HOLD

Steering Engine.
Capstan Engine
Engine Bed Plate
W.F.
Boiler
Boiler
Cross Bunker.
W.F.
Cross Bunker.
Fresh Water Tank 5'-0" x 10'-0" Long.
Metal Lockers 15" x 15"
Locker
Dish Rack & Dresser.
Sink.
Double Berths
Mast
Mess Table.
Windlass Engine.
Fore Peak.
Double Berths
Lockers
Fresh Water.
Cool Room Ice Box
70 68 66 64 62 60 58 56 54 52 50 48 46 44 42 40 38 36 34 32 30 28 26 24 22 20 18 16 14 12 8 4 2

STEEL SEA GOING TUG

Staten Island Shipbuilding Co., Staten Island, N. Y.

See Opposite Page

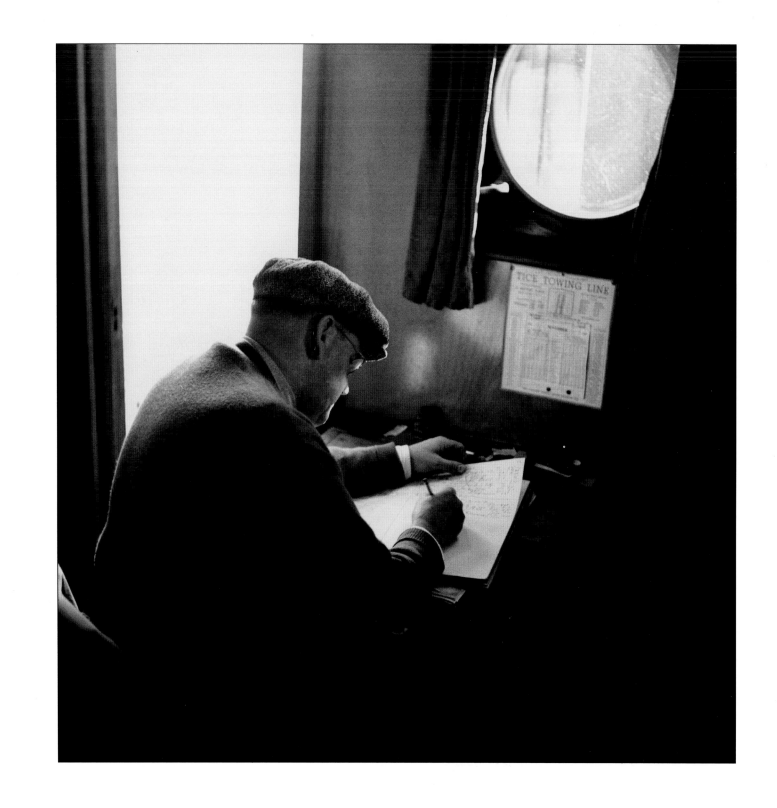

In fact, the conduct of a multiple-barge tow along the coast, particularly in the winter months, was often very difficult. Most accounts of such voyages contain one or more instances of the tug master having to change plans in midvoyage to accommodate a change in the weather or some greater of lesser catastrophe among the barges in tow. It appears that the proper temperament of the tug master around the turn of the century might be best described as "forthrightly indecisive" in that the success of a voyage often hinged more on the avoidance of fixed plans than on the dogged pursuit of them. For example, a tug departing from Norfolk with a three-barge tow bound for Boston is signaled by one barge that its crew has discovered a leak. The tug master turns around and returns to the shelter of Chesapeake Bay. He orders all the barges to re-anchor and spends the rest of that night and the next day sorting out the problem. He gets underway once more with a course plotted directly down the coast for Vineyard Sound. But twelve hours later the weather begins to show signs of going into the east, so the tug master elects to divert into New York. It will cost him most of a day to get the tow past Sandy Hook, gather the barges up into a bunch to bring them up through the East River, and once in Long Island Sound string them all out on the hawser once more. From there he travels the length of the Sound more or less protected from the bad weather out in the open ocean. He comes out into Block Island Sound as the gale is winding down and is able to continue on his way to Boston, only a couple days behind schedule—if he ever really had a schedule, and no experienced tug master of that time would have been so naive.

Captain Ole Olsen making entry in log of *Esso Tug No. 8*. Photograph by Sol Libsohn, November 1947, Special Collections, Photographic Archives, University of Louisville.

Caution and fine judgment as to weather, sea conditions, and the behavior of his tow were the intellectual capital of the coastwise master. Once underway, he was in sole charge of the voyage, and its outcome was his sole burden. Today, with instantaneous radio communications, radar, satellite-based navigation systems, highly accurate weather forecasting, and tugs and barges vastly stronger and more powerful than those of a hundred years ago, the captain's burden—and his need for flexibility—is greatly reduced. A decision to alter schedule due to weather will most likely come from the front office and will in any case have to be approved from there. Generally, a modern coastal tug may wait in port if the weather forecast is deteriorating badly; but once the forecast has begun to improve the tug and tow are expected to proceed. Once underway they are expected to keep going unless told to do something else. The hulls, the machinery, the towing equipment, and the electronics of modern tugs leave little place for the ancient art of seamanly indecision.

The difficulty of coastal towing at the end of the nineteenth century produced many casualties. Damaged and sunken vessels, loss of cargo, and loss of life increased with the pressure to move ever-greater quantities of coal to New England. Marine scholar Paul C. Morris reports that between July 1, 1905, and July 1, 1907, "35 barges foundered, 15 stranded, 5 were in collision, 3 burned, and 2 struck docks. Also listed aboard these 60 barges were 192 persons, and of these, 49 lost their lives."[9] These casualty figures do not include the damage and loss of life inflicted by these barges on other vessels, but the toll must have been significant. Finally, the U.S. Department of Commerce got involved and, on February 1, 1909, established regulations for the conduct of coastal tows operating in U.S. inland waters. The regulations limited the number of barges to three and the total maximum length of a tow to two thousand feet, with the added requirement that the length be further reduced as much as conditions permitted. At certain harbor entrances the rules required

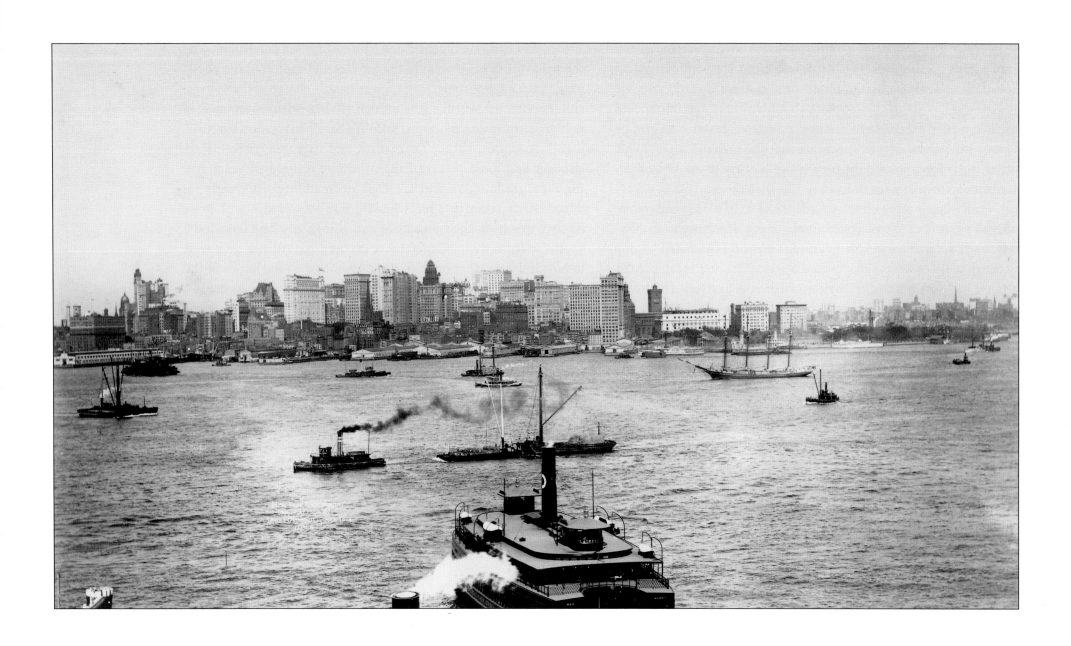

that barges be bunched alongside one another. Shortly after these regulations came into effect, on February 1, 1909, an additional requirement was imposed, that all seagoing barges be inspected annually. These regulations improved the situation but did not solve all the problems. Hard experience had already imposed a three-barge limit on most tows conducted during the winter months, and the details of the proper places for shortening up and bunching tows were obtained from the testimony of experienced and prudent tug masters.

The advent of government regulation in 1909 was, if nothing else, the announcement that coastal towing had established itself within the American economic scene. The shipment of coal, particularly to the New England states, had created an opportunity for tug operators to expand their business out of local waters. It had also led to the development of a distinct class of tugboat able to haul massive loads over long and exposed routes. The involvement of New York in the development of this new business was considerable. Of seventy-one major companies involved, thirty-two were based in New York Harbor, while the next most represented port was Philadelphia with thirteen, then various New England ports with nine. But the commodity shipped was not limited exclusively to coal. Barge loads of block ice from Maine and Hudson River producers were being towed as far south as Havana, and sugar was being towed north from the Caribbean. Gypsum was being barged from Nova Scotia, barge loads as well as free-floating rafts of timber were towed from New Brunswick,

A view across the Hudson from Jersey in about 1910 shows the CRRNJ passenger ferry *Plainfield* approaching her slip and behind her a sampling of harbor activity. A McAllister tug tows a pair of single-masted lighterage scows upriver. Farther back is a four-masted schooner being towed by a pair of tugs working side by side. The length of hawser seems quite excessive for the crowded conditions of the Upper Bay. Library of Congress, Prints & Photographs Division, LC-42734 H-65876.

and ships in ballast or in need of repair were being economically delivered all over the east coast of the Americas.

★ On the Hawser

Towing an object astern at the end of a long rope is called towing "on the hawser." It is tugboating at its most basic—the way that most of the big and complicated things get done. A barge too big for the tug to see over cannot safely be pushed or taken alongside; it must go on the hawser. An oil rig or a floating dry dock too unwieldy for a tug's rudder power alone to master must go on the hawser. A tow bound into the unpredictable wind and sea of the open ocean must go on the hawser. Of the three basic methods of towing—pushing and towing alongside being the other two—it is the slowest and most laborious both in terms of fuel burned and of human effort, but it is still the most dependable for the long haul.

The basic elements making up a hawser tow are the towline itself, whether it be made of fiber rope or wire, and then whatever devices are used to attach that line to the stern of the tug and to the bow of the object being towed. The purpose of the whole arrangement is to separate the tug and the tow from each other by a distance sufficient to allow the tug to maneuver freely and to provide enough stretch in the towline to keep it from parting under the strain of wave action or from sudden changes in speed and course. As much as the line must be protected against these sudden shocks it must also be guarded against chafe, which most often occurs at the points of attachment between tug and tow but can also occur at any point on the length of the line if it should come in contact with the sea bottom or any other obstacle.

Most hawser-towing arrangements are made up of a combination of fiber rope and wire, with heavy chain sometimes used in place of the wire. A simple arrangement would be a nylon tow rope secured to the towing bitts of the tug, stretching astern to a

On the after deck of the tug, deck hands splice hawser, parted during a tough pull.

The *K. Whittelsey* is proceeding through the canal which in this section runs in the course of the Mohawk River, dredged and dammed as necessary to provide a navigable channel. At each dam a lock is situated to afford passage to the next level of the river.

The men here are working on the tug's main hawser, ten-inch-circumference manila rope. When new, it has a breaking strength of about 38 tons. A few years after this photograph was taken, the manila rope was replaced by synthetic, nylon line, which in the same size holds almost 120 tons.

The *Whittelsey* would not be using this hawser in the canal, so the deckhands are either performing routine maintenance by cutting back the end of the line a few feet to remove the part that normally receives the most wear, or else they are getting it ready for a trip into the Great Lakes. Photograph by Harold Corsini, October 1946, Special Collections, Photographic Archives, University of Louisville.

heavily reinforced spliced eye that is shackled into each of the two legs of a wire or chain bridle. The two legs of the bridle stretch back to the forward corners of the barge. At the barge the bridle legs might either terminate in open spliced eyes that are fit over the mooring posts of the barge, or for longer, heavier towing they may be shackled into specially welded and reinforced fittings.

Either method of attachment must assure that the bridle legs "lead fair" from the barge (i.e., without sharp bends or chafe points that would weaken them). Likewise, along the short length of the hawser that stretches from the towing bitts of the tug to the stern of the tug, there must be careful protection against chafe, particularly where the line rides back and forth on the stern rail. This can be accomplished by securing a heavy timber shoe—a hawser board—around the line where it meets the stern rail. Other types of chafing gear, such as canvas or reinforced rubber wrappings, can be applied to the line; but none of these is suitable for long-distance voyages because they tend to shift position on the line and are themselves eventually worn away.

A more secure arrangement for a long tow is to shackle the tugboat end of the towline into a heavy wire or chain long enough to reach just past the stern of the tug. In this way the chafe is absorbed by the vastly more durable chain. Instead of a fiber-rope hawser, many larger tugs use wire-rope hawsers handled by winches. When a wire hawser is used there must be some provision to provide a shock-absorbing element to the system. This is most often done by inserting fifty to one hundred yards of very heavy nylon line—a shock pendant—between the towing bridle and the end of the tow wire; the same can be accomplished by making the bridle legs out of very heavy chain, the weight of which will have to be lifted before any shock can damage the rest of the towing gear.

On a long tow at sea, it is possible to further reduce the effect of chafe at the stern of the tug by fixing the position of the towline where it passes over the stern rail. For this, vertical pins can be installed on the stern rail on each side of the towline to re-

strain its side-to-side movement. Also, the hawser may be held in place by a short rope or wire pendant called a gob rope.

The length of hawser required varies according to the particulars of the voyage. A long trip in open water argues for a generous length of hawser so that there is no risk of parting the line in any weather conditions that might be met. If the tow will be passing through constricted or shallow channels, then less length is required. If too much line is put out, there is the risk that the barge will not follow the tug well enough to minimize the risk of collision with buoys or other vessels. With too much line out it is also very possible for the hawser to become entangled with obstructions on the sea bottom should the tug stop, slow down, or change course too sharply. Too short a line can also cause trouble. If inadequately separated, the propeller wash of the tug can work against the bow of the barge, slowing the tow unnecessarily. Too short a hawser also tends to exaggerate any difference in course between the tug and the barge and may encourage the barge to shear radically out of the wake of the tug. Usually, different phases of any voyage require the use of different lengths of hawser, and the tug master's experience and judgment decides when and where these changes must be made.

It is not usually possible to depart from the dock with a tow on the hawser. Because of congestion in the harbor, most tows begin with the barge either being pushed or alongside. It is only once the tug and tow are near the harbor limits that the hawser tow can begin. But that does not mean that preparations have not already been made. It is common practice when setting off on what will become a hawser tow for the tug to make up alongside its barge so that the stern of the barge is forward. Positioned in this way—with the bow of the barge riding next to the stern deck of the tug—it is possible for the crew to rig the bridle to the barge and lay out the hawser. With everything thus prepared, when the time comes to put the tow on the hawser it is a simple matter to slow the tug to a near stop, cast the barge off, and gently flip it around to follow the tug out to sea. At the end of the voyage it is often possible to reverse this process. The hawser is hauled back until the barge is close behind the tug and both are stopped. Then, with the remaining hawser and the bridle hanging slack, the tug gently turns 180 degrees to come back into position alongside the barge. In most cases the tug will use the wind to advantage by turning to put the barge upwind of the tug. By doing this, the barge will be blown toward the side of the tug, helping to bring them alongside each other. One frequently sees a tug passing through the harbor with a large empty barge alongside, the barge most often proceeding stern first. To the uninitiated, this appears to be an example of clumsy seamanship on the part of the tug, but it is actually the result of the very efficient maneuver just described.

12

Transatlantic Towing

The increasing capability of offshore tugs began to raise the tantalizing possibility of transatlantic towing. An article on this subject appeared in the June 20, 1901, issue of *Nautical Gazette* in which the tug *M. E. Luckenbach* is cited. The *Gazette* suggests that at 154 feet in length, 1,100 horsepower, a crew of fourteen, and a coal-fuel capacity adequate for sixteen days continuous operation, she was capable of towing over transatlantic routes.

The real planning toward this end, however, was coming from a different quarter. While on the East Coast towing practice developed almost exclusively around the use of tugboats, on the Great Lakes freight-carrying steamships were doubling as towboats. A steamer loaded with grain or timber could profitably tow one or two equally loaded schooners or specially built barges down the Lakes. This system offered the advantage of increasing the amount of cargo delivered in a single voyage since the towing vessel also served as a cargo carrier. The system carried with it the offsetting disadvantage that the towing vessel, like its barges, must be detained in port for loading and unloading, thus idling the capital invested in its engines and operating personnel. Clearly, the longer the duration of the tow in comparison to the length of the towing vessel's detention in port for cargo operations, the less this disadvantage will be felt. Thus, very long tows might be most profitable when conducted on the Great Lakes

Tug at the bow of the Grace Liner *Santa Ana*, at Pier 58, North River.

The tug *Grace 3* was owned and operated by the Grace Line to handle its docking and lighterage chores. It was quite common for steamship companies to maintain their own tugs. This boat, with its faceted pilothouse front is immediately recognizable as a former government boat, built for the Defense Plant Corporation. In October 1943, the Corporation ordered one hundred of these tugs and five hundred barges to expand wartime fuel-oil transportation in the Intercoastal Waterway (an inland route safe from U-boat attack). Six shipyards were given tug-building contracts; fifty-two hulls were awarded to two New York yards. The building methods were unusual in that all the fleet's deckhouses were fabricated in Cleveland and shipped in pieces to the shipyards.

Many of these boats found there way into civilian ownership after the war. They were considered unremarkable boats, no more than serviceable, but sturdily built and cheap to buy as government surplus. Despite their mediocre reputation there are still a few of them working today. Photograph by Arnold Eagle, August 1947, Special Collections, Photographic Archives, University of Louisville.

model rather than on the prevailing East Coast method of tug and barge. This was a theory that warranted experiment.

The Standard Oil Company, with its offices and much of its transportation and refinery operations based in New York Harbor, had been examining the best means of transporting its products from newly developed oil fields in Texas to its refineries in Philadelphia and New York and from there to the rapidly opening markets in England and Europe. Probably because the company's earliest refining operations had been conducted in Cleveland, where Great Lakes towing methods were in evidence, it decided to use self-propelled tankers and barges. Voyages along the Atlantic coast were successful enough that in December of 1904 the Standard Oil tanker *Atlas,* with a cargo volume of 1,243 tons, and the barge No. 93, with a volume of 3,939 tons, were sent on a voyage from New York to San Francisco via the Straits of Magellan.[1] The length of the journey necessitated that most of the *Atlas*'s cargo space be used for her own fuel. It was also the company's intention that both vessels remain on the West Coast to serve the oil fields there. The voyage was, therefore, more in the nature of a delivery trip coupled with a towing experiment rather than a purely commercial venture. Nevertheless, the successful result of that fifteen-thousand-mile test led inevitably to the next step —an attempt to cross the North Atlantic. The oil company selected the tank steamer *Colonel E. L. Drake* (named for the man who originally discovered drillable oil in Pennsylvania) and the barge No. 95, both loaded with petroleum, for the task. The tow arrived at London without reported mishap in July of 1905.[2]

The next major experiment in ocean towing was conducted by the U.S. Navy. The Philippine Islands had been taken in the Spanish-American War, and it was the Navy's plan to establish a major base at Manila. This base was deemed essential to the United States in establishing a global naval presence. To service the largest ships of the Pacific fleet a huge floating dry dock, the *Dewey,* was built at Baltimore, Maryland. Plans were then made to tow it to Manila by way of the Suez Canal. Two Navy colliers, *Caesar* and *Glacier,* were chosen to do the towing. A third collier, *Brutus,* and the tug *Potomoc* were sent along to assist as necessary. The voyage began from Chesapeake Bay on December 21, 1905, with a projected duration of 90 to 120 days.[3] It took 94 days just to reach Gibraltar. The trip across the Atlantic was punctuated by storms that blew the *Dewey* north, south, and west, but almost never east. Even when conditions were favorable the expected average daily progress of one hundred miles turned out to be more like forty-five. The complex towing equipment, which included a manila and wire hawser a mile and a half in length, failed repeatedly. Towing machinery on the colliers disintegrated, and on the dry dock the array of mooring points designed to spread the strain from the hawser was repeatedly uprooted.

The beleaguered little squadron arrived at the entrance to the Suez Canal on April 18. Two big tugs belonging to the Suez Canal Company towed the *Dewey* through the canal with the assistance of the *Potomoc.* Windy conditions made the passage particularly difficult. Four and one-half days were required, and thousands of dollars in damage was done to piers, buoys, and light beacons along the way. After completing the canal passage the *Potomoc* was sent home while the rest continued across the Indian Ocean. They were sighted in the Straits of Malacca on June 20, and they finally arrived at Manila in July, 193 days out. The man in charge of the expedition, Commander H. H. Hosley, was, briefly, a national hero.

The ultimately successful voyage of the *Dewey* demonstrated that in towing virtually anything is possible given enough perseverance. The experiments conducted by Standard Oil proved both the possibility of as well as the ultimate impracticality of transatlantic towing as a routine trade. Although Standard Oil continued tanker/barge passages to England through its Anglo-American subsidiary, the method proved to be more trouble than it was worth. The final tanker/barge combination was the 467-foot-long

Iroquois, built to tow the 450-foot, six-masted barge *Navahoe*. Both the tanker and the barge were fitted with towing machines, and at sea two eight-inch-circumference wire hawsers were used. The winch at the stern of the tanker managed one hawser while an identical winch mounted on the bow of the barge attended to the other. To coordinate the management of the two hawsers the ship and barge were in more or less constant wireless communication. The level of attention required to keep the two vessels attached to each other earned the pair the nickname "the terrible twins."[4]

But to say that the method was a failure would be inaccurate because, despite their difficult relationship, the "twins" spent a long and productive career together. The two were built in 1907–8 at Belfast, Ireland. From then until the outbreak of World War I, they made 148 crossings between England and the Texas/Louisiana coast. During the war they ran between Texas and Halifax and afterward resumed transatlantic service until 1930, when the barge was retired as a storage hulk in Venezuela.

The career of the twins, though a passable success, was overshadowed by the realization on the part of naval architects that the best way to transport oil or any other bulk commodity was in ever-larger single vessels, where the relationship of arithmetically increasing hull dimensions lead to geometric increases in carrying capacity (for example, a hull measuring 250 feet by 20 feet by 20 feet has a volume of 100,000 cubic feet, while a hull of just twice those outside dimensions—500 feet by 40 feet by 40 feet—has a volume of 800,000 cubic feet). Thus, the transport of freight, oil, and bulk materials is now accomplished by individual ships whose owners increase their payload by simply building to ever more gigantic proportions. Since this change in thinking, there have been no regularly scheduled transatlantic towing operations, although there have been any number of miscellaneous transatlantic tows performed by tugs. The special needs of salvage operations and the delivery of specialized objects such as

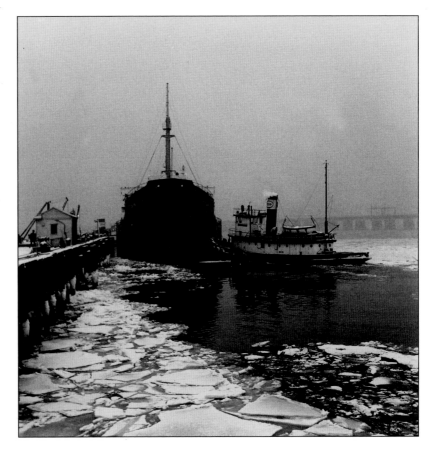

The *Esso Parkersburg* is eased away from the dock at Bayonne, New Jersey by an Esso tug. Photograph by Arnold Eagle, February 1948, Special Collections, Photographic Archives, University of Louisville.

floating oil rigs remain significant parts of the worldwide towing industry, but the experiments of Standard Oil Company and its Anglo-American subsidiary established a practical limit to the capabilities of North Atlantic towing that have not been seriously challenged since.

The towline and its attachments are the weak link in a towing operation. By calculation it is possible to size the hawser, the

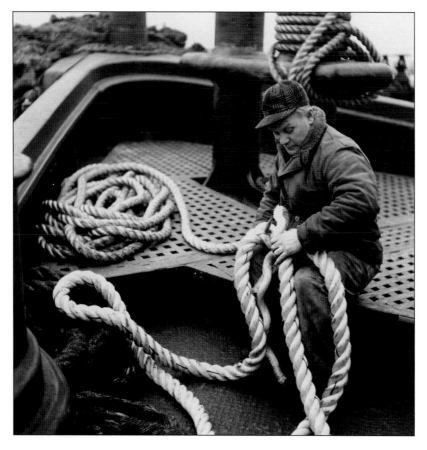

Deckhand John Carlson using fid in splicing loop into hawser on *Esso Tug No. 7*.

This slightly damaged photograph shows one of the ongoing tasks of a tug-boatman, particularly in the days before synthetic rope was introduced. This heavy manila line is not being spliced into a hawser but used as an ordinary working line for securing tows alongside and for docking work. These lines are normally twenty fathoms (120 feet) in length and have an eye spliced into each end. The size of the eye is such that if a man of average height holds the splice to his chest, the bottom of the eye will just touch the deck. This gives the eye enough girth so that it can be thrown, like a lasso, over cleats and mooring posts. Proficiency in throwing lines is an essential skill that deckhands must master. Failure to learn this skill is probably the single most common reason for deckhands to be fired. Photograph by Sol Libsohn, November 1947, Special Collections, Photographic Archives, University of Louisville.

towing bridle, and the shackle or "fish plate" that connects the two so that the entire assembly will comfortably withstand the normal strain imposed by the force of the tug's engine working against the resistance of the barge. This normal strain is what is expected when the tow is underway, running at full throttle in calm sea conditions. In this situation the strain on the hawser is actually quite little because the barge builds up its own momentum and keeps pace with the tug without a great deal of further effort. The hawser becomes relatively slack and most of its length sinks below the sea surface in a catenary, the depth of which is determined by the weight of the hawser and the tension that it is under. Excessive catenary when towing in shallow water may bring the hawser into contact with the sea bottom, which will quickly damage or destroy the line. To avoid this, either the length of the hawser must be shortened or the tug must apply more power. Some modern synthetic rope is buoyant and is sometimes used as towing hawser in particularly shallow water or in tight maneuvering situations where there is the risk that a sinking line may become entangled in the tug's propeller. But a moderate amount of catenary in the towline is a good thing, because it is the first line of defense against the single biggest risk to the security of the tow. An unpredicted strain caused by wave action, a radical shift in current, or a too sudden course change—anything that quickly changes the speed of tug and tow relative to each other—can lead to a catastrophic multiplication of the strain on the hawser. Such a sudden shock on the line is somewhat relieved by the damping effect of the catenary being pulled straight. A floating hawser or one that is either too light or too short lacks this initial damping effect and is endangered.

The next factor that works to preserve the towline from destruction is its ability to stretch. A sudden shock to a hawser is usually a very brief event, with the strain increasing rapidly to a very high peak and then as quickly receding. The ability of the

line to stretch allows the line to increase the time frame of the event and thereby reduce the peak load, which represents the greatest danger. Calculations performed in 1909 showed that a standard manila hawser was capable of stretching about 5 percent of its length before failure. A wire hawser of comparable strength stretched only half of 1 percent. Equal shocks applied to equal lengths of the two hawser types produced 8.5 feet of stretch and a peak load of 83.5 tons in the wire, while the peak load on the manila reached only 73.5 tons, due to a stretch of fifty feet.[5] (Modern synthetic hawsers are made of nylon fiber, which has the ability to stretch up to 50 percent of its length, giving it a tremendous ability to withstand shock loads.)

The elastic virtues of manila made it the material of choice in nineteenth-century towing, but there were also drawbacks. With its strength came tremendous bulk. A twelve-hundred-foot length of six-inch-diameter manila has a breaking strength of about sixty-eight tons, but weighs about six and a half tons when dry and considerably more when wet. It requires a team of men to handle it on deck and a powered capstan to haul it in. To keep it dry and unfrozen it must be stored below deck in a heated compartment. It is subject to both rot and chafe, either of which might cause sudden failure. In winter the seawater-soaked line quickly freezes as it is being hauled back aboard the tug, and if not immediately stowed below decks, it becomes totally rigid and impossible to handle. A modern nylon hawser of two and a quarter inches diameter will provide tensile strength equal to that of six-inch manila. The nylon hawser weighs only 234 pounds. It is impervious to rot and resistant to chafe. Last but not least, it possesses the ability to stretch generously under shock loads. As soon as nylon hawser started to become available in the 1950s it forever replaced manila.

Steel wire rope has been an alternative to fiber rope since the 1880s, when the John A. Roebling Company perfected a product that was flexible, uniform, and durable. The strength of good-

Deckhand John Carlson using fid in splicing loop into new hawser on *Esso Tug No. 7*. Photograph by Sol Libsohn, November 1947, Special Collections, Photographic Archives, University of Louisville.

quality wire rope is such that a wire of only one and a quarter inches is equal in strength to six-inch manila. It is very resistant to chafe and still lightweight in comparison to manila—a twelve-hundred-foot length of one-and-a-quarter-inch wire weighs only twenty-six hundred pounds. Its greatest disadvantages are that it has no ability to stretch under load and that it is impossible to handle without machinery.

To combat these problems, in the best spirit of the nineteenth century, a machine was invented to both efficiently handle wire rope and also give it the stretch it needed. The towing winch, or "automatic towing machine," was first developed by the Chase Machine Company of Cleveland, Ohio, for use on the big Great Lakes towing ships. It was later fitted on several of the ocean-going oil tankers and their barges. It consisted of a steam-powered winch, capable of winding up on a drum as much wire hawser as anyone might require. In addition to the manual steam controls for taking in and releasing wire, it was fitted with an automatic valve that adjusted itself to the steady tension on the towline. The towline was held not by a mechanical brake but by the constant steam pressure maintained by the automatic valve. If the tension on the line increased, the winch surrendered wire, and at the same time the valve increased the steam pressure. As the steam pressure increased, the release of wire was gradually slowed and then stopped, and then the wire was retrieved back to its original length.

Early problems with the valve design allowed too much wire to be released initially so that the tow sometimes accumulated momentum in the wrong direction.[6] This situation, called "shearing," can sometimes develop into a snowballing catastrophe in which a deep-loaded barge runs off on a course divergent from that of the tug. The angular force of the towline trying to turn the head of the barge back toward the course of the tug is transferred into the barge's forward momentum, causing it to run out alongside the tug under ever-increasing strain, which eventually either parts the towline or capsizes the tug. Later modification of the valve to more quickly increase steam resistance solved much of this problem. The early winches also had a tendency to take back wire far too quickly if the wire went slack. This situation caused the winch to haul back at overspeed, tearing up its gears. Again, modifications were made that permitted the valve to quickly throttle back if the wire went slack during retrieval.

By 1908 the automatic towing winch, with the necessary modifications to the valve mechanism, was being manufactured by the American Ship Windlass Company of Providence, Rhode Island. The company scaled down the design to fit neatly on the stern deck of a tug and designed guide rollers to automatically spool the wire back onto the drum. From that point on, the towing machine and its later modifications, employing electric and hydraulic power rather than steam, have become standard equipment on most large coastal and ocean-going tugs. (A second method for providing some stretch in a steel hawser is to insert a short length of fiber hawser into the towline assembly. Modern coastal tugs that do not have the luxury of an automatic winch include a short piece of nylon hawser between their wire towline and the barge's towing bridle.)

★ Communications

In the early nineteenth century New York was still a lonely outpost of European culture that, like the rest of the country, depended on its mother continent for commerce, culture, and gossip. New Yorkers, even as they waged their own local schemes of enterprise and fashion, always kept one eye trained on Sandy Hook for arriving ships that might bring news.

Daily reports in newspapers such as the *Commercial Advertiser* and, in later years, the various editions of the *New York Times* scrupulously listed the arrival of ships by name, the last name of its captain, the port from which it had come, and the local merchant to whom its cargo was consigned. Frequently a vessel was sighted while still offshore. As yet unidentified, its rig and its hull coloration were still described. Tugs arriving from forays offshore in search of incoming ships reported on what inbound vessels they had encountered.

Newspapers used ingenious means to acquire the most timely information about arrivals and to glean from those vessels every possible scrap of news from abroad. They built schooners to cruise in the offing and meet ships still hours or even days from the Manhattan piers. They arranged for packet captains to enclose passenger lists and foreign news in watertight bottles that they cast over the side as they sailed in through Sandy Hook Channel. The bottles were retrieved by small boats sent out from shore and the news transmitted to the city by semaphore tower or, later, by telegraph. The semaphore tower was located atop Atlantic Highlands, from which its operators enjoyed a view far out to sea, as well as inshore toward Fort Wadsworth on Staten Island at the Narrows. Messages were encoded in the gyrations of the mechanical arms appended to the tower. They were sent to Fort Wadsworth and from there relayed to the Battery.[7]

In 1844 Samuel F. B. Morse demonstrated his magnetic telegraph. By 1849 there was a telegraph line established from Coney Island into New York City, and the Atlantic Highlands semaphore for a few years used this quicker transmission path. In 1852 the Sandy Hook Telegraph Company was founded, and by the summer of 1853 constant telegraphic ship reports were flowing to the city.

Although the principal customers for this shipping information were speculators in stocks, finance, and commodities, the information link between the city and the sea also proved a powerful organizing tool for the tugboat industry. In the past, an arriving ship belonging to any one of the shipping companies that conducted regular business in the port was obliged to accept the services of whichever tug it met on its approach to the coast. Because the exact time of a ship's arrival was largely unpredictable it was impossible for a tug owner to guarantee his services to any particular customer. The accelerated flow of information from the coast to the waterfront towing offices encouraged the formation of durable relationships between shipping lines and tug oper-

ators. This trend worked to the advantage of the larger towing companies in that shippers naturally patronized those companies with multiple boats, on the assumption that there would always be a tug available to meet their needs.

The adaptation of Marconi wireless telegraph equipment to shipboard began in earnest around 1910. By 1918 it is estimated that there were about fifty-seven hundred wireless-equipped ships worldwide. But wireless probably had less overall effect on New York Harbor towing practice than did the Morse telegraph. Most wireless-equipped vessels were steamships, which only needed assistance in docking and were therefore met by their attendant tugs well after they had been reported in at Sandy Hook.

Wireless and cable both created a tremendous business advantage to salvage and long-distance towing because word of a calamity or of a ship broken down in a remote port could quickly reach a towing office. At long distance, a towing or salvage agreement could be established and a tug dispatched to bring the ship and its cargo to a major port for economical repair.

While the advances in communications between ship and shore were altering the way tugs responded to jobs, another technology was revolutionizing the way towers and their customers communicated. Telephone service appeared in New York City in 1878 with a subscriber directory of 271 names, none of which were companies involved with towing.[8] The very next year, however, eight lighterage and eight towing firms were on board. By 1885 the number of towing companies listed had risen to eighteen and included the full range of tugboat specialties from coastal, to harbor, to Long Island Sound, to Hudson River, to ship docking, to salvage.

The New York maritime community's embrace of the telephone as a tool of business was swift and general. As a class of business, the rate of towing's entry into the communications age quite closely matched that of the undertaker's trade, another field in which timeliness is of the essence. The Bell system largely solved

one of the most vexing problems in the tugboat industry, that of bringing towers and their customers into direct communication. It rendered obsolete the old system in which runners, scalpers, and saloon keepers were costly adjuncts to the business. It even rendered the business model of the towing agent less viable because it simplified the intermediary functions of agency so much that they could be more easily taken on by the boat owners themselves.

By the mid-1920s, advances in technology suggested that it might be possible to establish direct voice contact between a tug underway in the harbor and its dispatcher on land. Historically, upon completing a towing assignment, a tug was obliged to return to its home base to pick up its next orders. Tugs often tied up at the Battery because of its proximity to the building at 17 Battery Place, where many of the towing-company offices were located. Megaphones were used to call orders down from windows and rooftop to the tugs below, or else office runners or tug crewmen were obliged to scurry back and forth. But the spectacle of a half-dozen tugs waiting around for orders is not a pretty sight to a tug owner. If there was a holy grail in the tugboat industry, it was a device that would seamlessly link the desires of the office with the efforts of the tug. The telephone had made it possible for the tug captain to pull in to any pier near a phone and call in from there. But even then, the side trip to find a land line caused a serious disruption in the tug's earning power.

The first attempt to install radio equipment on a New York Harbor tug was in December 1924, when the *New York Central No. 18* was used in a trial conducted by the railroad and the Radio Corporation of America.[9] A low-power transceiver in the tug's pilothouse communicated with an RCA shore station at Bush Terminal in Bayridge, Brooklyn. From there the message was relayed by telephone to the New York Central dispatcher in Manhattan. The one-month trial was pronounced a success by both parties. The New York Central estimated that the system might save

their fleet as many as five hundred hours per month;[10] but apparently it was too cumbersome to warrant wide-scale adoption. In 1936 New York Telephone Company offered a service, which it originally tested on the *Alice Moran,* that provided a radio connection to and from the tug to a shore-based operator at RCA headquarters at 75 Varick Street. The operator then connected the tug to its office over telephone lines.[11] It was basically the same system that became the standard ship-to-shore marine-operator procedure that, despite deadly competition from cell and satellite phone technology, remains in use today.

By World War II, direct radio contact between dispatchers and tugs was established using High Frequency (HF) systems situated in the pilothouses of the tugs and in the dispatching offices of the larger companies. HF systems enabled boats to hustle efficiently from one job to the next and allowed the dispatcher to utilize a tug that was already in the vicinity of the next assignment, minimizing unprofitable "running time." Furthermore, tugs could be assigned almost instantaneously in cases of emergency or short notice. These complex and expensive arrangements were, of course, out of reach for the smaller companies.

Today, Very High Frequency (VHF) radio, which became widely used in the harbor during the 1960s and is universal today, makes it possible for vessels to freely communicate with one another and with colleagues or authorities on shore. Under Coast Guard and FCC supervision, frequencies are partitioned so that different types of traffic are handled over specific channels. Direct communication between the vessels for navigational and safety information is provided on one channel, Coast Guard vessel traffic-control systems occupy several other channels, and other channels are specifically reserved for general communications, weather forecasting, and either public or private ship-to-shore uses. In comparison to lower-frequency radio systems, VHF has a short range, traveling only by "line of sight" between transmitting and receiving antennae. This characteristic, which might

be thought a drawback, is actually an advantage in the crowded conditions of most harbors because it localizes communication to include only those vessels in close proximity to one another. This feature greatly reduces clutter on frequencies intended for terse navigational conversation.

Operating outside the harbor, either coastally or in deep sea, the modern tug has an array of communications systems available to it. The basic device is the single side-band radio, an AM short- and medium-wavelength system that has range enough to span oceans and to connect with shore-based stations that can relay messages worldwide. Data and weather facsimile services are transmitted over these same wavelength bands to automated shipboard receivers that are able to standby and communicate automatically. Satellite communications have added to the array of options and today offer near-instantaneous direct-voice, high-speed data and distress signaling to and from any place on earth.

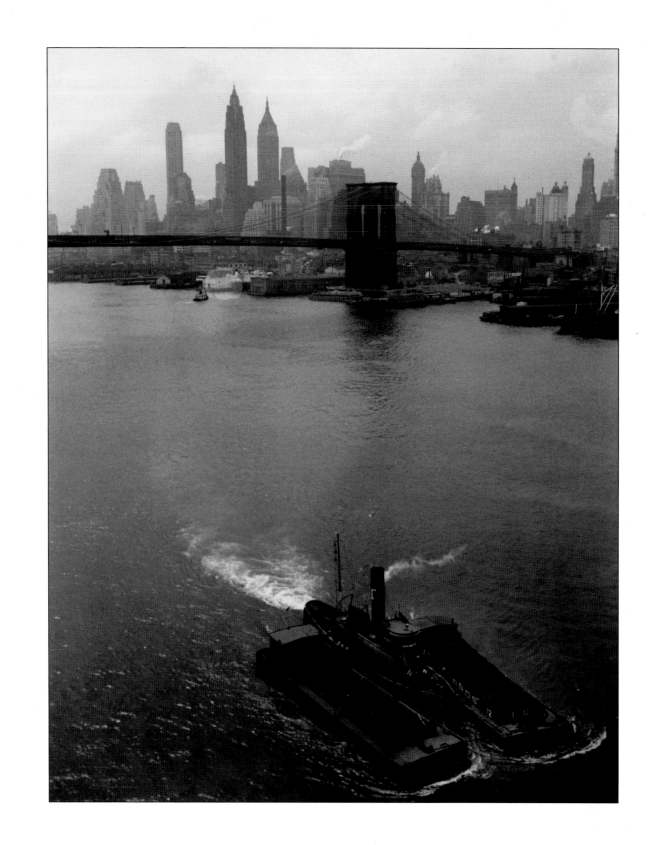

13

Fuel

Since coal's first use in the New York–based steamer *Portland* in 1835, it had become essential to marine transportation and to all other branches of industry. Prior to the adoption of coal during the late 1840s,[1] wood in the form of pine logs and branches cut to about five-foot length was the common steamboat fuel. The wood was bulky to store on board and difficult to handle. Also, its combustion was hard to control, and it tended to spew hot coals from the ship's stack, which caused a number of disasters. A voyage from New York to Albany might consume twenty cords of firewood,[2] and as demand increased, the supply of wood diminished. In light of these problems coal was recognized as a great improvement over wood.

Coal quickly became abundant on the eastern seaboard, and methods for its shipment, storage, and handling were developed to minimize the amount of manhandling required. From an elevated storage bin ashore it could be poured into a ship's bunkers much as if it were liquid, and it filled those bunkers much as a liquid might, settling to leave little wasted airspace. Pound for pound, coal produces about two and one-quarter times as much heat as wood: 890 pounds of coal will produce as much heat as a ton of wood.[3] Furthermore, the combustion of coal can be more evenly and safely regulated. Steady improvement in boiler design and in the efficiency of steam engines produced ever-greater energy returns from coal. In 1860 the amount of coal burned per

◄

Towing coal barges in the East River.

With a loaded barge on each hip, a boat with the stack emblem of the Tice Towing Line is eastbound passing under the Manhattan Bridge. At the time of this photograph, the tug and the rest of Tice were actually owned by Dalzell Towing, the Tice fleet was allowed to remain distinct because it engaged in coal and general towing while Dalzell concentrated on ship work. It was felt that the customer base of the two lines might be reduced if they were entirely merged. The tug is one of three sisters named *Perth Amboy 1, 2,* and *3,* all built in 1900 at Port Richmond, Staten Island, for the Lehigh Valley Railroad. All were 500 horsepower coal-fired steam. They were quite narrow for their ninety-six-foot length, which is characteristic of railroad tugs, particularly those built at the turn of the century. The photograph was taken in August, and three of the tug's crew sit on the rail just outside the engine-room door. Two more crew members relax on the foredeck. Photograph by John Vachon, August 1947, Special Collections, Photographic Archives, University of Louisville.

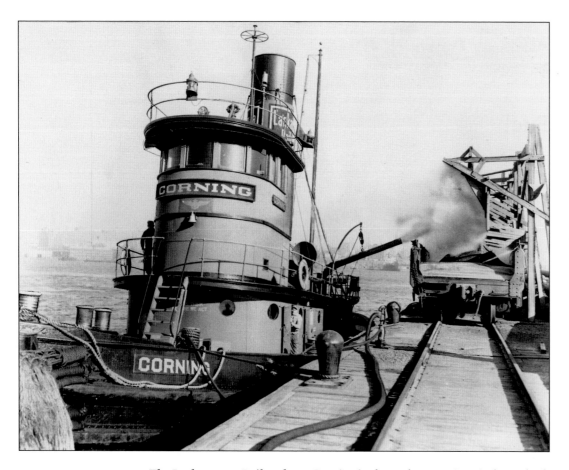

The Lackawanna Railroad tug *Corning* is shown here getting cinder and ash vacuumed from her ash pit. A modified rail car is used to collect the debris. The day-to-day care of a coal-fired steam tug such as the *Corning* was a costly and time-consuming business. Coal had to be loaded and ash removed every few days. Water was required every day, and stoking the boilers required the constant labor of at least one man. Husbandry of the engine itself required another set of engineers and oilers. Conversion from coal to oil-fired steam reduced crew, labor, and expense considerably; but the advent of the diesel engine interrupted the move toward better efficiency in steam power. Library of Congress, Prints & Photographs Division, *World Telegram & Sun* Collection.

hour to produce one horsepower was 4.5 to 5 pounds. The introduction of the compound engine in the 1870s reduced hourly consumption to about 2.25 pounds. A steady increase in boiler pressure from 60 to 80 pounds reduced this figure to 1.8 pounds. By the 1890s, development of the triple-expansion engine and boiler pressures of 160 pounds brought consumption down to 1.5 pounds per horsepower per hour.[4]

Still, coal had to be hand shoveled to the boilers. A tug of 1,200 horsepower might consume twenty tons a day. Then, the residue of ash and cinders had to be hauled back up on deck to be disposed of. Because of the endless unpleasantness of this labor, firemen were difficult to keep on the job. Every operating company was plagued by the nearly constant search for replacements for firemen who walked off the job or failed to show up for work.

Petroleum offered a solution to many of these difficulties, as well as a host of other advantages. However, between the time of its discovery and its acceptance as marine fuel there was a relatively long period of development. The first industrial use of petroleum was in the form of kerosene for illumination. It had been imported to the United States from Europe since the 1850s, but after the discovery of oil around Titusville, Pennsylvania, in 1859, kerosene was produced at refineries in Cleveland, Ohio, and around New York City. By 1861 it was being exported globally from America, packaged in tin receptacles, and transported mostly by sailing vessels. This "case oil" trade was the mainstay of John D. Rockefeller's Standard Oil Company through its entire formative period, with no other petroleum products providing significant markets or revenue.

Around the Caspian Sea, where in the late 1870s the Baku oil fields supplied most of Europe's petroleum, some of the residue left over from kerosene production was used as marine fuel.[5] But there was no concerted effort to develop oil as a fuel until about 1897. At that time Standard Oil experimented with the New York tug *White Rose* to learn how best to burn oil in what had

been coal-fired boilers.[6] The British-owned Shell Oil Company was also experimenting seriously with oil at this time; and both companies recognized that their future viability depended on expanding the market for oil into as many industries as possible. Another strong incentive for these two companies to develop the use of fuel oil was that newly discovered crude-oil resources in Texas and in Borneo (where Shell was the principal developer) were of a type that yielded little high-quality kerosene but could be used as boiler fuel without any refinement.[7] Both companies understood that the transportation of this crude oil to their refineries would be most economical if their tank ships were able to burn the same material that they were carrying.

With the introduction of electric lighting by Thomas Edison in 1882 the kerosene business began to dwindle. Almost simultaneously the introduction of the motor car sparked the ever-increasing production of gasoline that has continued unabated to this day. Even by 1929 fully 85 percent of American refinery production was gasoline and fuel-grade oil, while kerosene production had dropped to a negligible amount.[8] For most land-based industrial purposes coal remained the fuel of choice in the United States until after World War II, when the development of the Venezuelan fields brought huge quantities of fuel-grade oil to the Americas, while at the same time the nearly constant disruptions of supply brought on by John L. Lewis and his United Mine Workers convinced most industries to abandon coal for good.

As a marine fuel, however, oil won much quicker acceptance. Although heavier grades of oil required heating to make them less viscous, all grades could be handled entirely by pumping. Pound for pound, even the poorly refined fuel oil available in 1902 provided one-third greater energy than coal. Furthermore, compared to coal, twice the weight of oil could be stored in a given storage space. If a ton of the original steamboat fuel, pine wood, was replaced by 890 pounds of coal, that same coal was now replaced by 445 pounds of oil. There was no more shoveling,

no more cinders, no more ash. In coastal tugs the number of firemen could be reduced to one per watch, and in smaller vessels firemen could be eliminated altogether. The steaming range of vessels was more than doubled, and harbor boats that previously had been obliged to coal up every day could take on fuel every week or so.[9]

Although the long-term advantage of converting from coal- to oil-fired boiler systems is obvious, the immediate capital cost of conversion made it prohibitive for most operators. In a 1943 inventory of all tugs in the New York/New Jersey port and in New York State generally (including Great Lakes and canal operators), there were 580 tugs listed.[10] Of the 422 steam vessels, 279 were still operating on coal, 96 were oil fired, and the remaining 47 did not specify fuel type—though most of this group was probably coal fired, since an operator who had gone to the expense of converting to oil fuel would likely take pains to advertise the fact. The New York Central Railroad converted its entire harbor fleet to oil-fired boilers in the early 1920s, while other marine rail lines—particularly the Lehigh Valley, the Baltimore & Ohio, the Central Railroad of New Jersey, and the Delaware, Lackawanna & Western, all of which trafficked heavily in coal—had not converted to oil-fired boilers at all. The Pennsylvania Railroad operated a mixed fleet of twenty coal- and three oil-fired steam tugs.

Of private companies, Gowanus Towing, Dalzell, Tracy, and Carroll were four that as of 1943 operated entirely on coal. Companies such as Tice, Moran, McAllister, Red Star, and Russell operated mixed fleets while attempting to convert to diesel. Conners, which operated mostly among the state canals, and Ira S. Bushey, a very prominent builder as well as an operator of tugs, had entirely diesel-powered fleets.

The retrofit of a tug from coal to oil required installation of tanks, piping, pumps, and fuel-heating systems. The old firebox doors had to be replaced with oil spray and forced-air burner assemblies. The conversion was fairly complicated and involved

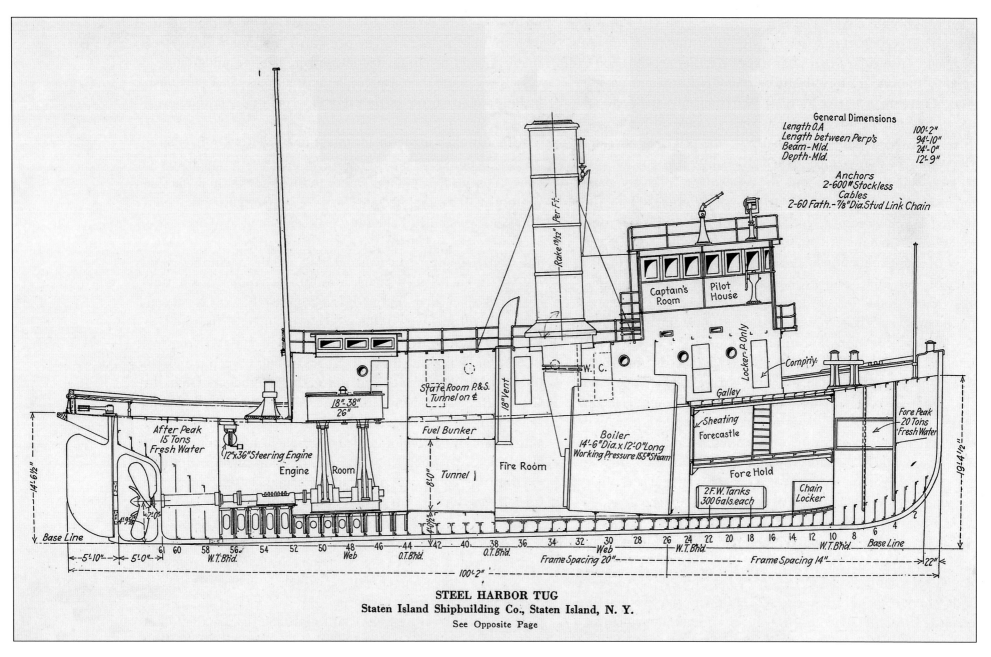

STEEL HARBOR TUG
Staten Island Shipbuilding Co., Staten Island, N. Y.
See Opposite Page

Shipbuilding Cyclopedia, 1920, Science, Industry, and Business Library, New York
Public Library, Astor, Lenox, and Tilden Foundations.

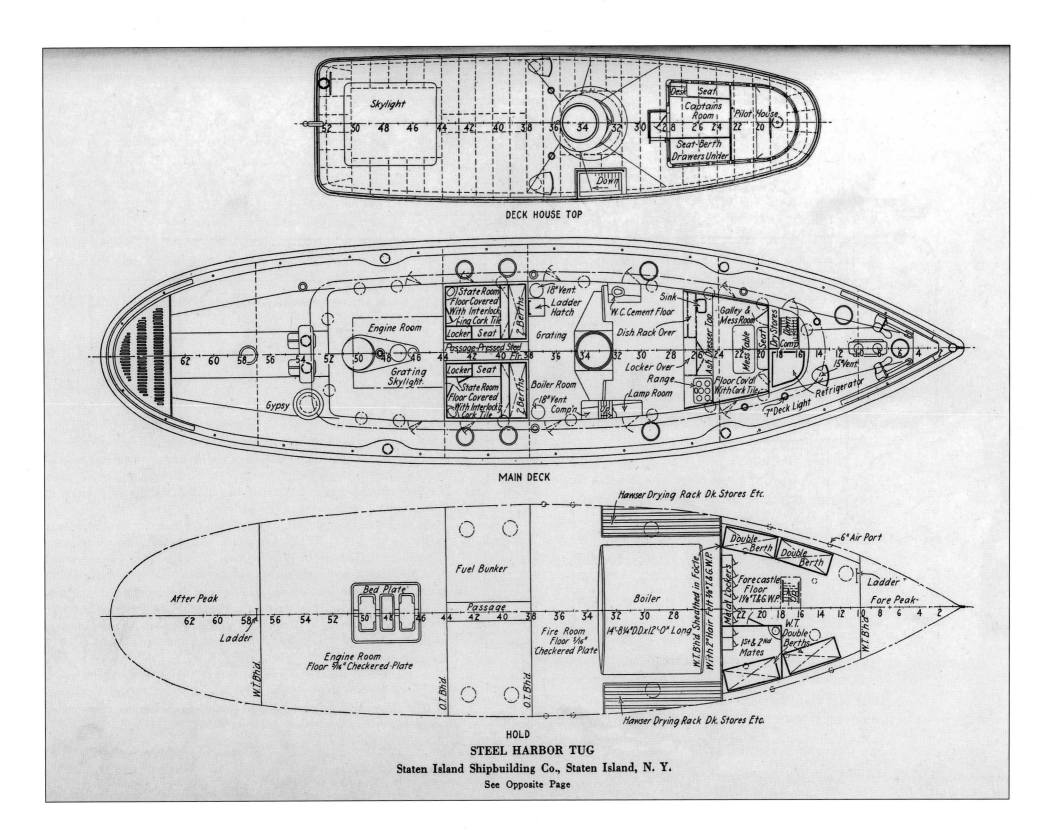

DECK HOUSE TOP

MAIN DECK

HOLD

STEEL HARBOR TUG

Staten Island Shipbuilding Co., Staten Island, N. Y.

See Opposite Page

considerable expense, which for tugs not constantly active might not be justified. Conversion to oil was easiest for boats under construction, and those operators who were prosperous enough to build new boats were thus doubly favored by their ability to provide themselves with more-efficient oil fuel. Conversely, the less prosperous operators—unable to afford either conversion or new construction—were put at an even greater disadvantage. This predicament was similar to the one in the 1870s in which companies made the switch from side-wheel to propeller boats. A very few years later the same predicament appeared again, with even more pronounced effect, when the diesel engine rose to dominate the industry.

★ On the Hip

The method of towing a vessel by securely lashing it alongside the tug is often referred to as towing "on the hip." There are two schools of thought about the origin of this term. The first is that the wide stern corners of a barge might be referred to as its "hips"; thus, towing "on the hip" would mean that the tug is secured to the hip of the barge. The other theory is that "hip" refers to the widest point on the tug, just about one-third of the distance back from the bow, which is precisely where an alongside tow normally rides—like a baby riding on a mother's hip.

To "make up" to a tow involves putting out three lines between the barge and the tug. The first is generally called the strap and leads aft from the side bitt on the rail of the tug just forward of the pilothouse to a mooring point on the rail or stern corner of the barge. If the tug always handles the same barge or barges with exactly the same configuration of mooring points, this strap will often be made up as either one very heavy line or a lighter line doubled up and eye spliced at both ends; that way the tug will always come to the same position alongside the barge when the line is put out. Once the strap is secured between tug and barge, the tug works ahead at low to medium power to stretch the strap tight. At the same time, the helmsman angles the tug so the bow is pressed as closely as possible into the side of the barge while the stern of the tug is angled away.

With the tug angled in this way, and still working ahead, the second line is put out. Called either the head line or the backing line, this line runs forward from the stem post of the tug to a mooring point on the barge. The line is pulled in by hand and secured to the stem post, and then the helmsman puts the rudder over the other way so the bow of the tug rocks away from the barge while the stern swings in. By this means, the head line is stretched tight.

Esso Tug No. 2 **tied to an oil barge pushes through New York Harbor. In this photograph the tug has its barge on the hip, and much of the relationship of tug to barge is apparent. A doubled line extends forward from the stem post of the tug to the barge. This is the head line, which does most of its work when the tug is trying to wrestle the barge into a turn or, more importantly, when the tug backs down to stop the tow. For this reason the head line is often referred to as the "backing line."**

The next line aft is also doubled and runs aft from the forward quarter bitts of the tug to the rail of the barge. It is through this connection that the power of the tug is transmitted to the barge. This line is sometimes referred to as the "strap," particularly when the line is cut and spliced to conform exactly to the dimensions of a specific tug and barge.

Far back on the barge, the stern line can be seen. This line is the last to be put out. The tightening of it, either by hand or by using the tug's capstan, brings the other two lines under tension, locking the tug solidly in place alongside the barge.

The tug heels noticeably away from the barge. This is because, to hold a straight course, it is necessary for the tug to steer away from the heavy barge by as much as fifteen to twenty degrees of rudder angle. Photograph by Harold Corsini, September 1946, Special Collections, Photographic Archives, University of Louisville.

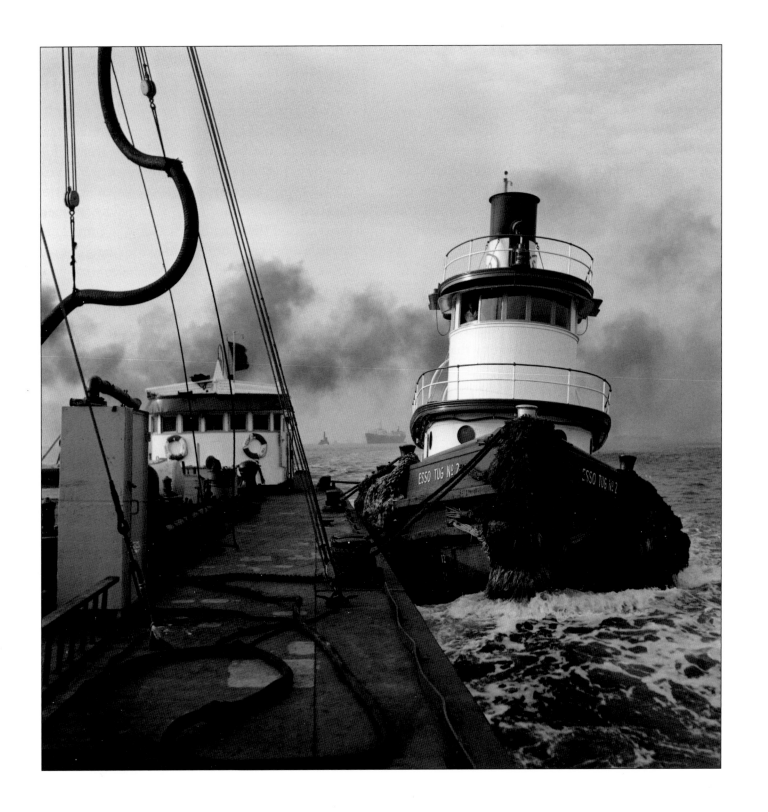

Still working ahead with the stern of the tug pressed as closely as possible into the side of the barge, the third line is put out from any one of the bitts or cleats on the stern of the tug, directly across to a mooring point on the stern of the barge. This last line is called the stern line, and it is really the key to successfully making up to a tow. The tension on the stern line (the force with which the stern of the tug is pulled toward the barge) determines how much tension is applied to the backing line; and the tension on the backing line maintains the tension on the strap. If the stern line is loose, the backing line will be loose, and so the strap will be loose. If everything is loose, the tow will lurch around when the tug tries to maneuver it, making it more or less unmanageable. Also, by allowing the tug and barge to gather contrary momentum relative to each other, it is likely that loose lines will break. On tugs equipped with power capstans on the stern deck, the stern line is often hauled in tight by that means. Without a capstan, the deckhand can get the line tight by having the helmsman turn the tug sharply away from the barge so the stern swings in with extra force, the line being taken in and then made fast just as the swing reaches its closest approach.

When made up properly alongside, the point of contact between tug and barge is right in the area of the side bitts, and the bow of the tug is pointed right at the forward corner of the barge. Thus, the barge is laid slightly diagonal to the centerline of the tug. The tug should also be positioned so its stern sticks out slightly aft of the stern of the barge; that way the tug's propeller and rudder are not hampered by water turbulence caused by the hull of the barge.

Depending on the size, weight, and shape of a barge made up in this way, there is a greater or lesser tendency for the barge to divert the tug toward the side that the barge is made up on. Angling the barge diagonal to the centerline of the tug corrects this tendency somewhat, but whatever wayward force remains must be controlled by the tug's rudder. To maintain a straight course the tug must steer *away* from the barge alongside. A light, well-shaped barge might require only a couple degrees of rudder to keep it on course. A heavily loaded or boxy tow might require twenty or thirty degrees of counter rudder.

The path that is followed by the tug and its barge alongside is never exactly the line described by the centerline of the tug. Rather, it is a vector resulting from the forward thrust of the tug, modified by the sideways drag of the barge. In extreme cases the actual line of advance might be deflected by as much as forty-five degrees toward the side that the barge is carried on. The helmsman of the tug must learn to ignore the centerline of the tug as his steering orientation and instead discover what course the combined tug and barge are actually making. This can be determined by very careful scrutiny of the visual field ahead. Fixed shore points will move to the left or right depending on which side of the true course line they lie on. Sometimes the tug and tow will be discovered to be making their way crab-like down a difficult channel, requiring extreme care and attention to keep them from getting into trouble. A difficult situation such as this can usually be corrected by choosing a different method of towing, gate lines or pushing ahead, which will offer far greater steering control.

The virtue of towing alongside under normal circumstances is that the tug and barge are entirely wed, and turning, stopping, and accelerating can therefore be done with precision. Although the overall width of the make up is much greater than it would be in a hawser or pushing situation, the overall length is considerably less, which can be an advantage in some situations.

One disadvantage to towing alongside is that any sort of rough sea conditions will cause the tug and barge to clash and will put excessive strain on the lines. Thus, a tug towing alongside in exposed waters must be constantly alert for any change in the weather that would require it to shift its tow onto the hawser. To delay making this change for even a few minutes in worsening conditions can lead to serious damage to lines, vessels, and crew.

It is customary to tow with the barge secured to the port side of the tug whenever possible. This practice stems from the requirement in the rules of the road that vessels—tugs included—keep as much as possible to the right-hand side of any channel. Because the barge alongside often more or less obstructs the helmsman's view, it is thought best to favor as much as possible his view of the right-hand margin of the channel ahead. This enables him to keep himself as far over to the right as possible, making available the greatest possible amount of open channel for vessels coming from the opposite direction. By carrying the barge on the port side, the tug may also protect itself somewhat from damage to its lines from the waves caused by vessels passing on the other side of the channel. The barge, particularly when it is loaded and deep in the water, will act as a very effective breakwater, minimizing strain and damage to the tug and its lines.

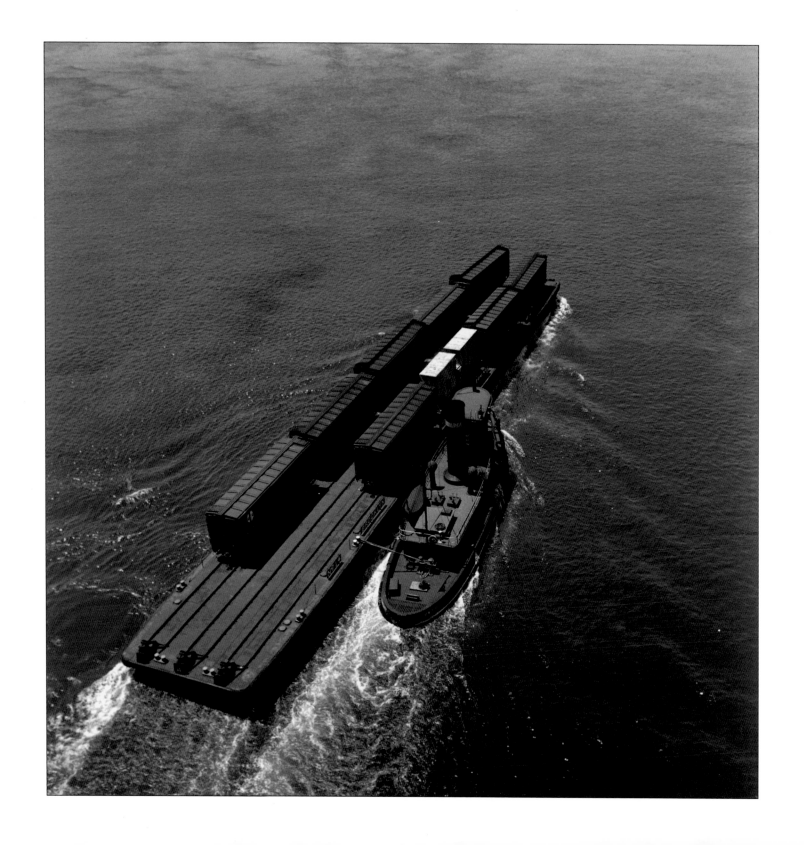

14

The Railroads

Tug towing car float in the East River.

The tug *Integrity*, ninety-five and a half feet long and rated at 450 horse-power, belonged to the Brooklyn Eastern District Terminal Company (BEDT); it has one of that same company's car floats alongside. This is a transfer float, equipped with three sets of track and capable of carrying seventeen cars. This type of float was used for transferring rolling stock from the trackage of one terminal to another. BEDT was located in Greenpoint, Brooklyn, and served as a shore terminal for delivery of trunk-line shipments to local factories and warehouses.

Note that the tug is made up alongside the float at almost its midpoint. This is the normal practice in towing car floats. With most other scows and barges it is customary when towing alongside for the tug to secure itself well back on the barge so that the tug's rudder and propeller are clear astern of the barge. To make up to a car float so far aft would leave so much of the barge projecting out ahead that it would be quite difficult to accurately control. Photograph by Esther Bubley, July 1947, Special Collections, Photographic Archives, University of Louisville.

The economic genius of New York City was founded on water. Natural connection to the sea, to the Hudson, and to the myriad coastal sounds gave the city its start. The subsequent construction of canals—the Erie, the Champlain, the Delaware & Raritan, the Morris, and the Delaware & Hudson—extended the reach of New York's waters far into the most productive regions of the nation in the early nineteenth century. Manhattan and its sister city, Brooklyn, were both served almost exclusively by water transportation; and through the age of sail and the advent of steam they prospered mightily because of it.

But, even as marine commerce was perfected, another force was gathering. Since 1812, John Stevens, along with his numerous advances in steamboat technology, had been toying with the possibilities of railroad locomotion. He had a little circular railway set up on the flat land below his Hoboken estate, where he tinkered endlessly, selling off bits of New Jersey to finance his obsession. He peppered the legislatures of New York, New Jersey, Pennsylvania, and Virginia with proposals for railroads until in November 1831 the Camden & Amboy Railroad was inaugurated. The line employed the British-built locomotive *John Bull* in service between the east bank of the Delaware River, opposite Philadelphia, and South Amboy, New Jersey, at the mouth of the Raritan River. The situation of the railroad was telling in two ways: First, its course almost exactly paralleled that of the

Delaware & Raritan Canal, a situation that became typical over time since canals and railroads both are constrained to use the most level right-of-way possible. (This constraint has always tended to lock them like spiteful conjoined twins in aggravated competition.) Second, though the ultimate objective of the Camden & Amboy was to establish a freight and passenger link between the cities of Philadelphia and New York, the goal could not be accomplished without a ferry connection across the Delaware River and, at the other end of the line, a steamboat ride of about twenty-two miles around Staten Island to Manhattan. The relative inaccessibility of New York City to direct rail connection became key to the later history of the harbor, its railroads, and its tugboats.

The late-nineteenth-century emergence of New York as the preeminent center of American commerce—both domestic and international—was a snowballing phenomenon. The more it grew, the more attractive it became. And the more it grew, the more essential it became for outlying industries to be connected to it. The railroads, far and wide, forged those connections. In 1841 the Erie Railroad established a marine terminal at Piermont, just south of today's Tappan Zee Bridge. The Erie shuttled its freight and passengers from Piermont to New York by water until it eventually established a direct rail connection to Jersey City in 1852.

Forty years later, when the Reading Railroad established a major coal terminal—Port Reading—on the Jersey shore of the Arthur Kill behind Staten Island, there were eleven major lines holding waterfront connections around New York: the Central Railroad of New Jersey, the Erie, the Lackawanna, the Pennsylvania, the Lehigh Valley, the Long Island, the Ontario & Western, the Baltimore & Ohio, the Reading, the New York, New Haven & Hartford, and the New York Central. Only one of these, the New York Central, held freight-bearing track that reached Manhattan itself. All the rest terminated at yards ranged around the harbor, separated from Manhattan by water. The majority lined the Jer-

sey waterfront from Edgewater to Bayonne, with other facilities along the Harlem River in the Bronx, in Bay Ridge in Brooklyn, on Staten Island, along the Arthur Kill, and at South Amboy. Measured individually, each railroad company's impact on the harborside was considerable; in aggregate their impact was enormous. The acreage of railroad sites plus their inland connections and classification yards made their combined footprint easily the largest industrial entity in the metropolitan region. One result of it all was to make an equally significant footprint on the harbor.

By the midpoint of the nineteenth century, immediately after the Civil War, the island of Manhattan and the East River frontage of Brooklyn were largely built out. Factories, warehouses, and grain, coal, and produce terminals all elbowed for space along the cities' combined waterfront while the railroads eyed these potential customers from the far Jersey shore. For each railroad company to establish extensive shore facilities within the cities' limits would have been exceedingly expensive, both for the initial land acquisition and in the long run for real estate taxes. Furthermore, most of the businesses the railroads hoped to serve already occupied exactly those waterfront properties that the railroads would have had to acquire and demolish to establish full-scale shore facilities. It quickly became apparent that the most efficient means of access to the cities' commerce was to rely on the waterways, just as marine commerce had in the century before. Rather than laying down track, the railroads set to building ferries, lighters, barges, derricks, and tugs to form a combined marine establishment remembered today as the "Railroad Navy."

The earliest methods of transfer between railroad and floating equipment was effected simply by the manual unloading of the contents of railroad cars into ferries, steamers, or barges. These vessels then transported the goods and passengers to their destinations around the harbor. The destination might have been the marine terminus of another railroad line, at which the goods would be reloaded onto railroad cars and sent on their way cross-

country. Or the destination might have been a ship taking on export or coastal cargo. Or it might have been a waterfront factory or warehouse. At these various destinations the goods were once again handled ashore, piecemeal. Obviously, the double handling of railroad freight around the harbor was both costly and inefficient.

The solution to the problem was to devise a means of transporting the railroad cars themselves on the water, right to their waterfront destinations, where they could either be reinstalled on land rails for through-shipment or else loaded or unloaded directly at the factory, warehouse, or shipside. The origins of this method stem from the Civil War, when Union quartermasters were called on to bring locomotives and rolling stock from the North to replace the Confederate equipment that had been either destroyed or withdrawn behind enemy lines to avoid capture. Empty railroad cars were carried South on the decks of merchant schooners and steamers while the much heavier loaded cars and locomotives were transported on ponderous catamarans cobbled together from two canal barges, joined side by side with heavy timber trusses. These contrivances were towed mostly to City Point and Aquia Creek, Virginia,[1] and there wrestled ashore by means of makeshift overhead gantries. Though the system lacked the sort of efficiency necessary for commercial application, it at least pointed the way toward further development.

Credited with that development is John H. Starin, who in the latter half of the nineteenth century rose to become the leading marine entrepreneur in the United States.[2] Born in upstate New York in 1825, Starin first studied medicine, then operated a drug store in Fultonville, New York, and attempted to market a line of patent medicines including Starin's Renovating Powders for Horses and Cattle, which he advertised for sale through his father's butter and cheese export business, M. W. Starin & Co., located in the city at 209 Duane Street,[3] in an area still known as the "butter and egg district." In 1856, at age thirty-one, Starin

John Henry Starin (1825–1909) created a comprehensive nautical empire in New York Harbor that encompassed every aspect of harbor transportation. Tugs, barges, lighters, grain elevators, excursion boats, and ferries were combined into a seamless network of commerce. His most singular achievement was the development of a system for marine transportation of railroad cars. The car float and the land-to-sea bridge systems necessary for safely moving rail cars on and off the water were his indelible contribution to the supremacy of the harbor for the century spanning the 1860s to the 1960s. Library of Congress, Prints & Photographs Division, LC-BH832-31687.

moved to the city and, probably as an adjunct to his father's business of bringing dairy produce from upstate, began to deal with the transportation of harbor freight. It soon became his passion; and that passion, combined with the booming transportation demands of the Civil War, became his life's reward.

Starin's principal business entity was the Starin City, River and Harbor Transportation Line, which provided lighterage services to the New York Central, the Morris & Essex, the Delaware, Lackawanna & Western, and the Central Railroad of New Jersey, as well as to a multitude of other customers. By the 1880s Starin operated a fleet of about 130 tugs, lighters, steamers, and barges and also operated a huge excursion business, particularly to his picnic resort at Glen Island in New Rochelle, New York. He was twice elected to the U.S. House of Representatives and was frequently coaxed but never induced to run for governor of New York on the Republican ticket. By the time of his death in 1909 he had sold out most of his marine interests, particularly his railroad lighterage operations, which were bought lock, stock, and barrel by the Lackawanna Railroad in 1904. But Starin's enduring contribution to harbor commerce long outlived him; described in his 1909 *New York Times* obituary as the "Starin System," it was a method of integrating rail and marine operations, a system that continues in vestigial form even today.

Central to Starin's system was the car float, a barge fitted with standard railroad tracks onto and off of which entire strings of cars and, when necessary, locomotives could be easily rolled from land across gangways, called float bridges, which could be quickly and safely locked onto the end of the car float during the transfer. The car floats were of two basic types. Interchange (sometimes called "transfer") floats were built large enough to carry as many as twenty-two cars on three parallel sets of tracks. Up to 360 feet long, these barges were very heavily built and when fully loaded were ponderous indeed. They were used for transporting cars between the harbor rail terminals of the various

A New York, New Haven and Hartford [*sic*] transfer tugboat moving a car float up the Harlem River.

This is the tug *Johnson City* and the car float number 4745, both belonging to the Erie Railroad. They have just entered the Harlem River at its north end, coming from the Hudson River through the railroad swing bridge at Spuyten Duyvil, then under the Henry Hudson Parkway Bridge, visible in the background. The photographer has apparently stationed himself atop the cliff that today has the huge letter C painted on it by enthusiasts of Columbia University.

The barge is a station float, designed to be positioned alongside a ship or at a warehouse or factory wharf so that freight may be loaded directly into or out of rail cars. The covered walkway down the centerline of the float is built to match the height of boxcar doors so that goods can be easily moved by cart or by hand truck. Ramps can be rigged to allow movement of goods ashore; or, if cargo is to be hoisted onto a ship, a flat car is included on the barge so that cargo can be moved down the walkway to the flat car, where the ship's hoisting gear can reach it.

Standing at the front of the barge is a floatman. He has helped to guide the tow through the Spuyten Duyvil bridge by giving hand signals to the captain of the tug. These signals do not tell the captain what to do so much as to confirm to him that his maneuvering is having the desired effect. For instance, to counteract a strong current it might be necessary to steer the tug and barge directly at the bridge structure until the very last minute. The floatman in this situation, seeing the tow headed for a collision, would signal the captain to steer away. This would be confirmation to the captain that the barge was shaped up as he wanted it. In the situation shown in this photo, with only one boxcar on the float, the captain has good visibility and therefore does not need the floatman's help so much. If the barge were fully loaded, however, the captain would be able to see very little and would have to rely on the floatman for a safe passage. In some cases, when the height of a barge severely restricts the helmsman's view, the captain turns the helm over to the mate and then goes out onto the front of the barge, where he can relay steering commands back to the pilothouse by hand signals or, nowadays, by hand-held radio. Photograph by Gordon Parks, December 1946, Special Collections, Photographic Archives, University of Louisville.

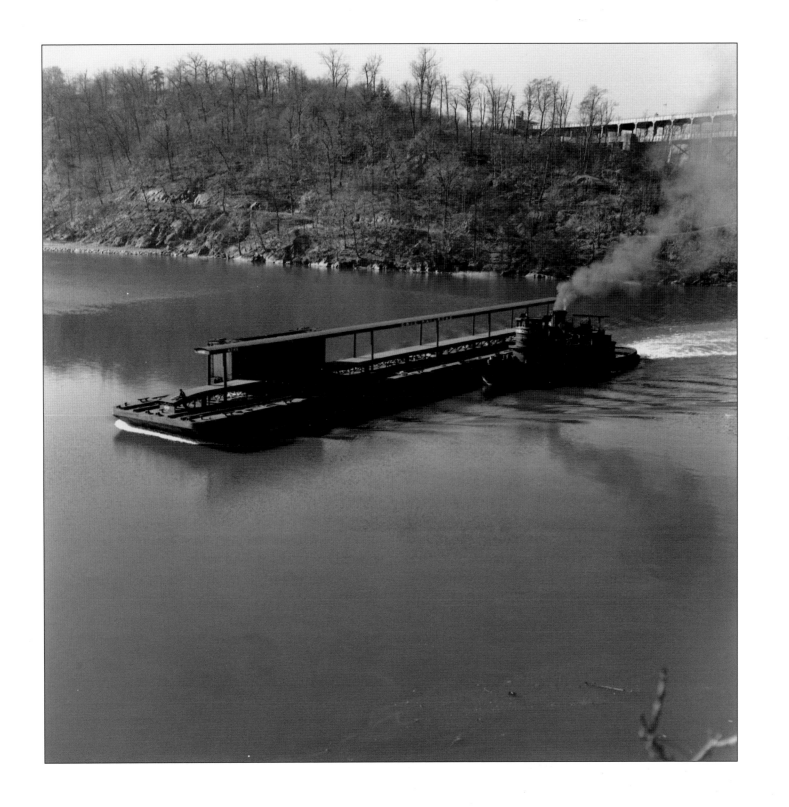

trunk lines for through-shipment. The largest proportion of this traffic was performed by the New York, New Haven, and Hartford Railroad from its terminals in the Bronx and, after the completion of the Hell Gate Railroad Bridge in 1918, from Bay Ridge, Brooklyn. Even in 1954, when harbor railroad traffic was in decline, the New Haven floated close to half a million rail cars at the very modest cost of $2.74 per car.[4]

The second basic type of car float, called a station float, might be sized to hold as many as twelve or as few as six cars. These floats were equipped with two sets of tracks, separated by a roofed-over platform running the length of the barge. The deck of this platform was set to conform to the height of the rail-car doors so that goods could be moved by hand truck into and out of the cars. Station floats loaded with railroad cars were typically towed early in the morning to a warehouse or factory along the waterfront. Gangways were rigged from the platform directly into the shoreside building. Cargo was handled in and out during the day, and then the float was towed back to the railroad yard the following night. There, the cars were rolled back ashore and sent on their way.

Station floats were also used to bring rail freight to ships in the harbor by securing the float to the side of the ship away from the pier at which it was docked. An empty flat car was included among the boxcars on the float so that the ship's cargo booms had a clear space to pick up or land the freight being transferred. This method greatly increased the efficiency of loading and unloading ships in New York because both sides of the ship could be used simultaneously and because the pier alongside which the ship was docked would be far less congested with goods awaiting loading. Furthermore, railroad goods destined for a specific ship could be conveniently stored by the carload in the Jersey freight yards and sent to the ship at the most convenient time at whatever pier it might be docked, rather than having to be stored for long periods in Manhattan warehouses in anticipation of the ship's arrival.

The result of this system was that any piece of freight could be efficiently transferred between carriers and customers, whether domestic or foreign, at minimum expense of money and time. By 1937 the normal daily interchange and pier-station traffic of railroad cars around the harbor was about fifty-three hundred.[5] This amounts to an annual traffic of almost two million cars. During World War II, the Department of the Army recognized that New York Harbor had a priceless and totally flexible system of connections between every railroad, every pier, and every ship. It proved to be the crown jewel of the country's wartime transportation system.

A survey of railroad facilities around New York Harbor in the years 1926 to 1930, compiled from several sources, shows an astonishing accumulation of equipment and services. There were no fewer than forty pier stations where float-borne rail cars were loaded and unloaded. There were seventy-five lighterage piers where "less than carload" freight was handled. There were more than fifty-seven float bridges where cars were rolled on and off the water. For handling foodstuffs there were ten milk stations through which fresh upstate milk flowed into the city, six poultry yards, four stock yards, and six massive grain elevators. For the delivery of coal there were thirteen piers, most of which were equipped with huge McMyler car dumpers, which could pick up an entire rail car and pour its seventy-one tons contents directly into the hold of a ship or barge.

The fleet of vessels serving this establishment was also vast. A small number of self-propelled lighters—about thirty-five—were used for moving relatively small items of harbor and export freight, usually objects of higher value such as machinery or mail. Everything else was transported by barge. At the end of the 1920s there were 389 car floats, 385 floating derricks and hoist barges, 687 covered barges including heated and refrigerated barges and dry-storage grain boats. There were 62 other barges for miscellaneous or specialized purposes. Added to this was a fleet

of about 2,500 coal barges that were privately owned by coal wholesalers because they were as much used for inexpensive waterborne storage of the coal as for its transportation from the rail terminals to customers. These 6,800 passive freighting vessels were all dependent on the motive power of tugs.

During the period between 1926 and 1930 there were about 146 railroad-owned tugs operating in New York Harbor. Some were designed as shifting tugs, intended for the transportation of scows, canal barges, and derricks and not much different from the legions of eighty- to ninety-foot non-railroad-owned tugs in the harbor. Quite distinct, however, were the tugs designed specifically for handling car floats. The most obvious feature of these tugs was the raised pilothouse. The height of a standard boxcar is seventeen feet, and the height of the car float off the water is about six feet. Thus, if the tug operator is to see over his tow, he must have a height of eye of about twenty-four feet, which is four to six feet greater than what would be needed for a tug of similar size engaged in nonrailroad work. New York car floats were always towed alongside, so the tugs carried heavy guards down the length of their sides with plenty of fenders hung outside of these. The tugs were built with relatively less overall width so that they were somewhat flat sided and thus able to lay close against the car float and so that when transporting two floats—one on each side of the tug—the resultant V or plow shape of the entire configuration would not be so wide as to diminish the speed of the tow or by its sheer size make it a danger to other harbor traffic. The tugs designed primarily for moving single car floats were between 100 and 110 feet long and were equipped with compound engines of about 500 horsepower. The boats intended for towing paired floats or for work into and out of the East River, where adverse currents would be encountered, were slightly larger and equipped with up to 1,200 horsepower.

The greatest volume of interchange rail-car traffic in the harbor was carried by the New Haven Railroad. The New Haven's aver-age number of cars transferred to and from the other harbor lines grew to two thousand per day by 1912.[6] Because of this high volume of traffic and the distance separating its facilities from the rest of the harbor, the New Haven Railroad was the first to tow pairs of car floats as a general practice. In June 1895 they commenced transiting the length of the East River between Hell Gate and the Upper Bay with tugs of only 600 horsepower, each towing a pair of car floats—one on each side of the tug. The bows of the floats were lashed together so that the overall configuration was that of an immense V, with a relatively small tug jammed bow first into the notch, like a small pig stuck between the jaws of a large alligator. Although there were dire warnings that this practice would result in mayhem in the narrow confines of the East River, the experiment proved successful. In fact, the double-float configuration was in some respects more manageable than that of single-float tows because the resistance of the float against the thrust of the tug was rendered symmetrical when the tug had a float on both sides. Though the double tow was much larger and slower, its overall steering qualities were improved.

Generally, car floats were and still are considered to be tricky vessels to tow. Extremely long and narrow, and very heavy due to their elaborate internal stiffening, they most resemble a great iron javelin and if improperly handled may well have a javelin's effect. It takes relatively little power to get them moving and a long time to get them to stop, and anything that gets in their way is done for. They are very responsive to small changes of course but go into a frightful sideways drift if muscled into a turn. With delicate, attentive guidance they are a pleasure to work with. If abused, they turn vicious. Towed on the hawser, they are even more unmanageable. They are quite as happy to be going sideways as head-on and can range far out to either side of the tug's wake, sometimes running ahead at a slant until they are almost neck and neck with the tug. It is possible to control a car float somewhat by adjusting the towing bridle so that one leg of it is

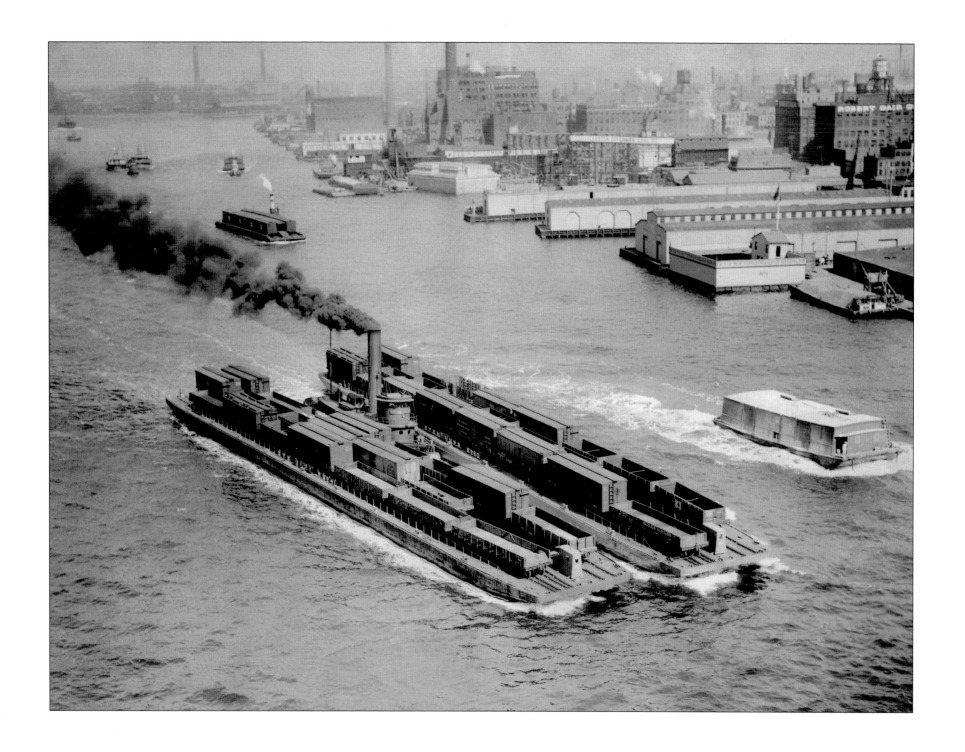

slightly shorter than the other. This tactic causes the tow to hang over to one side of the wake instead of swinging wildly to left and right, but even this device is not enough to pacify a car float so that it is towable in anything other than wide-open waters.

A remarkable feature of the entire lighterage system built up by the railroads was that it was operated at no cost to rail customers. Any piece of freight, whether one package or a dozen boxcars—provided that it had originated at a distance from New York or was bound from New York to a rail destination 150 miles distant—was handled free of charge by the marine department of the railroad to which it had been consigned. In other words, freight was transported gratis either by the carload or by the piece, either by car float, by barge, or by self-propelled lighter to or from any waterfront location or shipside within what were called the "free lighterage limits" of the Port of New York. Every railroad, every waterfront factory and warehouse, every shipping pier, every ship at anchor in the Upper Bay, and every one of the small off-line railroad terminals along the Brooklyn shore were equally and freely interconnected. This arrangement gave the Port of New York a strong advantage in trade during the last half of the nineteenth century and the first half of the twentieth.

In June 1895 the harbor community was alarmed to learn that the New Haven Railroad planned to commence towing pairs of fully loaded car floats the length of the East River from the company's principal terminal in the South Bronx to the terminals of the other trunk-line railroads in Jersey. Chaos and mayhem was the general expectation as these tremendous tows threaded the narrow and congested stream. Soon, the practice became routine, though still impressive, as this photograph demonstrates.

In the near background on the Brooklyn shore can be seen the granite pier from which the steel tower of the Manhattan Bridge was soon to rise. Closer to the camera, sporting a flag pole, is moored one of the Municipal Salt Water Baths. Mariners Museum, Newport News, Virginia.

The origin of the free lighterage system can be traced to a number of sources. One is the perpetual competition between the railroads and all other forms of inland marine transportation. Canal, Hudson River, and Long Island Sound freight arriving in barges, steamers, and canal boats at New York could be quickly and inexpensively distributed to points anywhere in the harbor. To successfully compete with this inland marine transportation network the railroads were under pressure to minimize their own lighterage fees. The businessmen of the Port of New York had always jealously protected the efficiency of port operations, whether by the simplification of the work of the U.S. Customs office, the reduction of insurance costs and port fees, the reduction of waterfront corruption, the arbitration of labor disputes, or the police protection of shipping and cargo. The Grinnells, Lowes, Minturns, and Howlands were all quick to petition, to committee, and as a last resort, to summon the mayor to insist that business be allowed to flourish.

J. P. Morgan was among the last of these oligarchs, and he took a keen interest in the railroads. He and his mostly British clients were heavily invested in railroad stocks and increasingly annoyed by the self-destructive manipulations and excessive competition of the different operators. He called them together and bullied them into accepting a consolidation of effort, particularly in the Port of New York, whereby the efforts of each individual rail company would be expended toward furthering commerce and industry in general, with the expectation that cooperation and efficiency would ensure greater profit than endless bickering.[7] The system of free lighterage is a logical result of the spirit of consolidation demanded by Morgan.

Another strong argument for free lighterage in New York Harbor was that the city's chief competitors in rail-based commerce and export, Philadelphia and Baltimore, enjoyed direct rail access to their principal waterfront destinations and thus were not obliged to provide any lighterage services at all. By 1882 the

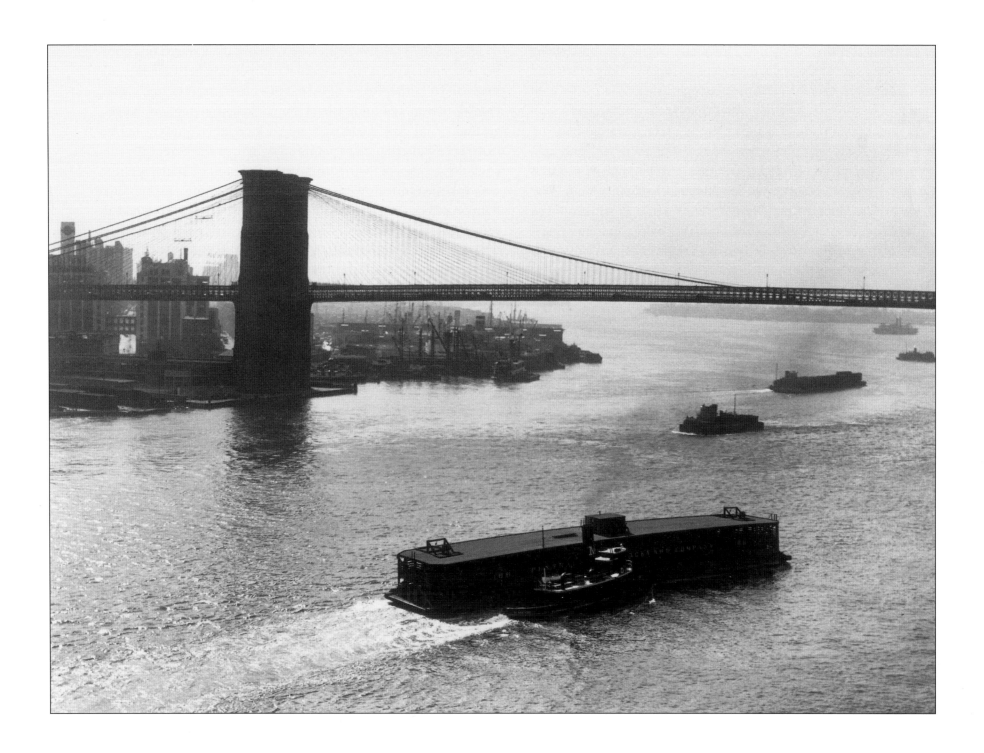

problem of port costs, particularly those associated with railroad lighterage, had become a matter of concern to New York business interests as well as to the editors of the *New York Times*.[8] By the mid-1890s, the editors noted, it had become a common practice for vessels to discharge their cargoes at New York but then to leave the harbor empty to load cargo at Boston, Philadelphia, Baltimore, and Norfolk, simply to avoid New York's port costs. Export freight, "having once arrived at Jersey City by rail cannot be transferred to shipboard without undergoing the tedious and expensive course" of lighterage. If New York was to remain competitive with the other East Coast ports, there would have to be a change in the way business was done.[9]

But the ultimate force that created free lighterage was the genius of another of the great American plutocrats, Cornelius Vanderbilt. The competition of the canal, river, and coastal lines might have put some pressure on the railroads and J. P. Morgan might have belabored the railroad men with hard logic and inducements, but it was Vanderbilt's great creation—the New York Central Railroad—that forced the hand of the other lines. Through decades of careful construction and acquisition, Vanderbilt's New York Central Railway had positioned itself as the controlling force in the New York Harbor rail system, with the greatest measure of its control lying in the fact that it alone had

View of the East River and Brooklyn Bridge looking toward Brooklyn from the Manhattan Bridge.

A Moran tug conducts a cattle barge westward in the East River, bound around the Battery toward one of the Jersey rail yards. The double-decked barge is empty, having discharged its live cargo into the slaughterhouses located in Newtown Creek. The development of railroad facilities around the harbor allowed the importation of abundant fresh agricultural produce, livestock, and dairy products, which greatly relieved the ill effects of urban poverty and overcrowding. Note the density of shipping among the piers fronting Brooklyn Heights just past the bridge. Photograph by Esther Bubley, October 1946, Special Collections, Photographic Archives, University of Louisville.

direct track access to Manhattan. By its exclusive route down the east bank of the Hudson River the New York Central possessed the least expensive means of access to the city and was therefore always in a position to charge the lowest rates, rates that all its competitors were obliged to match. In July of 1895 the competitors established a policy of free lighterage from the Jersey side of the Hudson to the Manhattan side and from the Battery to 135th Street.[10] With this move they announced as a group that they would absorb the extra cost involved in water transportation as a means of staying competitive with the Central.[11]

The next year the Free Lighterage Limits were extended to cover the Bayonne waterfront. In 1905 the limits were extended to the Harlem River and the Bronx, which brought the New Haven Railroad into the deal, and a few months later the entire length of the Jersey waterfront from Communipaw, directly behind Ellis Island, north to Fort Lee and the site of the present-day George Washington Bridge. Finally, in 1908 the limits were extended one last time to include the entire New York Bay and Staten Island, bringing the entire expanse of New York Harbor under the free system.[12]

Although the railroads had at first used outside contractors such as Starin, New Jersey Lighterage, and National Storage to perform their lighterage chores, the shift to the free system put increasing pressure on the trunk lines to bring their marine operations in-house. If the service was to be provided to customers free of charge, then the costs of the service had to be minimized. During the period from 1925 to 1930 the rate charged by the major towing companies in the harbor was $12.50 per hour.[13] The railroads were able to perform their own towing at an average cost of $8.47 per hour.[14] During this same period the railroads were hiring outside towing companies to perform whatever work their own equipment could not cover. In 1930 the railroads hired out towing services amounting to 27 percent of their total towing costs.[15] It is not known exactly what hourly rate the railroads

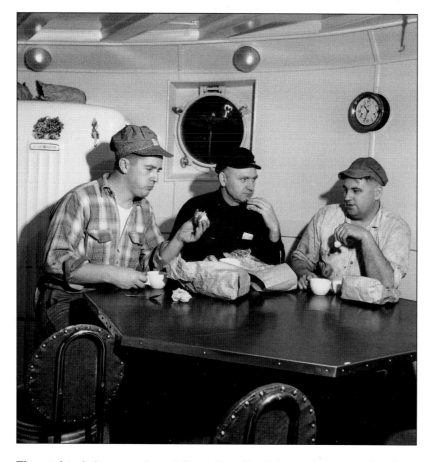

The night shift crew aboard *Esso Tug No. 7* bring their own lunches, because there is no cook on duty at night.

Many company-owned tugs, those belonging to the railroads in particular, operated on day and night shifts, with no crew living aboard full-time. In fact, the great majority of railroad tugs were built without any sleeping quarters at all. Photograph by Sol Libsohn, November 1947, Special Collections, Photographic Archives, University of Louisville.

offered these outside contractors; but, given the fact that the railroads could always threaten to use their own equipment if the contractor did not provide a favorable rate, it is a reasonable certainty that they were able to chisel their subcontractors' towing rates down considerably.

Except for a handful of tugs that specialized in round-the-clock towing of coal barges, railroad tugs were not fitted with living quarters. Crews worked twelve-hour shifts, which afforded the companies the flexibility of operating either one or two daily shifts as the assignment of a particular boat might demand. Shifting tugs and the smaller transfer tugs generally carried a crew of five during the day: captain, deckhand, cook, engineer, and fireman. If they also worked a night shift, they would add a second deckhand in lieu of the cook. The larger boats followed this same arrangement with cooks and deckhands but carried a second fireman at all times, bringing their number to six. When a car float was to be left at a remote location, the tug brought along a floatman, who worked as a deckhand with the tug's crew on the trip out and then remained on the car float as a watchman.

The employees of the railroads' marine departments enjoyed the same union representation as did other nonrailroad harbor employees: the National Organization of Masters, Mates and Pilots of America (AFL); the National Marine Engineers' Beneficial Association (CIO); and the International Longshoremen's Association (AFL).[16] Around the year 1914 the day captain of a Pennsylvania Railroad tug was paid $145.75 and the night captain $143.10 per month. Day engineers received $134.10 and night engineers $128.25. Firemen day and night received $75.80. The day and night deckhand was paid $69.95, while the cook or the night deckhand who replaced him was paid $64.15 per month. Each man of the crew paid the cook twenty-five cents per meal for provisions, while the company provided the kitchen facilities and fuel for the stove—the same coal as was fed to the boiler.[17] At this time, fully 30–40 percent of the self-propelled vessels work-

ing in New York Harbor—tugs, lighters, and ferries—were railroad owned. Therefore, the percentage of the members of the various marine unions whose employment stemmed from the railroads was roughly the same.

Railroad activity in the harbor remained strong through the Depression and boomed during World War II. During the immediate postwar period most of the railroads sought to modernize their equipment by building steel barges and diesel-powered tugs; but the demise of the Railroad Navy had already begun. The development of the modern tractor-trailer truck, the interstate highway system, and containerized cargo handling, along with the general increase in labor costs and the exodus of manufacturing from Manhattan and Brooklyn, all conspired to knock the underpinnings out from the East Coast railway system. Shipments of grain ceased. Coal was replaced by petroleum as the fuel of choice. Free lighterage was abandoned at the end of the 1960s, and when Conrail finally took over the entire decrepit system in 1976 its first move was to discontinue any remaining marine activity.

Today, there is a last vestige of car-float activity between Greenville, New Jersey, and Bay Ridge, Brooklyn. The New York Cross Harbor Railroad Company maintains a set of float bridges and a small fleet of car floats that still trundle back and forth across the harbor on an indifferent schedule, carrying mostly Long Island garbage and incinerator ash to the mainland. The floats are towed by hired tugs, none of which resemble the design of the traditional railroad tug.

★ On the Nose

Of the various methods of making up to a vessel to be towed, pushing or putting it "on the nose" is the most efficient. The bow of the tug is positioned as close as possible to the centerline of the barge's stern. Then lines, preferably wire, are run from each side

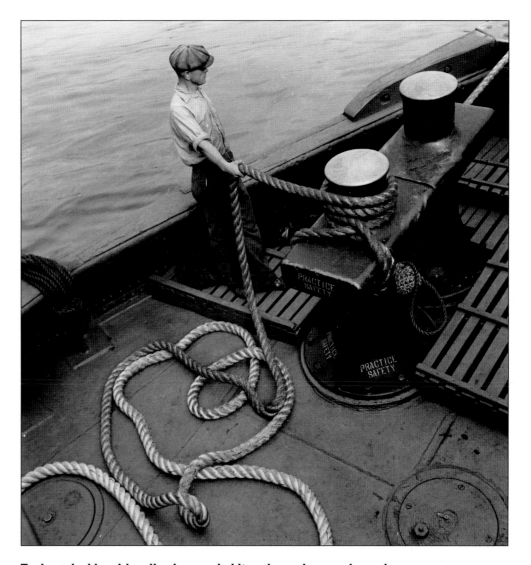

Tugboat deckhand handles hawser holding the tugboat to the tanker.
Photograph by Harold Corsini, August 1948, Special Collections, Photographic Archives, University of Louisville.

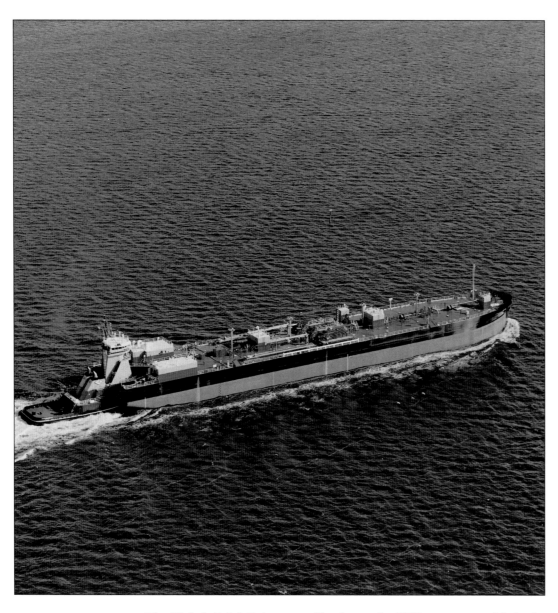

The *Nichole Leigh Reinauer* and her barge, the *RTC 135*, on sea trials in the Gulf of Mexico. The *RTC 135* is 460 feet long, 72 feet wide, and when fully loaded it carries 143,900 barrels of petroleum at a draft of 28 feet 6 inches. The tug is 124 feet long, 40 feet wide, and 21 feet draft. She has two engines capable of delivering a total of 7,200 horsepower. Thigpen Photography, Inc.

of the tug's stern to the corresponding corners of the barge. The wires are drawn tight usually by a power winch installed for this purpose or by the general towing winch to which the wires used for pushing ("face wires") are temporarily rigged. To prevent the bow of the tug from slipping out of position and in case one of the face wires should fail, safety lines are rigged from the stem post and forward bitts of the tug. The goal is to make the connection between tug and barge as rigid as if they were one unit. Because the barge is directly ahead of the tug, the whole steers reliably without the complications inherent in towing alongside. Because the tug and tow are married end to end, they share a greater waterline length than if they sailed separately. This affords a considerably greater potential for speed, thus saving time and fuel.

The distinct advantages of pushing a tow have led to constant development of methods to make it possible in a greater range of sea conditions. After the introduction of wire rope and machinery to assure the tension of the face wires, ever-greater advances have been made to ensure that the bow of the tug is securely attached to the stern of the barge. At first, tugs were fitted with push knees that would reliably bear on the flat stern of a barge. Tugs were designed exclusively for pushing, their bows truncated to present a broad, flat surface to the stern of the barge. These push boats have achieved their fullest development on the Mississippi River and its tributaries, while on both the East and West coasts they have been less developed, mostly because they are far less seaworthy than conventional hull forms.

Most of the development of pushing technology on coastal waters has involved the attachment between the bow of the tug and the stern of the barge. The first major step was the construction of a notch in the stern of the barge into which the bow of the tug could fit. This device both allowed a much sturdier connection and reduced the overall length of the tow by the depth to which the bow of the tug was buried in the notch. The stern notch of the barge has reached its greatest sophistication as a device for

ensuring a strong connection in rough seas. Today, tug and barge combinations as large as full-sized ships are traveling the coast in all weather conditions without ever having to resort to hawser towing. These "articulated tug and barge" (ATB) combinations are married together by massive hydraulically activated pins set in the bows of the tug. These fit into pockets on each side of the notch and result in a perfect attachment of the two—able to travel in almost any weather.

The move to large-scale ATB systems is not only because of navigational and safety considerations. Tugs and barges have always been subject to far simpler construction and manning requirements than have conventional ships, so any arrangement that allows a vessel to be defined as a tug and barge rather than a ship under U.S. regulations vastly reduces its construction and operating cost, particularly the number of crew it is required to carry. This wrinkle in the law has resulted in a few so-called tugs that are so ungainly when not married to their barges that they are barely able to traverse a sheltered harbor in flat calm. Furthermore, the perpetual marriage of a tug to a single barge violates one of the basic efficiencies of tug and barge operations, namely, that the tug, which generally represents the bulk of the capital outlay of a barging operation, can shift off to other profitable employment while its barge is idle or held in port for loading and unloading.

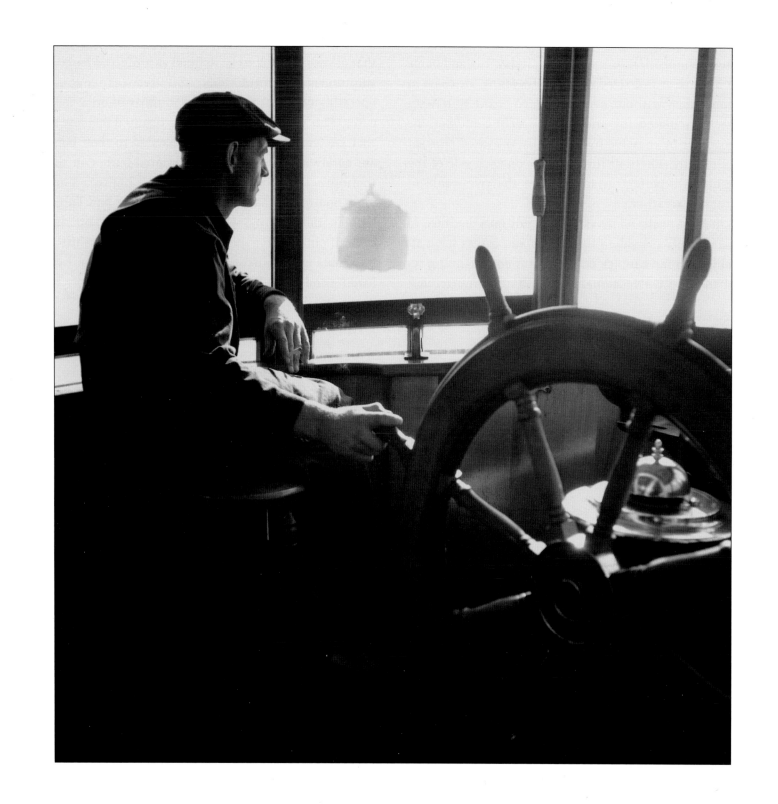

15

Trust and Honor:
The Rescue of the *Dalzelline*

The night of January 20, 1917, was long and dark.[1] The moon was in its thinnest phase, and in any case, it had set over Block Island Sound just a short time after the sun had gone down. The weather was good—clear with a light northeast wind and only a slight haze to limit visibility. During the late afternoon of that day the tug *Dalzelline* lay at the New Harbor in Block Island. She had just delivered the barge *Lee* there and was ready to return light to New York. Owned by Dalzell Towing Line, the tug had been under charter to Lee & Simmons Lighterage Company, owners of the *Lee,* for the tow out to Block Island but was manned by her regular crew of Dalzell employees including her captain, a man by the name of Nolan. At about 5:40 p.m. the *Dalzelline* got underway. Her departure coincided, not by accident, with the beginning of the flood tide, which would speed her back into Long Island Sound.[2] By the same calculation, Captain Nolan expected the ebb tide to meet him later the following day in the far end of the Sound and from there to carry him proudly through Hell Gate and the East River. It was a good and time-honored plan.

Nolan plotted a course into the Sound by way of Plum Gut, a narrow passage between Orient Point, Long Island, and Plum Island. The Gut, narrow and fraught with current, is infrequently used by tugs with tows and never recommended to one without excellent local knowledge; but for a light tug on a clear night the

Captain Carl Aslaksen at the wheel of the *Esso Tug No. 8* acting as relief skipper. Photograph by Sol Libsohn, November 1947, Special Collections, Photographic Archives, University of Louisville.

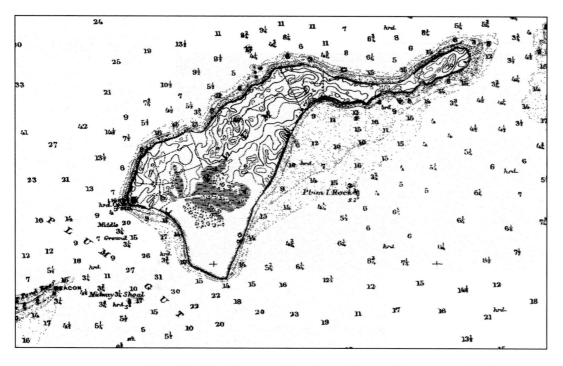

Plum Island, as it appeared on charts of 1891. Plum Gut, on the far left, was the *Dalzelline*'s goal as she entered the area from the far right. Alas, she ran ashore just inside the buoy marking Plum Island Rock, midway down the island's rocky south shore. (The water depths offshore are measured in fathoms—units of six feet—while closer to shore, in the shaded areas of less than three fathoms, the measure is in feet.) The tug came to rest near the ten-foot spot close inshore. During the first salvage attempt she was abandoned on the seven- to nine-foot shoal lying offshore. Later that night the gale drove her ashore again but farther to the southwest, where the beach is sandy and deeper close to shore. National Oceanic and Atmospheric Administration [NOAA], Historical Map and Chart Project.

passage through the Gut was not a serious risk, and it shaved several miles off the voyage.

Midwinter in New England is a difficult time for mariners. The days are painfully short and the nights oppressively long. The weather is often harsh and always changeable. On board a vessel working around the clock, fatigue sneaks aboard unnoticed and may before long be in command. Three hours later the

Dalzelline was running along the south shore of Plum Island. The man on watch in the pilothouse at the time, probably Captain Nolan, identified the low land off his bow as the approach to the Gut. He may also have sighted a buoy ahead that he thought would lead him into the narrow passage. He changed course about forty-five degrees to the right and within five minutes found himself spindled, flooded, and hard aground on the boulder-strewn shore of the island a good mile and a half east of his assumed position. The easy run back to New York was over, and a very different voyage was about to begin for the *Dalzelline*.

The grounded tug was one of nine boats owned by Dalzell. It was fifteen years old, having been built in 1902 as the *Samuel E. Bouker* for the White Star Towing Line. Ninety-two feet in length, built of wood, and powered by a single-cylinder steam engine of about 300 horsepower, its primary use, as with all of the Dalzell boats, was as a ship-docking tug in New York Harbor. Its insured value was $25,000, and both by its dollar value and its work potential it represented a major asset of the Dalzell Towing Line.

On Plum Island there was a U.S. Army coastal-defense battery named Fort Terry. The fort was equipped with a powerful searchlight used to identify vessels entering Long Island Sound. A sentry had seen the *Dalzelline* run ashore, and the searchlight was quickly brought to bear on the wreck. A motorboat was sent out from the fort, and soon the crew had been taken off the stranded tug, except for Captain Nolan, who insisted on remaining with the vessel, trying perhaps to atone for his lapse and thus salvage a little dignity from what would probably be the wreckage of his career. As soon as the motorboat returned to the fort, telephone calls went out to Frederick B. Dalzell, the towing line's president, in New York and to the T. A. Scott Company, one of the principal salvage companies on the East Coast, conveniently based only a few miles away in New London, Connecticut. Dalzell and Scott were in direct communication because it was agreed between

them that Scott would attempt to rescue the tug on a "no cure, no pay" contract. Given the pressing need for quick action, the agreement was an entirely verbal one but bore within its understandings a wealth of integrity and tradition. By midnight Scott's salvage tug, *Alert,* was headed for Plum Island.

The "no cure, no pay" arrangement under which Scott's services were arranged is based on the experience that salvage is a difficult and unpredictable adventure, the goal of which is the preservation of whatever of value may remain after a calamity has occurred. If nothing is saved—if there is no cure—then there is nothing of value with which to compensate the salvor. Conversely, from the value of what is saved, the salvor is entitled to a share. Because it is impossible to predict what of value the salvage may preserve, it is not productive for the parties involved to negotiate payment in advance. The compensation to the salvor is determined after the fact through mutual agreement, through arbitration, or if neither of these means is successful, through the courts.

The legal document most often invoked in matters of salvage is known as Lloyd's Open Form. This venerable contract, originated by London's Society of Lloyd's in the early 1890s, is a simple document by which all parties interested in the salvage of a vessel or its cargo agree to let the rescue operation begin immediately, with a clear understanding of the process by which fair compensation will be made afterward. The agreement establishes that a panel of Lloyd's appraisers or a panel appointed by them will assemble an entire account of the salvage—its danger, its difficulty, its efficiency, and its resultant savings to the owners— and come up with a suitable reward to the salvor. In a case where the salvor's work was brief and uncomplicated, the reward might amount to little more than what would be normal hourly charges for towing or basic marine services. In a case where the level of danger and difficulty was great and where the likelihood existed that everything of value would have been lost but for the extraor-

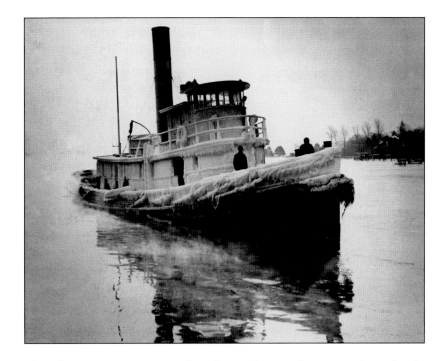

The *Alert* returns to New London after a winter assignment. Ninety feet in length, she was built at New London in 1913 and disappeared from the register in 1924. Photograph by Robert Beattie, Steven Lang Collection.

dinary enterprise of the salvor, the award of the Lloyd's panel may be far greater. (In modern times there is no such thing as "finder's keepers, loser's weepers" in salvage law. Any vessel or cargo, whether it has been sunk for a hundred years or aground for only a moment, is still the property of its owners or its insurers; and whoever salvages that vessel or cargo must reach an agreement regarding compensation.) Because the Lloyd's Open Form is simple and well known, it has become the basis of most salvage operations and is customarily agreed to verbally by all parties so that work can begin before documents are produced and formally signed.

By daylight next morning, January 21, the *Alert* had located the *Dalzelline* and put its salvage master aboard by rowboat to

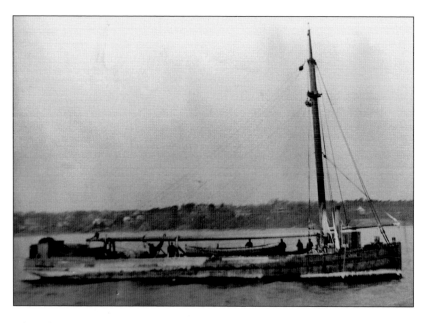

The salvage barge *Addie & Carrie* is shown here at anchor on a winter day. Built at City Island in 1884, this vessel served the T. A. Scott Company for many years and was acquired by the Navy during World War I. Despite her mundane appearance, she is a fairly sophisticated vessel. Equipped with a very sturdy mast and long cargo boom, which is shown here stowed horizontally, the barge was typically brought alongside a stranded or sunken vessel and used by the salvors as an all-purpose base of operations. Forward of the mast can be seen the stack of her steam boiler, which powered the boom, the barge's anchor windlass, and its powerful pumps. The short boom projecting forward from the mast was used for handling anchors. Stowed on deck is an oar-powered surfboat of about twenty-four feet, and farther back toward the stern is a smaller dory. A crew of six men is visible on her icy deck. U.S. Naval Historical Center.

assess the situation. Captain Nolan, who by now had had a few hours to himself on board the wreck, promptly requested that the rowboat deliver him to the beach, which was done. Nolan hung around Fort Terry for the next day or so. On the morning of January 22 he was chastised by the salvage office for not making himself available on board the *Alert*. By January 24 Fred Dalzell's son,

Freeland, who was sent up to observe the salvage operation, reported to his father that he had been obliged to search for the erstwhile captain and crew in downtown New London. There is no further mention of Nolan or the crew.

The salvage master, Captain Goodale, was more effective. Once aboard the stricken tug, he sent his men in the small boat to sound out the water offshore to locate the many off-lying boulders and to find a possible route for extracting the tug from the shoals. He had Fort Terry call the Scott offices in New London to send him the lighter *Addie & Carrie* in tow of the shoal-draft tug *Harriet*. By afternoon the reinforcements arrived, and the lighter had worked itself alongside the *Dalzelline* with pumps and a diving crew on board. By about 4:00 p.m. the divers had fitted patches on the several leaks, and the tug was pumped out and afloat on the rising tide. The *Alert*, which had been standing by offshore, then moved in as close as possible so that a five-inch-diameter hawser could be passed to the *Dalzelline*. It was almost dark by this time. The wind had come in strong from the southeast, and it had started to snow.

With a rising sea, both the *Dalzelline* and her rescuers were now getting into real danger. The *Alert* took a strain on the hawser, but it quickly parted—probably from snagging on one of the many submerged boulders that obstructed the shore. The smaller tug *Harriet* then moved in as close as possible and succeeded in passing another line—six-inch this time—and both she and the *Alert* started to haul the *Dalzelline* off the beach. The earlier soundings taken from the rowboat had discovered a sandbar about half a mile offshore with a depth of about five feet of water at low tide. Now with the tide high they might expect eight or nine feet. The *Dalzelline*, with a draft of eleven feet, was sure to run aground on this shoal; but the salvors hoped to drag her across just as they had dragged her off the beach. Unfortunately, she did not get over the bar, but stuck fast. With the tide now dropping, the sea and the blizzard steadily building, and the

rescue vessels themselves occasionally pounding on the bottom, Captain Goodale ordered the rescue suspended. The little salvage fleet ran for shelter, and the *Dalzelline* was left to the mercy of the storm.

Any tug—indeed, any vessel—may be employed in salvage operations. In fact, the majority of salvage events are probably performed by ordinary vessels that just happen to be in the right place at the right time. For example, a cargo ship loses power and drifts toward a dangerous shoal; a passing tug rushes to it, throws it a line, and hauls it out of danger, just like *Little Toot* in the famous children's story.[3] Or a modest fire is extinguished by the fire hoses of an available tug. Or a small boat, sinking, is pumped out; it may not even make the papers. These are all tasks that most tugs can readily perform and quite often do. But what of the really heavy-duty stuff?

Though eminently useful, an ordinary tug is only a sturdy boat, designed to be maneuverable and capable of pulling and pushing efficiently. It is designed to be only as seaworthy as its intended service requires. Thus, there is a hierarchy of tugboat classes ranging from those intended only for the most sheltered inland waters, which may more resemble some sort of amphibious potato harvester than a boat, through the various degrees of harbor, coastal, and seagoing tugs, culminating in the salvage tug. This last is a specialized type, but it comes directly from the traditions of towing.

The salvage tug is designed and equipped to meet all eventualities. In addition to its basic towing gear it comes with masts and booms strong enough to transfer heavy equipment back and forth between itself and its patient. Below decks it has storerooms where all manner of repair and pumping equipment is stored. It is equipped to handle divers and to fight fires. Perhaps its most unique feature is that it is equipped with extraheavy anchors, chain, and windlass. To rescue a stranded vessel a salvage tug typically sets out its anchors so that it can hold a position as close as

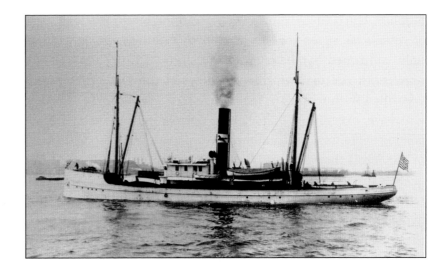

Built in 1907 at Wilmington, Delaware, the salvage tug *Relief* was the flagship of the Merritt & Chapman fleet. Emblazoned on her stack is the company's trademark, the black galloping horse that symbolizes the early days of American salvage when coast lookouts patrolled East Coast beaches on horseback. She is a large and elaborately equipped vessel. Her 185-foot length and 1,600 horsepower gave her excellent seakeeping and towing ability. A radiotelegraph antenna stretches between her topmasts, allowing her to remain in communication from almost any place in the world. Cargo booms fore and aft and a full array of workshops and stored equipment below deck permit the *Relief* to arrive at a salvage scene and remain until the job is done. U.S. Naval Historical Center.

possible to the wreck but still at a safe distance from the shore. It then passes a towline to the stranded vessel and endeavors to pull it off by a combination of the forward thrust of its engines and a steady hauling back on its anchors. The vast incremental force of the windlass added to the power of the tug's main engine provide the steady pull necessary to break a stranded vessel out of the sand.

Indeed, the vast majority of salvage work performed in the early days of New York Harbor involved the recovery of ships, passengers, and cargo cast on the Long Island and New Jersey

beaches. Until the advent of radio communications the distress of vessels far at sea was never known, and their loss at sea was only confirmed by their failure to return. During most of the nineteenth century the shipping news of the New York papers was filled with reports of incoming ships having passed floating wreckage, overturned hulls, and, occasionally, survivors. The reporting captains were careful to describe any identifying features of the debris that they encountered, even if it was only the color of the capsized vessel's bottom, in the hope that these small details might put to rest the terrible uncertainty of vessels long overdue. The term "*lost* at sea" had a particular and poignant meaning in the days before distress calls and satellite-based emergency beacons. Few vessels in distress in the open ocean received any outside assistance. They either survived by their own efforts or they disappeared. Thus, as a practical matter, there was no such business as high-seas salvage or rescue towing. The business of what we today call salvage was then known as "wrecking," and it was conducted along the shore—where the wrecks were.

The coastal approaches to New York from Montauk, Long Island, to Cape May, New Jersey, are an unbroken stretch of sandy beach. The only bit of rock to be found in the entire 210-mile expanse are the Shrewsbury Rocks, a small reef just off the Navesink Highlands within sight of Sandy Hook. Vessels going aground on this gradual coast were offered a possibility of survival denied those striking a rock-bound shore. Prompt assistance either from rescue vessels or from lifesavers on shore could retrieve a ship from the surf before it began to break up or, failing that, at least permit the safe transfer of crew, passengers, and valuable goods to shore. By the early 1850s the New York underwriters began to formalize the use of steam tugs in rescue and wrecking operations. In April 1852 Russell Sturgis contracted with six underwriters to have two boats, each the equal of the *Achilles*, available for wrecking services.[4] In November 1853 the Submarine Wrecking Company was incorporated under the auspices of the Commissioners of Underwriters; and in April 1860 the underwriters formed the Coast Wrecking Company.

Captain Israel J. Merritt was put in charge of the Coast Wrecking Company. He had served as an agent for the underwriters at the site of disasters for many years, and under his direction the company developed into the leading salvage firm in the United States. By 1880 Captain Merritt had bought out the stock of Coast Wrecking and had merged his new company with the Chapman Derrick & Wrecking Company to form the Merritt & Chapman Derrick & Wrecking Company. This company prospered until 1922, when it merged once again, this time with the T. A. Scott Company of New London, Connecticut—the same firm that in 1917 was effecting the rescue of the *Dalzelline*—to form Merritt, Chapman & Scott, a vast enterprise that conducted marine salvage and heavy-lifting work on the East Coast while diversifying into large-scale construction projects both alongshore and inland.

The T. A. Scott Company was the creation of Captain Thomas Albertson Scott, who was born in Maryland in 1830 and settled in New London about 1870, when he was hired to build the Race Rock Lighthouse at the narrow and turbulent easterly entrance to Long Island Sound.[5] After completing the lighthouse in 1878, Scott turned his attention to salvage work. Captain Scott died in 1907, and the company was taken over by his thirty-year-old son, T. A. Scott Jr. The son ran the company successfully and, also, during World War I was in charge of all government salvage work on the American coast. After the merger with Merritt & Chapman he continued as head of the new company until he retired in 1951. He died in 1961.

The rescue of the *Dalzelline* from the shore of Plum Island was certainly not the most difficult job that the T. A. Scott Company had been called to, but it still required a high level of skill and responsibility, not to mention luck. Certainly, when salvage efforts

were abandoned in the teeth of a rising gale and gathering darkness, it was anybody's guess what they would find when they returned. But to their great relief they found that the *Dalzelline*'s situation had actually improved. During the night the storm had swept the tug off the bar and cast it ashore again one-half mile to the west, this time not among boulders but onto a patch of sand. Although the storm continued all that day and made it impossible for Captain Goodale to work on the wreck, it lay comfortably where it was. That morning T. A. Scott reported to Frederick Dalzell that his tug was "away from the rocks, so I don't think there is any danger now of losing her." He failed to mention that the shift of the tug to a sand berth was the work of the storm and not of the salvage team. Dalzell asked that the Scott office call him either at work or at home to keep him abreast of the situation.

Not until two days later was the sea calm enough to get the *Addie & Carrie* back alongside the wreck. But, once there, she quickly pumped out the tug, then the *Alert* worked its way in to put a hawser on the wreck and quickly pulled it free. By evening the *Dalzelline* was secure in New London being prepared for tow down to a dry dock in New York for repairs.

But the affair was not over. The Scott Company was concerned that if the *Dalzelline* were lost during the tow to New York, or even after the repairs were complete and the tug put back in service, the loss would erase its as yet unpaid claim of $7,500, or 30 percent of the appraised value of the tug. The company sought a guarantee from the insurance adjuster to honor the salvage claim. The adjuster shot back that the operation had not involved salvage, which infuriated Scott. Eventually the adjuster was able to convince Scott that the "no cure, no pay" agreement did not actually represent salvage but, rather, an open-form contract that fully protected Scott, and that his claim was fully understood and fully covered. However, a sense of bad blood and distrust between the adjuster and Scott remained.

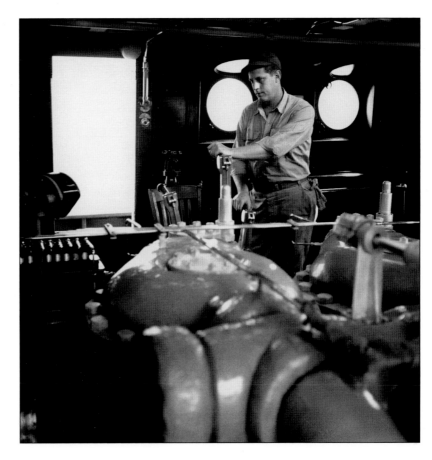

Charles Nesbitt, Chief Engineer, at engine room controls of the *Esso Tug No. 8*. Photograph by Sol Libsohn, November 1947, Special Collections, Photographic Archives, University of Louisville.

Then the underwriter entered the fray with the opinion, supplied by an independent marine surveyor, that the salvage claim was inflated and worth no more than 20 percent of the tug's value, or $5,000. Again, Scott erupted, but, interestingly enough, so did the adjuster, who quickly responded to the underwriter that first of all, the T. A. Scott Company was well known not to inflate its claims in any way and, second, if Scott and other reputable salvors were forced to negotiate terms before taking action, it

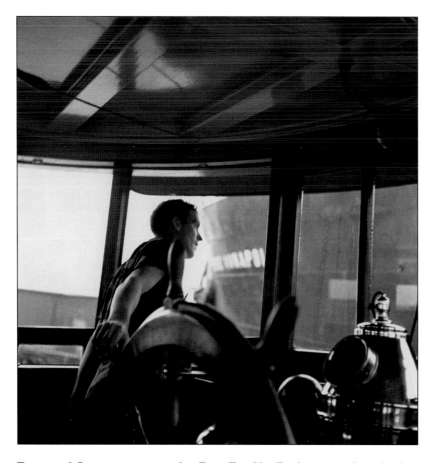

Townsend Carman, mate on the *Esso Tug No. 7*, takes over the wheel in docking operation of *Esso Annapolis* while captain Emil Leslie guides the latter from bridge by signaling tugs. Photograph by Sol Libsohn, October 1947, Special Collections, Photographic Archives, University of Louisville.

illustrates something more than the mechanical aspects of tugs, salvage, and insurance and something greater than the strengths and foibles of salarymen and seamen. The underlying currency of the entire series of events was trust and honor. A midwinter-night phone call from a remote fortress on Long Island Sound set in motion a complex series of obligations that were secured entirely by word of mouth. Dalzell and Scott achieved important understandings in brief, conclusive phone calls. The usual adversarial relationship of claimant versus adjuster and the usual alliance of adjuster and underwriter were set on their heads over a defense of the principle of the inviolability of a verbal promise. In this case it cost the underwriter $2,500, inestimably less than the value of the principle itself.

The bond of a promise has been shrugged off in much of today's business world, but in most corners of the harbor the principle that a man's word is his bond still persists. The basic measure of a boatman's conduct in business affairs is that he did what he said he was going to do. The strength of this principle likely stems from the earliest days of waterfront commerce, when agreements depended on all parties fulfilling their particular obligations even though at the time of their fulfillment they might be separated by great expanses of ocean and time. For such widespread commerce to function, a presumption of all parties' good faith and enterprise was essential.

In my own experience as a tug operator, many jobs came to me over the phone from people whom I had never and will never meet face-to-face. The voice on the other end of the line asked for a price to move a barge or floating crane from one place to another. The extent of the job might have been a brief shift from one side of a pier to the other; or it might have been a tow of many days. An agreement on a price was struck, and I performed the service, which often entailed picking the barge up at an unattended pier in the middle of the night and carefully mooring it at its destination with no one present to receive it. I sent the customer the bill, and

would be a disaster for the insurance industry (not to mention everyone else in the marine field). The underwriter capitulated, and the broker sent out the $7,500 check to Scott on January 20, 1918, eleven months after the *Dalzelline* went on the rocks.

The entire episode, an ordinary mishap, an ordinary rescue, and a routine, though somewhat tortuous, business negotiation

in thirty days or so I received my payment. Ironically, the only payment that I was unable to collect was one owed to me by a friend, who despite his failure to pay I still consider a friend—a paradox that speaks to the relative expectations of ordinary friendship compared to those of honor in New York Harbor.

⭐ Ship Work

During the nineteenth century the term used to describe the business of providing towing assistance to shipping in New York Harbor was "transport" work. The term described the escort of ships into the harbor and into their pier-side berths, as well as any subsequent movements within the harbor and, finally, their departure. The term might be better understood written out as "trans-port" since it encompassed the deep sea and coastal marine service aspect of the tugboat industry throughout the port. Today, the nineteenth-century usage of the term has been blurred into extinction by the far more general idea of "transportation" as it applies to the general regional traffic of commodities. A modern towing company that describes itself as being in the "transportation" business is undoubtedly talking about barge towing. Nowadays, the business of rendering assistance to vessels moving in the harbor is called "ship docking" or just "ship work." It is a branch of the towing business that has always possessed a degree of specialization in its methods, its economics, and its equipment. In the modern day, that specialization has become ever more distinct.

In the early days most of the towing business in New York was ship work. Sailing vessels entering from either Sandy Hook or via the East River became accustomed to accepting the services of tugs. With a great variety in the size of incoming vessels—from the largest deep-water merchantmen down to coastal schooners, river sloops, and fishing smacks—there was something for every

Two Moran tugs get into position to dock the *Queen Elizabeth*. The docking tugs position themselves according to instructions from the towing company's docking pilot, who controls the docking operation from the bridge of the ship. Photograph by John Vachon, Library of Congress, Prints & Photographs Division, *Look* Collection.

class of tugboat. The big guys ranged far out in the approaches while the smallest tugs lurked around the Fulton Fish Market. The formalities of the business were attended to by a range of characters, from the well-established towing offices of men such as Luther Adams, P. C. Schultz, and Reuben Coffin down to the various minor agents and unremembered scalpers who haunted the waterfront.

Some companies concentrated on transport work in the nineteenth century, but none dominated. The tug was still a generalized instrument, and tug operators—whether in the pilothouse or in the office—took any work presented to them. The year 1910 represents a clear divide in the industry because this was the year that Frederick Dalzell achieved his masterstroke by securing ship-docking contracts from a group of European shipping companies. This guaranteed Dalzell a specialized niche that became for many of his competitors the object of both envy and imitation. To hold on to his precious contracts, Dalzell knew that he had to excel in their performance. He built and acquired tugs best suited for ship work. Single-cylinder, noncondensing steam tugs were favored because of their simplicity and quick reaction time. He hired and trained captains and crews especially for that work and soon had the best in the harbor—so much so that when the company was finally acquired by McAllister Towing in 1964, the most coveted object in the deal was not the Dalzell boats but the combined expertise of the company's personnel.

Foremost in the ranks of expertise are the docking pilots, who accept overall control of any ship docking. The docking might involve the effort of anywhere from one to ten tugs depending on the size of the ship being docked, the conditions of wind and current, and of course, the power available in each tug. In a simple docking job, requiring only one or perhaps two tugs, often the captain of one of the tugs serves as docking pilot while the mate of that tug takes over the wheel. For more complex jobs the towing office sends a pilot who does only that work. In either case,

the pilot is put aboard the ship and from the ship's bridge coordinates the whole effort.

The basic procedure is to employ tugs at the bow and stern of the ship to turn it while the ship's own engines provide thrust in either forward or reverse. The usual problem is to bring the ship to a point off a pier and, there, to turn it ninety degrees and then insert it into the slip adjoining the pier. An adverse combination of wind and current can complicate this task tremendously, so whenever possible, dockings are scheduled to coincide with the four-daily brief periods of slack water. Even then, however, the operation is never to be taken for granted. Very reliable vessels are required. Communications between the ship and the tugs must be certain. The crews of both the ship and the tugs must carry out the orders they receive promptly and with absolute discipline.

Before radio came into use, orders were passed by whistle signals from the docking pilot to the tugs at bow and stern. The system was basically the same as the bell system employed between pilothouse and engine room. The designation of which tug the specific command was intended for was made by one, two, or more whistle blasts preceding the order. Sometimes the docking pilot used a hand whistle to direct one set of tugs and the ship's whistle to direct the other. Each signal from the bridge of the ship had to be acknowledged by the tug for which it was intended by a repetition of the command at the moment that it was executed. The tug's acknowledgment was usually sounded on a small, high-pitched whistle, usually referred to as the "peanut whistle" because it was the size and pitch of the whistle used on the carts of New York City peanut vendors. There was no provision for reverse

The **Queen Mary** is met by one of her docking tugs as she steams toward her West Side berth. As the ship approaches the pier she will slow enough for the docking pilot to transfer from the tug. Photograph by John Vachon, Library of Congress, Prints & Photographs Division, *Look* Collection.

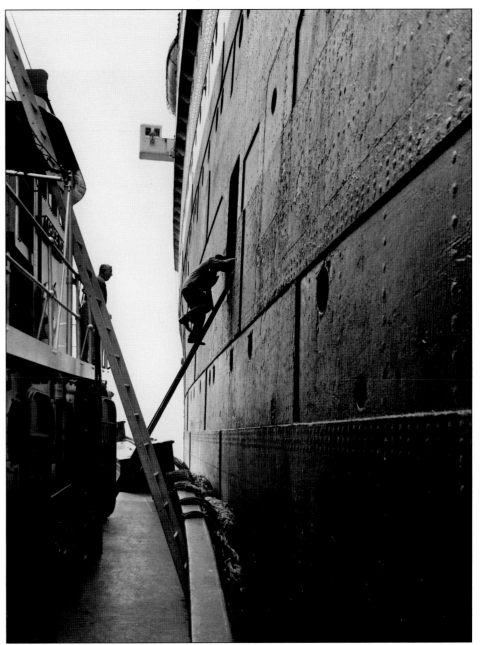

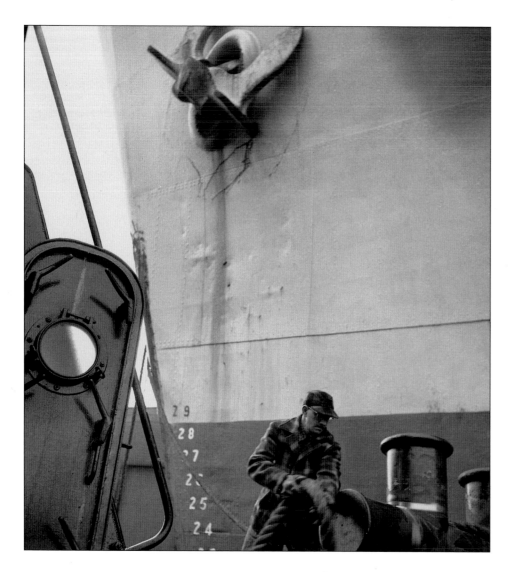

communication from the tug to the bridge of the ship except if the tug were disabled or in such danger that it could not perform its task. In this case it sounded a danger signal of four or more short blasts and left it to the pilot to figure out what to do next. Today, much of this system remains intact.

Even with hand-held radios that allow the pilot to speak directly to the captain of each tug and, theoretically, for the captain to speak back, the flow of communication remains as much as possible a one-way affair. The pilot gives an order to a specific tug and, ideally, the tug acknowledges with the peanut whistle. This reduces the risk that the tug responding over the radio will block out a subsequent command from the pilot to one of the other tugs. Even if the acknowledgment is made over the radio, it is expected to be as succinct as possible, including only the name of the tug and a repetition of the command (such as, "Seahorse, Half ahead"). The extreme abbreviation of the communications is necessary to avoid confusion. For the operation to be successful, direction must come from the judgment of one individual, not a committee. The docking pilot is put on the ship's bridge to have the best overall view of the operation—ahead, astern, and up and down both sides. The masters of the individual tugs, on the other hand, have little or no view at all. Bows pressed into the clifflike sides of the ship, they have little idea of what is going on. Their responsibility is only to do exactly as they are told.

Most often the docking tugs work with their bows against the hull of the ship. Usually a single line is used to help keep the tug in position and in case the tug is ordered to back away from the ship and pull rather than push. Here the deckhand makes the line fast to the well-polished forward bitt of the tug. During the rest of the operation he will tend the line, slacking or tightening it as the tug captain may wish and all the time alert to his own safety. A parting line may result in devastating injuries to anyone standing in the way. Photograph by John Vachon, Library of Congress, Prints & Photographs Division, *Look* Collection.

But given the abbreviated nature of the commands they are given by the pilot, the tug masters must have a great deal of experience to know exactly what those brief commands mean. "Seahorse, put two lines up next to the number two hatch, port side" does not mean much to the uninitiated, but to the tug master it tells him where to position himself along the length of the ship and, from the order to use two lines, the sort of maneuvers he can expect to be called on to perform. This allows him to get the tug into an initial position to be ready to respond promptly when the time comes. The initial command, however brief, specifies one precise action and at the same time implies a whole set of future actions that rely on the experience of the players. When this experience is absent, disaster can result. For example, one ship-assist maneuver routinely performed in the approaches to Newark Bay was for tugs to guide ships through the narrow opening of the Newark Bay Drawbridge. The customary practice was for the tugs to lay against the bows of the ship as it approached the bridge opening to ensure that it was lined up safely. The tugs backed away at the last minute before the ship entered the opening because there was not enough space to fit both the ship and a tug. On one occasion a tug had been hired that did not normally do ship-assist work and thus did not know that it was supposed to let go before the ship started through. The docking pilot had told the tug to stand by the ship's bow but nothing about when to let go. The unfortunate tug hung on dutifully and was crushed as the crew all jumped off onto the bridge fender.

Today, there are many ports along the East Coast, large and small, where there is virtually no work available to tugs other than ship docking, and even this is performed on such an infrequent basis that there is no direct economic justification for keeping a tug constantly available. Because it is in the interest of the local port authorities and of the shipping companies themselves to have tug service, tugs are often kept in standby on what

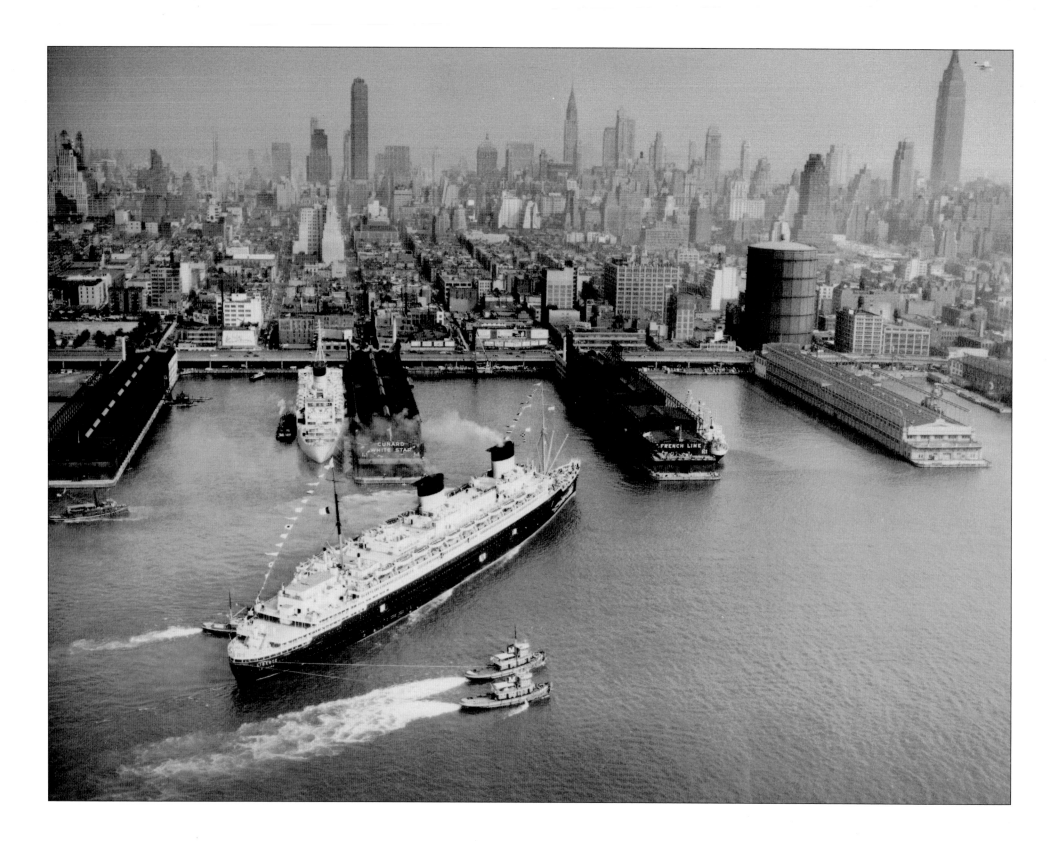

amounts to a subsidy from the local port or from the shipping company doing business to and from that port. A tower in New York may agree to keep a tug at an outlying port for the benefit of a shipping company in return for that company's ship work in New York as well. This obligation can be fulfilled either directly by the New York tower sending one of its own boats or by subcontracting the work to a local company. This sort of interconnectedness has led to the spreading out of several of New York's largest towing companies into ports up and down the eastern seaboard.

As ships have gotten larger and the cost of operating individual tugs has multiplied, the power and design of tugs has changed. Where in the past a whole fleet of small steam tugs assisted a single liner, now just one or, at most, two boats suffice. But the horsepower of either of those boats is probably greater than that of all the old steam tugs combined. Furthermore, with twin engines, flanking rudders, and now Z-drive propulsion, modern-day docking tugs can perform alongside a ship with phenomenal agility and, in spite of their high initial cost, provide lucrative service to their owners.

◄—————————————————————————

The French Line's *Liberte* moves toward her berth with the help of at least four Moran tugs—one at bow, one at stern, and two others controlling the stern with hawsers. Hawser work in ship docking was once very common in New York, but with the development of highly maneuverable twin-screw, Z-drive, and cycloidal tugs the method has almost completely disappeared there. Canadian, British, and most European tugs, on the other hand, still use hawser methods with regularity and success. Collection of the New-York Historical Society, Maritime History Collection, neg. 76793d.

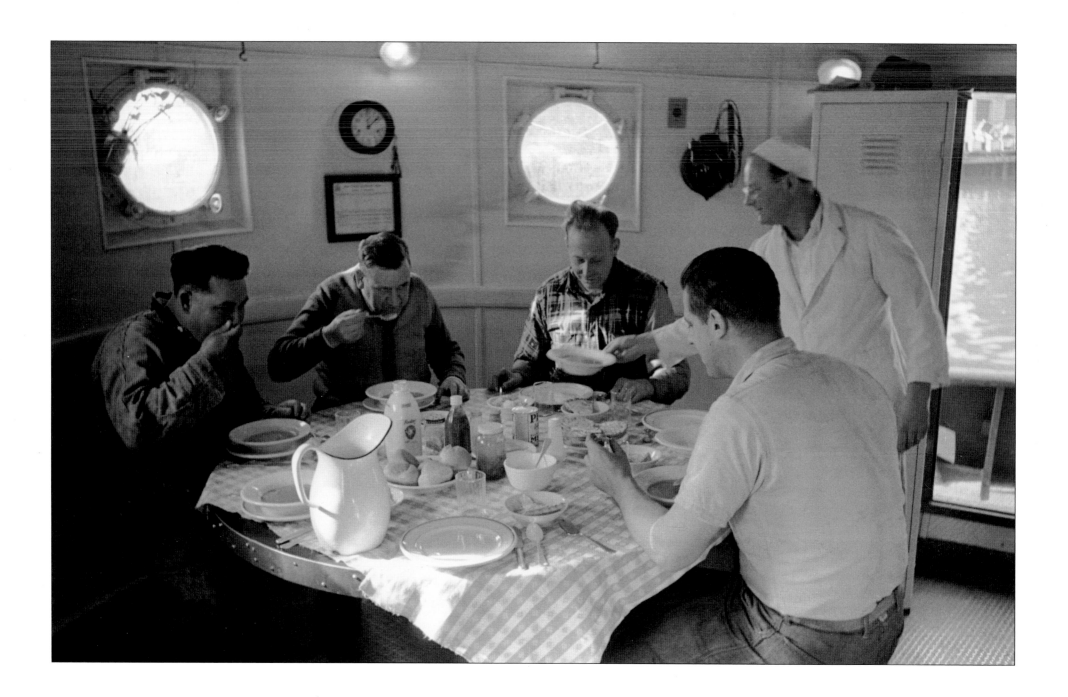

16

The Unions

The most controversial issue in the history of New York Harbor is the rise of the waterfront unions and their influence on the port. The scope of that influence can be discerned through the entire range of harbor activities, not only those relating directly to business and trade but also to the much more subtle issue of the harbor's social and political organization. Opinions about the effects of union–management relations in the harbor follow fault lines that are quite similar to those dividing all large-scale American industries with deep nineteenth-century roots. The New York waterfront has undergone many of the same postindustrial changes as most other old industries, and just as in those others, a few companies and individuals have prospered, while many have not. Accusations leveled against one side or the other regarding the causes and effects of this imbalance of fortune have been a staple of the New York Harbor debate for almost a century now. The unions are accused of being unrelentingly extortionate both toward management and toward the public at large. The mostly family-owned companies are said to be greedily obsessed with their own profits, to the exclusion of a decent livelihood for their employees. As in all incendiary debates, the truth lies somewhere in the middle. But while that middle ground has lain for so long undiscovered, the harbor has been drastically altered to neither side's advantage.

Meal time in the galley of the *Esso Tug No. 5*. Photograph by Sol Libsohn, December 1948, Special Collections, Photographic Archives, University of Louisville.

At the end of the nineteenth century the labor hierarchies of the waterfront were based on levels of skill. Pilots, captains, and mates ruled their vessels under both the mandate of maritime tradition and the more recently minted credentials of Steamboat Inspection Service licensing. Engineers, though they generally took orders from their captains, were also strictly licensed by Steamboat Inspectors and held firm authority over their assistants, firemen, and oilers. It was fairly typical for ownership to take the form of a partnership between captain and engineer. Hiring of crew aboard these vessels was relatively informal, with wages and living situations adjusted through individual negotiation. Much as in farm labor of that period, a substantial portion of a crew member's remuneration took the form of room and board on the vessel. Deckhands and firemen, working at the entry level of the industry, typically relied on the tug as a living place as well as a livelihood. The options of fixed residence ashore, marriage, and family were generally unobtainable unless a crewman advanced further in the industry. Because the crews tended to devote their time to their vessels and because those vessels were constantly on the move, a variety of small service businesses developed within the fleet. Rough tailoring and shoe repair were two common sidelines, with the object in need of repair being tossed aboard the tug on which the repairman worked and, next time the two tugs met up, tossed back. As a whole the harbor industries constituted a waterborne community that thrived in the shadow of the metropolis with few points of actual contact.

In 1916 the U.S. Bureau of Census found that the harbor contained 12,632 lives. Of these, 5,656 worked on self-propelled vessels—tugs, steam lighters, ferries, and passenger boats. The other 6,876 were employed on barges, hoisting lighters, and scows.[1] The variety of occupational skills ranged from the licensed men, who had a significant level of educational and professional attainment, down to the scow and barge captains, who were essentially unskilled and existed primarily as watchmen. The middle range of personnel—deckhands, cooks, firemen, and oilers—existed among the broad reservoir of unskilled or, at best, semiskilled workers who massed around the waterfront.

Hiring and discipline aboard harbor craft were far more relaxed than on long-voyage, deep-water craft simply because a discordant harbor crew member could be easily removed through transfer or dismissal, whereas deep-sea voyagers had little choice but to suffer any internal strife until the voyage was completed. Owners and masters hired and fired until a compatible and efficient crew was assembled. Family members and friends of friends were preferred. Of course, companies with multiple boats had to take a more impersonal approach to personnel matters while still relying on the licensed men on board to maintain quality and discipline.

Harbor employment took its first industrial turn with the tugs owned by the railroads. These boats were for the most part built without living quarters and were worked in shifts by crews who otherwise lived ashore, in much the same way as the railroads manned their trains. On most of the railroad-owned barges that required a full-time attendant, families were not allowed—a rigid policy that was the opposite of most private operators' preference for families living on board rather than single men. The antidomestic stance of the railroad managers required that crewmen establish residence ashore. This led naturally to the strict calculation of exactly how much was to be paid in cash and benefits for a day, a shift, or an hour of labor. Work on the railroad boats thus became less of a life and more of a living. In the railroad setting crew members were treated as unitary items with a certain cost, certain privileges, and a predictable degree of replaceability. The relationship between labor and management was impersonal, and the language spoken between them was candidly mercenary. The guarded tenor of this relationship owed much to both sides' experience of the bloody rail strikes of the

late nineteenth century in which unionism had established itself as a counterweight to management's will.

A much more tentative sort of unionism had developed within the harbor community.[2] It was divided into many jurisdictions defined by specific vessel type and skill level. The American Association of Masters, Mates, and Pilots, which had grown from a largely fraternal society of the late 1880s, represented the licensed mariners, while the Marine Engineers Beneficial Association, another fraternal organization dating from about 1870, represented the licensed engine-room population. Unlicensed crews of self-propelled vessels, both on deck and in the engine room, were represented by the Harbor Boatmen's Union of 1906, or, if they were working on railroad vessels, the Railroad, Port, and Terminal Workers, founded in 1918. Anyone operating steam-powered hoisting equipment was enrolled in the International Union of Steam and Operating Engineers of 1906. The captain of a lighter or covered barge was a member of the Lighter Captain's Union of 1913, and the captain of a coal or grain barge, a deck scow, or a dredge dumper was in the Tidewater Boatmen's Union, formed in 1902. The different skill and pay levels of each of these classes of employee tended to prevent them from presenting a unified set of demands in collective bargaining. Equally significant was the position of the licensed men relative to their unlicensed colleagues. Those with licenses were much more likely to identify their interests with those of their employers—if, indeed, they were not owner/operators themselves. Historically, the licensed men tended to ignore the isolated work stoppages of other classes of harbor employee. Also, they had on occasion enlisted replacement crews to keep the boats running.[3]

The approximately four hundred vessel owners of the time, meanwhile, were banded together as the New York Boat Owners Association. The fragmentation of the various employee groups made it quite easy for the Boat Owners Association to exercise a divide-and-conquer strategy that allowed them to keep control of

The *Watuppa* was built in 1906 at Port Richmond, Staten Island. She was 105 feet long and belonged to the McCarren Towing Line. Photograph by Berenice Abbott, WPA Federal Art Project, Milstein Division of United States History, Local History & Genealogy, New York Public Library, Astor, Lenox, and Tilden Foundations.

Tug boat crew member sitting on rear deck of tug.
These three tugs are part of the Meseck fleet. The boat in the foreground is the *George A. Keogh*, originally built as the *Asbury Park* in 1920. (See page 225.) Photograph by Harold Corsini, November 1946, Special Collections, Photographic Archives, University of Louisville.

wages and work rules and to avoid direct engagement with the unions. It was a common practice of the time for owners to listen to union demands but to then negotiate in a united way with the individual men in their employ rather than dealing with the unions themselves. Around this time there also appeared a "black list" that the owners maintained among themselves to identify and exclude workers judged to be either incompetent or troublemakers. This document, whether real or mythic, is believed by some to exist to this day, although the sorts of transgressions necessary for inclusion on it must be very, very great.

Events surrounding the U.S. involvement in World War I upset the already uneasy relations between the boat owners and their crews.[4] The need to facilitate wartime shipping to and from Europe brought New York Harbor under the control of the United States Shipping Board, which in turn delegated much of its authority to a locally formed entity, the New York Harbor Board. Railroad activities, including those afloat, were overseen by the Railroad Administration. The various harbor unions, meanwhile, had coalesced, under the auspices of the American Federation of Labor, into the Marine Workers Affiliation of the Port of New York. Under this umbrella the Masters, Mates, and Pilots, the Marine Engineers, and the Operating Engineers retained their separate organizations. The unlicensed Harbor Boatmen, the Lighter Captains, the Tidewater Boatmen, and the railroad marine employees threw in their lots with the International Longshoremen's Association, which also controlled the dock workers of the port. Historically, the boat owners had been comfortable in the belief that they enjoyed good relations with their employees and that workplace disagreements could be successfully addressed "in house." They were caught by surprise by the rapid movement of the harbor workforce into the union ranks.

In October 1917 the newly minted Marine Workers Affiliation presented a set of demands to the boat owners. The owners ignored the demands, which so raised the likelihood of a general harbor strike that the Shipping Board ordered the New York Harbor Board to begin hearings that might lead to arbitration. A complex series of moves followed that might best be described by picturing the Workers Affiliation peeking out around the petticoats of the Shipping Board while the Harbor Board pummeled the stubborn owners. To further complicate the matter, the Rail-

road Administration, as an adjunct to a broader effort to soothe its own nationwide labor troubles, granted the railroad marine employees a raise even greater than the Affiliation was asking for, plus an eight-hour working day. And this came at a time when the Affiliation was still resigned to a twelve-hour day.[5] Wages and working conditions for general harbor employees had customarily been identical to those of the railroad men. The surprising award given to the railroad contingent completely upset the harbor negotiations and sent all parties into an antagonistic spiral.

On January 9, 1918, all the members of the Marine Workers Affiliation went on strike, and the port was paralyzed until January 11, when President Woodrow Wilson ordered the War Labor Board to arbitrate the matter. The Labor Board struggled through hearings and negotiations with which the Affiliation generally cooperated and which the owners did whatever they could to impede. By March 4 an impasse was declared, and the strike resumed. Soon after, railroad and government marine workers settled for wage increases plus an eight-hour day, while the employees of the private boat owners remained on strike for a total of seven weeks. During that time, several of the owners advertised for strike breakers, particularly from the ranks of soldiers returning from the European war. Finally, some of the private owners dropped out and settled with the Affiliation. Then, with everybody worn out, all agreed to a ten-hour day plus a 10 percent increase in wages.

The strike ended, but its effects continued to reverberate. First, the harbor was left with a wage and workday differential between its railroad and its regular employees. This would not be rebalanced until 1923, when the regular employees received a raise of forty cent per week and the railroad men took a cut of fifteen dollars per month. Second, the balance of power in the harbor had shifted radically. The various union organizations had demonstrated the ability to maintain a united front against the owners and had, in the end, been able to separate them. The divide-and-conquer weapon that the owners had used successfully for so long had fallen into the hands of their employees, who had quickly learned to wield it. Third, the struggle of 1918–19 forced the companies into a tacit acceptance of the Marine Workers Affiliation, whose membership was now broad enough to create what was essentially a "closed shop" in New York Harbor. It is reported that when the Affiliation presented a formal demand for recognition of a closed shop in the harbor, the government negotiator escorted the employee representatives to a window overlooking the empty, smokeless harbor, saying, in effect, "You already have it."[6]

Like any argument in which much is left unsaid, there was more to come. As soon as the government stepped out of the business of labor, wage, and price control at the close of World War I, the owners began seeking a rollback of the gains achieved by the Workers Affiliation. The basic wage for a tugboat deckhand, which before 1918 had been $2.50 a day, rose to $3.63 by virtue of the strike settlement. By 1921 it was back down to $2.71, while the workday for nonrailroad employees had expanded back to twelve hours. In 1923 a one-day strike by the union group, now called the Associated Marine Workers, produced an increase to $3.13 plus a reversion to the ten-hour day.[7] An up-and-down cycle of yearly agreements from then until 1929 brought the basic wage to almost $4.00, and from then until 1937 it declined again to $3.26. This ragged advance was still enough to keep comfortably ahead of the rate of inflation, which between 1918 and 1937 had actually declined by about 10 percent.[8] William A. Maher, the general manager of the Associated Marine Workers throughout this period, apparently felt lucky to have kept his men employed at all. In 1932, as the Depression deepened, many tug crews were working only two days a week. It is estimated that only six hundred men were fully employed. In that year the licensed men accepted a reduction of ten dollars a

month, while the unlicensed were reduced by five dollars. Furthermore, their daily food allowance dropped from eighty cents to seventy. The owners and workers both were under excruciating financial pressure during this time. Companies failed one after the other. Boats were laid up or abandoned. For many crewmen, just to hold on to a job, with its promise of room and board, was a matter of life and death.

But underlying this climate of desperation was a persistent drumbeat of worker dissatisfaction. Many felt that too much had been extracted from labor in order to protect the interest of the owners. True or not, this sentiment was prevalent and ripe for exploitation. A newly constituted labor group with direct affiliation to the International Longshoremen's Association had emerged under the name Harbor Tugboatmen's Union (soon to be renamed ILA-Local 333). Captain William Bradley, its president, was eager to point out evidence of his rival Maher's too-friendly relationship with the owners. During negotiations between Maher and the owners in 1932, the *New York Times* began an editorial concerning the diminishing threat of a harbor strike with "In view of the amicable nature of the negotiations of the two groups in the last ten years . . ."[9] Four years later, after a strike was averted for the price of an across-the-board wage increase of ten dollars a month, the owners' representative imprudently exulted, "We hoped that no note of conflict would rise to mar the friendly relations we have maintained with the Workers Association since 1918."[10] That was the end of the road for Mr. Maher. Bradley proclaimed the past negotiations to be a sham. He demanded that the owners abandon Maher and his Association. With 80 percent of the rank and file in his pocket and a promise from the ILA that any strike would include the workers of all port industries,

Bradley and Local 333 quickly consolidated control of the tugboatmen.

By 1941, in the lead-up to war, the harbor was increasingly congested with lend-lease traffic to Britain. The city and the nation as a whole were becoming sensitized to the need for a concerted national-defense policy that stressed the necessary cooperation of business and labor. William Bradley decided that this was an opportune moment to test the muscle of Local 333. He claimed jurisdiction over 169 vessels in 105 companies, although available records seem to show that, in 1943 at least, there were only 103 private companies (i.e., not railroad or government owned) operating in the harbor with a total of 419 boats. Although it is difficult to reconcile Bradley's assertion with these figures, Bradley in any case presented the owners with a demand for an across-the-board wage increase of $20.00 per month. Within two days he was agreeing to $5.00 for the licensed men and $7.50 for the rest. The following year, when the contract again came up for negotiation, he was able to secure a $15.00 across-the-board increase, plus an increase of food money from eighty to ninety cents per man per day. As part of the agreement, Bradley pledged that for the duration of the war his men would refrain from further wage demands and would make every effort to speed the loading of men, equipment, and supplies. By all indications, he and his men kept their word both in letter and spirit, working very long hours in short-handed conditions.

The demands of wartime harbor work, grueling though they may have been, were also something of a windfall for the crews. Overtime was abundant, amounting to twenty to thirty-two hours per week.[11] In addition to overtime work some towing assignments such as the handling of munitions earned double pay for all hands. Furthermore, due to wartime shortages of civilian crewmen, undermanning of boats required that many hands work (and be paid for) more than one position on board. The war's end and the return to normal working conditions on the boats

Tugboats in the Gowanus Bay at the foot of Columbia Street, South Brooklyn. Photograph by Todd Webb, March 1947, Special Collections, Photographic Archives, University of Louisville.

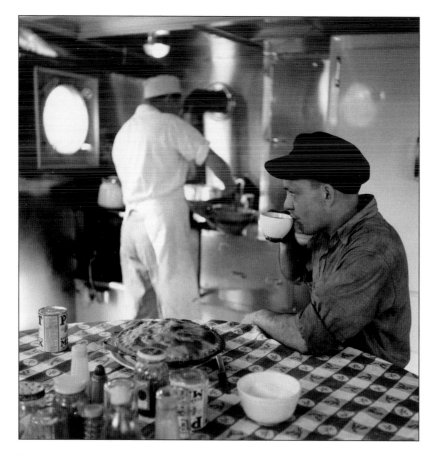

Oiler, Walter Cadell, drinks coffee in the galley of *Esso Tug No. 8* as steward, Jacob Mortinsen, in background, cooks mid-day meal. Photograph by Sol Libsohn, November 1947, Special Collections, Photographic Archives, University of Louisville.

was seen by many as the equivalent of a drastic cut in pay. An effort was launched by Bradley to preserve these wartime gains. Thus, the stage was set for one of the most difficult episodes in the history of New York, rivaled only by the Civil War Draft Riots and surpassed only by the events of September 11, 2001.

On February 4, 1946, immediately after midnight, the tugboatmen finished up whatever towing assignments they were en-

gaged in, took the boats back to their yards, tied them up, and walked out. The basic union demand was that the existing forty-eight-hour workweek be reduced to forty hours, for which the crews would be paid the same weekly amount. The leftover eight hours plus any time worked beyond that would be paid as time and a half. This arrangement would immediately increase the owners' payroll cost by 20 percent, and by increasing the proportion of overtime payable in every twelve-hour day, it would amplify all future wage increases as well. The owners could not agree to it; and despite optimistic comments from Captain Bradley and from Joseph Ryan, president of the ILA, the strike lasted for ten harrowing days.

The timing of the strike was the product of cold calculation on the part of Bradley and Ryan. Because of lingering wartime shortages of coal and oil, the entire city was relying on about a one-week reserve of fuel. The midwinter timing of the strike was specifically targeted at this vulnerability. At that time, 80 percent of the city's fuel was delivered by tug and barge from oil refineries and from railhead coal yards in Jersey and the Amboys. In addition, 50 percent of the city's food came in by water, especially produce and meat. With the help of winter cold, the strikers believed they could achieve their demands quickly through the public and governmental pressure that they expected would be brought to bear on the owners. But the owners would have none of it. On the third day of the strike President Truman ordered the seizure of the boats of ninety-one companies, on the theory that with the tugs under government control—and with the promise of government wages—the crews would return to work, relieving the city while keeping intense pressure on the owners. But the strikers did not grasp the logic of it, and their response was defiant. "Let Truman steer them," they jeered.

Next day, the U.S. Office of Defense Transportation was assigned the task of assembling government tugs and crews to alleviate the "creeping paralysis" spreading through the city. A

brownout was initiated through much of the city. The mayor ordered all illuminated billboards shut off and all places of amusement closed. He decreed that schools would be closed the next day. Thousands of buildings were without heat.

Over the fifth and sixth days of the strike, Bradley came under intense pressure from all sides, including Mayor O'Dwyer, to find a settlement. He took a proposal of a fifteen-cents-per-hour raise and a forty-eight-hour week to his men, who angrily voted it down by a margin of two to one. During the next three days of the strike the fuel situation hung in a critical balance, with Army and Navy tugs, along with trucks and the rail lines of the New York Central, able to bring in just enough to hold the city in a state of semihibernation. Then, late in the day on February 11 Mayor O'Dwyer ordered that at midnight the entire city would be shut down. All businesses were ordered to close. All workers would remain at home. Public transportation would be reserved only for emergency travel. The *New York Times* described it as seeing a city die—and this at a time when the memory of cities dying all over Europe and Asia was still painfully fresh.

The public was totally bewildered by the shutdown order. No one, not even the mayor, could figure out what it really meant. After eighteen hours of "unparalleled confusion and staggering economic losses" the order was rescinded. The mayor was fiercely criticized for the shutdown order, which in retrospect seems to have been largely the result of his own total exhaustion and bafflement resulting from the endless crisis. But the drastic shutdown seems to have injected a measure of reason into all parties. The enormity of what had happened seems to have sunk in, and negotiations resumed in earnest. At 8:00 a.m. on February 14 the crews went back to work with the understanding that their differences with the owners would be settled by arbitration. The owners agreed to arbitration with the understanding that they would be allowed by the Federal Office of Price Administration to raise their towing rates to compensate for the increased cost

This photograph appeared in the pages of the *New York Telegram* during the 1946 tugboat strike with the caption, **"Lone tug and coal barge nudge through Hudson River ice toward Manhattan shore. . . . Just a drop in the almost empty bucket."** Library of Congress, Prints & Photographs Division, *World Telegram & Sun* Collection.

resulting from the eventual settlement. The rate increase that emerged from this understanding was 16.5 percent.

The strike was over, but its effects lingered. The general public felt that it had been held hostage and economically brutalized by the strikers. The *Times* editorialized against the union, which in the editors' view habitually demanded the full range of government protections while accepting no public responsibility.

Seven months later, the harbor was on strike once again; the teamsters union had stopped all trucking into and out of the city. The longshoremen under Joseph Ryan struck, and the tugboatmen

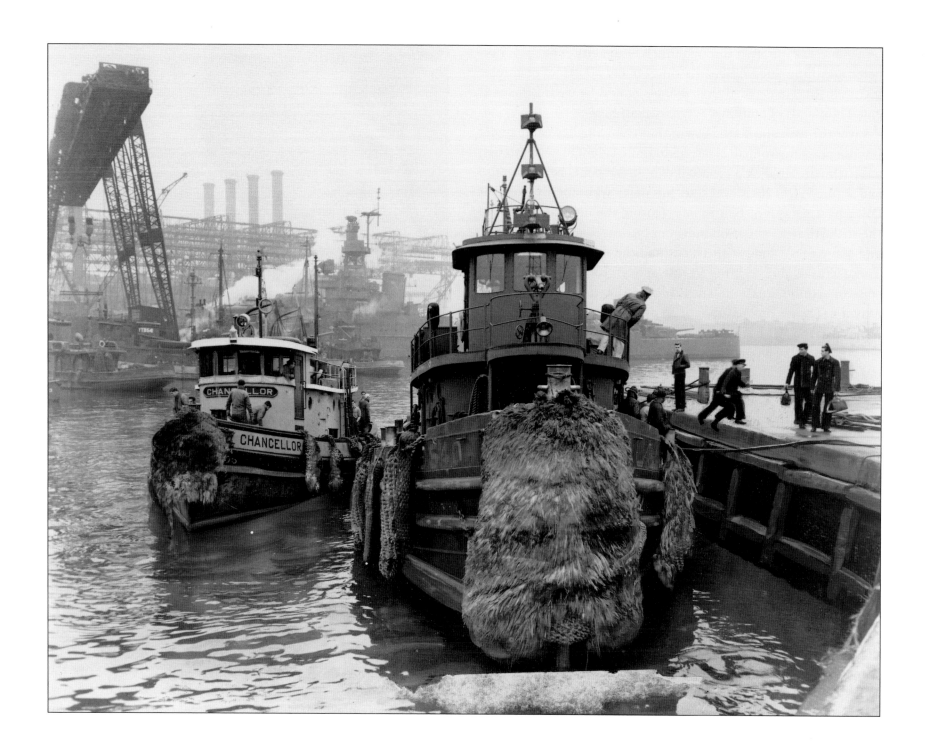

went out in sympathy. With the city once more under mortal threat the *Times* again denounced the victimization of the general public in strikes that result in little or no gain for either management or labor. The violent legacy of the railway strikes of 1877 and of the Pullman strike of 1894 were cited, and the suggestion was made that there was a strain of vindictiveness in these job actions that ignored any appeal to public sympathy. The debate regarding how far the labor–management fight should punish the general public was part of a growing conflict within the various union organizations about goals and tactics.

The 1946 strikes demonstrated that great harm could be done to the city but that little could be gained by it. Although shipping was hindered in getting in and out of port, it was by no means halted. By docking and undocking at times of slack water the great majority of ships went about their business without the aid of tugs. The curtailment of fuel supplies, seen as the ultimate point of leverage at the beginning of the strike, turned out to be unpersuasive. By the middle of the winter strike, the city had cobbled together a daily supply of fuel by the intervention of government tugs and by private truck transport. In fact, it became apparent to the unions that the strike had caused long-term harm to their own interests. Trucking companies were eager and able to deliver fuel oil to the city. Shipping companies faced with the unreliability of port operations in New York simply diverted their vessels to other East Coast ports. The tugboat owners compensated for the wage agreements forced on them by raising

On the morning of February 14 the strike ended, and the few Navy tugs that had been struggling to move essential fuel supplies were relieved. Here, the crew of a Navy Yard tugboat (YTB) scrambles ashore in the Brooklyn Navy Yard while the *Chancellor*, belonging to the Ira S. Bushey Company, which specialized in oil transportation, backs out of the slip to go to work. U.S. Navy photograph, Library of Congress, Prints & Photographs Division, *World Telegram & Sun* Collection.

prices to their customers and also by drastically limiting the scheduling of overtime work. The latter tactic both greatly reduced the take-home pay of the crews and noticeably deteriorated the efficiency of port operations in general. In short, neither side had gained significantly, and overall, the port had suffered.

In 1957 the two sides went at it again with a strike that lasted thirty-six days. At issue were a long list of union demands, including a 20 percent wage increase, eleven paid holidays, three weeks' paid vacation, and increases in pension and medical benefits. Two additional issues had far-reaching impacts.

The first was a demand that all towed barges be manned. Traditionally, almost all barges and scows had full-time personnel on board. Wooden construction required constant attention to maintenance and to pumping, which made full-time attendance necessary. By the mid-1950s, steel barge construction was predominant, and the barge operators were eager to get rid of as many employees as possible. In 1918 almost seven thousand men were employed as captains or watchmen on barges in the port. They lived on board, often with their families, moving constantly among the waterways of the region under the motive power of the tugs. Earlier tugboat labor contracts had specified that any tug deckhand who had to board a barge to handle its lines was entitled to a two-dollar fee. This measure served as a protection to the bargemen, but in the 1957 dispute it was stripped away, and the bargemen's livelihood was directly exposed to management's cost cutting.

The other critical point at issue in the strike was the demand that companies under union representation be forbidden to hire any tug belonging to a nonunion company. Before this time, the companies had made little distinction on this point, and such spot hiring of outside tugs represented a large proportion of many nonunion, "independent," operators' businesses. The demand represented an escalation in the increasingly bitter competition between union and independent boatmen.

Galley wall.

Aboard the *K. Whittelsey*. The cartoon reads, "Never mind those medals, sailor; try challenging him with a mop." The calendar illustration is entitled "Saul on the Damascus Road." Photograph by Harold Corsini, October 1946, Special Collections, Photographic Archives, University of Louisville.

After thirty-six days the strike ended with an 11 percent wage increase but little other gain for the employees. Lost wages to the men were estimated at $2–2.5 million, or about $600 per man. The loss to the companies was estimated at $3.6 million. The issue of protecting the resident bargemen was traded away,[12] and by 1964 only sixty scow captains remained. Today, the only barges that carry permanent crew are those equipped with extensive engine-room and power systems used for cargo handling—petroleum and liquid-chemical carriers for the most part. The demand that only union subcontractors be hired was not specifically decided, but the union companies increasingly avoided such hiring to preserve labor peace.

As in 1946, the winter timing of the 1957 strike targeted the city's need for fuel. As before, this tactic backfired as truckers eagerly stepped in to haul fuel, to the permanent loss of the towing industry. Furthermore, the perceived unreliability of towing transportation encouraged the construction of pipelines wherever possible. As in the previous strike, shipping was barely affected, with seagoing vessels working themselves into and out of dock at slack water. The *New York Times* observed that the result of the strike "showed Local 333's storied control of Port operations to be a myth."[13]

In 1964 and 1970 there were strikes of thirty-three and sixty days. The second of these was based on a union demand for a 100 percent wage increase over three years, which was eventually settled at 40 percent. The settlement led the major companies to increase their rates from $112 per hour to $155, bringing the cost of towing services in New York to the highest level on the East Coast. Lost wages and towing receipts resulting from the 1970 strike were estimated at $60 million. During these strikes the greatest economic impact to the city at large fell on the construction trades. In fact, the 1964 strike was finally settled when the five harbor companies that specialized in hauling sand, gravel, and cement capitulated rather than see their most productive

season destroyed. The progress of the Verrazano Narrows Bridge was greatly delayed by the contractor's inability to get delivery of prefabricated roadway sections. To better take advantage of the leverage obtained by staging a towing strike when it would do the most damage to city construction, the three-year contract resulting from the 1970 strike was written so that it and future agreements would expire on March 31.

The next major strike began at midnight, April 1, 1979. It lasted eighty-eight days, and it made fools of everyone involved. The union wanted a one-year contract with a 40 percent wage increase and, again, an eight-hour workday. The employers were offering a three-year deal with cost-of-living increases of 6 percent each year. The companies also wished to dispose of the cook's position on most of their boats. For the first time since the 1918 strike, shipping in the port was seriously hindered because a much larger class of container ship was being used and because most cargo-handling facilities were by then located at Ports Newark and Elizabeth, which are located far up the narrow and tortuous Kill Van Kull and Newark Bay Channels. During the course of the strike, eighty-nine container ships, carrying about $1.5 billion worth of cargo, were diverted to other ports. About 60 percent of that cargo had to be reshipped to New York in smaller vessels able to navigate the Kills, thus magnifying the losses of the shipping companies. In addition to the unpredicted effect of the strike on shipping, the tactical advantage of targeting the strike at the beginning of the construction season was predictably successful. Hundreds of building projects were delayed citywide, and thousands of workers were laid off.

But from a local point of view, the most significant issue in the 1979 strike was garbage—ten thousand tons a day of it, which Moran Towing & Transportation was under contract to move for the city. As Sanitation Department personnel worked around the clock trucking as much as they could to a makeshift dump in the South Bronx, the mess piled up everywhere. By early May, Mayor Ed Koch convinced President Jimmy Carter that a health emergency existed, and the Coast Guard was ordered to attempt to tow the barges using their own inadequate tugs. Later, the three Moran tugs that had been towing the garbage before the strike were seized by the city and reluctantly manned by Staten Island Ferry crew members. Faced with gigantic financial liability stemming from its inability to fulfill its contract with the city, Moran finally withdrew from the Employers Association and fashioned a three-year settlement with annual wage increases of 14 percent, 10 percent, and 8 percent. Shortly thereafter, the other owners fell into line. By all accounts it was a singular victory for Local 333. A final dash of salt was rubbed in the owners' wounds when the city successfully sued Moran for breach of contract. To an outside observer the entire affair resembled the sorry spectacle of two bald men fighting over a comb.

After the events of 1979 all sense of mutuality between Local 333 and the owners was gone. Many Local members were so hostile to the welfare of the companies that theft of company equipment and supplies was rampant. Mistreatment of the boats was tolerated even by captains and engineers. Crew members, on the other hand, felt that their livelihoods were in constant jeopardy as the companies schemed of ways to punish militant employees and to recoup what had been lost in the strike. The poisonous atmosphere obscured the reality that the towing industry had changed drastically since the 1940s.

First of all, since the construction of the interstate highway system, there was no guarantee that anything had to be handled by tug and barge. In fact, virtually anything that during any portion of its shipment had to or could be moved by truck was irrevocably lost to water transportation because of the added handling cost of shifting from one mode to the other. In fact, where towing had once been the preferred method of moving all kinds of goods around the harbor, it had now become the method of last resort. Containerization of cargo had cut deeply into local harbor towing

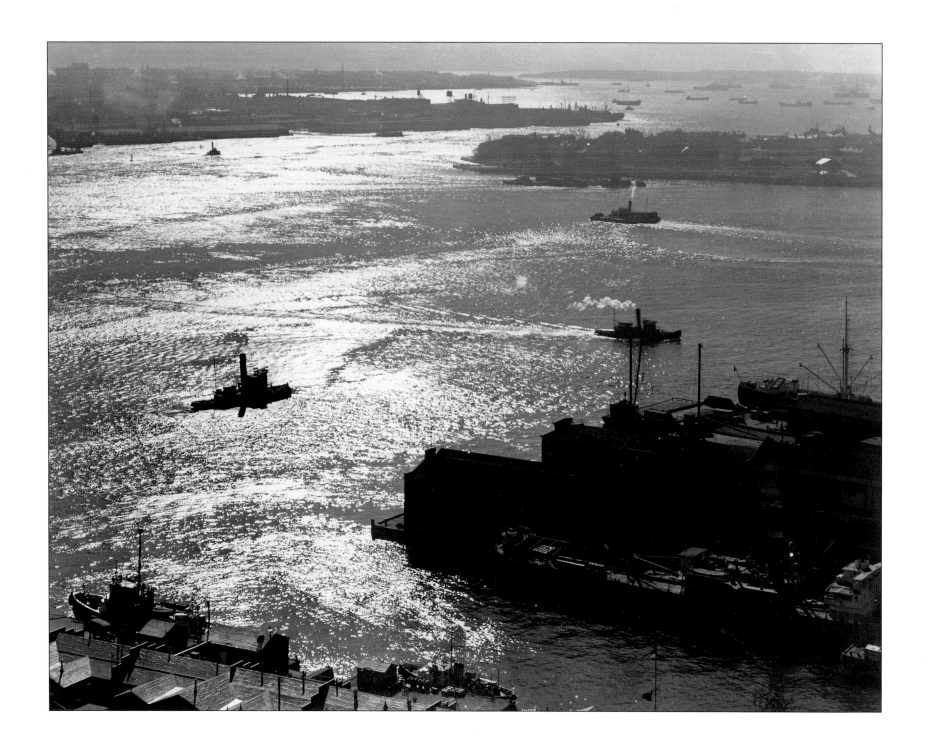

operations and had also favored the dissemination of cargo ships to smaller ports with less highway congestion and shorter travel distances to consignees. The ships themselves also had changed in that, though much larger than in the past, many were equipped with bow thrusters, which reduced their need for tugboat assistance.

By the mid-1980s the average operating cost of a New York tug was $2,000 per day, as opposed to about $1,000 per day in Philadelphia, Baltimore, and Norfolk. Although not all of this difference was directly related to crew cost, that expense was one of the few over which the companies could hope to exert any control. Between 1917 and 1946, increases in crew wages had kept pace with the cost of living, and neither had advanced significantly. After 1946, however, wages in the towing industry rapidly outstripped the cost of living, achieving a premium of almost ten to one by 1988. It must be pointed out that the wages listed in contract settlements are for work schedules of two weeks on/two weeks off. No wages are paid during the two weeks off, although other payroll and pension benefits accrue. Therefore, the annual take-home pay of a crew member is about one-half the amount mentioned in the settlement. The figure is, however, a constant factor in the boat's running cost because the boat operates and is crewed full-time. Traditionally, tugboat crew members have maintained shore jobs that mirror their work schedules on the water. Construction and mechanical work are frequent side operations. Some are more lucrative and physically demanding than the boat work. It was not uncommon for crew

members to use their two weeks afloat to rest up after swings of more arduous labor ashore.

Obviously, the outsized expansion of wages relative to the cost of living is explained not by greed on the part of the crews but on a radical shift in their life expectations. Throughout the nineteenth century and past the Great Depression a site on a tugboat represented a meager living. The major benefit to unlicensed men was a bunk to sleep in and steady meals. It was a life that allowed only limited onshore attachments. After World War II the idea of the "living wage" became deeply implanted in the American workforce. That idea bore the implied guarantee that an individual with a steady occupation, backed by the mechanisms of collective bargaining, could achieve a socioeconomic position

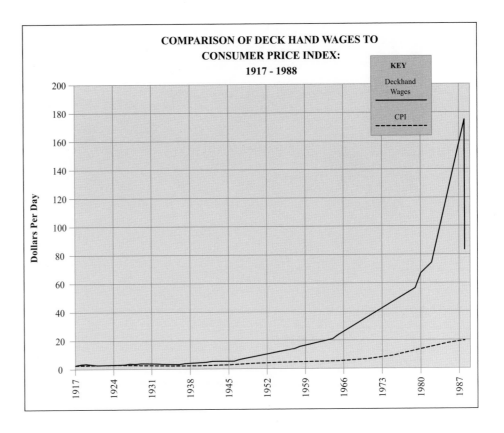

General view of the east side of New York Harbor. Brooklyn and Governor's Island and Buttermilk Channel separating them may be seen. In the far background is the entrance to New York Harbor from the Atlantic Ocean. Photograph by Harold Corsini, November 1946, Special Collections, Photographic Archives, University of Louisville.

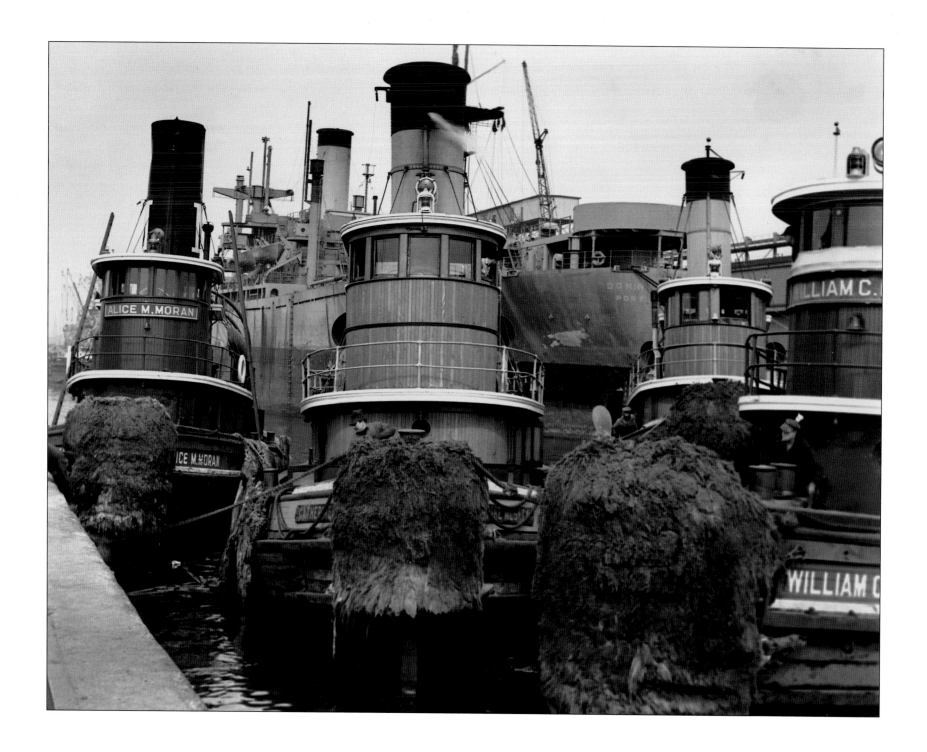

comfortably lodged within the lower middle class. Included among the expectations inherent in that position were the basic costs of marriage, child rearing, a modest home mortgage, one or two car loans, and the usual run of household goods and furnishings, with a little money left over for savings and college. A pension and the long-term benefits accruing from payroll taxes added to the individual's financial picture to form a quite substantial economic unit. By the 1980s a tugboat operating with two six-person crews had become responsible for generating the cash for a dozen such households, as well as paying for its own upkeep, fuel, and overhead. It also had to return enough to the shareholders to make it worthwhile for them to risk their money when they could comfortably make a return of 10 percent or so with far less risky paper investments. For a boat to accomplish all of this it had to be very well managed, constantly busy, and very lucky. The number of failed towing companies in the past seventy-five years is ample testimony to the difficulty of operating a successful towing business under the strain of these unremitting financial demands.

The long series of labor–management clashes that culminated in the 1979 tugboat strike left an atmosphere of hostility and distrust that only worsened thereafter. The larger companies felt that their very existence was threatened by the decline in port business and the unrelenting rise in operating costs. The experience of the 1979 strike convinced them that the union was uninterested in any form of cooperation. They viewed their differences to be irreconcilable and proceeded to terminate the relationship.

◄—

Tugs waiting for work in the Erie Basin at the foot of Columbia Street.
Photograph by Todd Webb, March 1947, Special Collections, Photographic Archives, University of Louisville.

In the spring of 1988 the then-current union contract ended, but in a departure from past practice, the companies did not bargain with the union as a group. Each operator dealt separately with the Local, trying to salvage essential bits of the relationship, if possible. About half of the companies managed to reach agreement with the union, but the seven largest made demands that could hardly be considered realistic. They wanted wage reductions of from 40 to 62 percent. All 750 of the remaining cooks would be dropped. The number of holidays would be reduced from ten to four. Most overtime would be eliminated. Ominously, the seven companies had begun advertising for replacement workers, particularly around the Gulf of Mexico, where the collapse of the offshore oil industry had left a multitude of experienced tugboatmen out of work.

The seven companies were Moran Towing & Transportation Company, Turecamo Coastal & Harbor Towing Corporation, Bouchard Transportation Company, Morania Oil Tanker Corporation, Reinauer Transportation Company, Eklof Marine Corporation, and the Spentonbush/Red Star Companies. Together, these companies operated better than half of the approximately 150 tugboats remaining in the harbor and employed better than half of the 2,500 existing members of Local 333. On February 16, 1988, they terminated their dealings with Local 333 and its members. The boats were sent out with replacement crews while the ensuing dispute went into federal court and to the National Labor Relations Board. Much of the companies' strategy was based on the recent examples of the Air Traffic Controllers and the National Football League strikes, in which replacement workers had been tolerated.

On the morning that the strike began, the level of activity in the harbor appeared to be completely normal. Tugs were moving. The only thing noticeably different was that the voices carrying on the radio communications throughout the port had changed overnight to Southern and Cajun dialects. One old-time harbor

voice was heard to say, "Geez, there's scabs out there." And another asked, "Where'd everybody go?"

The 1988 strike/lockout has continued in various forms to this day. Because it was determined in court that the companies had had no real intention to engage in collective bargaining in the lead-up to the strike, most of the original workers were ordered to be rehired; but the companies did this with such delay and reluctance that many workers had gone on to other occupations long before any settlement was offered. The companies were able to hire back many of the captains, engineers, and docking pilots who they considered to be both skillful and loyal. They made every effort to avoid rehiring those they considered incompetent or difficult. Today, Local 333 is greatly reduced in membership and bargaining power. Whereas before the 1988 strike, crews were composed of an aging, racially and ethnically uniform group of workers, today there is a far younger, more heterogeneous population of deckhands. This change suggests that base-level employment in the industry may once more be functioning as a stepping stone to financial security rather than as its guarantee. Wages and benefits are today hardly more favorable to the crewmen than they were in 1988. The companies, meanwhile, appear to have obtained a little breathing room in their running battle with Local 333 while they continue to grapple with the many challenges that confront them.

Frederick Annensen, cook on the *Esso Tug No. 7*, feeds the gulls.

The tug is laying at the Standard Oil Company's pier at Constable Hook, Bayonne. The Baltimore & Ohio railroad yard and the Staten Island Ferry Terminal are visible in the background.

A friend of mine who herself served as cook on an oil-company tug was also fond of feeding the gulls, as it is said that they are the vagrant souls of old sailors. Passing a city garbage barge aswarm with gulls, she remarked, **"And those, I suppose, are the cooks."** Photograph by Sol Libsohn, November 1947, Special Collections, Photographic Archives, University of Louisville.

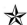 The Independents

Initially, all tugs and their operators were independent. The business of New York harbor towing was founded on direct competition. Tugs waited and sometimes raced for incoming business at the seaward limits of the port, while companies positioned themselves to dominate discrete territories within the harbor. Operators such as the Russells and Hugh Bond maneuvered themselves into control of Newtown Creek and the Gowanus Canal, respectively. Dalzell ran around his competitors by negotiating directly with shipping companies in Europe to secure all their New York docking work. Established towing agents fumed over the inroads made by scalpers, who with a little luck soon established themselves as agents and fumed in turn about the next generation of scalpers. Owner/operators worked their boats hard, kept costs to an absolute minimum by doing everything they possibly could by themselves, and shaved prices as much as necessary to get the work that would keep themselves and their boats afloat. The business at all levels was populated by individuals who operated privately and by their own wits.

This independent quality defied most attempts at regulation. Watermen have a well-documented taste for individuality. They are attracted to the water because it offers a simplified set of responsibilities that can be met by direct, personal effort rather than by more complex political and social devices. The tugboatmen were content to live or die on the basis of their seamanship, their mechanical ability, and their acquired skills in small business. Throughout the nineteenth century they defied all efforts to establish a uniform pricing system in the harbor. The result was a boisterous oversupply of boats and of the characters who ran them.

The New York Tow Boat Exchange, founded in 1917, was an attempt to rationalize the industry. Frederick Russell, Frederick B. Dalzell, and William S. Holbrook were principals in this effort

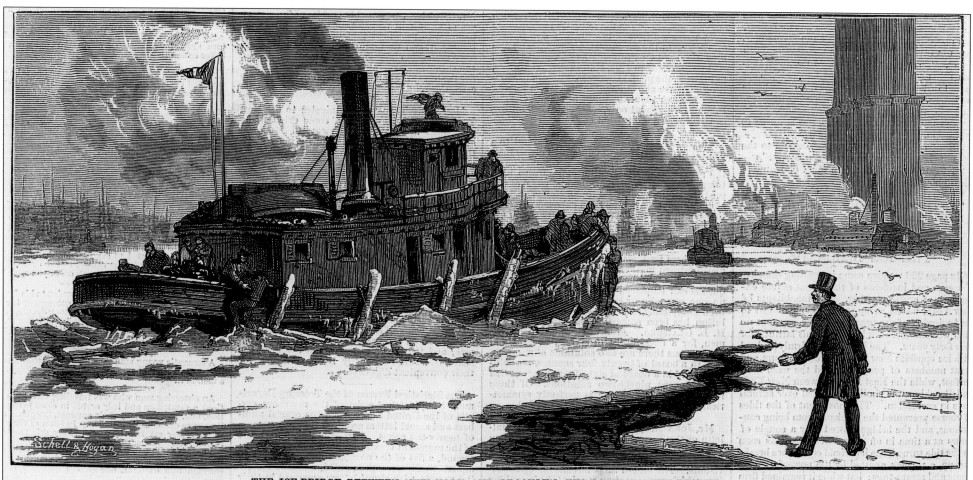

THE ICE-BRIDGE BETWEEN NEW YORK AND BROOKLYN—TUG-BOATS TO THE RESCUE.

THE ICE BLOCKADE—A TASTE OF ARCTIC WEATHER.—Drawn by Schell and Hogan.—[See Page 219.]

to establish a harborwide protocol for towing rates, crew wages, and harbor practices that would replace the chaotic methods of the past. The goals of the founders were marked by an unusual degree of enlightenment, for it was their stated intention to protect the basic fabric of harbor commerce by encouraging the membership of as many of the harbor's small operators as possible. They hoped that a broadly representative group would encourage cooperation and stem the twin faults of relentless price cutting by the small operators and predatory market practices by the large. Sixteen companies formed the original membership; within four years there were thirty-four companies, representing about 220 boats.[14]

Nowhere was it stated that Tow Boat Exchange membership was limited to companies that employed their crews under union contract; nevertheless, that situation soon developed as the Exchange became increasingly involved in the negotiation of industrywide labor–management issues. Nonunion operators shied away from the Exchange for fear of being rolled up in broad agreements. Because the nonunion operators generally paid less in crew expense, they were able to charge less for their services. Soon the old rifts in pricing began to reappear but characterized now by the basic distinction of owners using union versus nonunion personnel. Then the Depression struck, and within ten years better than half of the Exchange members had failed or had been acquired by their larger brethren. The consolidation of business into the hands of several large companies was accompanied by a consolidation of labor into a dominant pool of men under the protection of Local 333.

The antagonistic aspect of the relationship between the companies and their unionized crews is well known. Bitter strikes, lockouts, accusations, and occasional violence are legend. But in spite of their differences, the two sides did find it in themselves to make common cause against a mutual enemy—the small, nonunion companies, now called independents. Once unionized and faced with the resulting higher operating costs, the larger companies were forced to expand their fleets and gather in as much business as possible. Union rules made it very difficult to operate a boat on an occasional basis because crew members could not be juggled according to the pace of business. Because payroll expense was constant, each unionized boat had to be kept constantly at work. Nonunion operators enjoyed much greater flexibility in manning their boats. They could idle them when work was scarce and thus avoid ruinous overhead. Also, with lower overhead they could underbid their unionized competitors at almost any turn.

To neutralize the independents' advantages, the unions, with the tacit approval of the larger companies, began to systematically exclude the independents from work in vital areas of harbor commerce. Relying on a self-declared principle of closed shop, Local 333 claimed the towing rights to virtually every industry that was itself unionized. A floating crane manned by members of the Operating Engineers Union had to be towed by Local 333 boats. Unionized dredges had to be tended by Local 333 boats. Construction sites and sand and gravel operations required union boats. Because of fair-labor-practices laws, even the towing of city garbage became the exclusive province of Local 333. All steady work in the harbor was subject to seizure by the Local. Each small union victory in this campaign represented a small victory for the unionized companies and a relatively large defeat for the independents.

◄

On thin ice, a dapper New Yorker contemplates the consequences of independence. A particularly severe winter in 1875 froze the East River from shore to shore. The ferries could not operate, and the Brooklyn Bridge was far from complete, so pedestrians took to crossing the river on foot. A sudden breakup of the ice required tugs to rescue a number of these adventurers. *Harper's Weekly,* March 13, 1875, General Research Division, New York Public Library, Astor, Lenox, and Tilden Foundations.

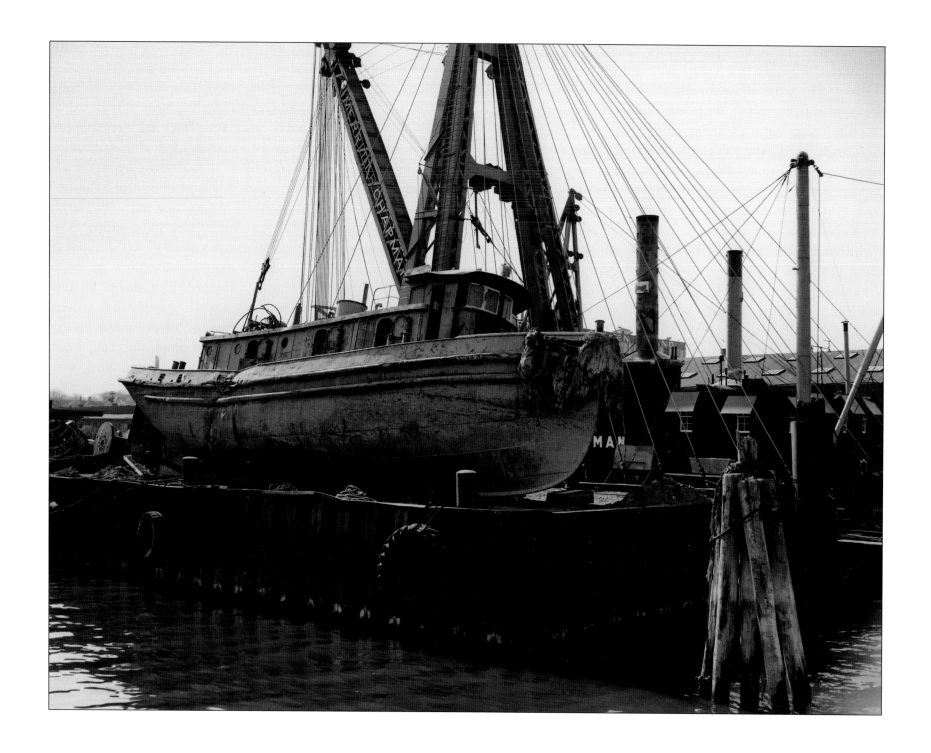

Within the heavily unionized confines of New York Harbor the independents became isolated and stripped of access to most customary sources of work. Without any guarantee of steady income their survival came to depend increasingly on management of expense. In order to survive in business an owner might be obliged to serve as captain, engineer, deckhand, bookkeeper, salesman, welder, carpenter, painter, mechanic, rigger, and cook whenever and as often as needed. Old boats and aging equipment had to be kept running for as long as possible with little prospect of replacement. As the scions of the big family-operated companies graduated from the wheelhouse to the office to the boardroom in a few short years, the independent owners graduated into an ever more grueling old age.

By the 1970s the independents occupied a floating world. Many lived on their boats in the backwaters of the harbor. While they lived in the very shadow of Manhattan these men became almost invisible to the world. They accepted work that others refused, towing decrepit barges off to scrap, frequently being victimized by their customers into towing things so deteriorated and unseaworthy that insurance was unobtainable. One captain was caught in winter weather on the Jersey shore while towing an old barge with his equally old boat. After a day and a half of struggling to stay afloat he was forced to beach the tug and tow, running it ashore through the surf. When asked by the Coast Guard why he never radioed for help he answered honestly that the thought had never occurred to him. When threatened with jail he asked if they could guarantee that he would serve his time next winter.

Today, there is no official patience for this sort of man. Coast Guard licensing procedures are viewed as a matter of national security. The rules have been altered to make it all but impossible for a prospective captain to obtain a license by virtue of work experience and training that he or she receives on board. The various merchant-marine academies, faced with the almost total disappearance of jobs in deep-sea employment for their graduates, have turned to training young men and women for careers in inland and coastal towing. Acting as advisers to the Coast Guard in drafting new licensing rules, the academies have been allowed to write their own curricula into the new rules, ensuring that their graduates will get first crack at whatever jobs there are. Under this influence a new style of officer has emerged, buttoned down and bureaucratic. They are undeniably diligent and intellectually well equipped for the job, but their arrival represents a clean break from the ancient unruly traditions of the harbor.

The *Hustler* sits on dry land after being salvaged by the tremendous Merritt, Chapman & Scott derrick in the background. The tug was capsized after being run down from behind by a freighter on December 9, 1965, just off the West Side Piers. The gash in her side is either the spot where the ship caught her or else was caused by the chain sling with which the derrick recovered her from the bottom. Miraculously, no lives were lost, but it was the end of the tug. Steamship Historical Society of America Collection, Langsdale Library, University of Baltimore.

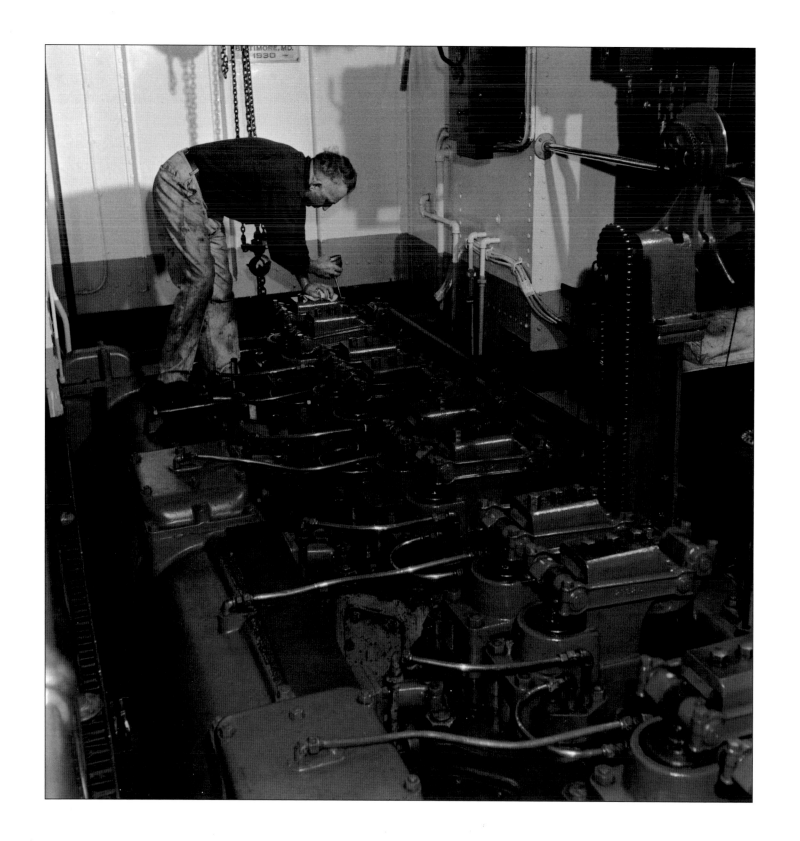

17

Diesel

The development of the diesel engine at the beginning of the twentieth century brought vast change to New York Harbor. Not only did the new engine change the way tugboats went about their work, but it also changed the type of work the tugs actually did. The labor and cost savings of diesel power gave tugboat owners an opportunity to salvage profit from what was becoming an increasingly stagnant business. Starting in the 1920s, those owners with the foresight and financing necessary to acquire the new engines were able to leap ahead of their steambound competitors. With the renewed profit margins that the more efficient power supplied, those same owners were able to seize new markets and, if they chose, acquire the assets of their competitors.

The diesel engine did not revolutionize only the marine industries. On land, the new power was wreaking even greater change. More-efficient railroad locomotion, long-haul trucking, and construction methods were developed using diesel. And all these land-based developments in turn influenced the tugboat industry. The principal effect of the diesel engine was that, compared to steam, useful work could be generated from much smaller, lighter machines—machines that could be used more flexibly and independent of constant human attention. This new dependability enabled the rise of long-haul trucking and, just as important, the construction of the ever more elaborate highway

Wilhelm Schmidt, oiler, oiling the diesel engine on the tug _K. Whittelsey_.
The _Whittelsey_'s engine is an 800-horsepower Rathbun-Jones diesel. It has six cylinders of eighteen-inch bore and twenty-eight-inch stroke. At 320 rpm it burns about thirty gallons of fuel per hour and turns a ten-foot-diameter propeller. The engine is said to weigh seventy tons. It is truly an engine you can walk around on, as Mr. Schmidt demonstrates.

 The oiler's job is the regular care of the tug's engine room and machinery, whether it be steam or diesel. During each watch he has a regular schedule of items to check, clean, and lubricate. The cleanliness and polish of the engine room is largely the result of the oiler's diligence. Modern diesel engines are almost entirely self-lubricating, so the oiler's job has disappeared and, with it, much of the traditional spit and polish that once typified a tug's engine room. Photograph by Harold Corsini, October 1946, Special Collections, Photographic Archives, University of Louisville.

systems on which those trucks ran. Diesel power altered traditional construction methods. For instance, reinforced concrete construction only became practical when dependable mobile delivery of ready-mixed concrete became available at construction sites.

The great efficiency of diesel power along with other broad changes in twentieth-century transportation, labor, and economics caused a rapid contraction of the New York Harbor tugboat industry. Approximately 156 individual companies, small and large, existed in 1917. There are only about 25 today. From an absolute peak of just over 800 tugs operating in New York Harbor and the Hudson River in 1929, today there are only 197. (There are another 110 boats owned by two New York firms, Moran and McAllister, that have home ports outside New York.) But to cite only these statistics leaves the impression that the New York towing industry exists only in some vestigial form, outmoded and hopelessly decayed. In fact, those companies that have survived or that have sprung up since the years of consolidation have emerged both well equipped and forward looking. Much of that well-being is due to the technological revolution that stemmed from the work of Rudolph Diesel.

Diesel was born in 1858 in Paris, France, to which his Bavarian parents had emigrated to work a small leather-goods shop. His family was scattered during the Franco-Prussian War, and Rudolph ended up living with relatives in Bavaria, where he was enrolled in technical school. His interests led him to an engineering degree at the Munich Polytechnic Institute and, after that, an apprenticeship with a Swiss builder of large steam engines and refrigerating machinery.

While there he developed an idea for a new type of engine that borrowed extensively from other internal-combustion designs then current but was distinct from them in two respects. First, the engine ran on nonvolatile fuel such as vegetable, animal, or petroleum oils rather than gasoline and naptha. Second, whereas gasoline engines had to rely on complicated electrical-spark ignition, Diesel's ignition was accomplished solely by the heat generated from the compression of the atmosphere within the cylinder of the engine. Once started, such an engine promised to run indefinitely on nothing more than air and a steady dribble of safe, inexpensive fuel. The diesel engine is so common today that it enjoys little admiration, but at the time of its development it was a remarkable invention. Since the fuel that the engine burned was less volatile than gasoline, the diesel's operation was far less risky. Also, when the heavier oil ignited in the engine cylinder it burned much more slowly than did gasoline. Its effect in the cylinder was characterized as "combustive" as opposed to that of gasoline, which was said to be "explosive." The longer combustion period of the diesel produced a far more robust impulse during the power stroke. This, in turn, allowed the diesel engine to be run at slower speeds than gasoline engines while still delivering equal or greater sustained power.

George Johannsen, 2nd Engineer, at the throttle of the diesel engine that powers the *K. Whittelsey*.

The *Whittelsey*, like the *Hustler*, is a bell boat. The speed and the direction of the tug's engine is controlled from within the engine room according to bell and jingle signals coming from the pilothouse. To shift between forward and reverse the engine must be slowed, then stopped, then restarted in the opposite direction. To restart, compressed air is injected into whichever cylinder has stopped with its piston in the right position to be forced downward in the desired rotation. The whole process takes about ten seconds when done expertly. Mr. Johannsen appears to be just such an expert.

To the left of Mr. Johannsen is the tug's main electrical panel—a direct-current, 120-volt system as opposed to modern AC-current systems of 110 and 220 volts. It is a well-kept engine room with polished handrails and, above his head, polished skylight-opening wheels. Photograph by Harold Corsini, October 1946, Special Collections, Photographic Archives, University of Louisville.

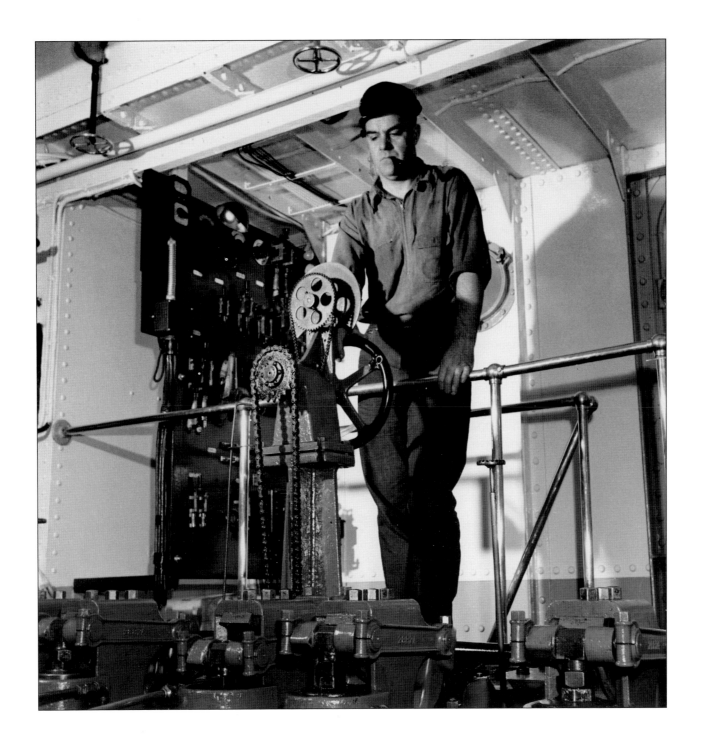

The idea for the engine was patented in 1892 and, two years later, a prototype ran for a minute, or a total of eighty-eight revolutions.[1] Development proceeded slowly, but by 1898 the engine had been successfully licensed to builders in England, Continental Europe, and the United States. Rudolph Diesel became celebrated and, for a time, wealthy; but licensing disputes and a number of disastrous investments led to his ruination. On the night of September 29, 1913, while on a passage from Antwerp to London, Rudolph Diesel committed suicide by jumping from the stern of the steamship *Dresden*.

The simplicity and efficiency of the diesel engine quickly endeared it to those who applied it to stationary purposes such as pumping, electrical generation, or in manufacturing applications where power was transmitted through factory buildings by shaft and belt systems. But these sorts of installation were far less complicated than those needed for transportation purposes. A stationary engine is required to run at a single steady speed and in only one direction, whereas an engine intended for vehicular, locomotive, or marine propulsion must be both reversible in direction and variable in speed. Lightweight applications such as automobiles and small boats could achieve reverse operation by means of gearbox and clutch arrangements, but these early transmission systems were inadequate to handle the heavy loads of railroading and marine towing.

The first effective solution to these problems was the development of diesel-electric propulsion. On a tug operating under this system one or more diesel engines power electrical generators, which in turn operate a large electric motor coupled to the tug's propeller shaft. The engines and generators are, in effect, a stationary unit just as in a factory, running always in the same direction. The speed and direction of the propulsion motor are controlled by electrical switching.

The diesel-electric system had several notable advantages:

1 Because the engine-generator units are separate from the propeller-shaft motor, they can be placed in the hull to best suit trim and stability requirements.

2 The drive motor used in diesel-electric installations is wired to deliver very high start-up power at low rpm. This characteristic is essential in both tugboat and railroad work, where heavy loads must be controlled precisely. In this important characteristic, diesel-electric drive compares favorably with steam.

3 The engine-generators in an installation may be assembled either as one unit or as several individual units. Two or more engine-generators contributing to the power demand of the drive motor permits an individual engine-generator to be shut down for servicing or repair without a full loss of power. It also allows the tug to operate on one engine when working at minimum load.

4 Because the speed and directional control of the drive motor is achieved through electrical switching, the controls can be mounted in the pilothouse, giving the pilot direct control of maneuvering.

Experiments with diesel-electric propulsion were conducted in Europe as early as 1906. The first wholehearted adoption of the method came with its adaptation to submarine propulsion. When running on the surface a submarine was able to power its shaft motor directly from its diesel generator; then, submerged and lacking sufficient air to operate the diesel, the shaft motor continued to draw power from storage batteries.

The first diesel-electric tug in the United States was the *Pennsylvania Railroad (PRR) No. 16*, built in 1924.[2] She was built of steel and intended for the medium-duty work of moving car floats and other marine equipment at the water margins of the rail yards and to and from city piers. She was virtually identical in size and purpose to the *PRR No. 10*, a traditional steam-powered boat. Detailed comparison of the performance of the two vessels showed them to be basically identical in the key areas of

speed as well as starting and stopping power.[3] The report notes that there was less physical work required of the engine-room personnel because there were no boilers to be tended, nor ashes to be hauled out, nor fresh supplies of fuel and boiler water to be taken daily. The report further states that the changed working conditions in the engine room could be met by "a better grade of men," which is code meaning that the perpetually troublesome firemen could be dispensed with. In every way the diesel-electric tug compared well to its steam-powered sister; and it was predicted that the new type would enjoy broad acceptance within the marine industry.

Also included in the study of the two Pennsylvania Railroad boats was a third, quite different type. This tug, named *Jumbo*, was slightly smaller, though—being of wooden construction— somewhat heavier than the two railroad tugs. She had been originally designed for steam power and had been built for the government at the end of World War I. By the close of the war she was not completed and was sold, without an engine, to the New London Ship & Engine Company (NELSECO). There, she was fitted with a diesel engine built by the New London firm. Upon completion, the innovative boat was purchased by the Cornell Steamboat Company.

The *Jumbo*'s engine was directly connected to the tug's propeller shaft, foregoing the electrical components of the *PRR No. 16*. There was no intermediary gearing or transmission of any sort; therefore, the tug's propeller was designed to turn at the same speed as the crankshaft of the engine itself, 202 revolutions per minute when running at full speed. By comparison, the steam-powered *PRR No. 10* ran at 118 rpm, and the diesel-electric *PRR No. 16* ran at 133 rpm. Though rated at about the same absolute horsepower as the other two boats, the greater speed of the *Jumbo*'s engine required that it be fitted with a propeller of less diameter and pitch. The No. 10 had a nine-foot wheel; the No. 16,

nine and a half feet; and the *Jumbo*, only seven and a half feet. Likewise, the pitch of the No. 10's wheel (the distance that one complete revolution of the propeller would carry it forward if the blades were carving through a perfectly yielding solid) was twelve and one-quarter feet; the No. 16, nine and one-third feet; and the *Jumbo*, only five and three-quarters feet. These deficiencies in the sizing of the *Jumbo*'s propeller compared to those of the other two boats translated directly into inferior performance in both starting and stopping a tow as well as in direct pulling power.

The relatively poor performance of the *Jumbo* came as no surprise. Seven years earlier the Pennsylvania Railroad had installed a direct-drive diesel engine in one of its boats but had quickly removed it. They had discovered that

> while the engine could be started, stopped and reversed satisfactorily, the wheel did not accelerate or retard the speed of the boat and its tow quickly and the maneuvering qualities were . . . sluggish . . . because of the relatively small diameter of the wheel inherent with the fast-running Diesel engine.[4]

The well-documented deficiencies of the direct-drive system were added to a list of other objections. Steam power was used aboard ship to do much more than simply spin the propeller. The towing winch, capstan, anchor windlass, steering engine, bilge, ballast and potable water pumps, ventilation fans, domestic heating, electric lighting, and last but not least, the whistle all were steam powered by means of auxiliary piping off the main boiler. To switch away from steam meant that alternative systems must be devised for each of these functions. The diesel-electric system promised that all of this could be accomplished electrically by borrowing power from the main generators. The direct-drive system offered no convenient solution. The only thing that the direct-drive installation produced other than rotary motion was

compressed air, which was used in early engine designs for fuel injection and for starting and reversing. But the compressed-air needs of the engine itself were small compared to the auxiliary demands of the entire vessel. Furthermore, compressed air is a very inefficient agent, subject to significant losses due to heating during pressurization and requiring complex, maintenance-hungry machinery both to produce and to employ.

The solution to providing auxiliary power in direct-drive installations was eventually found to be a mixture of electrical, hydraulic, and pneumatic (compressed air) power. One or more small auxiliary diesel engines have become standard engine-room equipment. An air compressor, a diesel-driven hydraulic pump, and a diesel-electrical generator all may run intermittently whenever a large tug is in service. Storage batteries may allow the generator to be shut down during times of low demand. Some tugs are fitted with generators that are driven by belt or chain attachment to the rotation of the propeller shaft itself. When the tug is underway on a long, steady tow this "tail shaft generator" may be brought on-line to relieve the auxiliary and battery systems. High-load devices such as the towing winch, capstan, or steering may be powered either electrically or by hydraulics.

Vessels of different types tied up at a South Street slip.

The *Lt. Chas. S. McHugh* was a sixty-two-foot diesel tug that was part of the four-boat fleet operated by John J. Mulqueen with offices at 15 N. Moore Street. Next to it is the *Defender*, whose home port was at Albany. At the left of the picture is a lighter barge with a watchman attending a deckload of large crates, at least one of which contains a Cadillac boxed up for shipment overseas. This lot of cargo was probably destined to go aboard the freighter *Eastern Guide*. Note that the ship has two of its cargo booms swung out over the slip to handle cargo brought to it by tug and barge. Photograph by Esther Bubley, November 1946, Special Collections, Photographic Archives, University of Louisville.

Another problem that had to be solved before direct diesel drive could be made workable was reversibility. For the diesel engine the precise timing of intake and exhaust valves and of fuel injection are critical. The engine's camshaft controls this timing. To run in one direction an engine must have one camshaft. To run in two directions an engine must have two different camshafts. To design two different camshafts into the same engine was a problem that had to be solved in order to achieve reversibility. As early as 1907 a solution to this problem was being tested in which a single camshaft was machined with forward and reverse lobes set side by side. By shifting the entire camshaft back and forth the appropriate set of lobes could be brought into play.[5] A second tactic was to shift the valve mechanisms from one set of lobes to the other. Refinement of these methods eventually led to reliable operation in either direction.

The control of the early direct-drive engine was complex. To shift from forward to reverse required a series of actions: First, the engine was stopped by cutting off the fuel supply to the cylinders. Then, once the engine had ceased to rotate in the forward direction, the camshaft or valve gear was repositioned either by hand or with the assistance of an air-pressure piston. The fuel supply was then restarted and compressed air was injected into whichever of the engine's cylinders held its piston in the best position to initiate the downward stroke of the reverse rotation. This involved process required that the various steps be performed in the engine room. Thus, the intentions of the man in the pilothouse had to be signaled to the engineer by the same system of bells as was used in steam navigation. In later years some direct-drive, direct-reversing engine models were refined to permit pilothouse control, but until well into the twentieth century the great advantage of pilothouse control could only be found in the diesel-electric method.

The other objection to direct-drive propulsion was that of the engines' high speed and the consequent reduction in propeller

size. As the comparative trials of the *Jumbo* and the two railroad boats demonstrated, a tug's effectiveness is derived not from its horsepower per se but from the way that horsepower is applied to the water under the boat. The challenge of obtaining the same thrust from a diesel engine as from steam was met by slow refinements of propeller design and hull form that improved the flow of water into and through the propeller's orbit.

Whatever the engineering challenges, the promise of direct-drive diesel was becoming obvious. Steam, for all its virtues romantic and otherwise, was grossly inefficient in terms of weight, fuel expense, and labor cost. Diesel-electric, though better on all these counts, was still problematic because of its elaborate equipment. It was also inherently inefficient because of the double conversion of the engine's rotary motion into electricity—the transmission of that power through wire to the drive motor, where it was converted back into rotary motion. The engine of the steam-powered *PRR No. 10* was rated at 715 horsepower, and, after losses to friction, was able to deliver 628 horsepower, or 88 percent of that power, to the propeller shaft. The diesel-electric *PRR No. 16*'s two generating engines were estimated at 1,175 horsepower, of which the propeller shaft received only 646 horsepower, or 55 percent. The *Jumbo,* for all its relative deficiencies, achieved 78 percent mechanical efficiency with indicated horsepower of 643 and shaft horsepower of 502. The first Pennsylvania Railroad tug to receive a direct-drive diesel engine in 1917 had been a total failure, while the *Jumbo* and her running mate *Lion*—an identical government boat finished out at

New London in 1920 and also operated by Cornell—had satisfactory careers spanning thirty and twenty-seven years, respectively.

Although all New York tug operators were alert to the potential of diesel power, some were more inclined to adopt it than others. Companies that specialized in ship docking stayed away from diesel because steam still offered the best absolute power when dealing with the dead weight of a ship. On the other hand, companies specializing in dredging, dock building, and salvage work tended to be attracted to diesel because tugs working in these businesses are often kept in a standby condition, fully crewed and attending a dredge, a crane, or other operations that might only need to be moved several times during the day. A steam tug engaged in this work was required to keep steam in its boiler all day for only a small amount of actual work. A diesel boat, on the other hand, only burns fuel when actually needed. Tugs that operated on the New York State Barge Canal—the successor to the Erie—were attracted to diesel because there were limited opportunities to purchase coal along the canal. To travel the long distances between coaling stops, steam-powered canal tugs with slow-moving tows were obliged to completely fill their bunkers below deck and then continue to pile up coal on deck until the crew had to skip along the deck railings to get from bow to stern. The owner/operators of single boats seem to have been particularly attracted to diesel power, presumably because they could operate with an absolute minimum of crew, which greatly simplified their management chores and lessened their vulnerability to union organizing. Also, diesel power exempted owners from the cost and potential loss of business stemming from boiler inspections. Although most owners of single boats operated on a shoestring, they also tended to be very shrewd and frugal small businessmen. They were quick to recognize the savings in overhead expense offered by diesel power.

For most of the larger towing companies the decision to try out the diesel engine was one to put off as long as possible. An already

This is the engine room of the diesel tug *Russell No. 10*, built in 1958 by the Jacobsen Shipyard in Oyster Bay, New York. Shown is a sixteen-cylinder General Motors engine rated at 1,640 horsepower. The No. 10 was owned by the Newtown Creek Towing Company and was the last boat built by them. In 1961 Newtown Creek sold the boat to McAllister. Steamship Historical Society of America Collections, Langsdale Library, University of Baltimore.

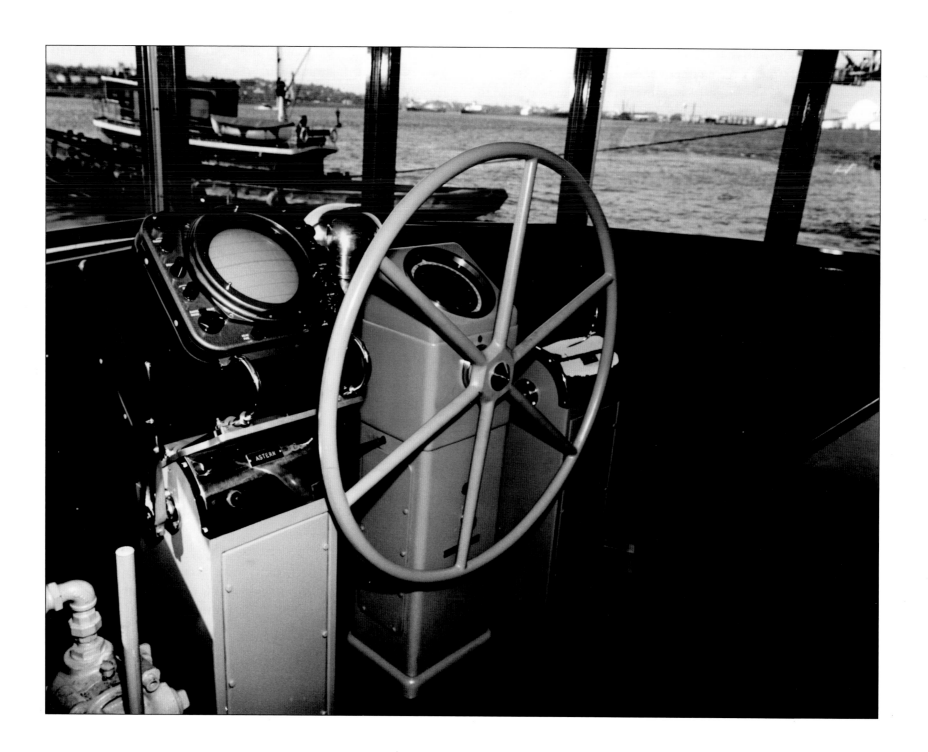

existing, well run-in steamboat could still make money. The cost of new construction or even the conversion of an existing boat could not be justified on the basis of day-to-day operations but instead had to be rationalized as a long-term investment. Because of the dissimilarities in the power generated, many owners were reluctant to convert from steam to diesel for fear that their customers would feel they were being provided with inferior service. Even companies that were forward looking enough to equip with diesel boats made little effort to advertise the fact. Some even went so far as to build or convert to diesel but disguise the fact by retaining the tall smokestack that was the most obvious characteristic of a steamboat but was utterly unnecessary with diesel power.[6]

Nevertheless, by 1929 there were seventy-four privately operated diesel tugs in New York Harbor and the Hudson River.[7] This amounted to 11 percent of the privately owned fleet. It appears that none were diesel-electric. Among the 159 railroad tugs in the harbor there were eight diesel-electric boats and one direct-drive.

In addition to these there were perhaps forty to fifty small gasoline-powered boats, usually less than forty-five feet long and employed in light shifting or in launch and lighterage tasks. Many, though listed as towing vessels, were part of the infamous fleet of junk boats and launches that prowled the harbor looking for goods and equipment either cast off or able to be taken off. These piratical craft were suspect in all sorts of mischief and were eventually forbidden to operate at night. But they contrived a livelihood for their owners by hook or by crook. One tactic was to sneak alongside a long tow of coal barges and shovel off a boatload. They also frequently targeted barges moored in the Lower Bay that were being used as platforms for burning the insulation from scrap electrical wire. Junk-boat men would sneak alongside the still-smoldering horde of valuable copper, heave a grappling hook onto the pile, and rake off as much as they could. At least one shady master came to grief when a massive coil of hot wire tumbled down, killing him and sending his boat to the bottom. These small gasoline-powered boats remained common in the harbor until small, inexpensive diesel engines became increasingly available at the end of World War II. The boatmen themselves disappeared from the waterfront only when the opportunity for small-scale employment dwindled to nothing in the 1960s.

By 1938, 26 percent of the privately owned tugs in the harbor were diesel powered, 159 boats in all, of which two were diesel-electric, both owned by Moran.[8] The railroads operated 187 tugs, of which fourteen were diesel-electric and eight were direct-drive. By 1955, 74 percent of private tugs were diesel powered. There were 136 railroad boats, of which twenty were diesel-electric and three direct-drive.[9] By 1976, 100 percent of private tugs were diesel powered. There were a handful of diesel railroad boats working for the Cross Harbor, New York Dock, and Brooklyn Eastern District Terminal companies; but all the great trunk-line fleets were gone. A scattering of diesel-electric boats—mostly resold railroad equipment—continued to operate. There were no steam tugs left.[10]

The pilothouse of the *Russell No. 10*. The pedestal on which the helm is mounted contains a gyrocompass, and a radar display is mounted next to it. Forward and reverse throttle controls stand on both sides of the wheel so that the captain can control the engine from whichever side of the pilothouse he may be standing. The tug would also have been equipped with an aft control station on the back end of the deckhouse roof, and that is apparently where the captain is working when this picture was taken, for the tug is in the middle of a job. Outside the pilothouse window, the *Russell No. 10*'s working partner can be seen with a short hawser angling sharply upward to what is most likely the deck of a ship being docked. Her captain can be seen working at the aft station, from which he can best see what is happening. Steamship Historical Society of America Collections, Langsdale Library, University of Baltimore.

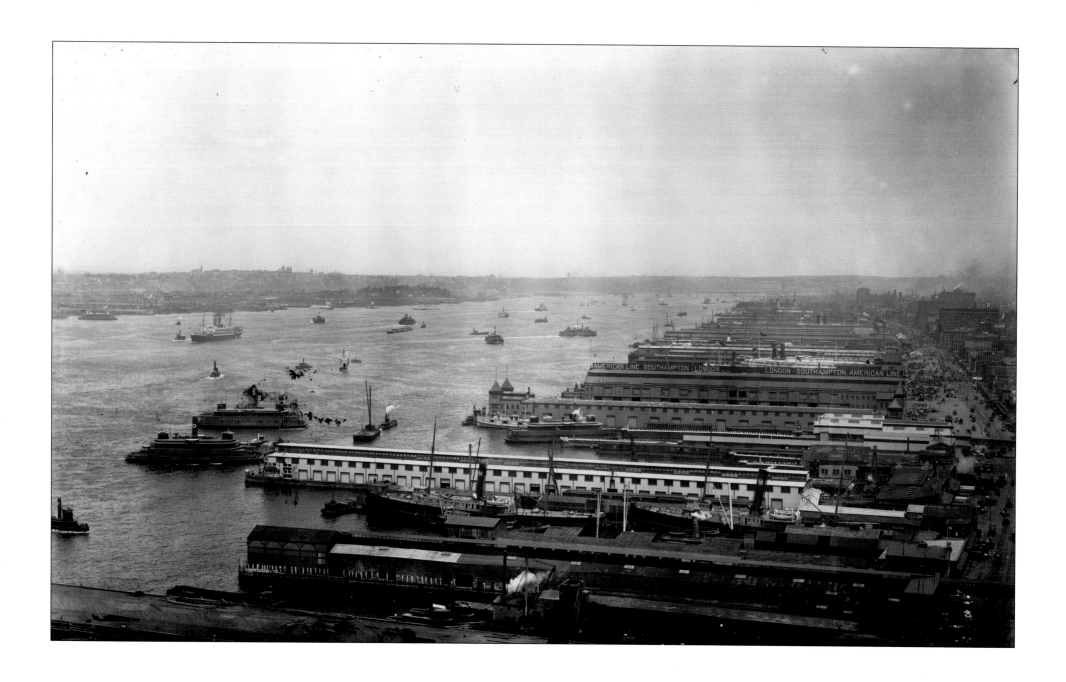

18

The Ebb Begins

The tide comes in, then the tide goes out. For New York Harbor tugboats, the tide turned in 1929. The obvious cause was, of course, the onset of the Great Depression—that climactic bursting of a financial bubble. A superficial examination of the dramatic rise and precipitous decline in the size of the port's fleet of tugs may suggest that this was the bursting of a bubble as well. But the concept of a bubble is that, for all of the thing's size, it is really nothing more than a mesmerizing veneer. When it bursts it reveals that there is nothing there—and that, perhaps, there never was anything there. This is certainly not the case with the tugs. Every one of them was built for a purpose, worked a long, arduous career, and was then retired. The towing industry powered up with the rising tide of the nineteenth century and then powered back down with the efficiencies of the twentieth. To put it more fancifully, the boats steamed their way up then dieseled back down.

Up until 1929 the port's oceanborne foreign trade had been steadily rising to a peak of better than 27 million long tons per year.[1] By 1933, four years into the Depression, that figure had been cut in half. The setback continued until the run-up to World War II, when, in 1941, lend-lease and domestic military preparations catapulted the trade figures back up to 31 million tons, only to crash again with the outbreak of hostilities. Not until 1943 did deep-sea trade into and out of New York again achieve the level

This 1904 panoramic view of West Street and the Hudson River shows the mighty scale of commerce and traffic in the Port of New York at the beginning of the twentieth century. Ferries tangle with tugs, lighters, and scows. Steamers line the wharves, and out in the middle of the river a lone sailing lighter makes its way downstream. Collection of the New-York Historical Society, neg. 56570.

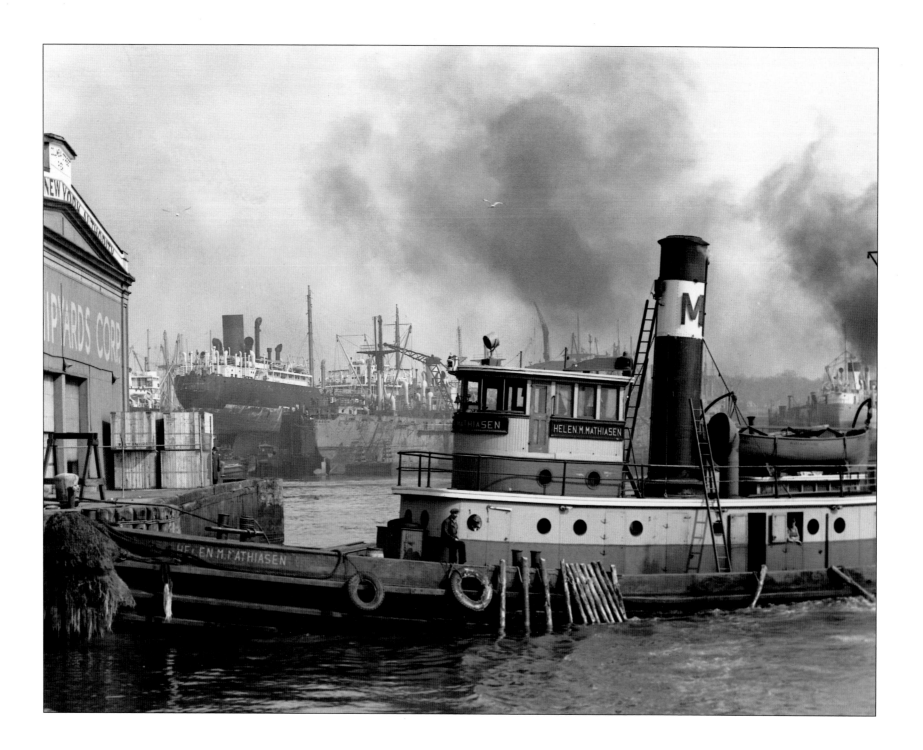

that it had reached in 1929, fourteen years earlier. It was an exceedingly difficult period for New York's towing interests.

But there had been hard times before. The post–Civil War period had seen a combination of circumstances that produced an oversupply of boats and a flattening of towing-business activity. Towing prices had deflated markedly, and the number of boats in the harbor had remained more or less constant from 1890 to 1917. Then the business had recovered. Between 1917 and 1929, the size of the fleet expanded by almost two hundred boats. After 1929, in hard times, the fleet numbers dropped without any sign of recovery. Meanwhile, however, New York's oceanborne foreign trade rebounded substantially. By 1968 it had reached about double the volume of 1929. But the towing industry seemed to enjoy no benefit.

The answer, of course, is that the well-being of the New York Harbor towing industry is dependent on a far broader universe of economic activity than just foreign trade. The industry had established itself as a vital service not just to shipping but to a far more expansive constellation of New York industries. Alas, after 1929, the individual stars of that mighty constellation were winking out.

◄─────────────────────────────────

Tug at Port of New York Authority pier at the foot of Columbia Street in South Brooklyn. Todd Shipyards and dry dock in background.

The *Helen M. Mathiasen* was built at Camden, New Jersey, in 1882 as the *Emma Kate Ross*. She later served in the Russell fleet as the *No. 5*. She is a strangely proportioned tug with very low freeboard and an extraordinarily extensive foredeck. Her odd appearance may be the result of her deckhouse having been rebuilt at some point. Note that the door out the side of her pilothouse leads to nowhere. Most of the fendering along her side is composed of the old-fashioned wooden staves with a couple truck tires mixed in. In the beginning, when tugs and barges were all built of wood, the wear and tear of one on the other was evenly shared. As iron and steel construction appeared, wooden hulls were increasingly disadvantaged. The ever-increasing horsepower of tugs during the twentieth century eventually made wooden construction entirely obsolete and, furthermore, required the development of ever more sophisticated fendering systems. Photograph by Todd Webb, March 1947, Special Collections, Photographic Archives, University of Louisville.

The most important loss was coastal trade. Since colonial times, New York had drawn a large proportion of its revenues from interport trade along the East and Gulf coasts. This interstate marine traffic had, in turn, contributed to the flow of foreign trade through New York either as direct trans-shipment or as processed and manufactured products, which brought even more wealth to the city in "value added" form. Coastal trade to and from New York was hit hard by the onset of the Depression but by 1935 had recovered to a level of about six million tons annually.[2] But the beginning of World War II hit the trade even harder, reducing it to less than half a million tons in 1943. Even by 1960 coastal trade was teetering around a scant three million tons annually, half of what it had been before the war. The figures for coastal trade had a direct impact on the towing industry because a significant proportion of this trade had been conducted by tug and barge. The danger of coastal shipment during the war had forced the use of rail and truck systems. The majority of shippers simply never bothered to shift back to marine shipment after the war danger passed.

Passenger-ship traffic recovered to about one million passengers annually after the war but remained steady thereafter until 1963, when competition from the airlines initiated a steady decline in numbers that only in the 1980s was stabilized by the rise in popularity of the cruise-ship industry.[3]

The number of rail cars carrying goods for export that were unloaded annually at New York fell from 334,000 in 1946 to 62,000 in 1968.[4] The entire railroad marine system for which the port had become famous had fallen into a state of collapse. Indeed, the railroad empire was put out of its misery entirely in 1976 when Conrail took over the ailing trunk-line carriers and discontinued all lighterage. The cause and certainly the greatest beneficiary of the departure of the railroads from the port was the trucking industry. Containerization of cargos, which had been initiated in 1956 by Malcolm McLean of the Pan-Atlantic Steamship Company (soon renamed Sea-Land), provided an utterly efficient linkage between

water and land transportation modes. It spurred the removal of all shipping activity from the Manhattan waterfront to the newly developed waterfront terminals in Newark Bay—Port Newark and Port Elizabeth—which had ample real estate available for sorting and storing containers and which was adjacent to the New Jersey interstate highways. The greatest effect of the shift to containers was felt by the corps of longshoremen, whose ranks have been reduced by about 90 percent between 1970 and today. There was a far lesser immediate effect on the towing industry because, other than railroad marine operations, relatively little of the ocean import/export traffic was handled by tug and barge lighterage. The container revolution was, however, symptomatic of a major advance in the pace and streamlining of port operations, a trend that the tugboat fleet was obliged to match if it was to survive.

The extreme difficulties that New York suffered after the Depression were not shared by other Atlantic ports. Although New York still handled by far the greatest amount of East Coast shipping, its growth was drastically stunted while other ports expanded rapidly. While total activity in the Port of New York increased by a modest 59 percent between 1935 and 1956, Philadelphia surged by 276 percent, Baltimore by 198 percent, Norfolk by 214 percent, and New Orleans by 293 percent.[5] Shippers increasingly sought alternatives to New York as its well-known reputation for costliness, inefficiency, waterfront crime, and labor unrest spread. At the same time, New York towing companies began to eye the booming conditions in those other East Coast ports as a potential alternative to the stagnant situation in home waters. Soon the largest New York firms had as many boats stationed outside New York as within.

The relative decline of New York as a national and international port was only a part of the problem for the tugboat fleet. There were also local changes that altered customary transportation practices that had endured for generations. A vast traffic of raw materials for the building and maintenance of the city—

stone, sand, cement, and brick—had traveled down the Hudson and in from Long Island Sound. Block ice, cut in winter from upstate lakes and from the surface of the Hudson itself, was an essential element of the city's survival. By the end of the nineteenth century virtually all these vital materials came to the city by tug and barge.

In 1906 there were 131 brick-making companies situated along the Hudson River.[6] In that year they produced 1.3 billion bricks, and almost all of them went down the river to New York City. A large brick scow could accommodate about 350,000 bricks, which suggests that about 3,700 brick scows were towed to New York and then returned upriver in that year. This was the peak of what had been a thriving industry in the Hudson Valley since the mid-seventeenth century. The industry had been propelled by the steady building out of New York City, but both the pace and the nature of that growth began to change.

The principal virtue of Hudson River brick was that it was made close to the city and that it could be conveniently transported there by water. In most other respects, it was an inferior product, made from limestone-contaminated clay that could not be fired sufficiently to make it fully strong or weathertight. As the sophistication of architecture and engineering increased, Hudson River brick fell out of favor. By 1927, cement blocks—each the equivalent of twelve bricks—were the material of

The *Callanan No. 1*, a World War II–vintage U.S. Army small tug (ST), prepares to land a string of six loaded sand barges. Three men are waiting on the foredeck of the lead barge, two others can be seen on the stern of the tug, and one stands at the aft control station on the deckhouse roof. The problem of landing a long, unwieldy tow such as this is not all that difficult so long as the tug is working against the flow of the tidal current. By idling ahead, the tug can keep the barges strung out behind itself while holding position relative to the shore. Delicate steering and throttle control will bring the tow gently into the landing. Steamship Historical Society of America Collections, Langsdale Library, University of Baltimore.

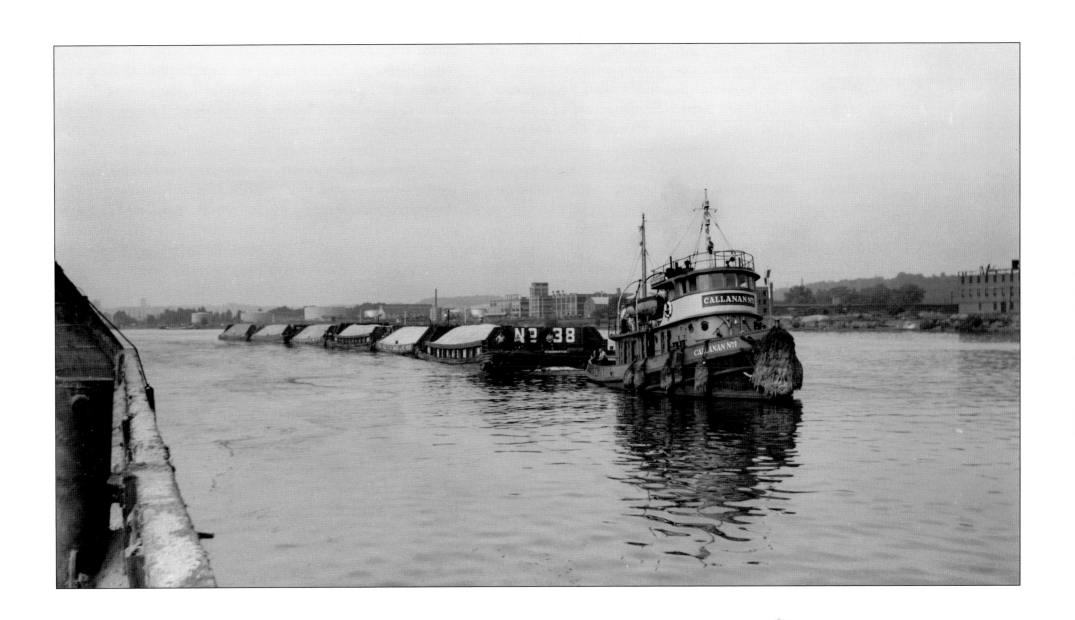

choice for common purposes. Higher-quality brick used for exterior wall facing was still in demand; but the Hudson River yards could not readily produce this grade of product and lost business to yards in North Carolina and even in Belgium. Increasingly, the transportation of brick relied on rail and trucking from the makers' yards direct to building contractors rather than to wholesale distributors situated along the city waterfront. The Depression, of course, cut heavily into the business; and World War II brought a complete closure, as it was deemed a nonessential industry. By the mid-1950s the business was only a remnant, surviving in a hand-to-mouth fashion by virtue of individual building projects such as Stuyvesant Town and Peter Cooper Village. The last Hudson River brickyard closed in 1979.

The Hudson River ice business, which in its heyday had involved the towing of perhaps eighty barges per week to and from the city, disappeared rapidly after about 1910 when mechanical refrigeration began to dominate the production of block ice.

Another mainstay of the towing industry was the barging of sand from Long Island into the city. All along the North Shore between Glen Cove and Mount Sinai, sand-mining operations sprang up after 1870 to supply material for New York City construction. The two largest operations were conducted at Port Washington and Port Jefferson. By 1930, Port Washington alone had supplied 100 million tons of sand to the city. This quantity, if poured over the Empire State Building, would completely cover it and extend in a conical pile south to Washington Square Park, north to 59th Street, and east and west to the banks of both rivers.[7] If this gigantic sand pile were combined with all the sand barged from other Long Island ports and then topped with all the brick, stone, gravel, cement, and ice from the Hudson, the city would be completely buried. But there is more. Millions of tons of coal were brought by barge to the city to be burned and the ashes then hauled away by barge. Countless tons of garbage, construction debris, and dredge spoil accompanied those ashes either to dumping grounds at sea or to landfills. An astonishing amount of very mundane material was moved locally by tug and barge during the first half of the twentieth century. This vast local traffic supported the majority of the harbor's tugs. As these local trades began to diminish with the final building out of the city and with permanent changes in methods of transportation, the fleet was forced into contraction.

And as the fleet contracted, it also began to consolidate. It is apparent that during the formative years of the towing industry, from the 1830s to the 1880s, profit margins were such that an owner of one or a few boats could survive and prosper. Toward the end of the nineteenth century, margins began to tighten; the earlier entrepreneurs left the scene, and a more incremental style of business developed. This style featured the careful nurture of customers and business territory and the careful accumulation of boats chosen for specific types of work. With ever-increasing competition for a shrinking pool of available work, owners were obliged to maintain a fleet big enough to guarantee boats to meet all customers' demand. If a boat were not ready to fill an order, the customer would be obliged to take his business elsewhere and might never return. The operational overhead of boats became critical as unionization brought ever higher labor costs. The savings in operating cost and crew size offered by conversion of coal-fired steamboats to oil and, ultimately, by conversion to diesel power offset much of this overhead pressure; but these conversions were costly and tended to be beyond the reach of small, low-profit operators. Only the most prosperous were able to take advantage of modernization, which in turn enhanced their prosperity.

The proceeds from the toil of any one vessel became less and less significant to a company's overall profitability. From the start of the twentieth century the small operators began to disappear, while several of the larger companies aggressively expanded. In 1916 the average fleet size (the average number of tugs under the ownership of one operator or company) was 3.2 boats.

By 1952 that figure had grown to 5.5, and by 2002 to 7.9. And even as these fleet averages were rising, the overall number of owners, companies, and vessels was rapidly diminishing. For example, in 1916 there were sixty-four single-boat operators and forty-eight two- and three-boat operators. By 2002 there were only six of each.[8]

With increased fleet size representing the best chance for survival, two methods toward this goal emerged. The first method was by new construction or purchase of individual boats either from within the harbor or from other ports. The second method was by merger or acquisition of local competitors. Although using one method in no way precluded an operator from also using the other method, certain companies developed a reputation for one or the other. The different experiences of two prominent modern companies, Moran and McAllister, make for useful comparison.

Michael Moran, the founder of Moran Towing & Transportation, favored new construction because it resulted in modern, low-maintenance equipment that enhanced the company's reputation. Also, the new, high-quality vessels represented valuable assets that could be resold profitably if business conditions warranted. Even in the mid-1930s, when business conditions were dreadful, the Moran Company embarked on a building program in which new, all-welded-steel tugs, equipped with modern diesel power, were built for oil-delivery work on the New York State Barge Canal. Most of the financing for this program came on favorable terms from the General Motors Corporation, which was eager to establish the reputation of its large marine engines.[9] By 1941 Moran's fleet had eleven diesel tugs ranging from 600 to 1,900 horsepower. After World War II, the company moved rapidly to rebuild its entire fleet with diesel power.

This is not to say that Moran did not make its share of acquisitions. The fleets of Dauntless, Olsen, Amboy, Barrett, John E. Moore, Oil Transfer, Meseck, and Turecamo have fallen into Moran's possession since the 1920s.

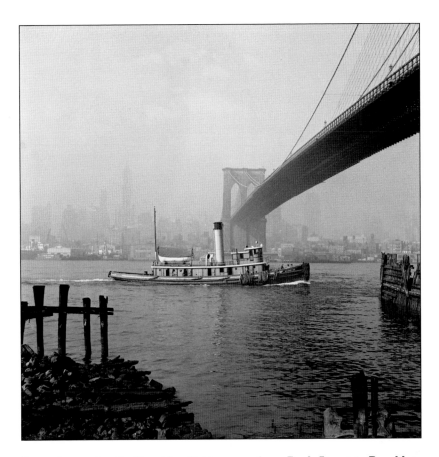

Tug going under the Brooklyn Bridge seen from Dock Street in Brooklyn. The tug is the *Augustine,* part of the Meseck Towing Line. Originally named the *Sea King,* she was built at Baltimore in 1908. Photograph by Esther Bubley, November 1946, Special Collections, Photographic Archives, University of Louisville.

McAllister Brothers, on the other hand, favored the acquisition of competitors over new construction. Their rationale was that each acquisition, if properly executed, would result in the expansion of their own fleet at a favorable cost and, at the same time, a significant reduction in direct competition. The acquired company typically brought with it a list of customers, which might

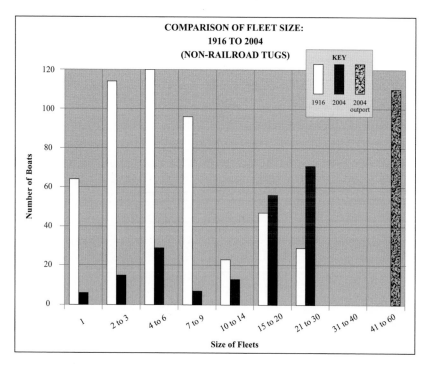

**COMPARISON OF FLEET SIZE:
1916 TO 2004
(NON-RAILROAD TUGS)**

KEY

1916 2004 2004 outport

Number of Boats

Size of Fleets

1 · 2 to 3 · 4 to 6 · 7 to 9 · 10 to 14 · 15 to 20 · 21 to 30 · 31 to 40 · 41 to 60

In 1916 the great majority of tugboats were owned either singly or in fleets of less than ten boats. In 2004 most tugs are owned in fleets of fifteen to thirty boats, and many of these fleet owners also maintain substantial numbers of boats in other East Coast ports.

have been the most valuable element of the deal. To retain the loyalty of the acquired customers it was not unusual for one or more of the principals of the acquired company to move into the offices or the board room of the acquirer. These arrangements were usually more symbolic than real, particularly in companies that were family owned, which tended to be exclusive toward outsiders.

Typically, a newly acquired fleet of tugs was sorted through and the better boats retained, while old or unsuitable boats were retired. Retirement might take the form either of outright scrapping or of resale, often to interests outside the harbor and with covenants attached that prevented the boat from ever again becoming a McAllister competitor. The boats that McAllister re-

tained were typically sound and efficient boats; but because they were acquired over time and from various sources, they gave the McAllister fleet a somewhat old-fashioned, vaguely miscellaneous appearance. To counter this tendency McAllister for a time refitted all its boats with a distinctive, modern-looking smokestack decorated with the company's emblem of two white horizontal stripes. Among McAllister's many conquests were Stanwood, Canal-Lakes Towing, the towing operations of the Southern Transportation Company, Card, Hudson Towboat, Lee & Simmons, Manhattan Lighterage, and Newtown Creek Towing, which included the Harlem River and Russell Brothers interests. In 1965 McAllister also acquired the Dalzell Towing Line, which itself had earlier swallowed the Downer, Carroll, Tice, and Mathiasen lines. The short-lived Lacey Line was spun off from the Dalzell takeover, briefly operated independently, and then reabsorbed by McAllister.

A side-effect of the acquisition tactic was that the acquiring company might not only gain good-quality used equipment, it might also gain highly experienced personnel. Through its acquisition of Dalzell, McAllister catapulted itself into the front ranks of the ship-docking business, not so much by gaining possession of the Dalzell fleet—which consisted of fourteen boats—but by acquiring Dalzell's cadre of captains and docking pilots, who were widely acknowledged to be the best in the business.

Another valuable asset that might be acquired was Federal Interstate Commerce Commission licenses that had been granted to companies to permit transport of cargo over certain routes. The possession of these licenses represented an exclusive source of work that was even more secure than the acquisition of a company's customer base.

The tug *Dalzellaird* runs light through driving snow. Library of Congress, Prints & Photographs Division, *World Telegram & Sun* Collection.

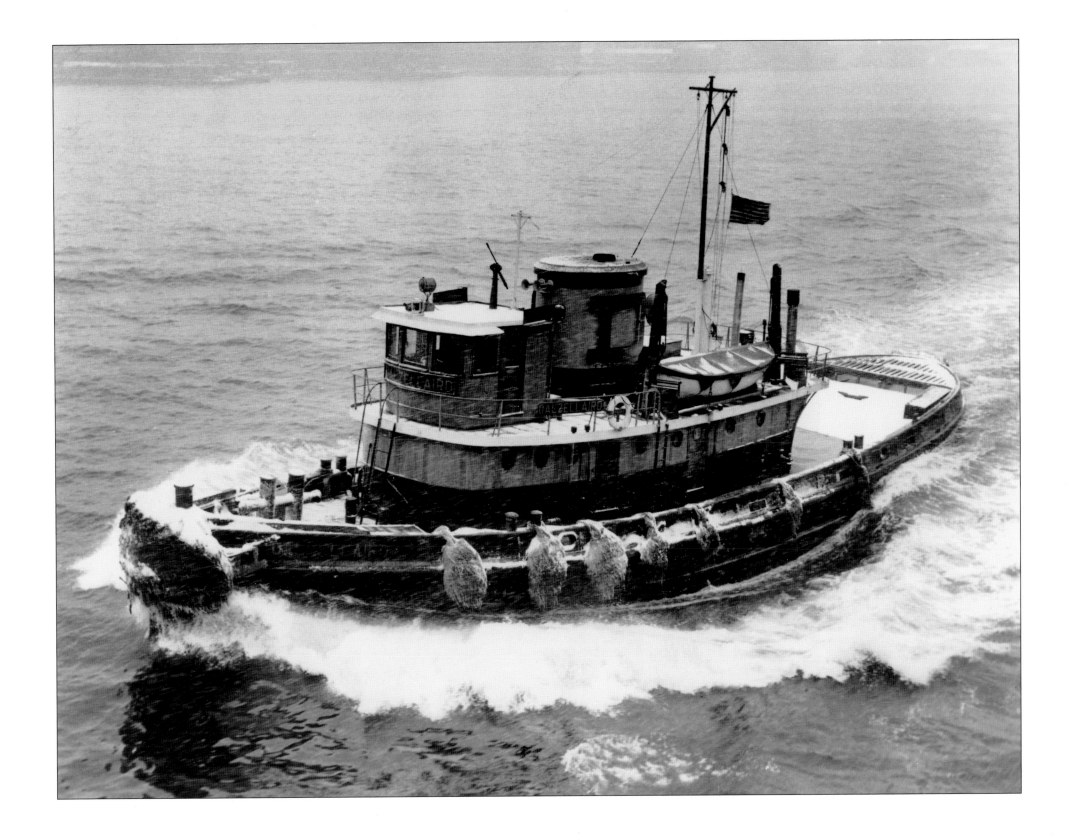

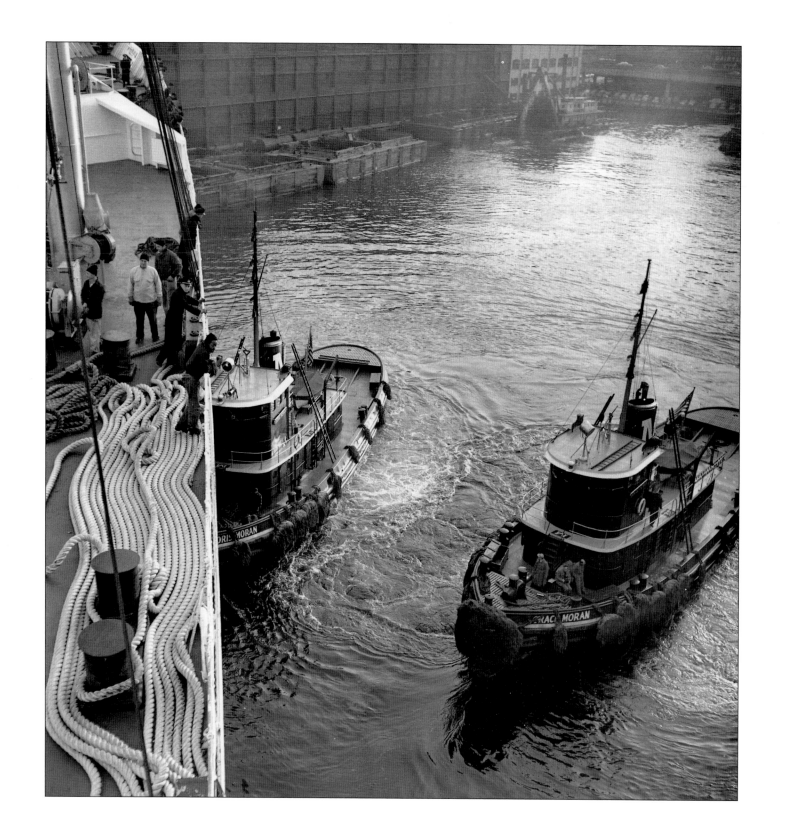

19

Towing in a New Century

By the midpoint of the twentieth century, New York Harbor had reached a state of economic and business maturity that made it unlikely ground for entrepreneurial ambitions in shipping in general and in tugboating in particular. Faced with a shrinking customer base, ever-higher operating costs, and ever more virulent competition from the trucking industry, most towing companies were forced into a defensive posture—conserving aging boats, cutting costs wherever possible, and struggling to hang on to dwindling sources of income. As the transport of raw materials diminished, the once-busy shorelines of Newtown Creek and the Gowanus Canal began to grow quiet. Companies such as Russell Brothers and Hugh Bond's Gowanus Towing, which had held the towing on these tributaries as strong profit centers, now had to look for work out in the broader waters of the harbor itself. There, they fell into direct competition with the major companies; and there they were consumed. Harbor businesses with aging steam equipment could not compete. Towers who clung to the towage of diminishing commodities such as brick, ice, and coal found themselves slowly wasting away. The general contraction of business in the harbor struck hard in the ranks of towing companies. Many went under, many merged, all were worried, and a few were clever enough to survive.

Survival depended on finding work. Taking it away from others was always a possibility, but because most tug service is acquired

Twin sisters *Grace Moran* and *Doris Moran* team up on the bow of a ship, sailing it from its North River pier. The *Grace* and the *Doris* were built in 1949. Each was 1,750 horsepower with diesel electric propulsion. Photograph by John Vachon, Library of Congress, Prints & Photographs Division, *Look* Collection.

THE NEW YORK FLEET

1857 to 2004

by competitive bidding, relentless internal competition for already-existing work tends to impoverish everyone by driving down prices excessively. The best hope of survival for the New York Harbor fleet was to somehow find new areas of business where competition was less stifling. Much as the coastal towage of coal had served as a rejuvenator to the harbor in the 1890s, the surviving companies of the late twentieth century began to look outside New York Harbor for relief.

Through dogged competition and careful acquisition Moran, McAllister, and Turecamo each had accumulated a solid list of customers within the harbor, among which were shipping companies that conducted operations in other American ports. Faced with cramped conditions in home waters they began to expand their ship-docking services into these other ports using their already-existing New York customer base as leverage. The presumed good will of their existing New York customers afforded the intruders a leg up on local operators. Today, Moran has fifty-seven boats stationed at twelve ports between Texas and New

Hampshire. McAllister has fifty-three boats stationed at nine East Coast ports. If these distant squadrons are included in the calculation of the average fleet size of New York companies in 2004, as discussed in chapter 18, the figure rises from 7.9 to 12.0.[1]

But ship-docking service is certainly not the only source of business. Each of New York's major companies maintains tugs intended for the transport of petroleum products, chemicals, and dry bulk materials such as coal for power plants and bulk cement from the few still-operating Hudson River plants. Although both Moran and McAllister operate small fleets of barges suited to these trades, most of the commodities towing done by their tugs is performed under contract to tow barges owned by the commodities firms themselves. Often the tugs are engaged in this work under long-term charter agreements, which result in the tug being painted over to the colors of the chartering company.

In addition to the few tugs chartered from the general towing firms, many of the commodities firms operate their own fleets of tugs to fulfill the bulk of their towing needs. Early in the twentieth century the main fleets of these "captive" vessels were owned by the railroads, of course, as well as companies that shipped bulk commodities such as coal, gypsum, ice, and sugar over coastal routes. Several of the larger shipping lines also maintained their own tugs at their New York terminals to handle both ship docking and their supply and lighterage towing. Of the 620 tugs operating in New York in 1916, at least 314 may be characterized as captive. Today, of the 208 towing vessels in New York, about 108 are captive. But even if their proportion has remained stable over this period of time, the occupations of these captive vessels have changed significantly.

Oil transportation makes up by far the largest group of captive tugs, with seventy-two vessels currently engaged exclusively in that work. Until recently the major oil companies maintained their own tugs. Exxon, Mobil, Sun, Texaco, Gulf, and Hess all had fleets to deliver their own products. Since the *Exxon Valdez* dis-

aster and the realization that the potential liabilities of transporting oil could overwhelm an entire corporation, the oil companies have avoided the transportation business, shifting the work to already-existing or else newly constituted transporters. Two of the older, well-established oil-transportation firms in the harbor, Bouchard Transportation Company and Reinauer Transportation Company, have benefited immensely from this development. A third company, K-SEA (which was reconstituted from the ruins of an earlier firm that was ruined by a major spill on the Rhode Island coast in 1996) has also increased rapidly in both size and sophistication. Combined, these three companies operate fifty-six tugs, with a total of roughly a quarter of a million horsepower. With these boats and others hired from private towing firms they operate ninety-five tank barges, with a total capacity of over 7.3 million barrels. Added to these three fleets is a fourth, Penn Maritime, which specializes in transporting heated asphalt products using fourteen tugs and twenty barges.

Oil transportation is extremely demanding. A small spill of even a few gallons can immobilize a tug and barge for days while cleanup and investigations are conducted. A large spill can devastate an entire region and drive companies and their insurers into ruin. Tremendous fines and in some cases the threat of prison result from incidents that thirty years ago would have gone unnoticed. The demands of this new climate have produced an extremely conscientious group of operators. In turn, the design, construction, operation, and manning of the tugs and barges has become ever more sophisticated. Twin-screw tugs are now required. Double-hulled barges will be required in 2005.

But in addition to these requirements imposed by governmental agencies and insurers, the operators themselves are voluntarily embarking on modernization programs to boost safety and efficiency. The power, seaworthiness, and maneuverability of the modern oil-transportation tugs are extraordinary. Eight thousand horsepower divided between two engines and delivered by way of

Townsend Carman, mate on *Esso Tug No. 7*, weaves a new bumper mat for the bow of the tug.

Today's bow fenders are made of rubber, either extruded especially for the purpose or made up of strips cut from truck tires. Before these were available, fenders were made from used rope. A coil or multiple lengths of manila were bound together and then covered with a woven jacket of rope. Over these bow fenders it was customary to spread a woven rope mat into the surface of which were tied long hanks of rope threads. These whiskers, as they were called, added padding to the bow fender, but more importantly they increased the surface area of the bow when it was pushed against the side of a ship or a barge. This helped to keep the bow from sliding along the side of the object being worked against.

Mr. Carman is apparently working below decks in the forward storeroom under the bow deck of the tug. He has finished the basic weaving of the mat and is just starting the job of working in the whiskers. Once completed and lashed over the bow it should survive three or four years of heavy use. Photograph by Sol Libsohn, December 1947, Special Collections, Photographic Archives, University of Louisville.

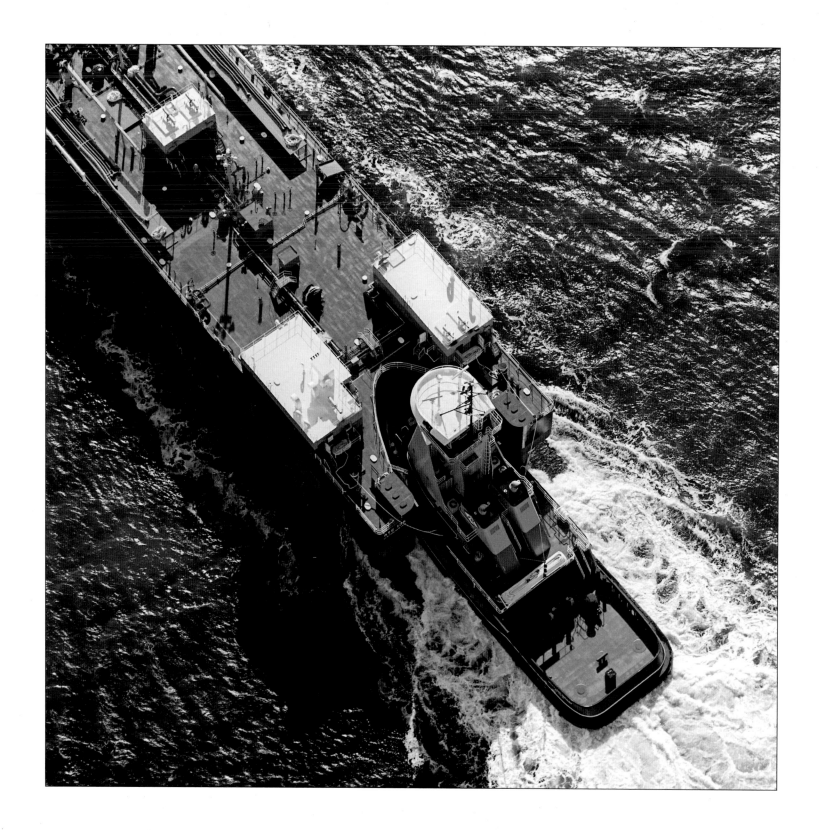

twelve-foot-diameter, five-bladed propellers are packed into a boat of less than 150 feet, manned by a crew of seven—captain, mate, cargo mate, two able-bodied seamen, an engineer, and an assistant engineer. Assigned to a barge nearly 500 feet long and carrying almost 150,000 barrels of petroleum, these tugs are capable of maintaining speeds of about fourteen knots light and thirteen knots loaded when pushing ahead. And pushing ahead is about all they ever do.

Pushing a barge has always been dependent on relatively calm sea conditions. To enable the tug and tow to push in rougher seas the stern notches in the barges have become ever deeper and ever more carefully designed to snugly fit the shape of the tug's bow. The need to match a barge to its tug has resulted in many tug and barge combinations being designed and built specifically for each other; and their careers may be spent entirely in each other's company.

But no matter how neat the fit, the traditional method has a fatal limitation. In a rough enough sea or in a hard enough turn the face wires holding the tug into the stern of the barge can break, which may cause the tow to jackknife and may capsize the tug. The risk of parting a wire while making a hard turn can be minimized by reducing power on the tug as the turn is initiated, but the risk inherent in rough seas cannot be so easily avoided. Until recently tug masters have been obliged to shift to hawser towing whenever they expect rough weather. Weather and sea conditions on many coastal routes are treacherous enough that pushing is never attempted, even if the weather forecast promises ideal conditions. To break away from a pushed barge in worsening sea conditions and to then have to get the barge set up on the hawser is not worth the risk. But routinely shifting back and forth between pushing and hawser modes is laborious, time consuming, and like all heavy marine work, dangerous.

Recently, the ability to push in virtually any weather has been achieved by a variety of systems that allow the tug and barge to make their attachment solely in the notch at the stern of the barge. One system locks the very bow of the tug into the apex of the barge notch. Another relies on massive steel pins of as much as five-foot diameter, which are housed in the tug's hull at a distance of about one-third of the hull length from the bow. Each pin is extended into a socket in the notch walls of the barge. Multiple sockets are arranged vertically, like a ladder, so that the pins will find an insertion point whether the barge is loaded down, light, or at any stage in between. The pins, combined with the precise fit of the bow of the tug to the barge notch, allow the two vessels to function as one—with one essential difference. Because the two are secured to each other at one horizontal axis they are permitted to ride over the waves as if hinged. This hinging or articulating ability relieves the greatest source of strain on a vessel in rough weather. The see-saw action of a vessel in high seas—pitching, as it is called—may alternately lift the bow then the stern clear of the water, putting enormous strain on the longitudinal integrity of the ship. In such a situation a tug attempting to push a barge by means of an entirely rigid connection, one that allows no freedom of motion, would be subjected to unendurable strain. The articulating system permits the tug to ride smoothly over the waves, keeping the weight and power of its stern in the water at all times.

These "articulated tug-barge" (ATB) designs have revolutionized the transportation of petroleum and chemicals along coastal

The *Nichole Leigh Reinauer* and her barge, the *RTC 135*, represent the most modern class of ATB vessels. Designed to work as a unit, the two vessels are married in the notch of the barge by means of two massive pins that allow the stern of the tug to rise and fall with the action of the sea. The strength of the pin connection combined with the freedom of motion allow the tug and barge to remain connected in sea conditions exceeding twenty feet. Just in case they should have to disconnect and switch to hawser towing, a length of line is coiled down just behind the *Nichole*'s stacks. Thigpen Photography, Inc.

routes. ATBs as large as full-sized tankers, carrying as much as a quarter of a million barrels of cargo, are now operating on the coast in all weather. Whereas a standard ship of equivalent capacity might be required by the Coast Guard to carry a crew of as many as twenty-five, the tug/barge combination, because it sails under a different set of regulations, is able to sail with a crew of seven. As a precaution, ATBs sail with an emergency hawser pre-rigged between the bow of the barge and the stern of the tug, in case extreme weather or some other calamity forces the tug to break loose from the notch. But this rarely, if ever, happens.

The origins of these massive coastal tugs lie in the steady perfection of diesel propulsion. Since its introduction, when it was a highly suspect alternative to steam, the diesel engine has come to entirely dominate the world of marine commerce. With minimal attention, the engines and their attachments will run for thousands of hours, providing a guarantee of reliability that an engineer of the early twentieth century could only dream of. The early problems of engine speed, reversibility, and pilot-house control have been solved through the development of highly durable transmission units that feature reduction and reverse gearing. These form the connection between the engine and the propeller shaft, mechanically reducing the engine rpm by a ratio suitable to the design of hull and propeller. Through compressed air or hydraulically activated clutches they provide quick and reliable shifting between forward and reverse, shifting that can be controlled from the pilothouse. A modern heavy-duty engine might operate at a maximum of 1,000 rpm. A reduction gear built to a ratio of 5:1 will reduce the shaft and propeller to 200 rpm, which is well within the efficient range of modern propeller design. A measure of the complexity and high quality of the modern reverse/reduction gearbox used on a large tug is that the transmission usually costs at least as much as the engine itself.

Another innovation that has greatly improved engine efficiency is the Kort nozzle, a carefully shaped tube that encloses the propeller and focuses its thrust. From the tube's mouth forward of the propeller the diameter of the tube reduces slightly until it reaches almost exactly the diameter of the propeller. Thus, an abundance of water is fed into the tube and into the propeller. Because the circumference of the wheel is enclosed in the nozzle, very little of the water can be shed radially from the tips of the blades, but rather is forced astern through the rest of the nozzle. A much greater percentage of the wheel's effort results in thrust than in the case of an unenclosed wheel of equal size. Power gains of up to 30 percent are common in well-designed Kort nozzle installations.

Also, the shape of a modern tug's hull has been refined to allow the maximum possible flow of water into the propellers. The stern sections of the hull are flattened so that turbulence is minimized, giving the wheels the most unobstructed environment possible. The underwater shape of a tug looks impossibly angular when compared the hull of a well-designed sailboat, but the purpose of the tug design is to maximize its engine power. A modest expenditure in terms of drag may more than pay for itself by feeding an abundance of water into the wheels.

Steering has been another subject of constant development. The effectiveness of a tug is not so much a matter of its raw power as exerted by the engine and propeller as of its ability to use that power with precision. In the mid-nineteenth-century shift from side-wheel to screw propulsion it was learned that placement of the rudder immediately aft of the propeller greatly improved the steering qualities of a vessel. The rush of propeller-driven water past the rudder magnified the rudder's effect dramatically and led to the consideration of "rudder power" as a major attribute of a successful tug. The force of quickwater emanating from a tug's propeller at full throttle represents the entire power output of the engine. For the rudder to manage this

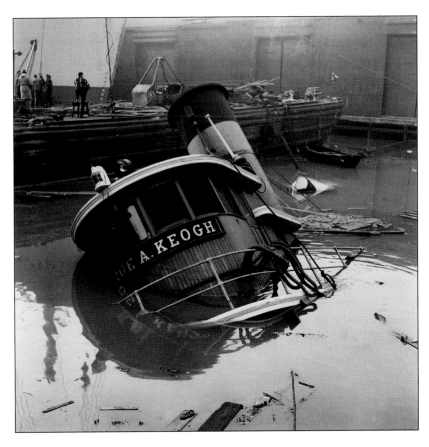

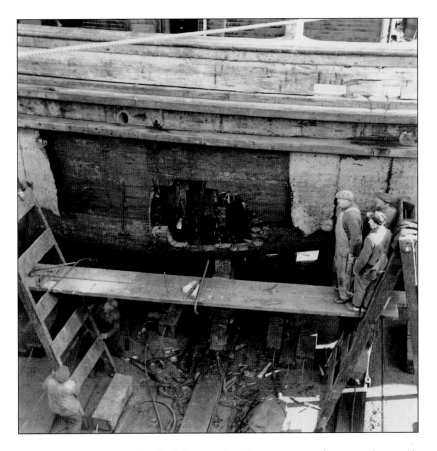

The ability of a tug to maneuver confidently can be critical to its survival. Here the Meseck tug *George A. Keogh* lies broken at the bottom of a Brooklyn slip. A salvage derrick has been moved into place, and divers will begin the task of passing heavy chain slings around the hull so that it can be hoisted to the surface and pumped out. Steamship Historical Society of America Collections, Langsdale Library, University of Baltimore.

The *Keogh* is now in dry dock for repair. The sequence of events that sunk her can be inferred from the gaping hole in her underbody. The tug apparently was drawn under the stern of a ship it was assisting. The first slice from the ship's propeller is marked by the vertical line to the left of the hole. The second blade opened up the left margin of the hole, and subsequent sweeps of the blades tore ever deeper and closer into the hull. The tug must have sunk like a stone. The tug was back at work in a few days. Steamship Historical Society of America Collections, Langsdale Library, University of Baltimore.

force—to divert it to left and right—requires considerable mechanical assistance, either in the form of gearing down the effect of the steering wheel or in providing steam, electrical, or hydraulic power to the movement of the rudder itself.

Today, most steering of tugs (not to mention most other commercial vessels) is hydraulically controlled, and in many cases the traditional steering wheel in the pilothouse has been replaced by nothing more than a small jog lever that delivers electric signals to the hydraulic switching system located below deck. The hydraulic power allows the helmsman to put the rudder hardover from one side to the other in a matter of seconds. A rudder-angle indicator mounted directly in front of the helmsman allows him to keep track of the rudder's position so that during careful maneuvering he can be certain that the rudder is positioned properly before he applies quickwater to it. This method of combining careful rudder control with either brief or sustained pulses of quickwater is the basis of operating a single-screw tug.

Twin-screw tugs operate quite differently. With two separately powered propellers located side by side at the stern, the tug is maneuvered primarily by combining or opposing the thrust of the wheels in either forward or reverse. With one engine operating forward and the other backing, the tug will turn in its own length without moving the rudders at all. More-complicated maneuvers can be accomplished by applying rudder power to the quickwater of both wheels. Many twin-screw tugs are also equipped with flanking rudders, which are located forward of the propellers and serve to manipulate the flow of quickwater when the tug is operating in reverse.

Since the 1960s there has been a strong movement away from building single-screw tugs in favor of twin-screw designs. Much of this change is because a twin-screw boat is more maneuverable and its operation much more easily mastered. Operators expert in handling single-screw tugs are becoming ever scarcer and someday will toss their skills down the memory hole to join the by-

gone skills of the sidewheel boatmen. The shift to twin screw is not solely for the convenience of the helmsmen, however. Tugs have become ever more powerful so that a single-engine, single-screw design of, say, 8,000 horsepower would require a gigantic propeller to make full use of that power. This outsized wheel would in turn require the depth of the tug's hull to be greatly increased and the rest of the hull's dimensions to be increased proportionately. These considerations are slowly bringing about the virtual extinction of the single-screw tug.

But there is evidence that the twin-screw boat may be threatened with extinction as well. There are presently two new propulsion types that might one day replace the current models. The first, and most unusual, is powered by what is called "cycloidal" propulsion. This type of drive runs off a diesel engine, but instead of delivering thrust through one or more propellers located at the stern, it drives the hull by means of a horizontal fanlike rotor mounted under the forepart of the hull. The diameter of this rotor is about one-half the beam of the tug, and it is fitted with five or more vertically mounted blades, projecting downward. As this circular fan rotates at moderate speed, the angle of the individual blades adjusts in unison to provide thrust. Precise electronic control of the blade angles will move the boat forward, backward, or to either side in accordance with a simple

———————————————————————→

The tug *Russell No. 19* tows the barge *Hughes 37* on gate lines through the Upper Bay during the 1950s. The tug was built for Newtown Creek Towing in 1942. The construction was performed at Brooklyn's Liberty Dry Dock, which was also a part of the Russell family's small empire.

The sand barge being towed belongs to Hughes Brothers, a family-run company that has prospered since 1894 in the business of leasing barges and equipment and in arranging the transportation of complicated or very large articles. The company's trademark calling card reads, "Clearinghouse for Marine Difficulties." Steamship Historical Society of America, Langsdale Library, University of Baltimore.

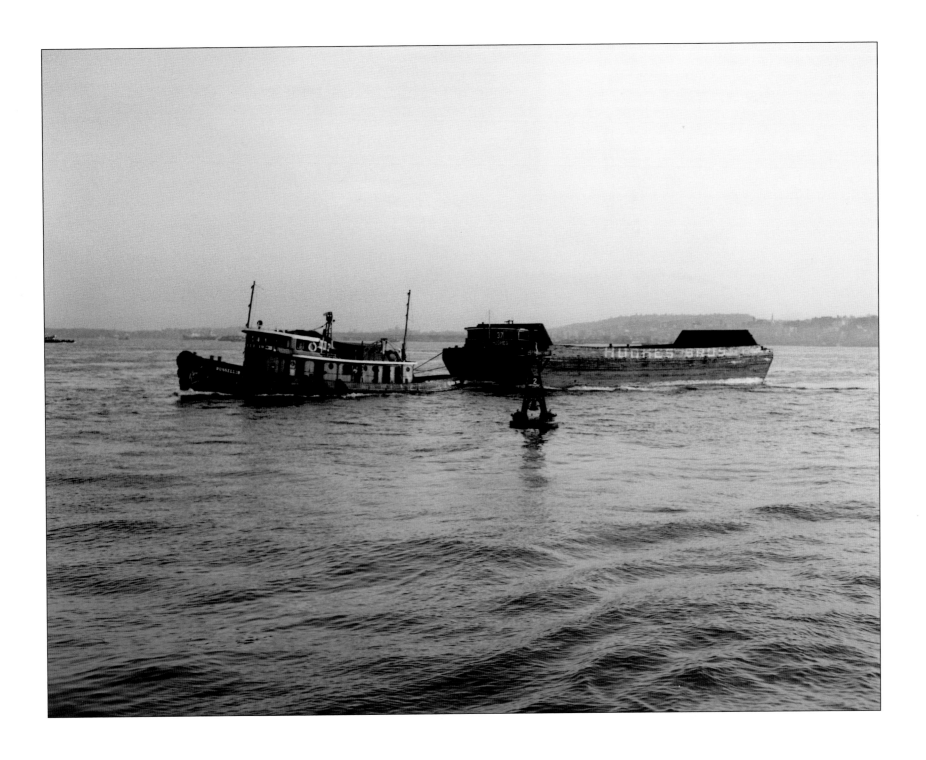

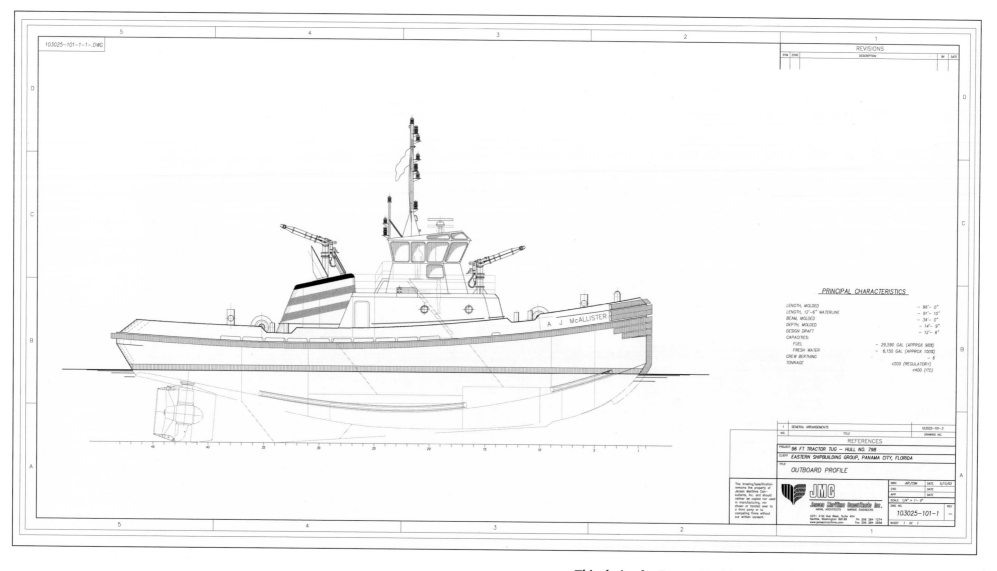

This design by Jensen Maritime Consultants, naval architects, represents the most modern class of Z-drive tug. Several of these vessels have recently been built for McAllister Towing as part of a major ongoing fleet modernization. Twin drive units produce a total of 4,600 horsepower or 55 tons of bollard pull. Intended for handling U.S. Navy vessels and liquefied-natural-gas tankers, the tug is also equipped with prodigious firefighting capability including two 5,800-gallon-per-minute fire monitors plus a storage capacity of 3,000 gallons of extinguishing foam. For handling the rounded underwater hull form of submarines, rubber fendering has been installed along the hull edges below the water line.

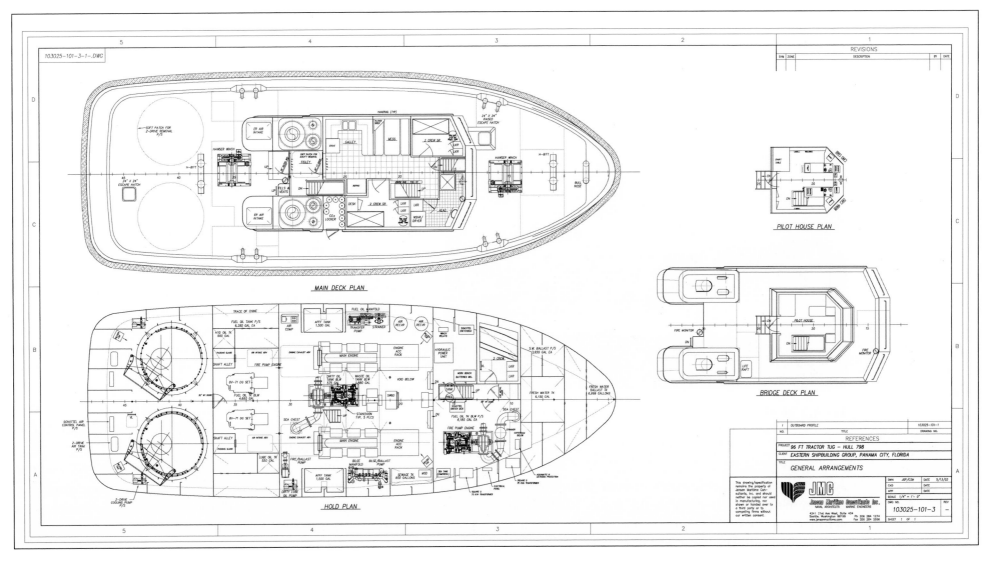

Because of the dramatic increase in power and maneuverability afforded by Z-drive propulsion, many ship-handling tasks are performed using a single line deployed through hawser winches mounted on the tug's bow and stern. By shearing the tug left or right, forward or back at the end of this single line, the direction and speed of the ship can be precisely controlled.

The tug contains an astonishing amount of machinery. Propulsion, electrical generators, and fire pumps are all diesel powered. Hydraulic pumps, air compressors, bilge, ballast, fresh water, sewerage, fuel and lube-oil transfer pumps are all electrically powered. Tankage exists for 6,700 gallons of drinking water, 7,600 gallons of adjustable ballast water, and almost 30,000 gallons of fuel. There are living accommodations for a crew of six, all in a hull ninety-six feet long. McAllister Towing and Transportation Company Inc. and Jensen Maritime Consultants Inc.

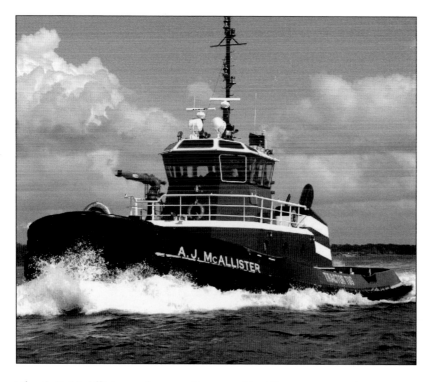

The *A. J. McAllister* underway. Courtesy of McAllister Towing and Transportation Company, Inc.

pointer under the helmsman's control. This type of drive has been employed successfully in the Staten Island ferries but has yet to appear in a New York tug. On the West Coast it has been used successfully for ship-docking work and for the escort of ships bearing hazardous cargoes in narrow channels.

The second innovative propulsion type is called the "Z-drive" tug. These are powered by two engines operating through massive drives that project downward through the hull at the stern of the tug. Each drive is fitted with a propeller equivalent in size to those on a standard twin-screw tug of equal horsepower, and each propeller is fitted with a Kort nozzle to maximize power. The unusual virtue of the Z-drive arrangement is that each drive unit is

able to swivel horizontally through 360 degrees, thus moving the hull in any direction. Each unit operates independently and, working in an almost unlimited set of combinations, can maneuver the tug with unnerving agility. Control of the two units is in some cases entirely under the manual control of the helmsman, who with a good deal of practice may perform almost acrobatic feats. Many other units are designed for computer control, in which the helmsman operates a single directional and throttle control from which the on-board computer derives the necessary combination of directional thrusts and power.

The first Z-drive tug in the United States was built at the Gladding-Hearn Shipyard in 1977 for a ship-docking firm in Wilmington, Delaware. The type had been developed in Europe and in Japan previous to that, and though well accepted in those places, it has been considered a novelty in this country. Recently, however, the type has taken hold on the West Coast both for ship assist and for ocean towing. Even more recently the type has begun to appear on the East Coast for use in ship-docking work. Both Moran and McAllister have built several tugs of this type and have converted several other boats to resemble the highly modern Z-drive configuration.

It seems unlikely that either of these two types will come to dominate tugboat design. The cycloidal system, though highly effective in close-in ship-assist roles, is relatively inefficient when engaged in straight towing assignments. The Z-drive, on the other hand, is both nimble and efficient, which proves it to be a highly versatile type and probably more likely to proliferate. Both types, however, suffer from a high degree of complexity, which increases both initial expense and maintenance. Another factor is that the propulsion units of both types are mounted in exposed positions

The *Emily Anne McAllister* performs. Courtesy of McAllister Towing and Transportation Company, Inc.

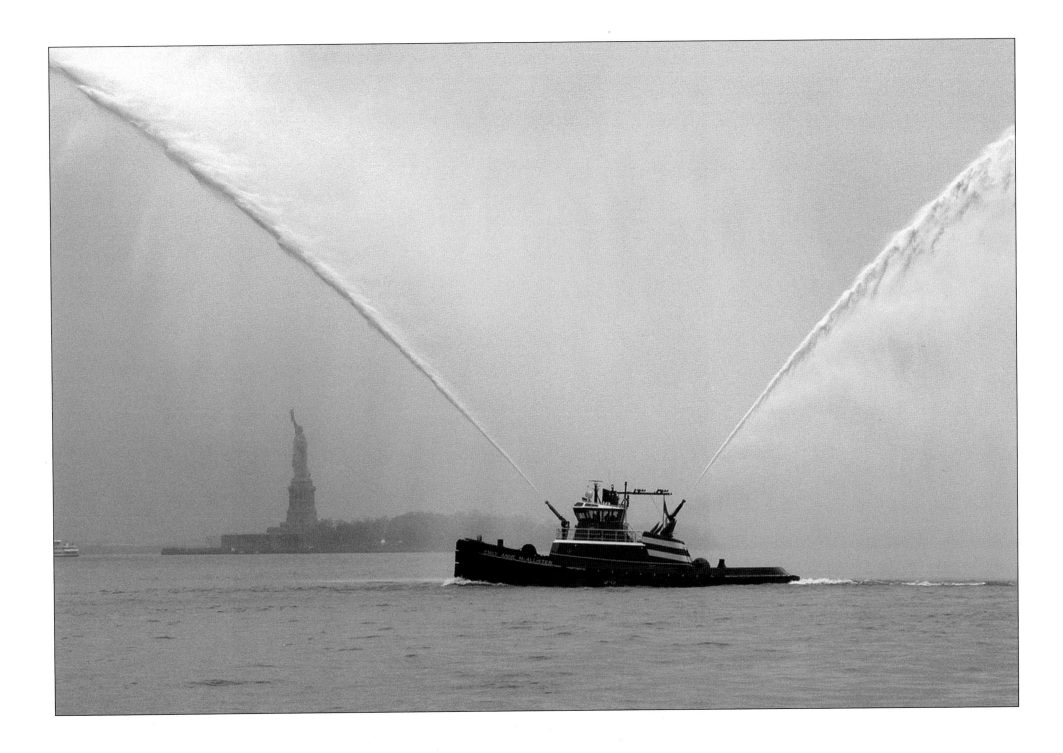

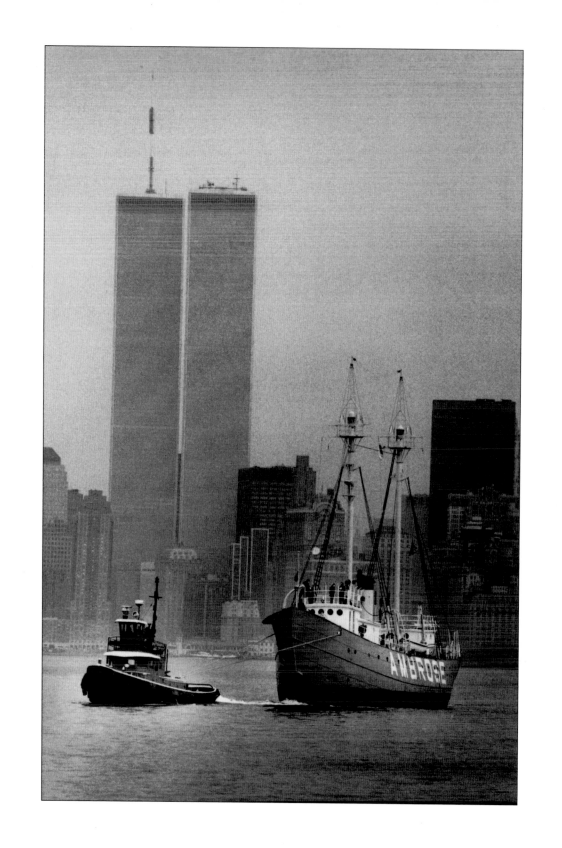

at the deepest part of the hull so that a grounding or collision with a submerged object may result in outlandishly costly damage.

There is an even more fundamental question as to whether the extra maneuverability that these expensive devices provide is even necessary. The protocols of ship docking are quite standard and today are performed by one or, at the very most, two tugs. Is there a rationale for replacing an inexpensive but fully adequate tug with a superadequate and much more expensive one? There is a belief that both of the new types represent a necessary protection from the threat of hazardous-cargo casualties, particularly for outsized ships transiting narrow inland channels. Indeed, these new tugs are capable of controlling a large ship traveling at moderately high speed simply by trailing astern of the ship at the end of a single line. By backing down hard or shearing off to either side they are able to quickly stop or turn the ship, providing better control in normal conditions and absolutely critical assistance in an emergency. For example, when a standard-propeller tug attempts to reverse while being pulled forward at high speed, the propeller will stall or "spin out" and be rendered ineffectual. For this reason tractor and Z-drive tugs are mandated for tanker and hazardous-cargo escort duty in localities such as Puget Sound. It is likely that the Coast Guard or local authorities will require the same for hazardous-materials situations in other ports. As this occurs, the tractor, the Z-drive, or both will proliferate, at least in this niche. It is also apparent that the unit cost of building these innovative vessels has come down substantially as shipyards and machinery builders achieve both experience and volume of orders.

Today, there is a general movement toward modernization of the New York Harbor fleet. The various oil-transportation firms as well as Moran and McAllister have been rapidly adding new boats that are blessed with high power, great reliability, and relatively low operating cost due primarily to fuel efficiency and reductions in crew size. Paradoxically, much of this modernization appears to be driven by the increasingly high potential liabilities of tugboat work and the increasing need to satisfy governmental regulations. Although these two forces are commonly viewed as negatives to the conduct of private business, in this case they seem to have exerted a reorganizing effect on an industry that previously had lacked any rational conception of its future. Starting in 1929 the towing industry became habituated to a defensive posture. Starting with the Depression years and continuing to the end of the century, traditional harbor business withered, as companies battled one another toward extinction. A dogged conservatism, enforced by tenuous profit margins and rigid labor practices, locked the towing industry into a downward spiral that seems only recently to have abated. With new tugboat construction and the promise of a few enduring markets, the tugs of New York Harbor appear to have weathered a long and mighty storm and today, as ever, have another tide to catch.

★ Canal Work

Four canals built in the early nineteenth century contributed to New York's prosperity. The Erie Canal is the earliest, the best known, and also the sole survivor of the four. Though the Delaware & Hudson Canal, the Morris, and the Delaware & Raritan are now gone, their significance was considerable in bringing the raw materials of industry, particularly anthracite coal, to the metropolis.

The Delaware & Hudson Canal linked the coal fields along the Lackawanna River Valley above Honesdale, Pennsylvania, to the

The sixty-five-foot former Navy tug *Spuyten Duyvil*, built in 1941, tows the historic 1907 lightship *Ambrose* from its berth at the South Street Seaport Museum to Staten Island for dry-docking and regular maintenance. Keith Meyers/*New York Times*, April 22, 1989.

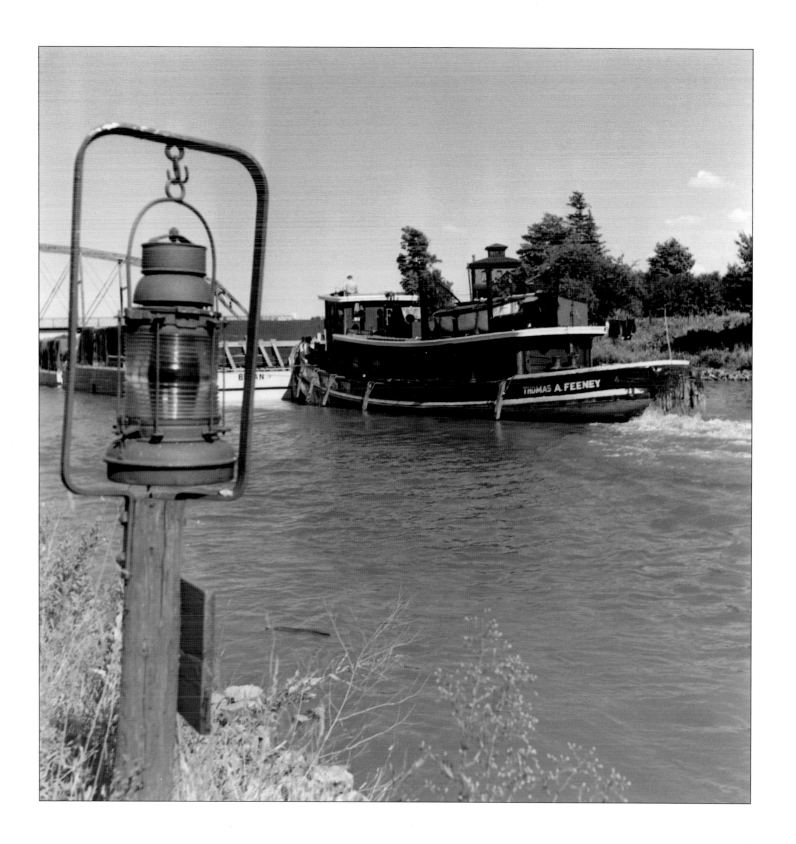

Hudson River at Rondout Creek—a distance of about 108 miles. It was completed in 1829 and closed in 1891 after its usefulness had been reduced to nothing by the development of the Delaware & Hudson Railroad by the same group of owners. During its lifetime the D&H Canal made Rondout Creek a major East Coast port for the trans-shipment of coal. The output of the canal was the mainstay of business for the Cornell Steamboat Company.

The Morris Canal at first connected the Delaware River at Phillipsburg to the Passaic River at Newark, New Jersey. The first canal boats passed over that route in 1831. By 1836 an extension had been pushed eastward to reach Jersey City, directly across the Hudson River from the Battery. Part of the canal's

Lockport, New York. Paper barge and tug boat passing down the Erie Barge Canal toward Gasport, New York.

The *Thomas A. Feeney* is pushing two barges. Passing through Lockport, they have 324 miles and thirty-three locks to go before they reach Troy. The total length of the tow will probably require sending the barges through each lock one at a time. This double-locking procedure is time consuming, as the crew must first separate the tow, then haul the first barge through the lock by hand with the help of a capstan mounted on the lock wall, and then pass through the lock with the tug pushing the second barge, reassemble the tow, and continue on. A single locking takes about twenty minutes from start to finish. Double locking requires the better part of an hour. If they run around the clock, they will reach Troy in about three and a half days.

To see over the barges, the tug's helmsman must stand up in the hatch in the roof of the pilothouse. He and his mate will operate like this all the way to Troy—day and night, rain or shine.

Up until the 1960s most of New York City's newsprint came from Canada by way of the Erie Canal either in towed barges such as this or in specially built freight boats.

The lantern in the foreground is kerosene fueled. The state kept a fleet of small lamplighter's boats that daily traveled up and down each section of the canal maintaining these lights. Photograph by Gordon Parks, August 1946, Special Collections, Photographic Archives, University of Louisville.

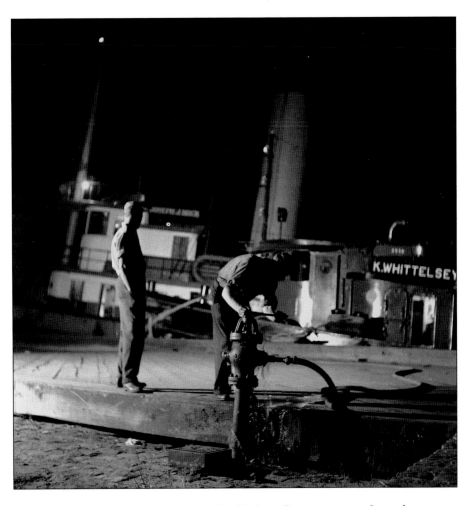

Before starting to tow oil barge up the Hudson River, water is brought aboard the tug, *K. Whittelsey*, from a hydrant near Port Richmond, Staten Island, New York.

The *Whittelsey* is a diesel boat so the water that they are taking on is for domestic purposes rather than for making steam. The tug will finish getting its water and then may load fuel before it picks up the barge assigned to it. These preparations will likely consume most of the night. Behind the *Whittelsey* is the coastal steam tug *Joseph J. Hock*, which was based at Baltimore. Apparently, she has also come in to get water. Photograph by Harold Corsini, October 1946, Special Collections, Photographic Archives, University of Louisville.

ninety-mile length and 914-foot climb was accomplished by a system of inclined planes over which canal boats were dragged. The canal company was constantly beset by competition from the railroads and never enjoyed the level of profitability that its developers had expected. Indeed, by 1871 the entire operation was leased by the Lehigh Valley Railroad, which was most interested in gaining control of the canal's Jersey City real estate fronting New York Harbor. After several attempts to close the canal were blocked by the New Jersey legislature, the Lehigh Valley was finally successful in 1924, long after the canal had ceased to have any financially viable existence.

The Delaware & Raritan Canal was completed in 1834 and connected the New York Harbor port of New Brunswick, New Jersey, to Bordentown, a few miles north of Philadelphia on the Delaware River. The canal mostly served to transport coal from the Delaware River drainage to New York, but it served the equally important function of linking Philadelphia and New York with a forty-four-mile sheltered passage that avoided the far lengthier and more difficult coastal route. Unfortunately, railroad track was laid alongside the canal route, and by 1892 the canal had lapsed into unprofitability. It was closed in 1932 after the federal government was persuaded by the railroad interests that a takeover and modernization of the canal, along the lines of what had been done with the Cape Cod Canal, was not a good idea.

The use of steam-powered vessels, whether tugs or self-propelled barges, never fully developed in either the Delaware & Hudson or the Morris canals, both of which relied almost exclusively on horse- or mule-towed barges. The Erie and the Delaware & Raritan, however, moved readily toward steam as suitable technology became available. In fact, the first commercially successful propeller-driven vessel in the United States, the *Richard F. Stockton*—built in England by John Ericsson—found many years of employment as a towboat on the Delaware & Raritan beginning in 1840.

The Erie Canal was modified several times to accommodate larger vessels and steamboats. Efforts to widen and deepen the canal route originally set out by DeWitt Clinton were eventually abandoned in favor of channelizing the Mohawk, Oneida, Seneca, and Oswego rivers with a series of locks and dams. This approach entirely ended the old horse-drawn canal method.

Since its final enlargement, completed in 1918, the Erie Canal has been known as the New York State Barge Canal. From Troy, New York, various routes on this canal system allow passage to

---→

Looking up the length of the barge from the pilothouse of the tug. Captain's hand is on the wheel. Hudson River near West Point.

All through the next day and night, the *K. Whittelsey* and its barge will push their way up the Hudson River. Secured together by a combination of wire and fiber rope they steer more or less as one. The weight of the loaded barge makes the steering feel slow and stately. It is about eighteen hours up the river to Troy for this tug, provided they do not have to stop for river fog in the early morning hours.

Directly in front of the steering wheel is the compass binnacle, and perched above the compass is a light for nighttime illumination. Mounted below the compass on the binnacle is an inclinometer, which is used mostly to determine when the loading of fuel and ballast tanks in the tug have achieved a proper trim. The two black balls at either side of the binnacle are called "quadrantal spheres," sometimes referred to as "the captain's balls." They are cast of solid iron and by precise adjustment toward or away from the magnetic compass will neutralize any compass error resulting from the tug's mass of steel fabric lying to right and left. The horizontal pipes in front of the binnacle are elements of a steam radiator. To reduce interference with the compass these pipes are made of nonmagnetic brass.

At the very left edge of the pilothouse's center window can be seen an irregularly shaped grey object, which proves to be a sheet of newspaper plastered against the screened hatchway of the barge's living quarters. It is the front page of the *Toronto Star*, which suggests that this barge has made at least one recent transit of Lake Ontario from Oswego, New York, to Canada. Photograph by Harold Corsini, October 1946, Special Collections, Photographic Archives, University of Louisville.

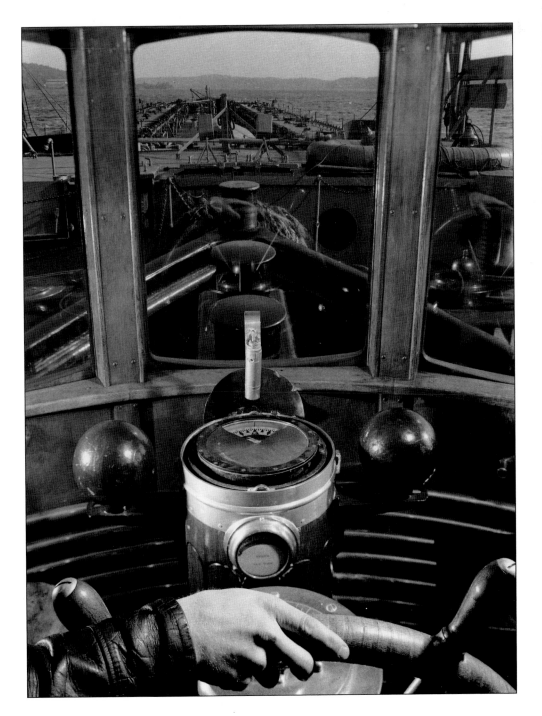

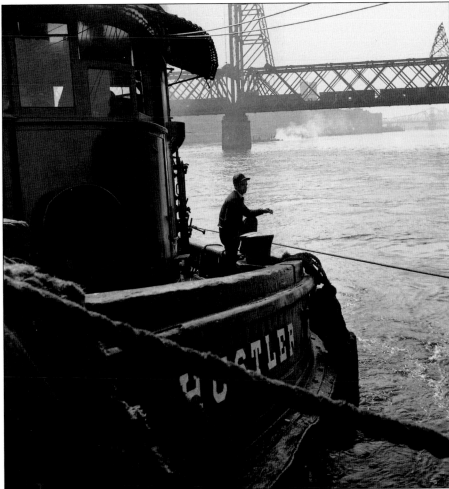

Tug *Hustler* with Troy bridge behind it, on its way to the Erie Canal.

The *Hustler* was built in 1923 for the Oil Transfer Corporation, also owners of the *K. Whittelsey*. She was intended for coastal, inland-waterway, and canal work towing oil barges. Here, she has reached Troy and in a few minutes will enter the first lock of the canal system, the Federal Lock. *Hustler* met her end in 1965 when she was run down in the North River by a freighter. No lives were lost. (See pages 194 and 195.) Photograph by Harold Corsini, October 1946, Special Collections, Photographic Archives, University of Louisville.

Before entering the Erie Canal the mast of the tug is taken down. Clearance under bridges in the canal will not permit the mast.

The Barge Canal allows a twenty-foot height between Troy and Lake Ontario at Oswego and fifteen and a half feet to Lake Erie at Buffalo and to the Finger Lakes and Lake Champlain. Vessels operating in the canal are obliged to reduce their height to meet these restrictions. Masts come down and stacks are shortened. Here, the crew of the *K. Whittelsey* removes the forward mast on which are mounted the tug's towing and anchor lights. In the canal these otherwise necessary items are dispensed with.

The Oil Transfer Corporation tugs were built to operate in the canals during the spring, summer, and fall and were designed with the distinctive low profile of typical canallers. The wheel seen in this photo, exposed to the weather on deck, was used by the helmsman for piloting the tug when the barge being pushed ahead was too high to be seen over from the pilothouse, which can be seen through the open companionway on the right. On each side of the wheel are vertical plates on which are mounted the bell pulls used for signaling commands to the engine room.

In winter the Oil Transfer tugs operated in New York Harbor and on coastal routes as far south as Mexico. During that season, when bridge clearance was no longer a critical problem, these boats were fitted with an upper pilothouse that enclosed the wheel and bell pulls seen here. In front of the wheel, mounted on the back wall of the permanent pilothouse, is a steam radiator ready for use once the space is closed in. Photograph by Harold Corsini, October 1946, Special Collections, Photographic Archives, University of Louisville.

Roy Atkins, deck hand acting as cook, brings food supplies to barge near Waterford.

Until 1984 the cook's position was a union job on boats working around the clock, so either the *Hustler* is not a union boat or else some special arrangement has been made. The stake truck in the background belongs to the nearby shipbuilding yard of John E. Matton & Son, which was a very prominent builder and operator of tugs at that time. This photograph was taken at the canal terminal just below the first lock in the State Barge Canal, which happens to be numbered lock 2 to account for the federal lock a short distance downstream, built and operated not by New York State but by the Army Corps of Engineers. Photograph by Harold Corsini, October 1946, Special Collections, Photographic Archives, University of Louisville.

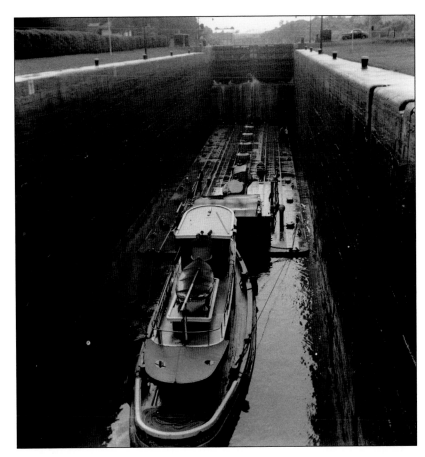

Waterford, New York. An oil barge entering the last lock of the flight of five where it will be lifted to the 1650 foot level.

The Flight is a series of five locks that, in a distance of about two miles, carry Erie Canal traffic around the rapids and falls of the Mohawk River where it joins the Hudson at Waterford. Averaging about 33 feet per lock, the total lift of the Flight is 169 feet. Adding the 14-foot lift of the federal lock a mile downstream results in an altitude at the top of the Flight of 183 feet above sea level. Because of the federal lock, the locks of the Flight are numbered 2 through 6. The number 6 can be seen painted on the square structure to the left of the lock gate.

The tug is the *John A. Becker*, belonging to the John E. Matton & Son Towing Corporation. Originally named *Protector*, she was built as a steamboat in 1894 at Long Island City. At the time of this photograph she is diesel powered and rated at 210 horsepower. Her seemingly low horsepower is not a problem in the canal, where the effects of wind and current are minimal and speed of over five knots is prohibited. Photograph by Gordon Parks, August 1946, Special Collections, Photographic Archives, University of Louisville.

Waterford, New York. Oil barge and tugboat being raised to the fourth level in the flight of five locks located near the entrance of the New York Canal system.

The *John A. Becker* and its barge wait in the lock chamber for the 34.5-foot lift to begin. There has been a summer shower, leaving puddles on awnings and decks and mist in the air. It will take no more than ten minutes for the chamber to fill. Two deckhands stand well forward on the starboard side of the barge tending a line to keep the tug and tow from surging back and forth as the water flows in through ports in the bottom of the chamber. Recesses visible in the chamber walls hold mooring posts, or "Panama Pins," which the deckhands must lasso from below as the water level rises.

The locks of the Canal System are 300 feet long, 43.5 feet wide, and 12.5 feet deep. These dimensions control the size of all vessels working there. The trick of moving oil efficiently on the canal is to design tug and barge to fill the lock chamber as completely as possible. Photograph by Gordon Parks, August 1946, Special Collections, Photographic Archives, University of Louisville.

Lake Champlain, to Lake Ontario, to three of the Finger Lakes, and ultimately to Buffalo on Lake Erie. Among the cargoes that traveled by tug and barge and by motor ship on the canal in the twentieth century were automobiles and auto parts, newsprint, cement, and chemicals. But by far the greatest bulk of cargo was petroleum products. Domestic heating oil, heavy industrial fuel, gasoline, and jet fuel moved constantly from refineries and tank farms around New York Harbor and Albany into upstate New York, Vermont, and to Great Lakes ports. The tug and barge combinations used for this work were designed to fit the volume of the canal locks—300 feet long, 43.5 feet wide, and 13 feet deep. A barge containing about twenty thousand barrels of oil became the standard unit.

Overhead clearance to allow passage under the many bridges along the canal route required that tugs and barges be built low. The passage from Troy to Oswego was the most generous, with 20 feet clearance, while all other routes—Champlain, the Finger Lakes, and Buffalo—permitted only 15.5 feet. This restriction produced a distinctive type of tug that featured a pilothouse that projected above the height of the deckhouse only enough to allow a small window or two through which the helmsman could look astern when necessary. Late in the twentieth century some canal tugs were built or refitted with pilothouses that could be raised and lowered hydraulically so that the helmsman's height of eye could be raised to provide an adequate sight line over a barge and then lowered to sneak under the bridges.

From some time in December through April the canal is closed by ice. The river sections are frozen, and the locks are drained. The working season on the canal is thus confined to the warmer part of the year, and because of this most who have worked any time on the canal remember it with great fondness: the security of being protected from weather, the constant interest of scenery and people passing by, the easy day and night routine of traveling through the summer countryside, and with the frequent appearance of heavy river fog in the wee hours, the prospect that the tug will have to stop for a few hours, allowing for uninterrupted sleep.

Today, the canal sees very little commercial traffic. Small quantities of scrap iron and, occasionally, a piece of machinery too large to travel by road or rail are the only significant cargo. Efforts are underway to develop the waterway for recreational and tourist use, for which it should remain as attractive as ever.

Roy Atkins, deckhand on the tug *Hustler*, adjusts searchlight used at night to spot canal banks. Searchlight is controlled from pilothouse on tug by means of ropes strung between pilothouse and light.

Through much of its length the canal follows the course of the upstate rivers, Mohawk, Oneida, Seneca, and Oswego, as they wind in tight bends through the terrain. In the ditch sections, where the canal departs from the rivers, the banks are only two hundred feet apart. Needless to say, pushing a barge around the clock on the canal requires constant attention.

It is customary for the tug to employ two searchlights, one mounted on the bow of the barge, as seen here, and the other mounted in its normal position on the pilothouse of the tug. These lights are trained on each bank of the canal and thus provide a good view of the course ahead. Whenever a vessel is met coming from the opposite direction the two lights must be trained away from the oncoming vessel so as not to blind its helmsman. Photograph by Harold Corsini, October 1946, Special Collections, Photographic Archives, University of Louisville.

Stanley Szerzerbiak, 2nd Assistant engineer on tug *Hustler*, near control board in engine room.

Reflected in the porthole glass behind Mr. Szerzerbiak can be seen the face of the engine-room clock. It reads 8:25. Outside the glass, it is dark, so the long October night has begun. Mr. Szerzerbiak will remain on duty until midnight, when he will be relieved by the next watch. Above his head is the gong that transmits engine commands from the pilothouse. The gong, mounted horizontally, is partially enclosed in a brass shroud that connects to a brass tube running back up to the pilothouse. The tubing transmits the sound of the gong so that the helmsman gets an audible confirmation of his signals. Behind the engineer, to the right of the porthole, is the mouthpiece of a speaking tube through which the helmsman and engineer can communicate by voice if necessary. To the left, down the passageway, is mounted a smaller bell, the jingle, which is used in the bell system to adjust the throttle up or down beyond the basic forward, stop, and reverse commands that are communicated by the gong.

Throughout his watch the engineer of a bell boat, whether steam or diesel, must be instantly available to answer any bells. Because this voyage is in the constricted waters of the canal, where there is always the likelihood that quick maneuvering will be necessary, the engineer must remain close to the controls at all times. Photograph by Harold Corsini, October 1946, Special Collections, Photographic Archives, University of Louisville.

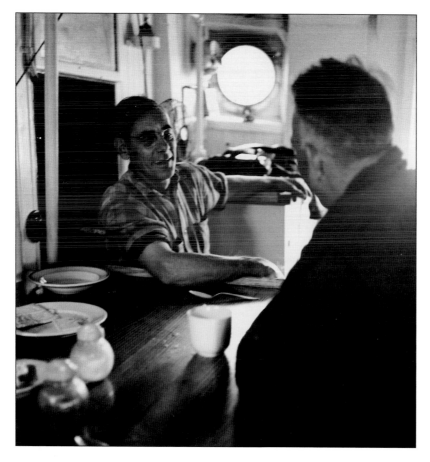

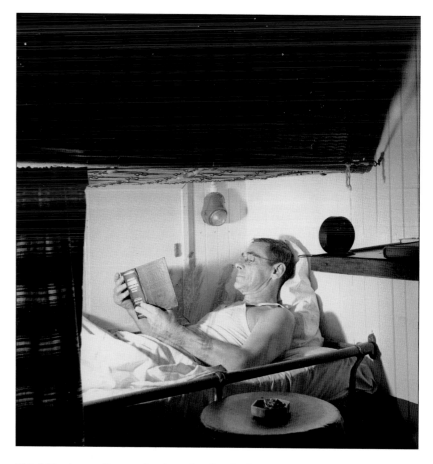

After lunch, crew members sit around over coffee in the galley of the *K. Whittelsey*.

Travel on the canal has a timelessness to it in which the poise of water and the swell of the hills holds more sway than night or day. The successive locks arrive at certain intervals, and the pace of life aboard the tug is governed by them. To climb or descend the Flight at Waterford requires two hours of nonstop effort. Elsewhere, the hurdles are farther between: less than three miles between Canajoharie and Fort Plain (barely enough time for a cup of coffee); eighteen miles on the long, straight ditch of the Rome level between Utica and lock 21; twenty-three miles between locks across Lake Oneida. Meal times, maintenance, and sleep all are subject to the routines of locking on through. Photograph by Harold Corsini, October 1946, Special Collections, Photographic Archives, University of Louisville.

Chief Engineer, George Leek, in his bunk. Each cabin except the captain's has bunks for two men.

Chief Leek is studying the *Marine Engineer's Handy Book*, filled with tables and reference information necessary to his profession.

The panel in the bulkhead next to him is an escape hatch leading either into a central passageway in the tug's deckhouse or else into an adjoining cabin. The only other egress is through a heavy watertight door letting out onto the side deck, which in severe conditions might be impassable. If Engineer Leek persists in the habit of smoking in bed, as evidenced by the ashtray next to him, he may someday need his escape hatch.

Underway, the customary watch schedule on tugs is six hours on, six off, dividing at midnight, 0600, noon, and 1800. Most crew will try to sleep a part of each off-watch. Some sleep best at night, others during the day. Photograph by Harold Corsini, October 1946, Special Collections, Photographic Archives, University of Louisville.

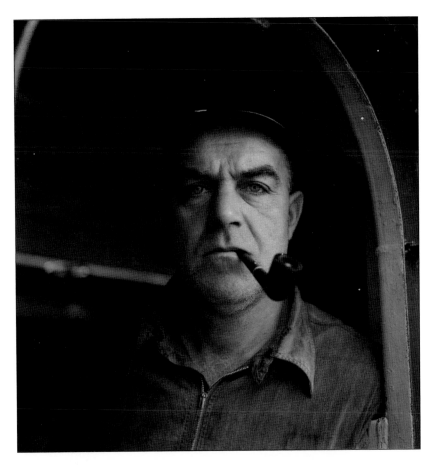

George Johannsen, 2nd Engineer, of the tug *K. Whittelsey*.

Photograph by Harold Corsini, October 1946, Special Collections, Photographic Archives, University of Louisville.

Daniel Hall, cook on the tug *K. Whittelsey*, preparing lunch.

Photograph by Harold Corsini, October 1946, Special Collections, Photographic Archives, University of Louisville.

Tug *K. Whittelsey* after having bow repaired is lowered into water on floating dry dock.

The tug has suffered some sort of mishap that has sprung one seam in its bow plating just in the area of the nine-foot-draft mark painted on its bow. The point of impact is below the water line but certainly far above the keel, which suggests that she did not run aground but perhaps hit a partly submerged log (the Hudson River has plenty) or perhaps a dislodged block of stone in a city wharf.

The fin running in a curve fore and aft along the turn of the tug's bilge is a "rolling chock" riveted to the hull to slow the hull's tendency to roll when working offshore. A second chock is fitted on the opposite side of the hull. A tug that was restricted to working in the harbor, the river, and the canal would not be so equipped—further evidence of the seagoing versatility of these Oil Transfer Company tugs. Photograph by Harold Corsini, October 1946, Special Collections, Photographic Archives, University of Louisville.

Epilogue: A Race of One

We were southbound in the Hudson, just coming out of the gutter above Saugerties and riding the freshet. We had left the canal just a little after midnight, running light back to New York after dropping off a contractor's barge just east of Little Falls. I had been steering since daylight. My relief and the deckhand were asleep below. It had been five days since we had started on this job, and we were all tired. It was a bright sunny morning in early spring. The maples on the hillsides were showing no green as yet —only the deep-red haze of quickening buds and twigs.

In the settlements along shore it was still the season of blue tarps. The worst of the winter was past, but the river remained high and muddy, cluttered with winter straw, gnarled tangles of snags and limbs, and, sown in every whorl of current, those little, black water-chestnut seeds, twin-spiked and alien. The quarries along the river had amassed huge piles of crushed stone that awaited transport to the city now that the ice was gone and the scows could come back up to load.

Downstream at the bottom of the next reach was a big north-bound tug pushing a loaded oil barge. It labored upriver against the current and the backdrop of its own black smoke. The sun glanced off the flat face of the tug's radar antenna each time it completed a rotation, and the vessel thus appeared to possess a tiny heartbeat. Normally there would be no need for communication between a light tug and a tow meeting in broad daylight on an open stretch of river. By custom the light tug is entrusted to stay clear of the other, a professional courtesy. But this morning the captain of the northbound tug called me in a gravelly Southern voice.

He had a deckhand on board who had to get home for a medical emergency. Did I know someplace downriver where he could catch a train? Would I take him there? As we came together the larger tug throttled back, and I swung around to follow in its wake, easing up to its stern. Painted there was a name like *Jubilation* or *Endurance* and the port of hail, Morgan City, Louisiana. Standing ready on the stern of the bigger tug was my passenger. He was dwarfed by the gear and machinery around him. There was nothing back there that one man could even pick up except a small overnight bag. I nudged up close. He picked up the bag, jumped up onto the rail, and stepped across. With that one step he seemed to change scale and become full blown. He was dressed in traveling clothes—jeans, a much-washed flannel shirt, a windbreaker, a ball cap, well-shined black shoes. He landed on the foredeck and stopped, uncertain of where to go next. Through the pilothouse glass I gestured for him to come inside.

By the time I had dropped away from the other tug and was headed back downstream he was sitting on the wooden stool on the other side of the pilothouse from where I occupied the helmsman's chair.

"Thank you for taking me up," he said. "I'm trying to get back home to my wife who is having our baby."

"Where?" I asked.

"At our home. In the town of Sweet Lake that's not far from Lake Charles."

"That's in Louisiana?"

"Yes sir. That's where my wife is having our baby."

"You've got a long way to go," I said.

"The company says they have a plane ticket waiting for me at an airport down in New York City." He began fishing in the breast pocket of his shirt and produced a neatly folded slip of paper. 'La Gardé,' it says. Do you know that?"

"La Guardia. You should have no trouble getting there once you get to the city. There are buses that run back and forth every few minutes."

"Well, my company said that if I could get to a train up here, that would get me to New York City. I could be back home tonight. Do you think that's possible?"

"Yes," I said, "so long as you keep moving."

The railroad tracks ran right along the east bank of the river from Albany to New York; and on them the trains flew back and forth night and day. Often, when towing north on the river at night, hugging the steep shoreline to avoid the ebb current, I would come around a bend and find myself blinded by the headlamp of a southbound express. The first reaction would be that we were about to collide, but then I would remember that we traveled in entirely different media and could never touch. The engine would pass, followed by its warmly lit coaches, then more river darkness.

"I think that you should be able to catch a train at Kingston," I said. "They call it Kingston, but the train actually stops on the other side of the river at Rhinecliff. There's a bulkhead there right by the train station where I can drop you off."

I had used that bulkhead many times when overtaken by river fog late at night, to wait out foul current, or just because of plain fatigue. It was a good place to tie up and get a few hours of sleep, or you could hop ashore, cross the parking lot, squeeze through a hole in a fence, then carefully cross the tracks; and right there just past the station was a decrepit little hotel with a bar that stayed open to all hours to serve the old guys who lived upstairs. Often as not there was some old gaffer coughing horribly in the men's room. Not a pretty place; but you could get a beer there just about anytime and, if you were lucky, a nice pickled egg or a spicy pig's knuckle—just another bit of the local knowledge that in the tugboat business makes life a little easier.

We traveled in silence for a little while. He looked to be in his midtwenties. Healthy. Clean about his person, as they say down south.

"You been working on that boat for long?" I asked him.

"Oh, it's been about three years I've been working on that boat you saw. This trip I've been on since January, since right after the first of the year."

"That's a long time."

"Yes, sir, it is. In that time we started out from Morgan City and brought a bargeload of vegetable oil to Puerto Rico and back, and since then we have been towing oil all up and down the East Coast. I was supposed to get off in late February, but the other guy quit so they said they wanted to keep me on; and I said alright so long as you promise, and I mean promise, that you let me home before the baby comes. And that's what I'm doing here."

I had seen his tug in the harbor a few times over the years, laying with its barge in the Kills, loading and/or unloading. Just another one of the Southern boats that all the local New York crews despised because they were taking the work away.

"It's the first time I've ever been up this river here," he said. "I can't remember where the captain said we were going to."

"If you were up this far, then you must have been going to Albany. There's nothing else up here for a barge like yours. You must get pretty sick of it, being on there for months at a time."

"Oh, they keep us busy, and the pay is better than anyplace back home; and I have needed to save up with the baby coming and all. I do miss my folks and my wife, though. We all live close by to one another."

"This is your first child?"

"Yes, sir. It is," and his answer made me doubt that he would go back on the boats again.

Rhinecliff was in sight ahead, only a few more minutes separated us, when far behind on the bank of the river the southbound train appeared as a line of silver on the muted shore. It streaked downriver while we continued full speed toward the bulkhead. But if the train flew down the tracks like an arrow, we waddled like a duck.

"I don't think we're going to catch that one, sir."

The train was already gliding into the station while we were still a quarter of a mile away, still coming on at full throttle but clearly out of the running.

"You go out onto the foredeck, and when I blow the whistle you hold your bag up in the air and wave it around."

Once he was out there I gave four short blasts, and he stood there with his bag held way up over his head. I blew the horn a couple more times for good measure. The train lay silent alongside the platform. The doors of its coaches were open, and passengers shifted in and out. Then the doors slid shut, and the train became one long silver skin once more. But it didn't move. I held on toward the shore as fast as possible, only slowing and backing down at the last instant.

As quick as I could I told the man about the parking lot and the hole in the fence. I warned him to be careful crossing the tracks and told him to hurry and he might still make it. I didn't tell him about the terrible old place just beyond.

The moment the bow of the tug touched, he was off and running. Across the lot he scrambled, through the fence and, looking both ways, across the tracks. His hat fell off, and my heart sank when he darted back to retrieve it; but the train seemed to countenance this and held fast. He tossed his bag up onto the platform and scrambled up behind to finally stand supplicant before the closest door of the nearest coach. All the doors popped open simultaneously. He made one long stride through his own and they all closed behind him.

The train gave a blast on its horn and began to drag out. I leaned out my window and waved to it. The port on the side of the locomotive slid open, and the engineer waved back.

Notes

Notes to the Introduction

1. The towing hawser connects by means of a heavy shackle or steel plate to a wire bridle, which in turn is attached to the forward corners of the barge. This shackle or plate is the focal point of much of the stress generated between tug and tow and therefore is built extra heavy.

Notes to Chapter 1

1. Yngvar W. Isacksen, "The Manhattan Prong: Continental Collisions and Ancient Volcanoes," *NAHO*, vol. 13, nos. 1&2, 1981, 18–23.

2. Simon Schaffel, "New York City and the Ice Age," *NAHO*, vol. 13, nos. 1&2, 1981, 31–35.

Notes to Chapter 2

1. Jonathan Hulls, *Description and Draft of a New-Invented Machine* (London, 1737).

2. James Cleland, *Historical Account of the Steam Engine and Its Application in Propelling Vessels* (Glasgow: Edward Khull & Son, 1829); and Brent Dibner, "The Earliest Days of Tugboating." *Tugbitts*, Spring/Summer 1995, 5.

3. Interestingly, the Court and perhaps the world at large seemed to consider the basic motive force of the *North River Steamboat* to be fire rather than its by-product, steam. The Court's ruling was careful to specify that not only vessels propelled by steam but, more generally, those propelled by fire are entitled to the freedom of navigable waters.

4. Paul E. Fontenoy, *The Sloops of the Hudson River: A Historical and Design Survey* (Mystic, Conn.: Mystic Seaport Museum, 1994), 36.

5. Advertisement and schedule for New York & Albany Mail Stage, *Commercial Advertiser* (New York), December 23, 1817.

6. Kirkpatrick Sale, *The Fire of His Genius: Robert Fulton and the American Dream* (New York: Free Press, 2001), 128.

Notes to Chapter 3

1. *Commercial Advertiser*, February 19, 1818.

2. Ibid., January 16, 1819.

3. Ibid., January 11, 1820.

4. Carl C. Cutler, *Greyhounds of the Sea: The Story of the American Clipper Ship*, 3rd ed. (Annapolis, Md.: Naval Institute Press, 1960), 503–524; and John H. Morrison, *History of American Steam Navigation* (New York: W. F. Sametz and Co., 1903), 540.

5. Manuscript logbook of brig *Galen* (December 30, 1834–March 2, 1837), Logbook 13, G. W. Blunt White Library, Mystic Seaport Museum.

6. Robert Carse, *Towline: The Story of American Tugboats* (New York: W. W. Norton, 1969), 214.

7. Norman Brouwer, "The Port of New York: Moving People in the Port," *Seaport*, Winter 1986–87, 37.

8. A. G. Fuller Jr., "The Analysis of Innovation: The Philadelphia Steam Tow Boat Company, 1832–1840" (master's thesis, University of Pennsylvania, 1975).

Notes to Chapter 4

1. Morrison, *History of American Steam Navigation*, 75.

2. Robert Greenhalgh Albion, *The Rise of New York Port: 1815–1860* (New York: Charles Scribner's Sons, 1939), 86.

3. Ibid., 91.

4. *New York Shipping and Commercial List*, October 22, 1825.

5. Residence addresses and, frequently, family and business affiliations are derived from the annual New York City directories, which were published by several different firms. Full sets of these are available at the New York Public Library and at the New-York Historical Society.

6. Vessel ownership, dimensions, place and date of building, name of master, and other details are recorded in the *Certificates of Vessel Enrollment*

from the New York Customs House (Records of the Bureau of Marine Inspection and Navigation: Record Group 41), housed at the U.S. National Archives, Washington, D.C. (consulted for this work: October 31, 1817, to March 24, 1868).

7. Fontenoy, *Sloops of the Hudson River*, 64.

Notes to Chapter 5

1. Morrison, *History of American Steam Navigation*, 122.

2. Ibid., 140.

3. The records of the *Austin's* operations are contained among the papers of the Hudson River Day Line housed at the Library of the New-York Historical Society.

Notes to Chapter 6

1. *New York as It Is* (New York: T. R. Tanner, 1835), 151.

2. New York State Commissioners, *Report of the Commissioners Relative to Encroachments in the Harbor of New York*, New York State Senate, 80th leg. sess. (1857), Senate doc. no. 40, 78.

3. Manuscript logbooks of ship *Bridgewater* (6 vols., 1864–1873), Collection 114, G. W. Blunt White Library, Mystic Seaport Museum.

4. Manuscript logbook of ship *Germania* (1858–1866), Logbook 122, G. W. Blunt White Library, Mystic Seaport Museum.

5. Charles Hazzard was born December 6, 1820, in Delaware and relocated to New York at age eighteen. In 1844 he married Miss Julia Sherwood and the next year, in partnership with Joseph T. Martin, became owner and master of the tug *Duncan C. Pell*. In 1851 he became captain of Russell Sturgis's new offshore tug, *Achilles*. The next year, he was transferred to the newly built *Titan*; and, the year after that, he moved to the firm of Spofford, Tileston to command the *Leviathan*. In 1856 he assisted in the design of the *William H. Webb* and served as her original captain for the firm of Chambers & Heiser. After the *Webb* was sold to New Orleans in 1860 he returned to Russell Sturgis to command the *Yankee*.

From 1851 to the outbreak of the Civil War, Charles Hazzard was the preeminent towing master on the Atlantic coast. He was involved in most of the important rescue and salvage operations of the time and became something of a hero to New York's newsmen for his terse dockside accounts of skill, daring, and watery death.

During the Civil War he commanded a troopship and then returned to the salvage and towing business in command of the *Gladiator* and the *Philip*, belonging to the Submarine Wrecking Company. In 1883 he served for a year as captain of the new excursion steamer *Taurus* belonging to the Iron Steamboat Company and then partnered with John L. Brainard to set up the towing

company of Hazzard & Brainard at 60 South Street. Together, they operated the tugs *N. B. Starbuck*, *Jack Jewett*, *Wallace B. Flint*, and *Charm*.

By the early 1890s Captain Hazzard and his wife were living in the household of their daughter, Abbie, in Stamford, Connecticut. Their second daughter, Phoebe, was also married and living in Stamford.

Charles Hazzard died of heart failure on September 12, 1899. Eight days before, one of his tugs, the *Jack Jewett*, was destroyed by fire while towing at Newburgh, New York. A fireman was killed.

Julia Hazzard lived on until 1910. She and the captain are buried side by side in Stamford's Woodlawn Cemetery.

6. "Search for the Pacific," *New York Daily Times*, March 21, 1856; and "Loss of the AJAX," *New York Daily Times*, February 3, 1858.

7. Carl C. Cutler, *Queens of the Western Ocean: The Story of America's Mail and Passenger Sailing Lines* (Annapolis, Md.: Naval Institute Press, 1961), 414.

8. "Steam Tugs in New York Harbor," *New York Daily Times*, January 12, 1857.

9. Manuscript logbook of brig *Scotland* (1859–1864), Miscellaneous vols. 34 and 35, G. W. Blunt White Library, Mystic Seaport Museum.

10. "Court Records," *New York Times*, March 27, 1861.

Notes to Chapter 7

1. "Court Records," *New York Times*, November 4, 1853.

2. Edwin G. Burrows and Mike Wallace, *Gotham: A History of New York City to 1898* (New York: Oxford University Press, 1999), 337.

3. Thomas E. Rush, *The Port of New York* (Garden City, N.Y.: Doubleday, Page, 1920), 166–167.

4. "Burning of the *Leviathan*," *New York Daily Times*, March 21, 1856.

5. "Explosion in the Bay," *New York Daily Times*, January 4, 1866.

6. "Court Records," *New York Times*, June 8, 1860.

7. Most of the genealogical information contained herein was obtained from the many record types available through on-line subscription to Ancestry.com. These fee-based resources include many local birth, death, and marriage records, federal and state census records, and historic newspapers.

8. *New York Times*, October 27, 1860, 5.

9. *New York Times*, March 21, 1869, 5.

10. The Crary brothers, sons, and nephews had part or whole interest in the following boats from 1850 to 1877: *Catherine*, *J. S. Underhill*, *Rattler*, *Kate*, *C. P. Smith*, *J. A. Stevens*, *John Styles*, *Emily*, *J. L. Lockwood*, *President*, *Ceres*, *T. Foulks*, *Stillman Witt*, *J. S. Williams*, *Ida*, *R. L. Mabey*, *L. Boardman*, *D. E. Crary*, *Polar Star*, *Amanda Winants*, *Byron Crary*, *Active*, *Gladiator*, *Pilot Boy*, *C. P. Davenport*, and *Black Bird*.

11. "Death List of the Day," *New York Times*, November 25, 1897.

12. In addition to those listed in the advertisement, Hammond and Potts had part or whole interest in the following boats from 1857 to 1865: *Emily, John R. Vinton, H. H. Cool, Port Royal, Wm. Wells, David Cox, James G. Stevens, Telegraph, Joseph Johnson*, and *D. J. Stetson*.

13. New York State Legislative Committee of Commerce and Navigation, *Report in Relation to the Official Conduct of the Harbor Masters of the City of New York* (Albany: C. Van Benthuysen, 1857). This document in its entirety along with frequent accounts in the *New York Times* spanning the dates June 28, 1859, to March 2, 1861, provide a good description of the manner and scope of the corruption of the harbor masters.

14. Alexander H. and Peter C. Schultz had part or whole interest in the following boats from 1843 to 1886: *James Fairlie, Wave, James M. Hoyt, Storm, Fairfield, Joseph Johnson, Only Son, L. L. Schultz, I. N. Seymour, Virginia Seymour, P. C. Schultz, Thomas Cornell, Wm. Tittamer*, and *Delaware*.

15. The history of the Cornell Steamboat Company is fully explored in Stuart Murray's *Thomas Cornell and the Cornell Steamboat Company* (Fleischmanns, N.Y.: Purple Mountain Press, 2001).

Notes to Chapter 8

1. U.S. Congress, House of Representatives, *Report of the Secretary of the Navy—Report of the Bureau of Steam Engineering*, Ex. Doc. 1, 39th Cong., 1st sess., 1865, 1092.

2. Richard S. West Jr., "The Morgan Purchases," *U.S. Naval Institute Proceedings*, January 1940, 73–77.

3. Charles Dana Gibson and E. Kay Gibson, *Assault and Logistics: Union Army Coastal and River Operations, 1861–1866*, The Army's Navy Series 2 (Camden, Maine: Ensign Press, 1995), xx–xxi.

4. William M. Fowler Jr., *Under Two Flags: The American Navy in the Civil War* (Annapolis, Md.: Naval Institute Press, 1990), 51.

5. U.S. Congress, Senate, *Letter of the Secretary of the Navy*, Ex. Doc. 15, 37th Cong., 2nd sess., 1862, 5.

6. Ibid, 10.

7. Ibid., 22–25.

8. Ibid.

9. George Morgan to Gustavus Fox, August 2, 1861, Naval History Society Collection, Gustavus Fox Papers, New-York Historical Society (hereafter NHSC).

10. Morgan to Fox, October 16, 1861, NHSC.

11. Morgan to Fox, September 26, 1861, and Fox to Morgan, February 8, 1862, NHSC.

12. U.S. Congress, Senate, *Letter from Merchants and Shippers of New York; January 11, 1862*, Ex. Doc. 15, 37th Cong., 2nd sess., 1862, 19.

13. Fox to Morgan, December 15, 1862, NHSC.

14. Samuel F. Du Pont to Fox, August 21, 1862, NHSC.

15. Robert M. Browning, *From Cape Charles to Cape Fear: The North Atlantic Blockading Squadron during the Civil War* (Tuscaloosa: University of Alabama Press, 1993), 56–59.

16. "Schooners as Convoys for Steamers," *New York Times*, October 22, 1861, 4.

17. Goldsborough to Fox, February 23, 1862, NHSC.

18. Gibson and Gibson, *Assault and Logistics*, 24–25.

19. U.S. Congress, House of Representatives, *Vessels Bought, Sold, and Chartered by the United States*, Ex. Doc. 337, 40th Cong., 2nd sess., 1868, 1–227.

20. Ibid., 12.

21. Ibid., 4.

22. Charles Dana Gibson and E. Kay Gibson, *Dictionary of Transports and Combatant Vessels, Steam and Sail, Employed by the Union Army, 1861–1865*, The Army's Navy Series 1 (Camden, Maine: Ensign Press, 1995), 6.

23. Sturgis to Morgan, December 9, 1861, NHSC.

24. U.S. Congress, Senate, *List of Vessels Purchased by the Navy Department for Naval Purposes*, Ex. Doc. 1119, 37th Cong., 2nd sess., 1862, 126.

25. Frank L. DuBosque, "A Diesel Electric Tug," *Transactions of the Society of Naval Architects and Marine Engineers*, vol. 23, 1924, 195.

Notes to Chapter 9

1. H. F. J. Porter, "The Introduction of the Screw Propeller in Marine Service: A Chapter in New York's Port History," *Port of New York Annual*, 1929, 139.

2. U.S. Census data for dates and counties given courtesy of Geostat Center Collections at Fisher Library, University of Virginia. Available on-line at http://fisher.lib.virginia.edu/collections/stats/histcensus.

3. Ibid.

4. *Nautical Gazette*, February 18, 1897, 291.

5. "Coney Island Channel, New York Harbor," *Nautical Gazette*, February 10, 1898.

6. *New York Evening Post*, August 8, 1816.

7. "The 'Permit' Excursion Fleet," *Nautical Gazette*, April 25, 1889.

8. "The Tugboat Nichol Disaster," *Nautical Gazette*, June 28, 1894.

9. "New York Harbor Tugboats: *James D. Nichol*," *Nautical Gazette*, August 13, 1896.

Notes to Chapter 10

1. *Merchant Vessels of the United States* (Washington, D.C.: U.S. Government Printing Office, 1890).

2. *Certificates of Vessel Enrollment*, New York Customs House, Records of the Bureau of Marine Inspection and Navigation: Record Group 41, U.S. National Archives, Washington, D.C.

3. "Scalpers," *Nautical Gazette*, February 2, 1887.

4. Joseph T. Martin (1813–1881) was active as an agent from about 1849 to 1865. He had offices at 37, then 68, and finally 77 South Street. He started in business as a sparmaker on the corner of Front and Montgomery streets around 1840. Except for sharing ownership of the *Duncan C. Pell* with Charles Hazzard in 1845 he appears never to have held any ownership interest in tugs.

5. Solomon Thomas was an early steamboat captain, born in Hudson, New York, in 1821. While in his thirties he developed an association with Burrell (born in 1806 in Norwalk, Connecticut) and Benjamin (born in 1814 in New York) Betts who had been operating towboats since at least 1843 and had opened a towboat agency (B. & B. F. Betts & Company—Steam Towboats) at 39 South Street. By 1851 Thomas appears to have become a partner in the firm and by 1860 had assumed control of the business, in which he remained active until about 1893. From about 1878 he was joined in the business by William D. Fernald, who had been active as an agent at other South Street addresses since 1855. After Solomon Thomas retired from the company, William Fernald and his son George continued in business until 1902. During the period from 1840 to 1869, the successive Betts, Thomas, and Fernald companies held part or whole interest in the following boats: *New York* (appears to have been built as a steam-powered canal boat in 1838 and converted to towing service by Burrell Betts in 1843), *Thomas Salmond*, *Storm* and *Tempest* (these two boats were built in 1849 and were fitted with twin engines taken from the passenger steamer *General Lincoln*), *Active*, *C. Durant*, *Dutchess & Orange*, *Herbert Lawrence Jr.*, *M. M. Caleb*, *Wm. H. Foote*, *Solomon Thomas*, *Wyoming*, *Uno*, *Solomon Thomas Jr.*, *George O. Vail*, *Samson*, *Richard Dean*, and *Washington*.

6. Luther Adams and Henry Storms were frequent partners in the ownership and management of tugs from 1853 to about 1878. Adams's original occupation was that of ship master, and Storms was originally a machinist/engineer. In addition to serving as agents for vessels in which they had no ownership interest, they were invested in the following boats: *Portland*, *Plato*, *Ceres*, and *R. S. Carter*.

7. "Port Towing Rates," *Nautical Gazette*, July 25, 1889.

8. Towage receipts in the manuscript collections of the Mariners Museum, Newport News, Virginia.

9. Brent Dibner, "Eagle 872: The Story of the Dalzell Towing Line," *Tugbitts*, Spring 1992, 12.

10. Burrows and Wallace, *Gotham*, 744.

11. *Nautical Gazette*, May 12, 1886; and "Port Towing Rates," *Nautical Gazette*, July 25, 1887.

12. *Nautical Gazette*, June 20, 1901, 5.

13. "River and Harbor Notes," *Nautical Gazette*, April 10, 1902.

14. "River and Harbor Notes," *Nautical Gazette*, May 15, 1902.

15. The story of the Sing Sing Stampede is derived from articles appearing in the *New York Times* as follows: August 18, 1871, 1:3; August 19, 1871, 8:1; August 20, 1871, 1:5; August 22, 5:3; August 24, 8:3; and August 26, 6:1.

16. This fact figured large in both men's eventual exoneration because as John Earl was quick to point out, the prison break itself "was an enterprise that could not possibly be profitable."

Notes to Chapter 11

1. "A Great Coal Carrying Fleet," *Nautical Gazette*, July 13, 1905, 20–23.

2. "Barge Construction," *Nautical Gazette*, October 8, 1903.

3. "The Premier Coast Towing Line," *Nautical Gazette*, November 27, 1890; "Death of Lewis Luckenbach," *Nautical Gazette*, August 23, 1906; and Paul C. Morris, *Schooners and Schooner Barges* (Orleans, Mass.: Lower Cape, 1984), 9.

4. Morris, *Schooners and Schooner Barges*, 132.

5. Theodore Lucas, "Towing and Towboats," *Nautical Gazette*, April 4, 1901, 7.

6. *Nautical Gazette*, June 20, 1901, 5.

7. Ibid., 12.

8. *Nautical Gazette*, April 27, 1905.

9. Morris, *Schooners and Schooner Barges*, 14.

Notes to Chapter 12

1. "To Tow Oil Barge 15,000 Miles," *Nautical Gazette*, December 22, 1904.

2. "Transatlantic Towing," *Nautical Gazette*, July 27, 1905.

3. Progress reports on the voyage appeared in the *Nautical Gazette* on December 21, 1905; April 5, 1906; April 26, 1906; and May 31, 1906. The *New York Times* reported on the voyage on April 3 and April 18, 1906. The *Washington Post* reported on the voyage on June 21, July 11, and July 17, 1906.

4. W. H. Mitchell and L. A. Sawyer, *Sailing Ship to Supertanker: The Hundred-Year History of British Esso and Its Ships* (Lavenham, Suffolk: T. Dalton, 1987), 27–28; and "Tanker with a Difference," *Sea Breezes*, February 1968, 84–88.

5. Thomas S. Kemble, "Towing Problems," *Transactions of the Society of Naval Architects and Marine Engineers*, vol. 17, 1909, 51–75.

6. Ibid., 55.

7. An early lookout atop the Merchants Exchange Building was James Farrell, until one summer he asked to be transferred to the Highlands so that he could enjoy a season of the fine weather there:

> He was forgotten at the end of the summer and never recalled. He was seldom in the city subsequently. He grew to be somewhat reserved, but not morose. He lived in his cabin, or lookout, on the mountain, with a dog as a sole companion for years and became known as the Hermit of the Highlands. Notwithstanding his old age, his eyesight was remarkable. He could tell an incoming vessel's name when first visible above the eastern horizon by the peculiarities of her upper rigging.

Obituary, *Nautical Gazette*, December 3, 1885.

8. Early telephone directories are held in the collections of the New York Public Library and at the Library of the New-York Historical Society.

9. *New York Times*, December 20, 1924, 1:6.

10. *New York Times*, November 15, 1925, II, 9:1.

11. *New York Times*, May 10, 1936, III, 9:1.

Notes to Chapter 13

1. Morrison, *History of American Steam Navigation*, 107.

2. Ibid., 55.

3. U.S. Department of Energy, National Renewable Energy Laboratory, "Approximate Heat Content of Selected Fuels for Electric Power Generation," *Power Technologies Databook*, available at http://www.nrel.gov/analysis/power_databook/tables.asp?chapter=8&table=50 (accessed September 22, 2003).

4. "Development of Marine Engines," *Nautical Gazette*, June 18, 1896.

5. Daniel Yergin, *The Prize: The Epic Quest for Oil, Money, and Power* (New York: Free Press, 1991), 116.

6. "Petroleum Fuel for Tugs," *Nautical Gazette*, August 5, 1897.

7. Yergin, *The Prize*, 86, 116, 153–157.

8. Ibid., 209.

9. C. A. McAllister, "Economy in the Use of Oil as a Fuel for Harbor Vessels," *Transactions of the Society of Naval Architects and Marine Engineers*, vol. 19, 1911, 179–186; and "Oil Fuel," *Nautical Gazette*, September 11, 1902.

10. *Inventory of Tug Boats Operating in New York Harbor, Long Island Sound, Hudson River, and New York State Barge Canal*, compiled by the New York State Division of Commerce, Executive Department, Albany, 1943 (New York Public Library, call no. *C+p.v. 4193).

Notes to Chapter 14

1. Christopher R. Gabel, "Railroad Generalship: Foundations of Civil War Strategy," Combined Arms Research Library, Command and General Staff College, Fort Leavenworth, Kansas, available at http://www.cgsc.army.mil/carl/resources/csi/gabe14/gabe14.asp (accessed June 2, 2003), 5; and Michael Krieger, *Where Rails Meet the Sea: America's Connections between Ships and Trains* (New York: Michael Friedman, 1998), 87.

2. "John H. Starin Dead," *New York Times*, March 23, 1909; and "John Starin, Pioneer in Transportation, Dead," *New York Herald*, March 23, 1909.

3. "Starin's Renovating Powders for Horses and Cattle" (advertisement), *New York Times*, July 2, 1863.

4. New York, New Haven & Hartford Railroad, "NHRR Archive Notes on NES and NHRR Operations," record group 1, series 2, Archives and Special Collections, Thomas R. Dodd Research Center, University of Connecticut Libraries, available at www.trainweb.org/rmig/nh_news.pdf (accessed August 23, 2004), 14.

5. Thomas R. Flagg, *New York Harbor Railroads in Color*, vol. 1 (Scotch Plains, N.J.: Morning Sun Books, 2000), 5.

6. Ibid., 5.

7. Krieger, *Where Rails Meet the Sea*, 41.

8. *New York Times*, March 10, 1882, 4.

9. *New York Times*, April 8, 1896, 12.

10. U.S. Department of Commerce, Interstate Commerce Commission (ICC), Docket 572, *In the Matter of the Investigation and Suspension of Lighterage and Storage Regulations at New York, N.Y.—Brief for Trunk Lines* (New York: Evening Post Job Printing Office, 1914), 9.

11. Parker McCollester, Counsel for New York State Special Commission on Railroad Freight Rates in New York Harbor, *Memorandum for the Attorney General of New Jersey on Lighterage Question*, New York, 1929 (New York Public Library, call no. VBA p.v. 251); and ICC, Docket 572, 5, 7.

12. ICC, Docket 572, 9.

13. Port of New York Authority, "Memorandum of New York Harbor Practices," October 5, 1925 (New York Public Library, call no. doc. 16 in *VBA p.v. 157).

14. Port of New York Authority and Committee of Railroad Executives, *Joint Report on Marine Cost of Handling Railroad Freight in New York Harbor as of October 1924* (New York: Port Authority of New York, 1926), table 34.

15. Ibid.

16. Bureau of Information of the Eastern Railways, *Railroad Wages and Labor Relations, 1900–1946: An Historical Survey and Summary of Results* (New York, 1947), 18.

17. Details of manning, wages, and usage of all classes of Pennsylvania Railroad tugs and lighterage vessels are contained in a set of reference cards entitled "Fleet Classification" created by the railroad's Steam Towing and Lighterage Department, now in the Melville Library Collections of the South Street Seaport Museum.

Notes to Chapter 15

1. This chapter is based on correspondence, internal reports, and telephone transcripts from the T. A. Scott Collection at the G. W. Blunt White Library, Mystic Seaport Museum.

2. The time of high and low tide in New York Harbor was published daily in the New York newspapers throughout the nineteenth century. From this data the tide and current conditions of any point on the coast can be determined.

3. Hardie Gramatky, *Little Toot* (New York: G. P. Putnam's Sons, 1939).

4. "Court Records," *New York Times,* November 4, 1853.

5. Paul C. Morris and William P. Quinn, *Shipwrecks in New York Waters: A Chronology of Ship Disasters from Montauk Point to Barnegat Inlet from the 1880's to the 1930's* (Orleans, Mass.: Parnassus, 1989), 67–69.

Notes to Chapter 16

1. Benjamin F. Squires, "New York Harbor Employees," *Monthly Labor Review,* July 1918, table 1, p. 5.

2. A broad account of the origins of all New York Harbor marine labor organizations is contained in Benjamin F. Squires, "The Marine Workers' Affiliation of the Port of New York," *Journal of Political Economy,* vol. 27, no. 10, December 1919, 843–853.

3. Ibid., 853.

4. A broad account of the 1918 New York Harbor strike is contained in Benjamin F. Squires, "The New York Harbor Strike," *Monthly Labor Review,* February 1919, 330–345.

5. The issue of the length of a working day on board ship is quite different from that of most shore jobs. Many boats work around the clock with two crews standing watches of six hours on, six off. Day boats work with one crew that stays on board until its day's work is completed, whether it takes eight, twelve, or even twenty-four hours. The issue involved in both types of boats is when overtime pay rates—time and a half—kick in. The central issue in the argument over the length of the day in the marine field is over-time, as opposed to concerns about having time off to share with the kids or mow the lawn.

6. Squires, "Marine Workers' Affiliation of the Port of New York," 871–872.

7. Except as otherwise noted, the narrative of labor–management relations, including wage and work-rule details, is derived from articles published in the *New York Times* in the following issues: February 27, 1921, 12:1; January 19, 1923, 19:5; June 30, 1923, 20:5; July 11, 1923, 4:6; September 10, 1923, 26:3; December 24, 1924, 31:5; January 7, 1926, 41:2; April 16, 1926, 1:4; March 27, 1927, 27:1; September 27, 1928, 59:1; September 30, 1928, II, 19:2; October 16, 1931, 47:3; October 14, 1932, 14:1; October 15, 1932, 33:2; October 17, 1932, 33:2; October 18, 1932, 41:1; November 8, 1932, 43:1; October 19, 1933, 41:1; October 21, 1933, 31:1; October 24, 1933, 43:3; July 20, 1934, 33:3; July 31, 1934, 37:3; October 6, 1936, 51:8; October 12, 1936, 3:1; October 16, 1936, 51:1; October 17, 1936, 35:1; October 19, 1936, 39:8; October 29, 1936, 8:6; October 30, 1936, 47:2; April 1, 1941, 16:3; April 2, 1941, 47:1; April 3, 1941, 47:8; April 7, 1941, 11:4; February 21, 1942, 27:8; March 24, 1942, 11:5; January 30, 1946, 1:6; January 31, 1946, 12:1; February 1, 1946, 17:6; February 2, 1946, 1:1; February 3, 1946, 1:4; February 4, 1946, 1:1; February 5, 1946, 1:5, 14:4; February 6, 1946, 1:5; February 7, 1946, 1:6, 1:8, 2:3; February 8, 1946, 1:4, 1:7, 8:1; February 9, 1946, 1:5, 3:1, 3:3, 3:5; February 10, 1946, 1:5, 3:2, 3:7, 4:1, 4:4, 7:2, Ed. 8:1; February 12, 1946, 1:5, 1:6, 1:7, 1:8, 18:3; February 13, 1946, 1:6, 1:7, 1:8, 2:1, 2:3, and many related items; February 14, 1946, 1:8, 2:4, 2:5, 2:6, 3:1, 3:3, Ed. 24:1; February 15, 1946, 1:4; May 5, 1946, 1:7; August 9, 1946, 35:4; September 8, 1946, 1:5, 8:1, IV, 1:2; September 9, 1946, 1:5, 1:6, 1:7, 1:8; September 10, 1946, 6:5; September 11, 1946, 1:5, 2:1, Ed. 6:1; September 12, 1946, Ed. 6:1; February 1, 1957, 1:8; February 2, 1957, 1:5; February 3, 1957, 1:1; February 4, 1957, 1:2; February 5, 1957, 1:1; February 6, 1957, 1:1, 18:4; February 7, 1957, 8:6, 18:2; February 8, 1957, 1:1, 1:2, 25:1; March 8, 1957, 1:6; March 9, 1957, 1:2; February 2, 1964, 1:1, 74:2; March 3, 1964, 69:1; March 5, 1964, 1:5, 44:2; February 19, 1973, 37:7; August 3, 1975, IV, 6:4; April 2 1979, A, 1:2; April 3, 1979, B, 3:3; April 5, 1979, B, 1:1; April 21, 1979, 22:8; April 20, 1979, A, 1:3; April 21, 1979, 1:1; April 22, 1979, 1:2; April 25, 1979, B, 4:1; May 6, 1979, 1:1; May 9, 1979, B, 3:3; May 18, 1979, B, 4:2; May 19, 1979, 28:1; June 14, 1979, 1:3; June 22, 1979, 1:1; June 28, 1979, B, 3:7; February 17, 1988, B, 4:2; March 7, 1988, B, 3:6; June 8, 1988, B, 1:1; June 12, 1990, B, 1:8.

8. U.S. Department of Labor, Bureau of Labor Statistics, "Consumer Price Index, Urban Wage Earners and Clerical Workers, NY-NJ-CT-PA, 1918–1990," available at http://data.bls.gov (accessed February 13, 2004).

9. *New York Times*, October 21, 1932.

10. *New York Times*, October 12, 1936.

11. "Earnings on Tugboats and Barges in New York Harbor, January 1945," *Monthly Labor Review*, December 1945, 1200.

12. A number of veteran watermen I have known cite the companies' and the ILA's 1957 abandonment of the bargemen as the turning point in the history of the harbor.

13. *New York Times*, March 9, 1957.

14. A. R. Smith, *Port of New York Annual* (New York: Smith's Port Publishing, 1920), 409.

Notes to Chapter 17

1. Martin Leduc, "Biography of Rudolph Diesel," Martin's Marine Engineering website, http://www.dieselduck.ca/library/articles/rudolph_diesel .htm (accessed December 14, 2004).

2. It is frequently stated that the railroad companies were the strongest proponents of diesel-electric tugs because of their very positive experience with diesel-electric locomotive designs. This is generally true, but it should be noted that the *PRR No. 16* was completed in July 1924, while it was not until 1925 that American Locomotive Company was able to make the first sale of a diesel-electric locomotive—and this not to the Pennsylvania but to the Jersey Central Railroad.

3. DuBosque, "A Diesel Electric Tug," 195–211.

4. Ibid., 195.

5. Theodore Lucas, "Reversible Oil Engines for Marine Service," *Nautical Gazette*, January 3, 1907, 33.

6. Steven Lang and Peter H. Spectre, *On the Hawser: A Tugboat Album* (Camden, Maine: Down East Books, 1980), 84.

7. *Merchant Vessels of the United States* (Washington, D.C.: U.S. Government Printing Office, 1929).

8. *Merchant Vessels of the United States* (Washington, D.C.: U.S. Government Printing Office, 1938).

9. *Merchant Vessels of the United States* (Washington, D.C.: U.S. Government Printing Office, 1955).

10. *Merchant Vessels of the United States* (Washington, D.C.: U.S. Government Printing Office, 1977).

Notes to Chapter 18

1. Port of New York Authority, *Foreign Trade at the Port of New York: An Analysis of the New York–New Jersey Port's Position in the Handling of Oceanborne and Airborne Foreign Trade* (New York: Port Authority of New York and New Jersey, 1970), 13.

2. Ibid., 24.

3. Ibid., 26.

4. Ibid., 25.

5. John I. Griffin, *The Port of New York*, Institute of New York Area Studies 3 (New York: City College Press, 1959), 45.

6. George V. Hutton, *The Great Hudson River Brick Industry* (Fleischmanns, N.Y.: Purple Mountain Press, 2003), 110.

7. Elly Shodell, ed., *Particles of the Past: Sandmining on Long Island, 1870s–1980s* (Port Washington, N.Y.: Port Washington Public Library, 1985), 10.

8. Data from 1916, 1952, and 2002 is derived from Eads Johnson, *Johnson's Steam Vessels of the Atlantic Coast* (New York: Eads Johnson, 1916, 1952); *Merchant Vessels of the United States* (Washington, D.C.: U.S. Government Printing Office, 1916, 1952); U.S. Army Corps of Engineers, *Waterborne Transportation Lines of the United States* (Alexandria, Va.: U.S. Army Corps of Engineers, 2002); and from current information provided by individual companies on-line.

9. Eugene F. Moran and Louis Reid, *Tugboat: The Moran Story* (New York: Charles Scribner & Sons, 1956) 166.

Notes to Chapter 19

1. Moran merged with Turecamo in 1998.

Bibliography

Albion, Robert Greenhalgh. *The Rise of New York Port: 1815–1860.* New York: Charles Scribner's Sons, 1939.

Association of American Railroads, Railroad Committee for the Study of Transportation and Traffic. *Report on Anthracite and Bituminous Coal.* Washington, D.C.: Association of American Rail Roads, 1947.

Bayor, Ronald H., and Timothy J. Meagher. *The New York Irish.* Baltimore: Johns Hopkins University Press, 1996.

Bell Telephone Company of New York. "Subscriber's List," 1878 and January 1, 1880. New-York Historical Society Collections.

Blank, John S. *Modern Towing.* Centreville, Md.: Cornell Maritime Press, 1989.

Bogen, Jules Irwin. *The Anthracite Railroads: A Study in American Railroad Enterprise.* New York: Ronald Press, 1927.

Bone, Kevin, ed. *The New York Waterfront: Evolution and Building Culture of the Port and Harbor.* New York: Monacelli Press, 1997.

Bowen, Frank C. *A Hundred Years of Towage: Messrs. William Watkins, Ltd., 1833–1933.* Gravesend, U.K.: privately printed, 1933.

Boynton, Charles B. *The History of the Navy during the Rebellion.* New York: D. Appleton, 1867–68.

Bradley, David L. "Bradley's Reminiscences of New York Harbor." Bayonne, N.J.: n.p., 1896.

Brady, Edward M. *Tugs, Towboats, and Towing.* Centreville, Md.: Cornell Maritime Press, 1967.

Braynard, Frank O. "World's Largest Towing Organization (Moran)." *Ship and Boat (Tugs),* March 1968, 36–39.

Brouwer, Norman. "The Port of New York: The Canal Network." *Seaport,* Spring 1986, 30–36.

———. "The Port of New York: The Coming of the Railroads." *Seaport,* Summer 1986, 42–47.

———. "The Port of New York: Moving Goods within the Port." *Seaport,* Spring 1987, 30-35.

———. "The Port of New York: Moving People in the Port." *Seaport,* Winter 1986–87, 36–40.

———. "The Port of New York: Resources of the Hudson River Valley." *Seaport,* Winter 1986, 12–19.

Browning, Robert M., Jr. *From Cape Charles to Cape Fear: The North Atlantic Blockading Squadron during the Civil War.* Tuscaloosa: University of Alabama Press, 1993.

Bureau of Information of the Eastern Railways. *Railroad Wages and Labor Relations, 1900–1946: An Historical Survey and Summary of Results.* New York, 1947.

Burrows, Edwin G., and Mike Wallace. *Gotham: A History of New York City to 1898.* New York: Oxford University Press, 1999.

Canney, Donald L. *Lincoln's Navy: Ships, Men, and Organization, 1861–1865.* London: Conway Maritime Press, 1998.

Carse, Robert, *Towline: The Story of American Tugboats.* New York: W. W. Norton, 1969.

Cleland, James. *Historical Account of the Steam Engine and Its Application in Propelling Vessels.* Glasgow: Edward Khull & Son, 1829.

Clements, Calvin. *Barge Girl.* New York: Fawcett, 1953.

Cohen, Paul E., and Robert T. Augustyn. *Manhattan in Maps, 1527–1995.* New York: Rizzoli International, 1997.

Connolly, James B. "New York Harbor." *Harper's,* July 1905, 228–236.

Cutler, Carl C. *Greyhounds of the Sea: The Story of the American Clipper Ship,* 3rd ed. Annapolis, Md.: Naval Institute Press, 1960.

———. *Queens of the Western Ocean: The Story of America's Mail and Passenger Sailing Lines.* Annapolis, Md.: Naval Institute Press, 1961.

Davidson, G. C. "Heavy Oil Engines for Marine Propulsion." *Transactions of the Society of Naval Architects and Marine Engineers*, vol. 19, 1911, 231–254.

Dibner, Brent. "Eagle 872: The Story of the Dalzell Towing Line." *Tugbitts*, Spring 1992, 11–26.

———. "The Earliest Days of Tugboating." *Tugbitts*, Spring/Summer 1995.

———. "A Graphic Timeline of the New York Port Tugboat Fleet, 1820–1976." Collections of the Melville Library, South Street Seaport Museum.

———. "History of the Red Star Towing and Transportation Company." *Tugbitts*, October–December 1991, 1–11.

DuBosque, Frank L. "A Diesel Electric Tug." *Transactions of the Society of Naval Architects and Marine Engineers*, vol. 23, 1924, 195–211.

Dunbaugh, Edwin L., and William du Barry Thomas. *William H. Webb: Shipbuilder*. Glen Cove, N.Y.: Webb Institute of Naval Architecture, 1989.

Farb, Peter. "New York's Mighty Tugboat Fleet." *Think*, February 1954, 16–17.

Federal Writers' Project (WPA). *New York Panorama*. American Guide Series. New York: Random House, 1938.

Flagg, Thomas R. *New York Harbor Railroads in Color*, 2 vols. Scotch Plains, N.J.: Morning Sun Books, 2000, 2002.

Fontenoy, Paul E. *The Sloops of the Hudson River: A Historical and Design Survey*. Mystic, Conn.: Mystic Seaport Museum, 1994.

Fowler, William M., Jr. *Under Two Flags: The American Navy in the Civil War*. Annapolis, Md.: Naval Institute Press, 1990.

Fox, Gustavus V. *Confidential Correspondence of Gustavus V. Fox, Assistant Secretary of the Navy, 1861–1865*. Robert Means Thompson and Richard Wainwright, eds. New York: Naval History Society, 1918–19.

———. *Papers*. Naval History Society Collection, Manuscripts Department, New-York Historical Society.

Fuller, A. G., Jr. "The Analysis of Innovation: The Philadelphia Steam Tow Boat Company, 1832–1840." Master's thesis, University of Pennsylvania, 1975.

Gabel, Christopher R. "Railroad Generalship: Foundations of Civil War Strategy." Combined Arms Research Library, Command and General Staff College, Fort Leavenworth, Kansas. Available at http://www.cgsc.army.mil/carl/resources/csi/gabe14/gabe14.asp (accessed June 2, 2003).

Garrity, Richard. *Canal Boatman: My Life on Upstate Waterways*. Syracuse: Syracuse University Press, 1977.

Gesh, Lynn. "Dalzell." *Ships and the Sea*, Winter 1955.

Gibson, Charles Dana, and E. Kay Gibson. *Dictionary of Transports and Combatant Vessels, Steam and Sail, Employed by the Union Army,* 1861–1865. The Army's Navy Series 1. Camden, Maine: Ensign Press, 1995.

———. *Assault and Logistics: Union Army Coastal and River Operations, 1861–1866*. The Army's Navy Series 2. Camden, Maine: Ensign Press, 1995.

Gramatky, Hardie. *Little Toot*. New York: G. P. Putnam's Sons, 1939.

Griffin, John I. *The Port of New York*. Institute of New York Area Studies 3. New York: City College Press, 1959.

"Harbor Fleet." *Fortune*, May 1943, 99–176.

Hazzard, Charles. "The Steam Tug *Leviathan* of New York Harbor." *Monthly Nautical Magazine and Quarterly Review*, October 1854, 202–207.

Heyl, Erik. *Early American Steamers*, 6 vols. Buffalo: privately printed, 1953–1969.

Homans, J. Smith, and J. Smith Homans Jr. *A Cyclopedia of Commerce and Commercial Navigation*. New York: Harper, 1858.

Hulls, Jonathan. *A Description and Draft of a New-Invented Machine*. London, 1737. Rare Books Division of the New York Public Library.

Hutton, George V. *The Great Hudson River Brick Industry*. Fleischmanns, N.Y.: Purple Mountain Press, 2003.

Isacksen, Yngvar W. "The Manhattan Prong: Continental Collisions and Ancient Volcanoes." *NAHO*, vol. 13, nos. 1&2, 1981, 18–23.

Jensen, Vernon H. *Strife on the Waterfront: The Port of New York since 1945*. Ithaca: Cornell University Press, 1974.

Johnson, Eads. *Johnson's Steam Vessels of the Atlantic Coast* (a biannual registry). New York: Eads Johnson, 1910–1954.

———. *Johnson's Steam Vessels of New York Harbor, 1912–1915*. New York: Eads Johnson, 1915.

Johnson, Harry, and Frederick S. Lightfoot. *Maritime New York in Nineteenth-Century Photographs*. New York: Dover, 1980.

Jones, Harry E. *Railroad Wages and Labor Relations, 1900–1946: An Historical Survey and Summary of Results*. New York: Bureau of Information of Eastern Railways, 1947.

Kemble, Thomas S. "Towing Problems." *Transactions of the Society of Naval Architects and Marine Engineers*, vol. 17, 1909, 51–75.

Kreiger, Michael. *Where Rails Meet the Sea: America's Connection between Ships and Trains*. New York: Michael Friedman, 1998.

Lane, Carl. *American Paddle Steamboats*. New York: Coward-McCann, 1943.

Lane, Wheaton. *Commodore Vanderbilt: An Epic of the Steam Age*. New York: A. A. Knopf, 1942.

Lang, Stephen, and Peter H. Spectre. *On the Hawser: A Tugboat Album*. Camden, Maine: Down East Books, 1980.

Lardner, Dionysius. *The Steam Engine Explained and Illustrated: With an Historical Sketch of Its Progressive Improvement, Its Applications to Navigation and Railways, with Plain Maxims for Railway Speculators.* Philadelphia: E. L. Cary and A. Hart, 1836.

Leduc, Martin. "Biography of Rudolph Diesel." Martin's Marine Engineering website, http://www.dieselduck.ca/library/articles/rudolph_diesel.htm (accessed December 14, 2004).

Lesher, Robert A. *Railroad Lighterage and Car Float Service in New York Harbor.* New York: Port of New York Authority (and Committee of Railroad Executives), 1930.

Logbook. brig *Galen* (December 30, 1834–March 2, 1837), Logbook 13, G. W. Blunt White Library, Mystic Seaport Museum.

———. brig *Scotland* (1859–1864), Miscellaneous vols. 34 and 35, G. W. Blunt White Library, Mystic Seaport Museum.

———. ship *Bridgewater* (6 vols., 1864–1873), Collection 114, G. W. Blunt White Library, Mystic Seaport Museum.

———. ship *Germania* (1858–866), Logbook 122, G. W. Blunt White Library, Mystic Seaport Museum.

Lucas, Theodore. "Reversible Oil Engines for Marine Service." *Nautical Gazette*, January 3, 1907, 33–37.

———. "Towing and Towboats." *Nautical Gazette*, April 4, 1901, 6–7.

Luraghi, Raimondo. *A History of the Confederate Navy.* Annapolis, Md.: Naval Institute Press, 1996.

MacElrevy, Daniel H. *Shiphandling for the Mariner.* Centreville, Md.: Cornell Maritime Press, 1983.

McAllister, C. A. "Economy in the Use of Oil as a Fuel for Harbor Vessels." *Transactions of the Society of Naval Architects and Marine Engineers*, vol. 19, 1911, 179–186.

McCollester, Parker, Counsel for New York State Special Commission on Railroad Freight Rates in New York Harbor. *Memorandum for the Attorney General of New Jersey on the Lighterage Question.* New York, 1929. New York Public Library, call no. VBA p.v. 251.

McKay, Ernest A. *The Civil War and New York City.* Syracuse: Syracuse University Press, 1990.

McQuade, Walter. "Tugboats: Power in a Small Packet." *Fortune*, April 1968, 120–127.

Marshall, David. "The Railroad Navy." *Railroad Magazine*, August 1959, 18–25.

Mason, Charles A. "Evolution of the Towboat Industry: Towboats and Towboating, 1737–1923 (Prepared for Tice Towing Line)." *Maritime Exchange Bulletin*, vol. 10, no. 9, January 1923.

Merchant Vessels of the United States. Washington, D.C.: U.S. Government Printing Office. Published annually, with several gaps from 1867 to 1989, under the auspices of various government bureaus.

"Merritt-Chapman and Scott Corporation, 1860–1960: A Century of Pioneering." *New York Times*, Supplement, March 20, 1960.

Metropolitan Telephone and Telegraph Company. *Subscribers List.* New York City, November 16, 1885, and September 1, 1892. Library Collections of the New-York Historical Society.

Miller, Benjamin. *The Fat of the Land: Garbage in New York—The Last Two Hundred Years.* New York: Four Walls Eight Windows Press, 2000.

Minick, Rachel. "New York Ferryboats in the Union Navy." *New-York Historical Society Quarterly*, October 1962, 422–436.

Mitchell, C. Bradford. *Supplement to "Merchant Vessels of the United States, 1790–1868" (the Lytle-Holdcamper List).* Staten Island, N.Y.: Steamship Historical Society of America, 1978.

Mitchell, W. H., and L. A. Sawyer. *Sailing Ship to Supertanker: The Hundred-Year Story of British Esso and Its Ships.* Lavenham, Suffolk: T. Dalton, 1987.

Monthly Labor Review. "Award of Board of Arbitration in New York Harbor Wage Adjustment." January 1918, 230–233.

———. "Labor Agreements, Awards, and Decisions: Longshoremen and Lighter Captains, Port of New York." December 1923, 127.

Moran, Eugene F., and Lois Reid. *Tugboat: The Moran Story.* New York: Charles Scribner & Sons, 1956.

Morris, Paul C. *Sailing Coasters of the North Atlantic.* Chardon, Ohio: Block and Osborn, 1973.

———. *Schooners and Schooner Barges.* Orleans, Mass.: Lower Cape, 1984.

Morris, Paul C., and William P. Quinn. *Shipwrecks in New York Waters: A Chronology of Ship Disasters from Montauk Point to Barnegat Inlet from the 1880's to the 1930's.* Orleans, Mass.: Parnassus, 1989.

Morrison, John H. *History of American Steam Navigation,* New York: W. F. Sametz and Co., 1903.

Murphy, Stephen J. "Union Local 333, Tugboat Workers for the Port of New York/New Jersey, 1945–1994: A Case Study." Master's thesis, State University of New York, Maritime College, May 1991.

Murray, Stuart. *Thomas Cornell and the Cornell Steamboat Company.* Fleischmanns, N.Y.: Purple Mountain Press, 2001.

New York as It Is (directory). New York: T. R. Tanner, 1835.

New York, New Haven & Hartford Railroad. "NHRR Archive Notes on NES and NHRR Operations." Record group 1, series 2, Archives and Special Collections, Thomas R. Dodd Research Center, University of Connecti-

cut Libraries. Available at www.trainweb.org/rmig/nh_news.pdf (accessed August 23, 2004).

New York State, Commission on Encroachments in the Harbor of New York. *Report of the Commissioners Relative to Encroachments in the Harbor of New York*. New York State Senate, 80th leg. sess. (1857), doc. no. 40.

————, Division of Commerce, Executive Department, comp. *Inventory of Tugboats Operating in New York Harbor, Long Island Sound, Hudson River, and New York State Barge Canal*. Albany, 1943. New York Public Library, call no. *C+p.v. 4193).

————, Legislative Committee of Commerce and Navigation. *Report in Relation to the Official Conduct of the Harbor Masters of the City of New York*. Albany: C. Van Benthuysen, 1857.

Nicholls, William Jasper. *The Story of American Coals*. Philadelphia and London: J. B. Lippincott, 1904.

Nicholson, Tim. *Take the Strain: The Alexandra Towing Company and the British Tugboat Business, 1833–1987*. Liverpool: Alexandra Towing Company, 1990.

Parks, Alex L. *The Law of Tug, Tow, and Pilotage*. Centreville, Md.: Cornell Maritime Press, 1971.

Pearce, David. "Handling Railroad Barges in New York Harbor." *Transfer*, no. 38, May–August 2003, 17–23.

Pennsylvania Railroad, Steam Towing and Lighterage Department. "Fleet Classification" (a set of reference cards detailing the manning, wages, and usage of all classes of Pennsylvania Railroad tugs and lighterage vessels). Melville Library Collections of the South Street Seaport Museum.

Plunkett, Margaret L. "Earnings on Tugboats and Barges in New York Harbor—January 1945." *Monthly Labor Review*, December 1945, 1192–1200.

Port of New York Authority. *Foreign Trade at the Port of New York: An Analysis of the New York–New Jersey Port's Position in the Handling of Oceanborne and Airborne Freight Trade*. New York: Port Authority of New York and New Jersey, 1970.

————. "Memorandum on New York Harbor Practices." October 5, 1925. New York Public Library, call no. doc. 16 in *VBA p.v. 157.

Port of New York Authority and Committee of Railroad Executives. *Joint Report on the Marine Cost of Handling Railroad Freight in New York Harbor as of October 1924*. New York: Port Authority of New York, 1926.

Porter, H. F. J. "The Introduction of the Screw Propeller in Marine Service: A Chapter in New York's Port History." *Port of New York Annual*, 1929, 139.

Reid, George H. *Primer of Towing*. Cambridge, Md.: Cornell Maritime Press, 1975.

Renwick, James. *Account of the Steamboats of America*. Contained in Dionysius Lardner, *The Steam Engine Explained and Illustrated: With an Historical Sketch of Its Progressive Improvement, Its Applications to Navigation and Railways, with Plain Maxims for Railway Speculators*. Philadelphia: E. L. Cary and A. Hart, 1836.

Rush, Thomas E. *The Port of New York*. Garden City, N.Y.: Doubleday, Page, 1920.

Sale, Kirkpatrick. *The Fire of His Genius: Robert Fulton and the American Dream*. New York: Free Press, 2001.

Schaffel, Simon. "New York City and the Ice Age." *NAHO*, vol. 13, nos. 1&2, 1981, 31–35.

Shodell, Elly, ed. *Particles of the Past: Sandmining on Long Island, 1870s–1980s*. Port Washington, N.Y.: Port Washington Public Library, 1985.

Skinner, E. G. "A Tanker with a Difference." *Sea-Breezes*, February 1968, 84–88.

Smith, A. R. *Port of New York Annual*. New York: Smith's Port Publishing, 1919, 1920, 1929.

Smith, James C., comp. "U.S. Navy Tugboats of the Civil War Era." National Association of Fleet Tug Sailors website, http://www.nafts.com/images/Smith%20List/jcs001.html (accessed January 15, 2003).

Smith, Stephen Russell. *A Study of the Utilization of Tractor Tugs to Aid Shiphandling in Charleston Harbor*. Kings Point, N.Y.: United States Merchant Marine Academy, 1997.

Squires, Benjamin M. "Associations of Harbor Boat Owners and Employees in the Port of New York." *Monthly Labor Review*, April 1918, 265–282.

————. "The Marine Workers' Affiliation of the Port of New York." *Journal of Political Economy*, vol. 27, no. 10, December 1919, 840–874.

————. "New York Harbor Employees." *Monthly Labor Review*, July 1918, 1–21.

————. "The New York Harbor Strike." *Monthly Labor Review*, February 1919, 330–345.

————. "Readjustment of Wages and Working Conditions of New York Harbor Employees." *Monthly Labor Review*, August 1919, 475–487.

Stanton, Samuel Ward. *American Steam Vessels Series*, 10 vols. Upper Montclair, N.J.: H. K. Whiting, 1974.

Tri-State Transportation Committee. *Study of Consolidated Railroad Marine and Lighterage for New York Harbor*. New York, 1964. New York Public Library, call no. F-11 3414.

Turnbull, Archibald Douglas. *John Stevens: An American Record.* New York: Century Company, 1928.

U.S. Army Corps of Engineers. *Waterborne Transportation Lines of the United States.* Alexandria, Va.: U.S. Army Corps of Engineers, 2002.

U.S. Bureau of the Census. Historical Census Data. Collections of the Geostat Center, Fisher Library, University of Virginia. Available at http://fisher.lib.virginia.edu/collections/stats/histcensus (accessed September 14, 2004).

———. *Water Transportation.* Washington, D.C.: U.S. Government Printing Office, 1929.

U.S. Congress, House of Representatives. *Report of the Secretary of the Navy, Report of the Bureau of Steam Engineering,* Ex. Doc. 1. 39th Cong., 1st sess., 1865.

———. *Vessels Bought, Sold, and Chartered by the U.S.,* Ex. Doc. 337. 40th Cong., 2nd sess., 1868.

U.S. Congress, Senate. *Letter from Merchants and Shippers of New York; January 11, 1862,* Ex. Doc. 15. 37th Cong., 2nd sess., 1862.

———. *Letter of the Secretary of the Navy Relative to the Employment of George D. Morgan, of New York, to Purchase Vessels for the Government,* Ex. Doc. 15. 37th Cong., 2nd sess., 1862.

———. *List of Vessels Purchased by the Navy Department for Naval Purposes,* Ex. Doc. 1119. 37th Cong., 2nd sess., 1862.

U.S. Department of Commerce, Interstate Commerce Commission. *In the Matter of the Investigation and Suspension of Lighterage and Storage Regulations at New York, N.Y.—Brief for Trunk Lines,* Docket 572. New York: Evening Post Job Printing Office, 1914.

———. *In the Matter of the Investigation and Suspension of Lighterage and Storage Regulations at New York, N.Y.—Brief for the City of New York,* Docket 572. New York: Evening Post Job Printing office, 1915.

———. *In the Matter of Lighterage and Storage Regulations at New York, New York—Brief for Protestant, the Merchants Association of New York.* New York: W. Siegrist, 1915.

———. *In the Matter of Rates, Practices, Rules, and Regulations Governing the Transportation of Anthracite Coal,* Docket 4914. Washington, D.C.: U.S. Government Printing Office, 1915.

U.S. Department of Defense, Naval History Division. *Dictionary of American Naval Fighting Ships.* Washington, D.C.: U.S. Government Printing Office, 1959–1981.

U.S. Department of Energy, National Renewable Energy Laboratory. "Approximate Heat Content of Selected Fuels for Electric Power Generation." *Power Technologies Databook.* Available at http://www.nrel.gov/analysis/power _databook/tables.asp?chapter=8&table=50 (accessed September 22, 2003).

U.S. Department of Labor, Bureau of Labor Statistics. "Consumer Price Index, Urban Wage Earners and Clerical Workers, NY-NJ-CT-PA, 1918–1990." Available at http://data.bls.gov (accessed February 13, 2004).

Webster, F. B. *Shipbuilding Cyclopedia: A Reference Book and Composite Catalogue of Marine Equipment.* New York: Simmons-Boardman, 1920.

West, Richard S., Jr. "The Morgan Purchases." *U.S. Naval Institute Proceedings,* January 1940, 73–78.

Wolff, Douglas M. *The Articulated Tug-Barge: A Case Study.* Elliot Bay Design Group, 2004.

Yergin, Daniel. *The Prize: The Epic Quest for Oil, Money, and Power.* New York: Free Press, 1991.

Index

86–88, 95, 138; hawser towing (*see* Hawser towing); helper boats, 32, *33*, *108*, 109; on the hip, 136–139, *137*, *140*, *145*; important firms, 4; inbound towing, 22–23, 43; as a loss leader, 27; as method of last resort, 185; methods of, 117, 138–139, 155; on the nose, 153–155, *154*; obstacle to profitability, 41; outbound towing, 23, 54; positioning and, 22–23; principles of, 22–23; pushing, 153–155, *154*, 222, 223, 241; under sail, 17; sail boats and, 17, 23; seasonality, 41; steam towing in New York Harbor, 21–27; steam towing on the Hudson River, 29–32, 37–41, 61–63; transatlantic towing, 121–123; versatility and, 22–23

Towing bitts, 4, 86, 117

Towlines. *See* Hawsers (towlines)

Townsend, Charles, 45

Tracy Towing Line, 4, *133*

"Tramp" arrivals, 95

Transatlantic towing, 121–123

Transfer No. 8 (tugboat), 12, *13*

Transport work, 165, 166

Trow's New York Directory, 56

Troy Line, 31

Trucking, 183, 219

Truman, Harry S., 180

Trust among tugboatmen, 164–165

Tugboat industry: advantage of larger companies, 127; agents in (*see* Agents); as an investment opportunity, 53, 56; beginnings, 1, 6; bidding/price wars, 47, 51, 63; bribery in, 58–59; buy-outs in, 51; captive tugboats, 220–221; charter agreements, 66, 72–74, 220; in Civil War, 65–74; coastal towing business, 105–117, 211; consolidation in, 191–193, 214–216; contraction of, 198; decline of, 2, 209–214, 219–220; dispatchers in, 4; diversification in, 57–58; entrepreneurship and, 53, 56; generational concentration in leadership, 93; government regulation, 233; harbor excursion business, 84–86, 144; hiring boats from other companies, 4; Hudson River market, 51–52, 61–63; idleness between assignments, 111; importance to commerce, 44, 82; independent (nonunion) companies, 183, 191–195; information about arrivals, 126–127; innovation in, 36–37, 51, 52; interconnectedness along eastern seaboard, 171, 212, 220; Irish in, 95–98; justifying using tugboats, 23–24; knowledge of tides and currents, 12–14, 254n15.2; late nineteenth century, 92–103, 149; legal liabilities, 233; maturation of, 93–95, 219; mid-nineteenth century, 35–41, 43–49, 51–63, 142; migration of used tugboats from one region to another, 91; modernization of the fleet, 233; movement to articulated tug and barge (ATB) systems, 155; nepotism in, 2, 174, 216; New York Harbor market, 52–53; "no cure, no pay" arrangements, 159, 163; obstacle to profitability, 41; ownership patterns, 57, 91–92, 153–154, 214–215; post-Civil War era, 72, 79–86, 91, 211; purchases by Union Navy, 67; railroad tugboats, 142, 152; rationalization of, 191–193; rescue operations, 52, 127, 162; salvage operations, 159–165, *194*, 195; scalpers in, 92, 128, 191; seasonality, 41; separation from passenger business, 85–86; ship-to-shore communications, 126–129, 162; skill requirements, 54; sources of information about, 7; specialization in, 95, 101, 165; superadequate tugboats, 233; survival in, 219–220; theft of company equipment and supplies, 185; towing as a loss leader, 27; "tramp" arrivals, 95; transport work, 165, 166; trust and honor in, 164–165; unions in (*see* Unions); wrecking operations, 162

Tugboatmen: charts to, 14; individuality of, 191; journeymen's notebooks, 14; payments to harbor masters, 59; trust and honor among, 164–165; wages (*see* wages)

Tugboats: acceptance of, 47–48; advantages over schooners in shipping coal, 111; articulated tug and barge (ATB) combinations, *154*, 154–155, 222, 223–224; awareness of, 1; boilers in (*see* Boilers); bulkheads in, 85; captain's balls on, *236*, *237*; captains of (*see* Captains); captive tugboats, 220–221; cargo-carrying by, 121; classes of, 47, 161; coal shipments, 107–110; coastal (seagoing) tugboats, 110–117, *112–113*; compass binnacles on, *236*, *237*; conversion from coal-fired to oil-fired systems, 132, 133–136, 214; cooks on, 38, 152, 238; cost to operate, 38, 187; crew accommodations, 110; crew size, 54, 205, 223, 224; deckhands on (*see* Deckhands); design of, 171, 224; docking tugboats, *168*, *169*; "drill" tugboats, 76; durability of, 59; effectiveness of, 224; engine-room space, 85–86, *204*; engineers on, 91–92, 152, 174; engines on (*see* Engines); firemen on (*see* Firemen); freeboard on, 86; functions of, 1, 80, 82–86, 95, 107; harbor tugboats (*see* Harbor tugboats); helper boats, 32, 33, *108*, 109; "hip" of, 136; Hook boats (*see* Hook boats); hull styles, 35, 91, 224; Kort nozzles, 224, 230; as living places (residences), 174; mates on, 164, 221; offshore (seagoing) tugboats, 110–117, *112–113*; oil company tugboats, 220–221; oilers on, 197; owners of, 51–63, 72, 91–92, 175–176; pilothouses on, 147, 206; power of, 171; quadrantial spheres on, *236*, *237*; rail caps on, 59; railroad tugboats, 142, 152; resistance to using, 45; retirement of, 216; rudders on, 224–224; salvage tugboats, 161, *161*; seagoing tugboats, 110–117, *112–113*; seamanship and, 2; seaworthiness of, 161; ship-to-shore communications, 126–129, 162; side-wheel tugboats (*see* Side-wheel tugboats); specialization among, 95, 101, 165; speed of, 111; steering control, 138, 147–149, 154, 224–226; steering wheels, *206*, 226; stevedores on, 59, 97; tow fenders on, 221, *221*; towing bitts on, 4, 86, 117; towlines on (*see* Hawsers (towlines)); tug and barge combinations, *154*, 154–155, 240; twin-screw tugboats, 77, 221, 226; watch schedules on, 38, 242, 254n16.5; Z-drive tugboats, *228–229*, 228–230, 233

Turecamo Coastal & Harbor Towing Corporation, 189, 215, 220

Twin-screw tugboats, 77, 221, 226

Underwriter (tugboat), 47, 74

Union Army, 72–74

Union Navy, 65–72

About the Author

George Matteson has operated tugboats since 1979, most recently as president and master of the *Spuyten Duyvil*, a sixty-five-foot tug engaged in general towing. He has also worked as waterfront manager at the South Street Seaport Museum. He is the author of *Draggermen: Fishing on Georges Bank.*